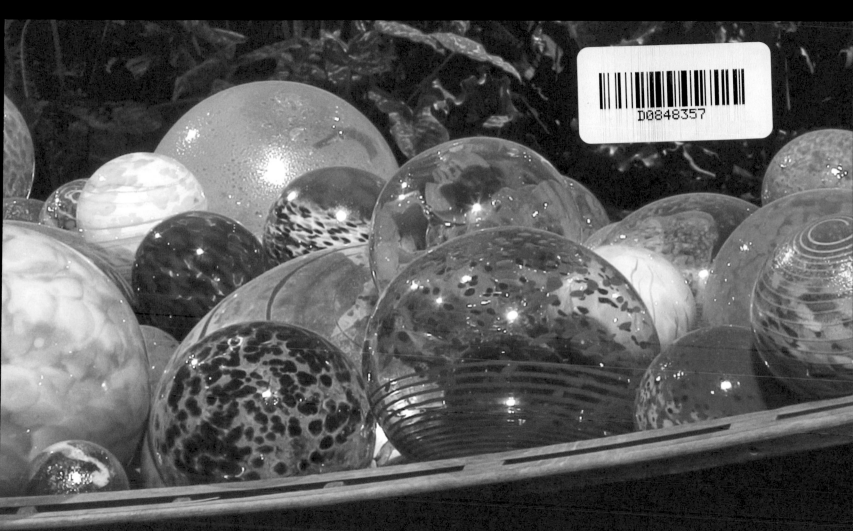

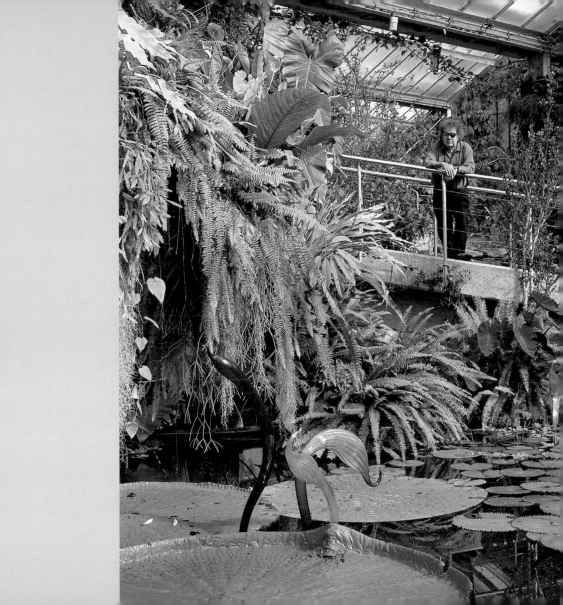

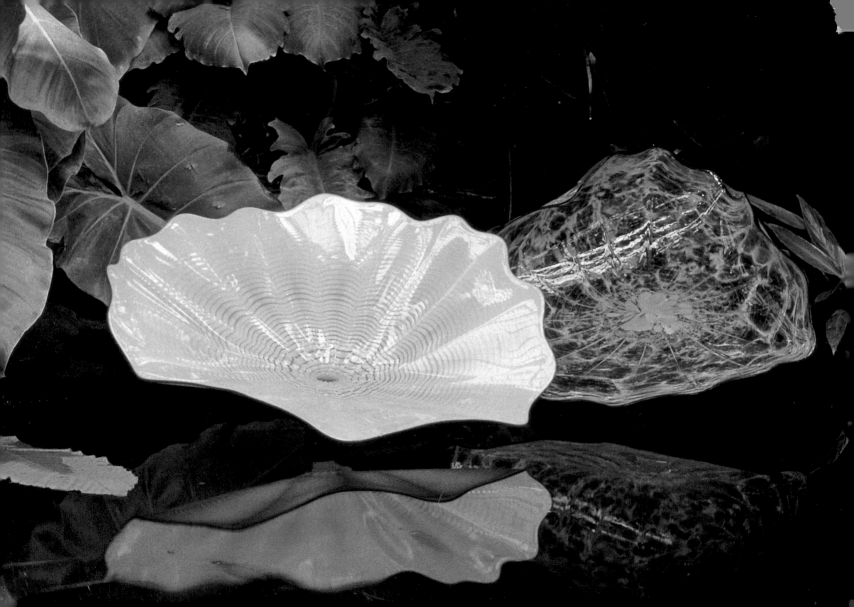

Dale Chihuly

365 Days

ABRAMS, NEW YORK

I started working with glass in 1962, and during that time I was getting a degree in interior architecture in Seattle. I went to work as a designer for John Graham, which was the largest architectural firm here, but I worked with glass a lot during this period.

I started by fusing bits of glass together and then started weaving bits of glass into tapestries, because I was very interested in weaving and was taking a lot of weaving courses. About the time I graduated, I applied for a Fulbright in weaving to go to Finland. I received the Fulbright, but was turned down by the host country because I didn't have a place to go to study. So when I applied for a Fulbright two years later, to go to Italy to study glassblowing, I wrote all the factories in Italy. Only Venini said I could come—probably I got the Fulbright because of that. Had I gotten the original Fulbright, I might have ended up being a weaver.

Weaving with Fused Glass, **1965, 48 x 66 inches**

Chihuly at the Venini Fabrica, Murano, Italy, 1969

One night I melted a few pounds of stained glass in one of my kilns and dipped a steel pipe from the basement into it. I blew into the pipe and a bubble of glass appeared. I had never seen glassblowing before. My fascination for it probably comes in part from discovering the process that night by accident. From that moment, I became obsessed with learning all I could about glass.

Uranium Neon Installation,
in collaboration with James Carpenter, 1971,
glass, neon, argon, 15 x 15 x 15 feet

2

Chihuly and James Carpenter, Venice, Italy, 1972

At the time I came to Venice in 1968, glass artists in the United States worked by themselves. I realized that if you worked with half a dozen or more people, you could achieve things you could never do alone. In 1969, at the Rhode Island School of Design, I started working with my students as a team. And now I have a really big team, and access to the best glassblowers in America and Europe as well.

Glass Forest #2, in collaboration with
James Carpenter, 1971–72,
glass, neon, argon, 500 square feet.
Rhode Island School of Design, Providence

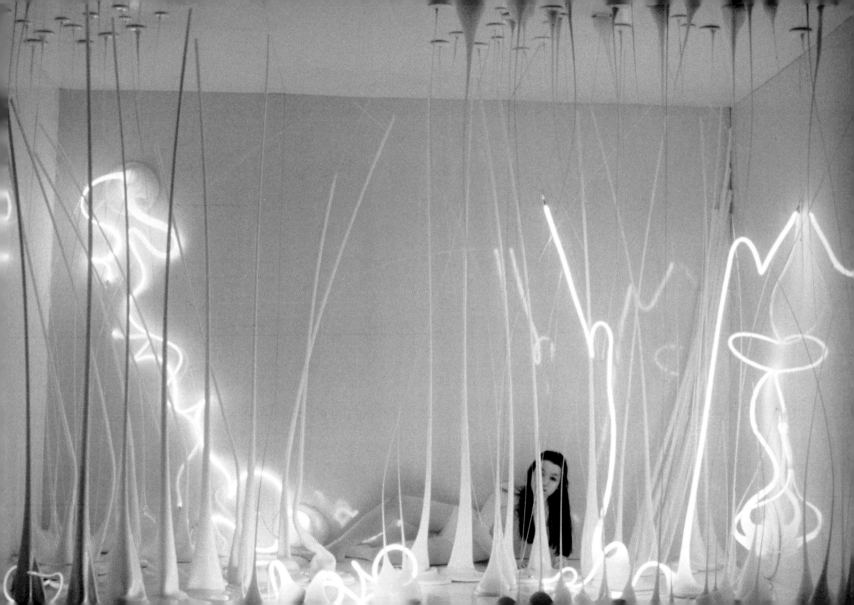

In 1971, some friends and I started Pilchuck Glass School, which was an experimental glass workshop in Stanwood, north of Seattle. The first pieces of glass that were made at Pilchuck were a series of "floats" that Jamie Carpenter and I blew together and sent off like soap bubbles to sail in the pond behind the glass shop.

Glass Forest #1, in collaboration with James Carpenter, 1971–72, glass, neon, argon, 500 square feet. Museum of Contemporary Crafts, New York

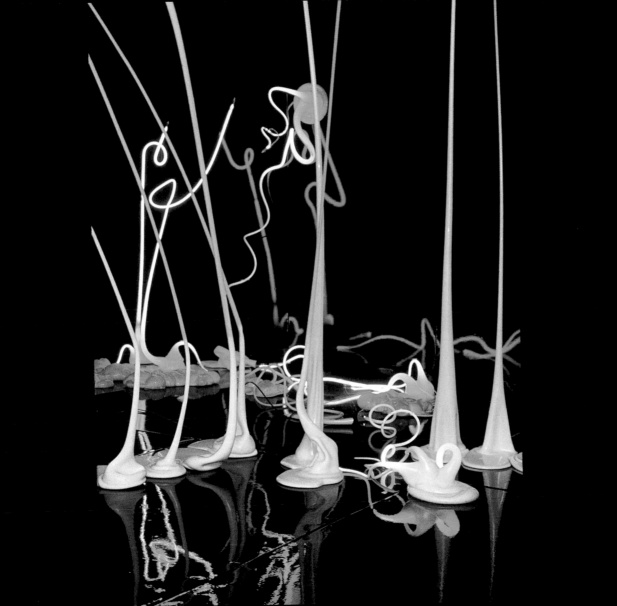

Working on Shaare Emeth Synagogue windows,
Providence, Rhode Island. 1980

If one is looking at a stained-glass window, the window usually doesn't look as colorful when there is a bright blue sky in the background as it does when it's foggy.

Niagara Gorge Installation,
in collaboration with Seaver Leslie, 1975.
Artpark, Lewiston, New York

5

I was at the Rhode Island School of Design for about twelve years. During that time I had dozens of great students, many of whom now are at the top of the glass world. It was one of those situations of being in the right place at the right time, which for me was the right school. Maybe I sensed that this was a time for glass, and a time for a school to do well with glass.

Artpark Installation #4, 1975, in collaboration with Seaver Leslie

With Erwin Eisch and a student, 1972. Pilchuck Glass School,
Stanwood, Washington

If students could spend enough time with the glass, I knew their talent would ultimately surface. Instead of handing out assignments along conventional lines, I asked them to come up with projects and ideas of their own. Then I let them develop the skills necessary to execute their personal vision by having them work alongside the most accomplished visiting artists I could find.

Irish Cylinder #38, 1975, 10 x 8 x 8 inches

I use glass-thread drawings inspired by Native American textiles on the sides of many of my *Cylinders*. Carefully laid out in an intricate design, colorful threads are fused onto the vessel while it is in its molten stage. This is known as the "glass pick-up drawing" technique.

Irish Cylinder #25, 1975,
10 x 8 x 8 inches

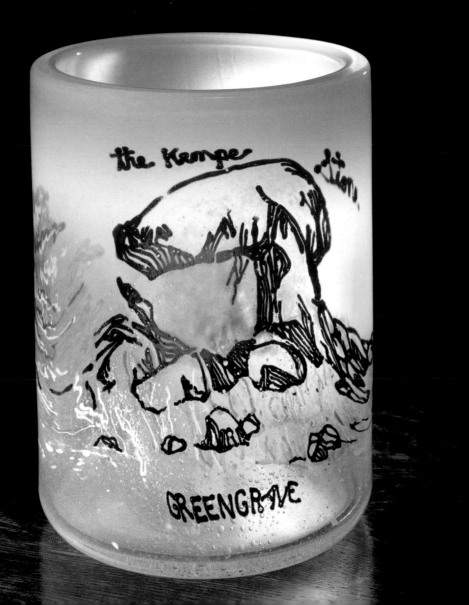

Navajo Blanket Cylinder process, 1975. Rhode Island School of Design, Providence

I worked with glass from 1962 to 1976—fourteen years—without ever really selling anything. I sold a few things in the very beginning, like at a craft fair or something when I was just starting, a few tapestries, a few bottles. But for all intents and purposes, I really sold nothing for fourteen years.

Irish Cylinders #26 and #17, **1975**

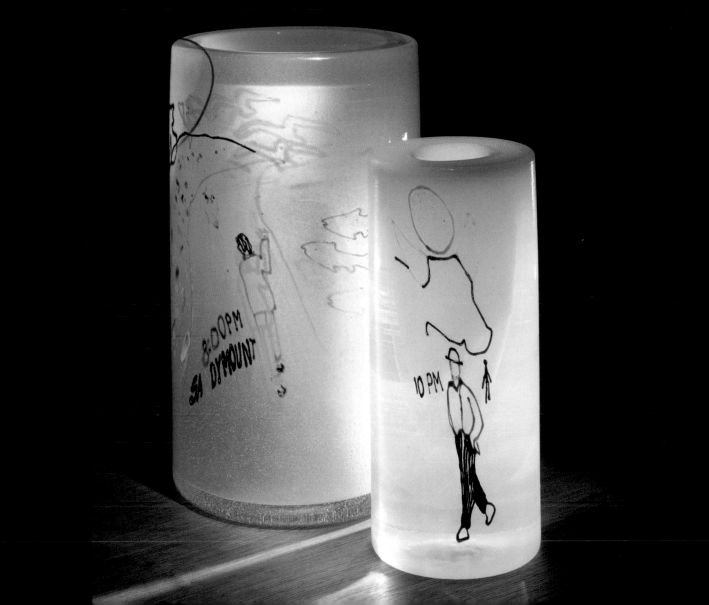

Kate Elliott learned how to bend the threads with a small torch to make curves, and the blanket designs became more complicated. I became very interested in barbed wire, because it had been invented around the same time as the most beautiful Navajo blankets were being woven. Kate was actually able to bend glass threads to make glass barbed wire by knotting it in the same way in which real barbed wire was constructed.

Irish Cylinder #27, 1975

10

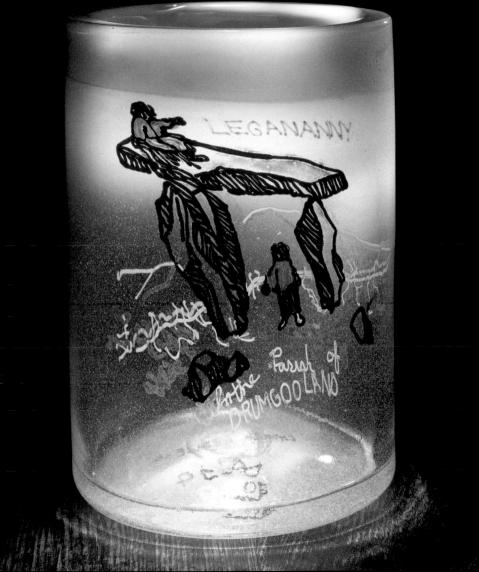

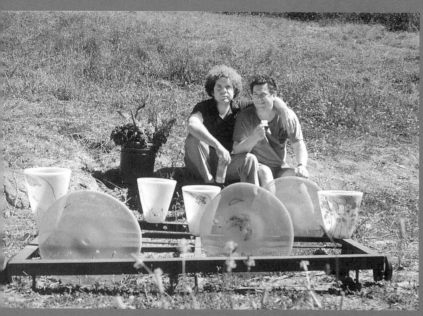

Chihuly with Italo Scanga, 1974. Pilchuck Glass School, Stanwood, Washington

We started using optical molds—ribbed molds that we would blow the glass into, and then the *Baskets* started looking like shells. It was really an accident, that they started looking like shells, as I recall. But as soon as I saw that the *Baskets* began to look like shells and things from the sea, I pushed the idea of the transparency of the glass and the sea and that connection became important to me.

***Pilchuck Baskets*, 1979. Stanwood, Washington**

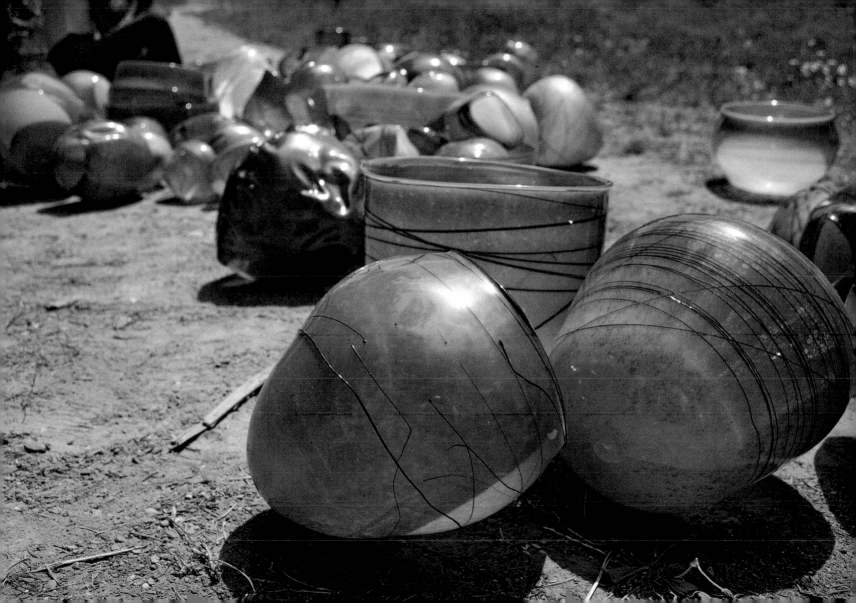

I'm drawing, you know, fifty pencils in each hand. And I draw over glass or over rice or beans. My mother used to watch me draw and she'd just shake her head and walk away, wondering what the hell I was doing.

Seaform Basket Drawing, 1982,
22 x 30 inches

12

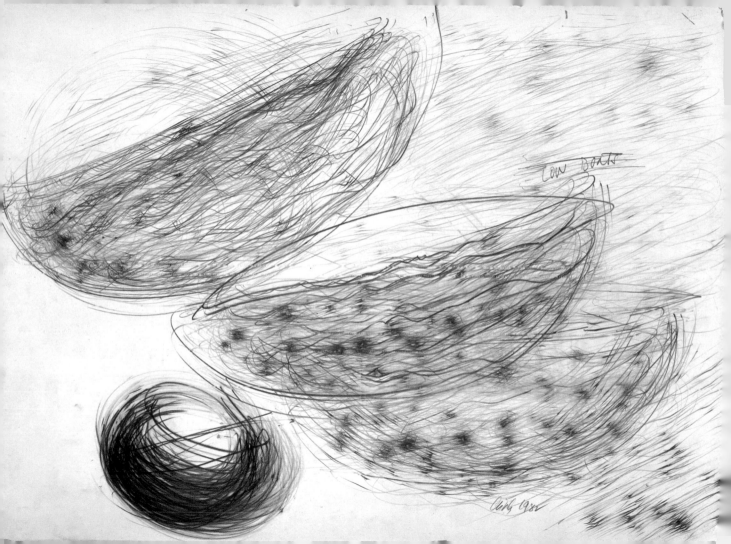

I don't know how I started with the idea of the pencils. I'm sure that it started because I was making a drawing and there were a dozen pencils lying there and I wanted to fill in some part of the drawing.

13

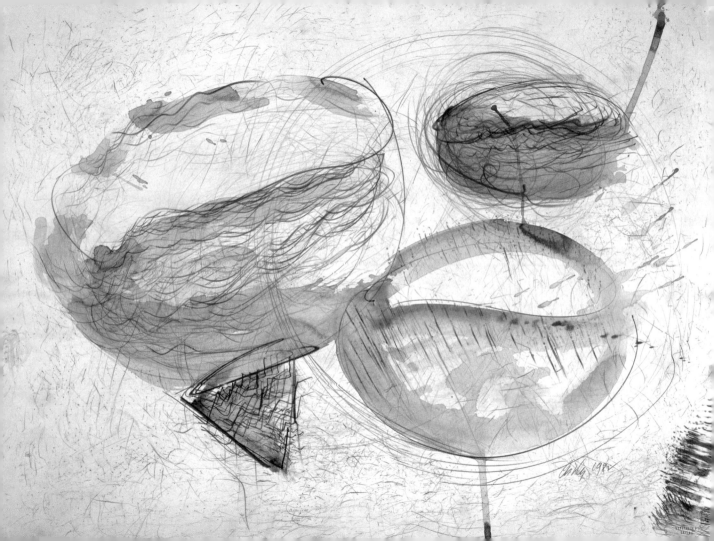

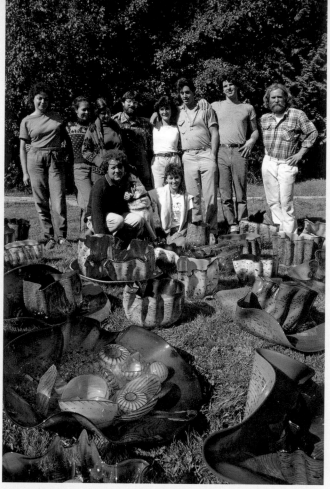

Pilchuck Team, 1983. Stanwood, Washington

Every summer we went back to the Pilchuck Glass School. It was kind of a school, but more than anything it was a place where we developed ideas and experimented—back when we really didn't care about sales or anything like that. So nothing held us back from doing a lot of experimentation.

Macchia **on the grass at Pilchuck School, 1983.**
Stanwood, Washington

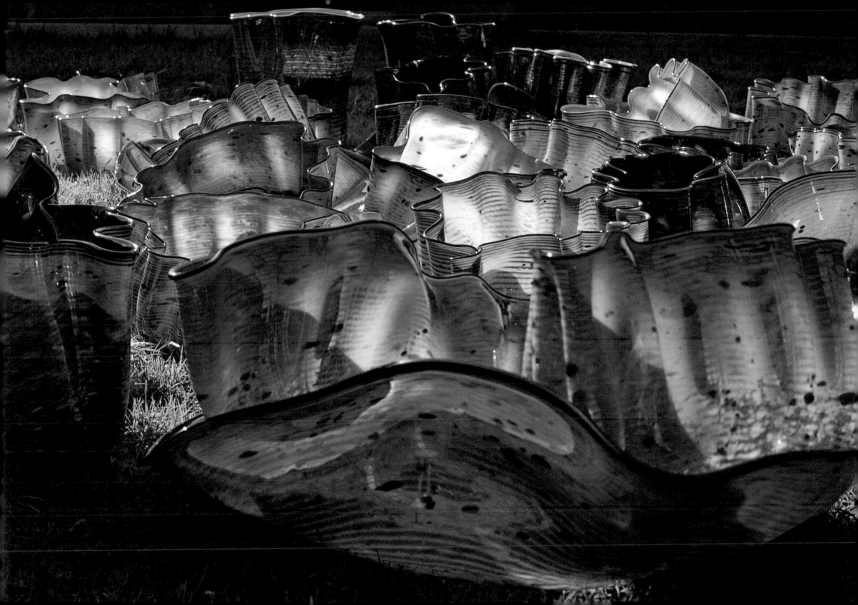

The drawings on the *Cylinders* are very spontaneous and molten and rely on chance and gravity, like the work that followed. Those drawings are very much in the fashion that I like to work, which is quick and immediate and spontaneous, with an element of chance.

Sky Blue Soft Cylinder with Drawing, 1984,
10 x 12 x 12 inches

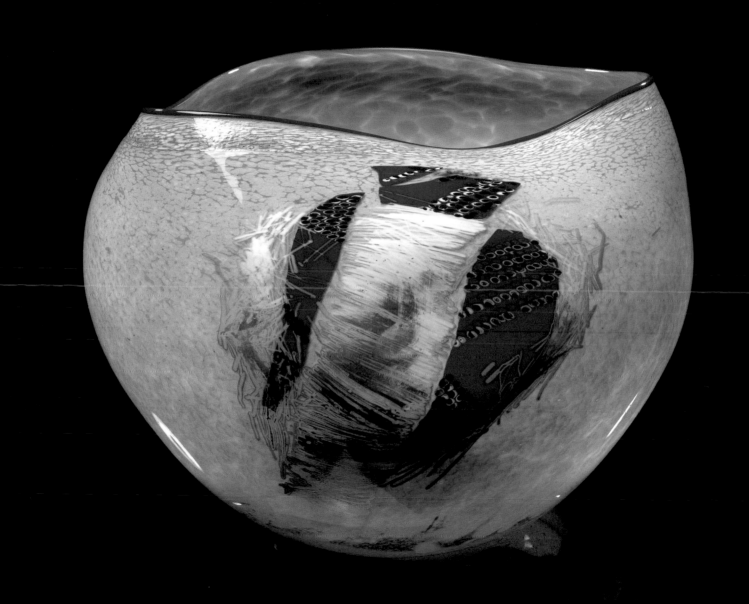

In 1981, I began the *Macchia*, or "spotted" series, which have contrasting hues on their interiors, and exteriors separated from the interiors by a layer of white glass "clouds" so that the elements do not blend. A lip wrap of yet another color highlights the opening of the vessel.

Amethyst Macchia Set with Slate Lip Wraps, 1984

16

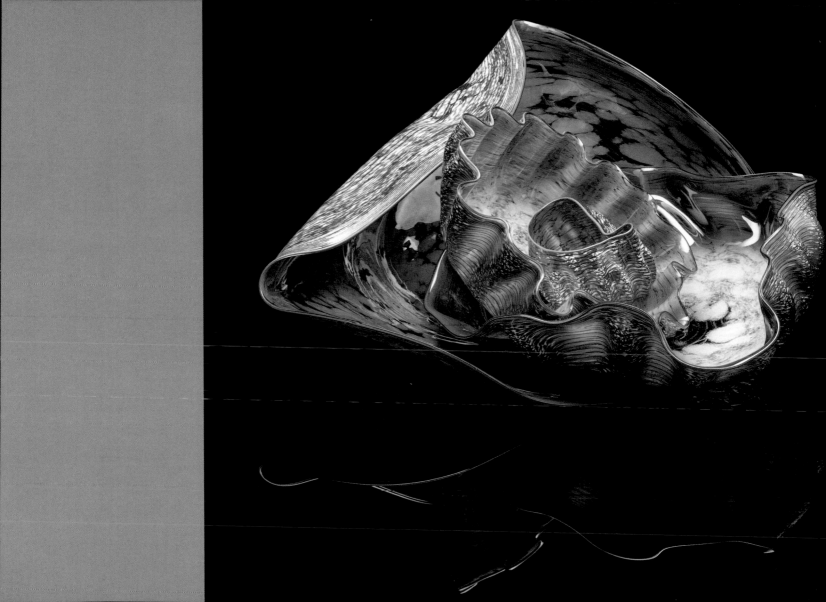

Dale Chihuly and William Morris at Pilchuck Glass School, 1983. Stanwood, Washington

I moved back to Seattle officially in 1982. From the beginning, I wanted to find a studio on Lake Union, but I couldn't find anything. Lake Union is a "working lake" that serves the fishing and boat building industries. I got lucky—Pocock, a famous boat builder, was selling his business and building. I was fortunate to be able to take over the building, which I call "The Boathouse."

Pale Pink Seaform Set with Ruby Lip Wraps, 1981

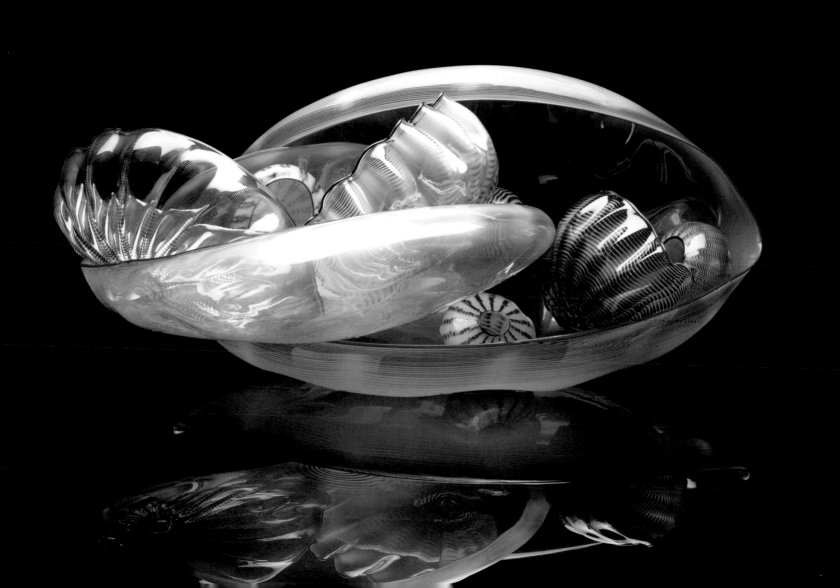

My basic teaching philosophy had already been established. It was quite simple and founded on the theory that if you got the best artists to come to Pilchuck, they would attract the best students. I always expected students to work independently and didn't give assignments. I preferred the European atelier example, where students are more like apprentices. They assist the master artists and craftsmen, and then they are given time to develop their own skills and usually assist one another when necessary.

Marine Blue Cylinder
with Royal Blue Lip Wrap, 1984

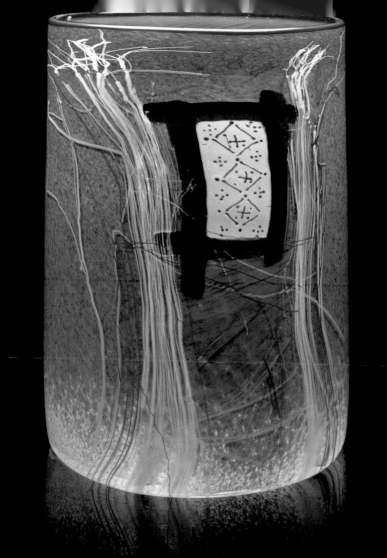

Pilchuck team, 1985. Stanwood, Washington

The original concept behind Pilchuck was that people would assist the faculty, work together, and collaborate on projects. It's changed over the years. It's now an international glass center where we have thirty faculty during the summer, about half of whom come from Europe. We have 200 students and at any one time there are seventy-five or eighty people at Pilchuck. There are two- or three-week sessions where people learn about stained glass or glassblowing.

Charcoal Persian Set, **1989**

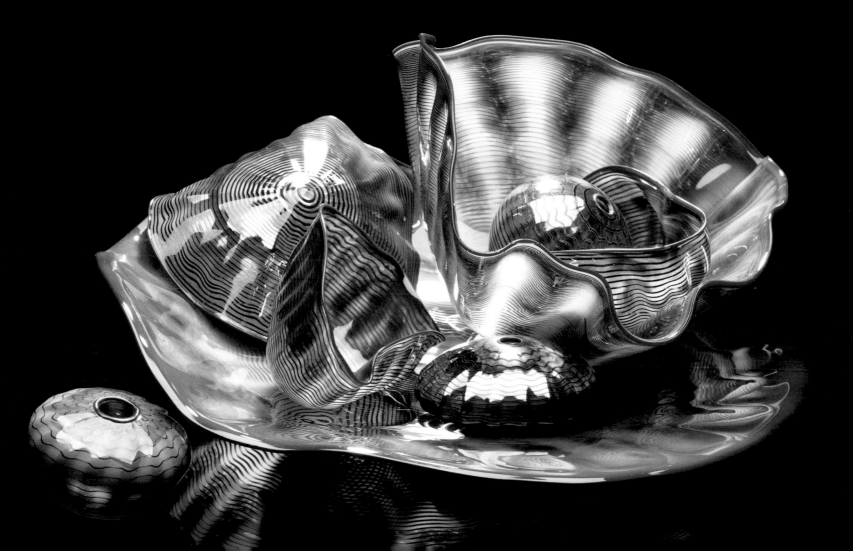

The *Basket* series metamorphosed into *Seaforms* in 1980. More delicate and thin-walled, and made up of subtler blues, pinks, and grays than the *Baskets*, the *Seaforms* conjure up underwater life but do not imitate it. The use of optic molds in the glassblowing process creates ribs that increase the strength of the thin-walled glass, and thin lines of color, known as "body wraps," emphasize their undulating form. Like the *Baskets*, they are often grouped together into sets.

*Pearl White Seaform Set
with White Lip Wraps*, 1984

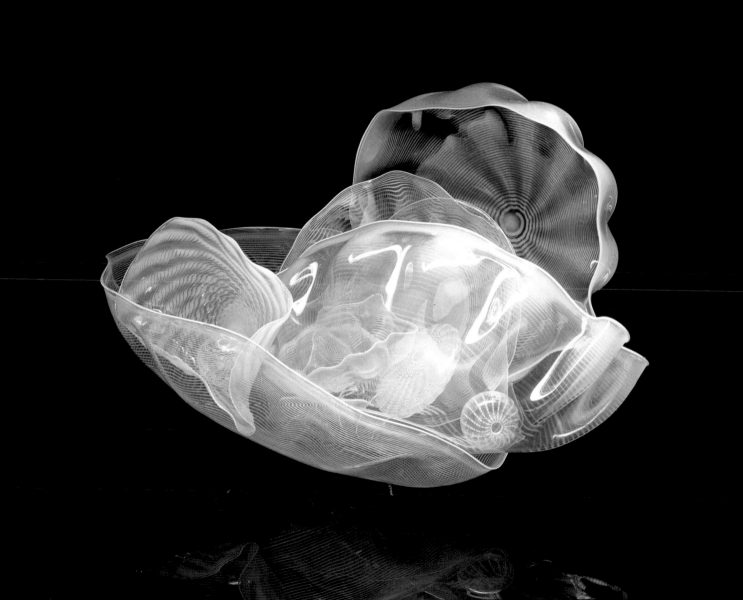

I just liked the name "Persian." It sort of conjured up the Near East, Byzantium, the Far East, Venice—all the trades, smells, senses. I don't know; it was an exotic name to me, so I just called them *Persians*.

Olive and Oxblood Persian Set, 1987

21

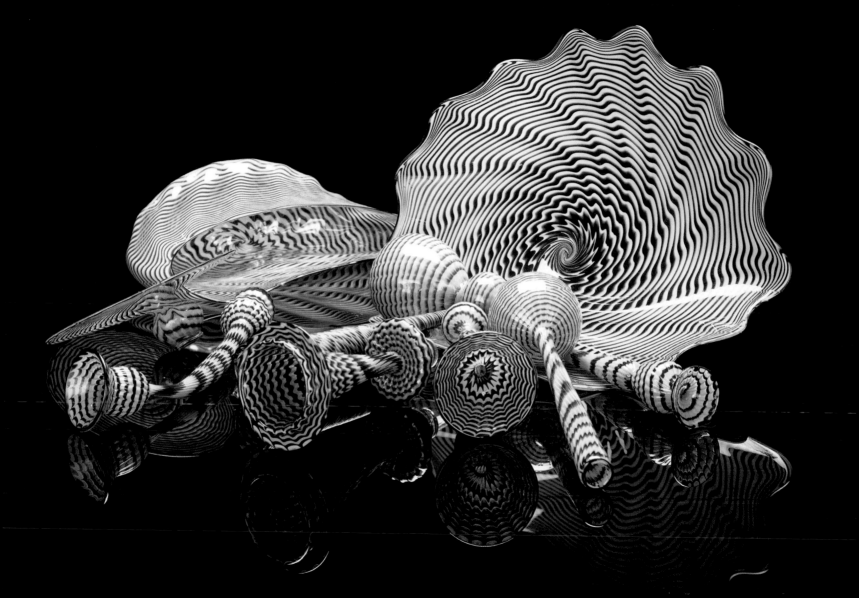

All you have to do is blow glass once and you want to become a glassblower. It's so magical.

Experimental Persian forms, 1986

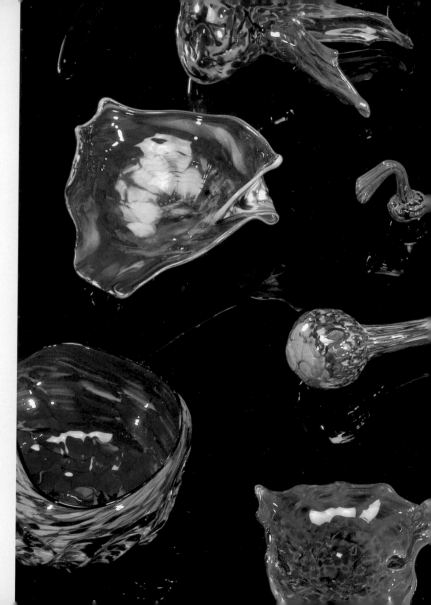

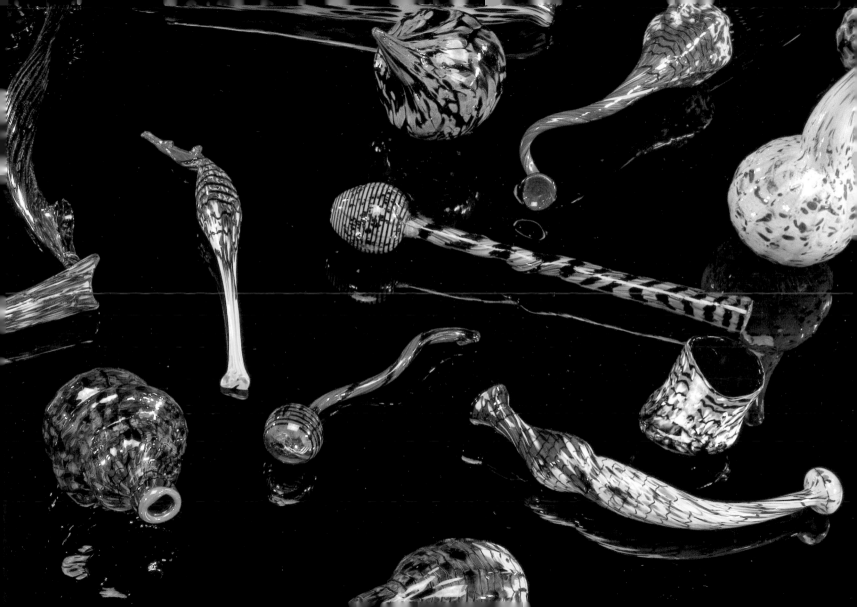

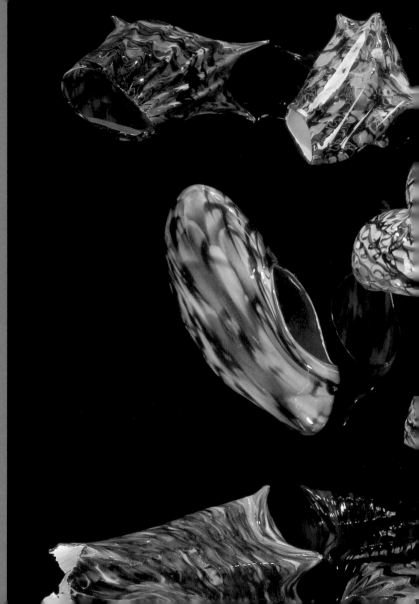

It's important that we lose pieces. You get there faster, I think, by losing pieces, because you're pushing yourself and you know how far to come back.

Experimental Persian forms, 1986

23

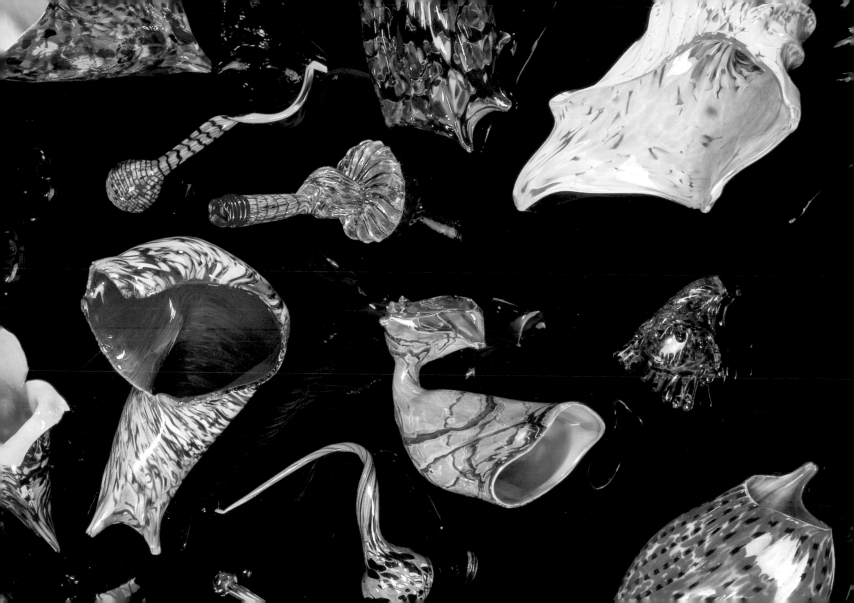

In order to start at four o'clock, I used to get up at two, think about what I wanted to make, make some drawings, if necessary. Mostly think. Have a cup of tea. And so I would get down there, to Pilchuck, about three o'clock, before anybody. Then, soon after, people would start coming in, we'd start cranking up the shop, lighting the glory holes, getting the color ready. And by four o'clock, we'd be working.

Now the issue of what I am—am I a craftsman? A designer? An artist? Or just what am I?—This issue is much less important to me today. To be really honest, I don't care what they call me, or my work, as long as they look at it.

Windsor Green Cylinder with
Cobalt Violet Drawing, 1984, 6 x 4 x 4 inches

You don't teach art, that's the last thing you'd ever teach—how to make art. All you have to do is set up the environment and it happens.

Cerulean Blue Soft Cylinder
with Lavender Alizarin Drawings,
1986, 10 x 10 x 9 inches

25

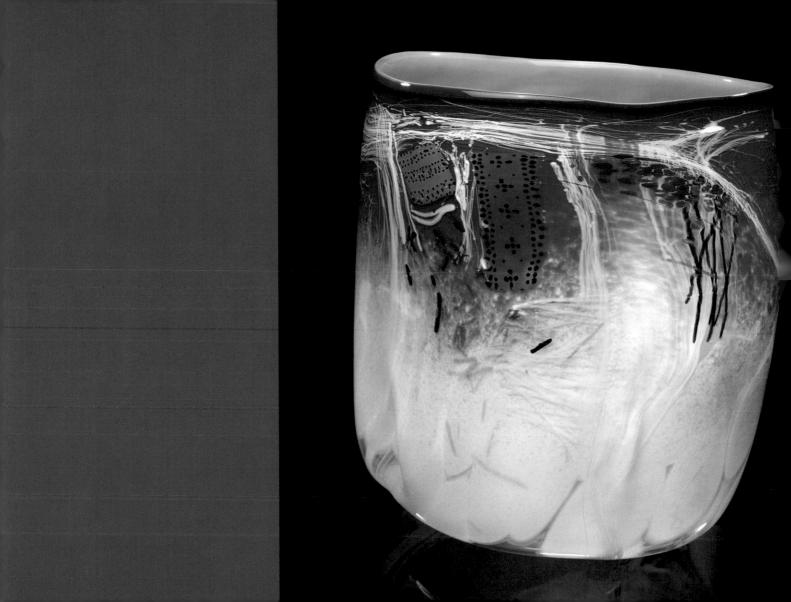

I don't know what it is about drawing. It is a very physical thing. You get into it. It's like a workout—
you start sweating and working with it. The bigger the drawings are, the more physical they are.

Venetian Drawing, 1988,
22 x 30 inches

I saw a great collection of Art Deco Venetian glass in a Venetian palazzo in 1987 that I'd never seen before, and I was stunned at how unbelievably innovative and beautiful these pieces from the 1920s and 1930s were. I thought when Lino Tagliapietra came next summer, I would have him make these for me. I would pretend that I was a designer in the 1920s and make these eccentric pieces with reds and blacks and golds and greens—and handles. Within about a day of doing these pieces, I started making them more eccentric and more bizarre and less Art Deco and using any sort of source I could. You can see the progression very simply from the drawings: from classic Art Deco pieces to more radical pieces with horns and snouts and flowers and big handles coming out of them. So the series, within a few days, changed from being something I was going to replicate to something with a life of its own.

Cobalt Blue and Naples Yellow Venetian,
18 x 21 x 10 inches

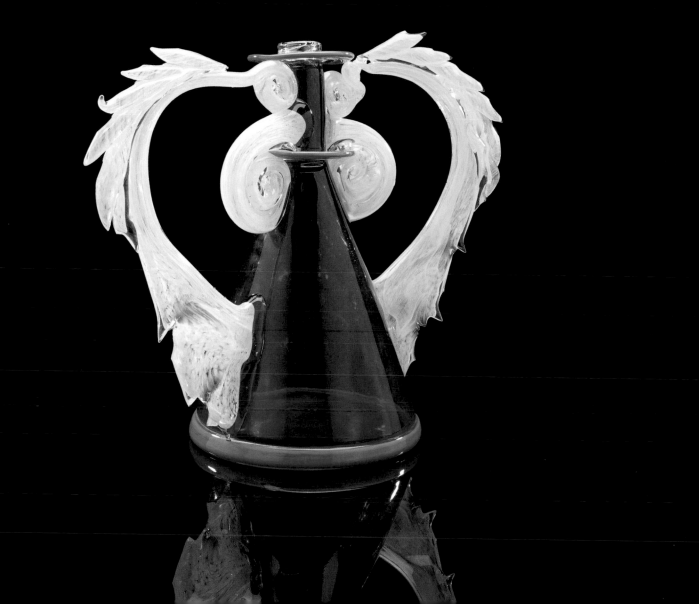

Chihuly drawing, 1990, Seattle, Washington

One of the big differences between the Venetian series and my earlier work is that in these pieces the form is made and then things are added to it. I never made additions before this, nor had any of my crew.

Gold over Cobalt Venetian #140,
1989, 22 x 12 x 11 inches

28

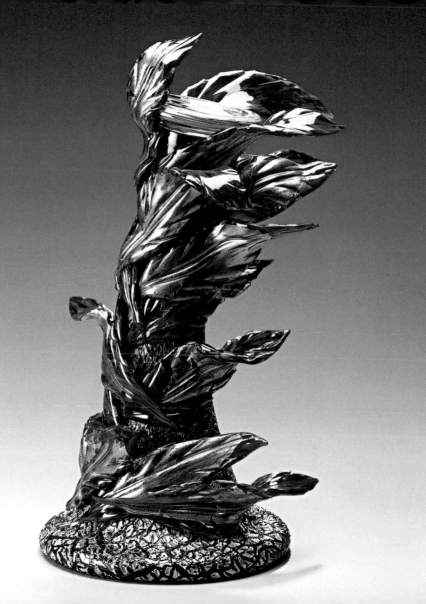

Prunts are small pieces of glass fused to the main body of a glass work and are then shaped or pressed, for decoration. They can also be used to afford a firm grip in the absence of a handle.

Purple Venetian with Banana Prunts,
1989, 10 x 12 x 12 inches

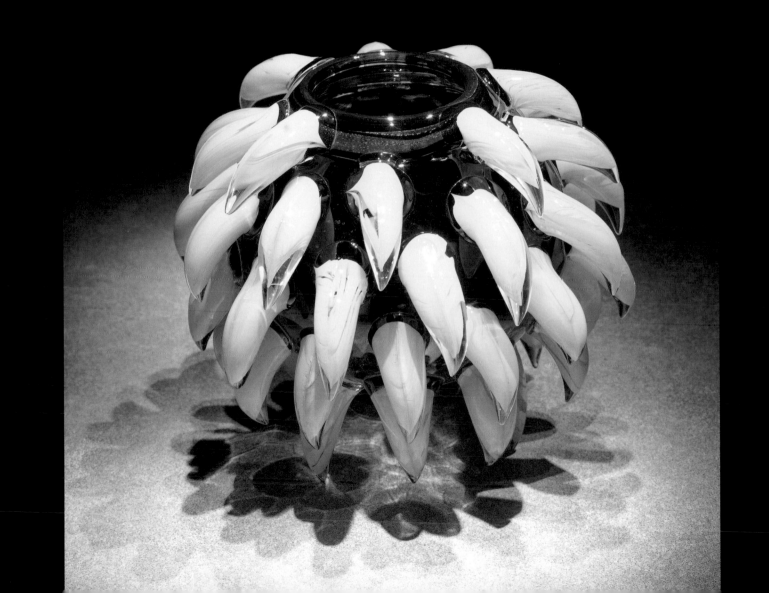

In the first three weeks of blowing glass, I made one vase, and then I never made another for years. Instead, I made sculptures, combining materials such as metal with glass slumped over it. My first show at the Attica Gallery in Seattle in the late 1960s was all sculptural, using mixed materials and glass.

Cobalt and Light Blue Venetian,
1989, 26 x 15 x 14 inches

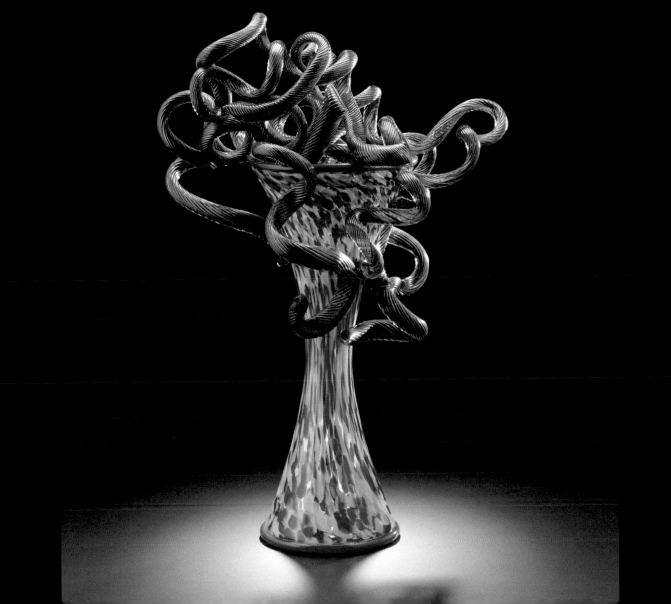

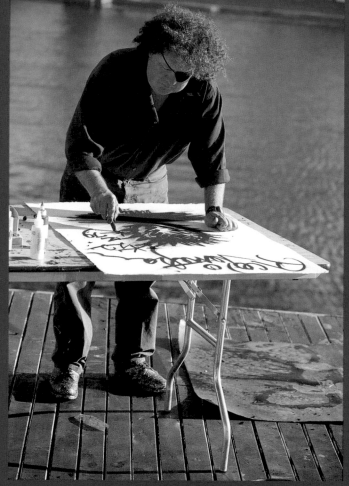

Chihuly drawing, 1994. The Boathouse deck, Seattle, Washington

A lot of creativity comes from Lino Tagliapietra and the other people on the team. All I have to do is make a drawing, put it up on the wall next to the furnace, and Lino interprets it in his own way.

Vermilion Venetian, **1989,**
17 x 15 x 15 inches

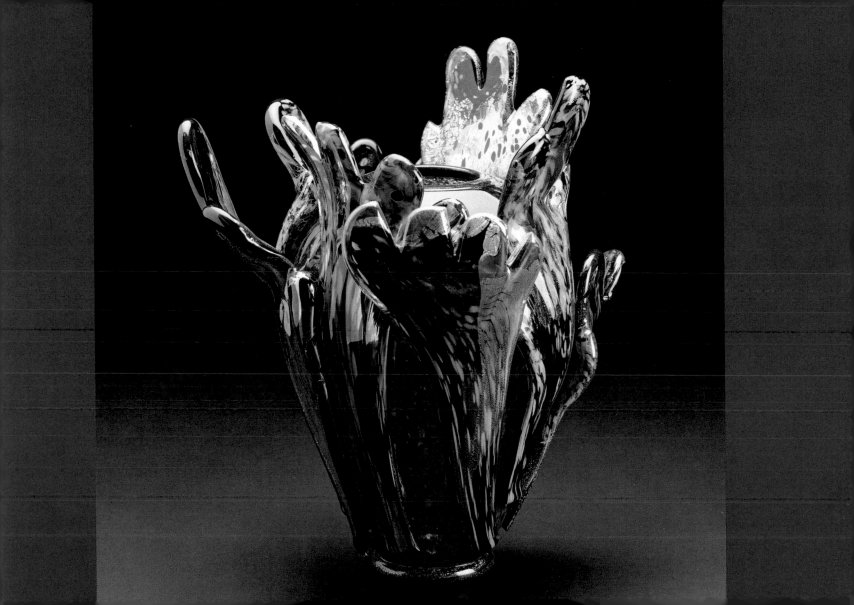

I'm not the type of artist whose work evolved over a logical progression. It's not the way I work. I work on some series that you might say evolve, but then there will be something very fresh and new that appears which might not make any sense. I like that. I like to be motivated by new things. If I had to do the same thing all the time, I would get bored out of my mind.

Gold Over Cobalt Venetian,
1989, 22 x 12 x 12 inches

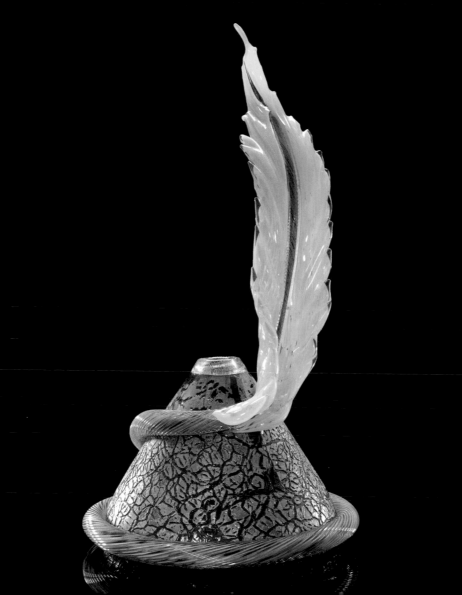

Glassblowing is a little like making a drawing, or the way that I draw anyway, which is very spontaneous, fast, immediate. I don't work it over. I do the damn thing and get it over with. I don't go back in and work on it. I'd rather just start over. Same with the glassblowing. Make the piece, get it done and finish it. You just have to go with this wonderful material the way it wants to go.

Venetian Drawing, 1989

33

Drawing really helps me to think about things. Because I don't blow glass anymore, maybe I get a little frustrated—I'm not as hands-on as I used to be. So I'm able to draw and work with a lot of color and that inspires me. Maybe it inspires the glassblowers too, to see me back there working on ideas. I rely very heavily on them to look at the drawings and on the gaffers—the head glassblowers—to see things in the drawings and to talk about it—sort of a symbiotic relationship that goes back and forth.

Venetian Drawing, 1990,
22 x 30 inches

34

No Serpents

Same

8 fins

K3 gold pink
K99 adventurine
fins

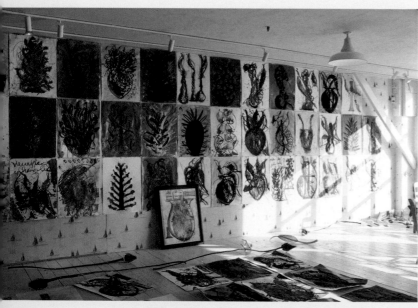

Venetian Drawing Wall at the Boathouse, 1990.
Seattle, Washington

I often think that had I not been a sculptor or an artist, I might have liked being a film director or an architect.

Clear Venetian with Gold Leaf,
1989, 17 x 19 x 19 inches

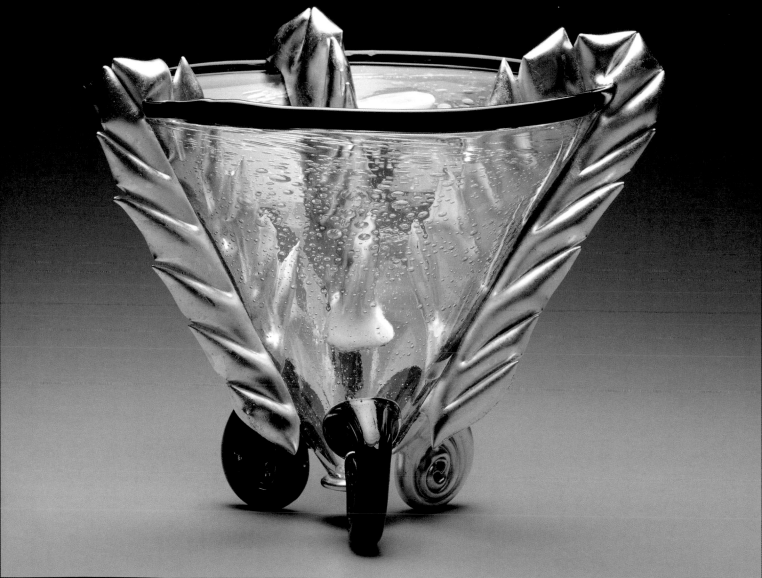

Most of the work I did in the first ten years wasn't very salable, even if there had been a system or some way to sell it, because a lot of it was environmental and temporary, and I used a lot of ice and neon.

Yellow Green Venetian,
1990, 47 x 12 x 9 inches

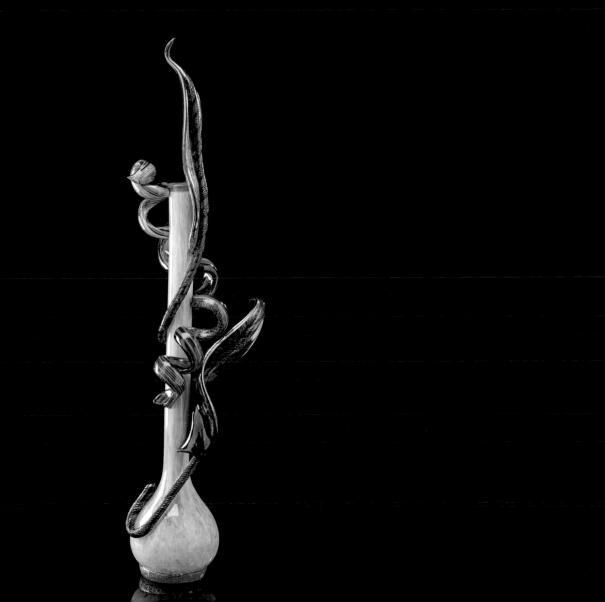

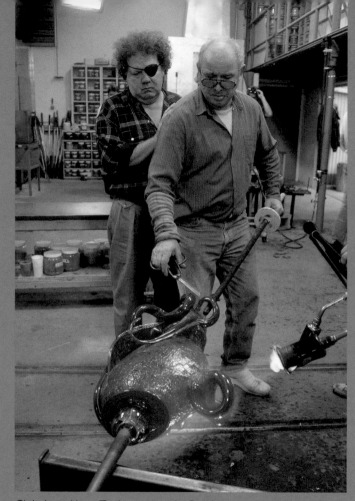

Chihuly and Lino Tagliapietra at the Boathouse, 1991.
Seattle, Washington

With Dale's *Venetians*, the mental spirit
was totally different. They are inspired
by Venetian influence—a mixture of two
cultures. But they are more American than
Venetian—this is important.

Lino Tagliapietra, *Chihuly and the Masters
of Venice*, video directed by Ken Samuelsen,
Michael McCallum, and Peter West; produced
by Portland Press, 2001

Deep Green Venetian,
1990, 25 x 22 x 19 inches

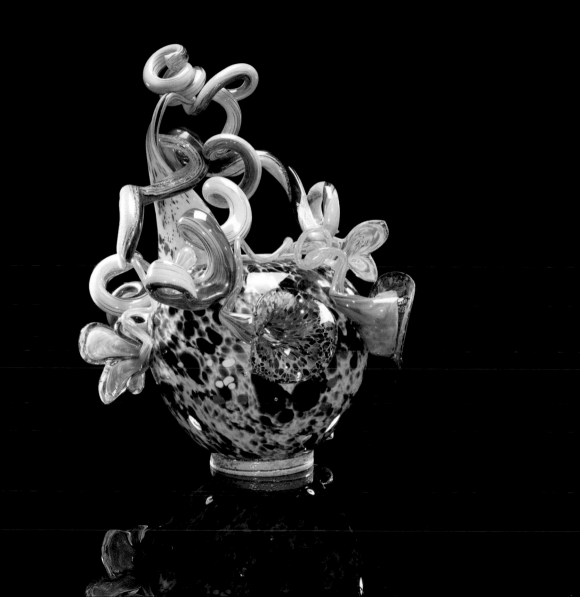

The more I drew, the more I liked it. Sometimes the drawings would be about the glass; sometimes they'd just be drawings, a way to release the energy, or a way for my mind and body to be creative while the glassblowing was going on.

Venetian Drawing, 1990,
30 x 40 inches

Unlike many sculptors' drawings, Chihuly's do not function as designs for future pieces or as documents of completed works. Rather, they are an ancillary and independent activity—a two-dimensional record of the spontaneous process of glassblowing that has been Chihuly's aesthetic focus for over twenty years.

Henry Geldzahler, *Dale Chihuly: Glass*,
Taipei Fine Arts Museum, Taiwan, 1992

Venetian Drawing, 1990,
30 x 22 inches

Red

Black
slugs
with gold
leaf & green
black mix
with gold leaf.

Slug piece
slugs on about
2/3 of form.

Somebody once said that people become artists because they have a certain kind of energy to release, and that rang true to me. That's really why I draw.

Cadmium Yellow Venetian,
1991, 17 x 13 x 13 inches

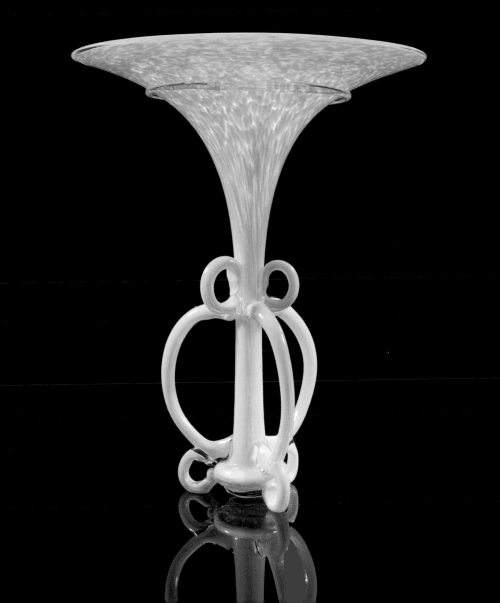

Lino Tagliapietra, Chihuly, and team, 2006.
Tacoma, Washington

With Dale I breathed freedom—the freedom of
doing and doing. Dale is truly a great master,
because he doesn't teach how one must do
things in terms of technique, but he pushes
people to do their best, which requires one to
look inside and do for him the very best work. It
is hard to beat this!

Lino Tagliapietra, *Chihuly and the Masters of Venice*,
video directed by Ken Samuelsen, Michael McCallum,
and Peter West; produced by Portland Press, 2001

*Chartreuse and Black Venetian with
Orange Coil*, 1991, 30 x 13 x 12 inches

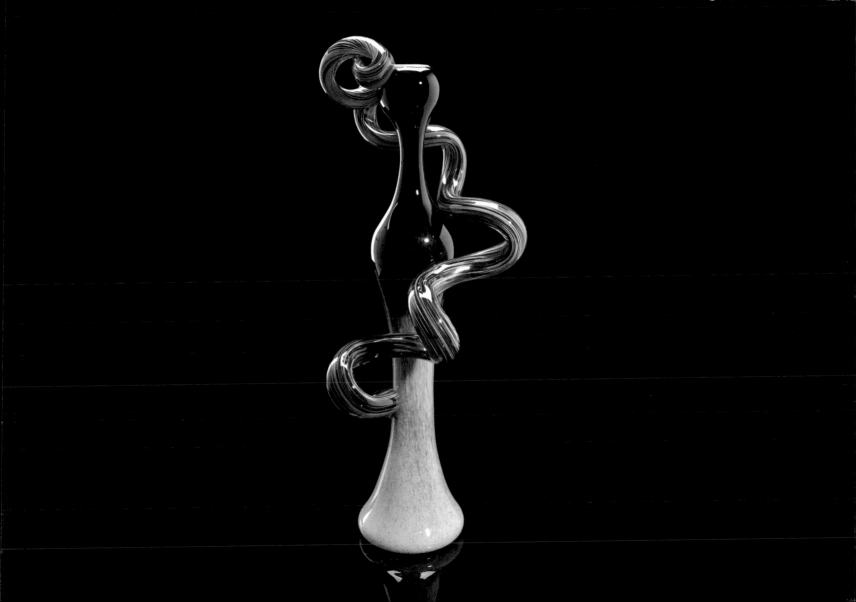

I love Venice and their culture of glass, so the idea of a *Venetian* series made a lot of sense. I was lucky to have not only Lino Tagliapietra, one of the really extraordinary glass masters of the world, but also Ben Moore, a great gaffer—head glassblower—from Seattle. We put anywhere from twelve to eighteen glassblowers together, primarily from Seattle, to make the most extreme pieces that I could imagine and that they were willing to try to do.

Cerulean Blue Venetian with Violet Leaves,
1991, 25 x 19 x 12 inches

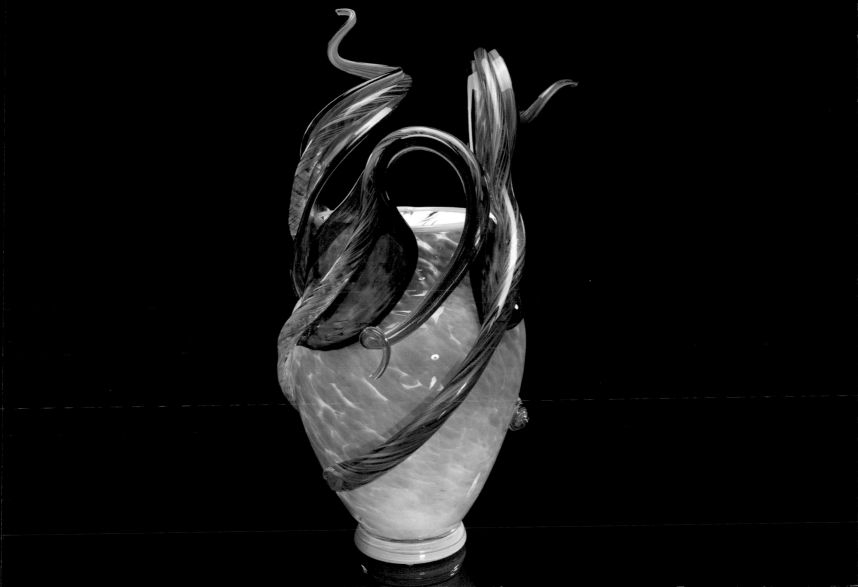

When I quit blowing glass, I would do a lot of drawings, and they related pretty much to the glass. Then, over the years, I just started to like making drawings—so now sometimes they'll relate to the glass and sometimes they won't.

Venetian Drawing, 1991,
30 x 42 inches

43

I don't think much about the past. I think more about the future.

N.Y. Lino Blow Venetian Drawing, 1992,
30 x 22 inches

44

You have an idea; it comes from somewhere, and it works. It always comes from deep down. You don't know why you do it; you don't know what makes it work; you don't even know until afterwards, maybe, what happened. It just sort of happened.

Black Basket Set with Sulfur Lip Wraps, 2006, 15 x 35 x 30 inches

45

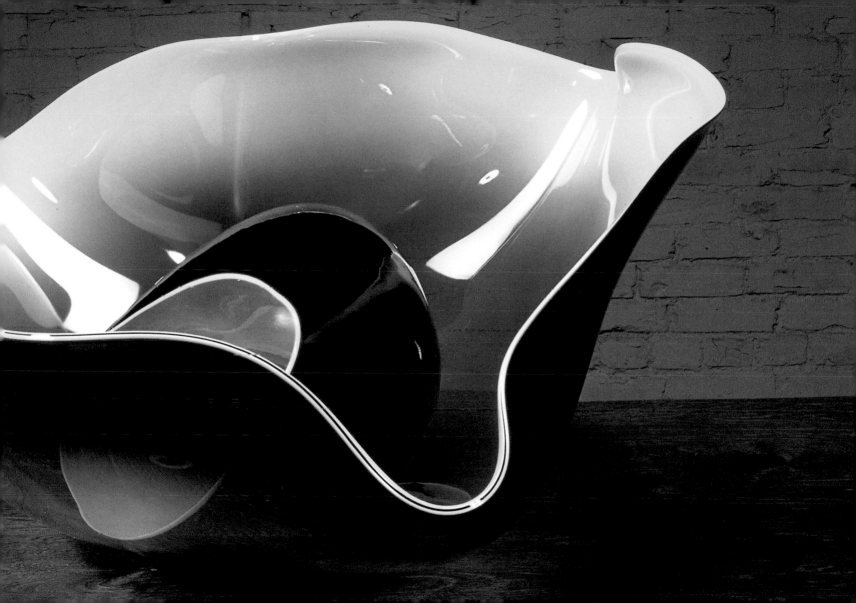

Putti are these little characters, they're male, and they were used in Renaissance and Baroque times, and they were put up in the churches, or in the paintings—they were carved out of wood or made out of plaster. And they were meant to make people feel good. And to get people together...and maybe they were a little mischievous. They were just meant to suggest a good time, and they looked good. And they probably made people think about youth and this was a great symbol.

Putti detail, 1991.
The Boathouse,
Seattle, Washington

46

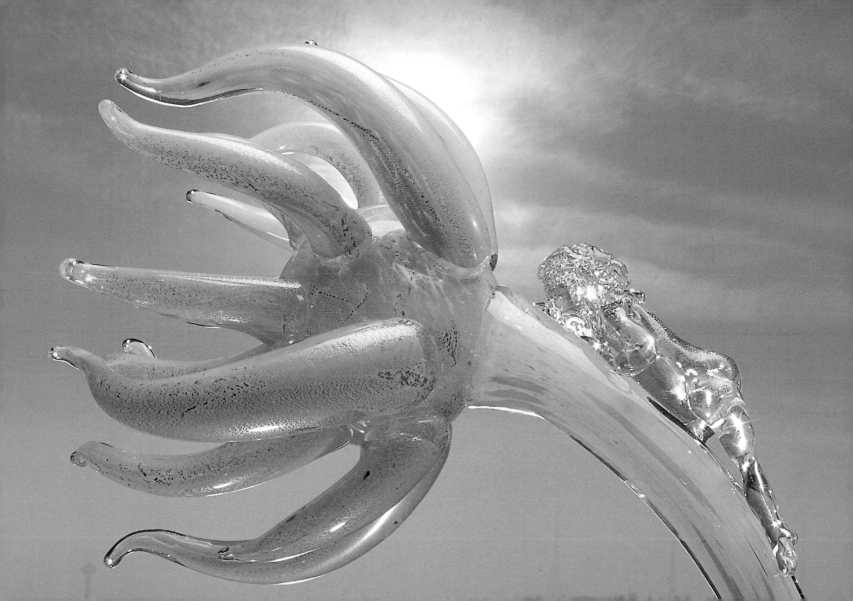

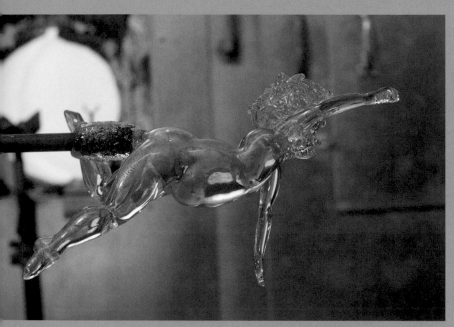

I asked Pino to make a putto and I just loved it in glass.

Putti detail, 1991. The Boathouse, Seattle, Washington

***Putti* detail, 1991.
The Boathouse,
Seattle, Washington**

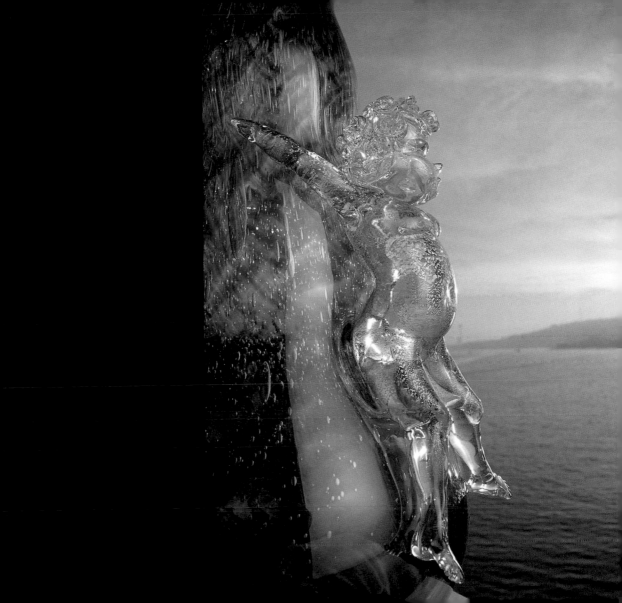

To me, the *Putti* look best made out of glass. I don't know what it is. Maybe it's because you can see through it. They're happier in glass.

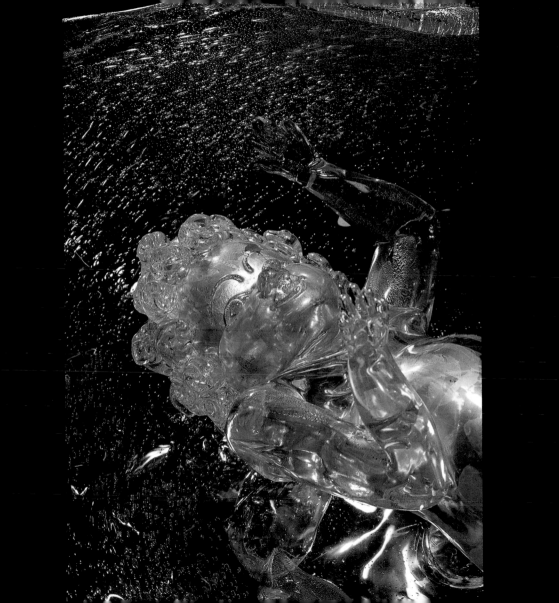

Chihuly drawing, 1991. The Boathouse, Seattle, Washington

The fact is that I can go down and make something that no one's ever seen before, even though they've been making stuff out of glass for 5,000 years.

Acrylic Venetian Drawing,
1991, 30 x 22 inches

49

The *Ikebana* series began as a development of the *Venetians*, when we put long floral stems into the *Venetian* forms. Eventually, we replaced the *Venetian* forms with simpler, over-scaled vases.

May Green Ikebana with Putti Stem,
1991, 50 x 24 x 11 inches

50

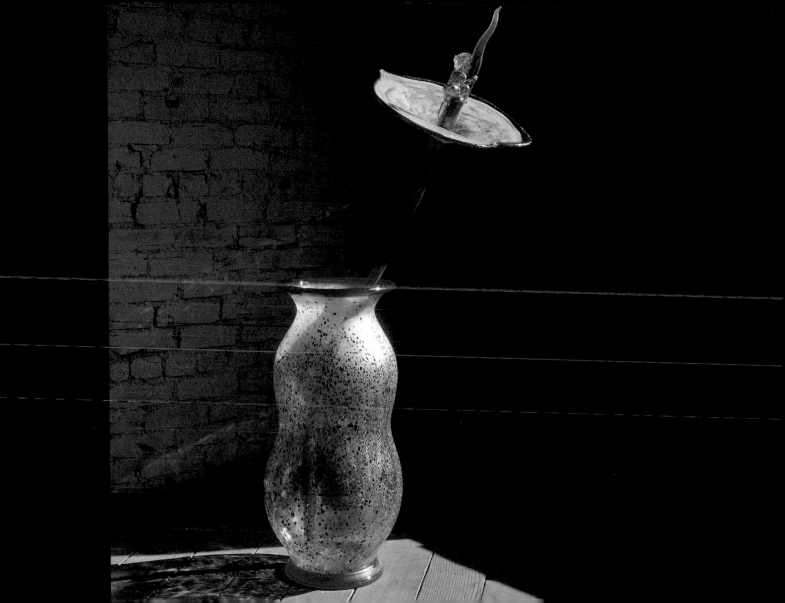

Chihuly's work is American in its apparent vulgarity, its brazenness, and its fearlessness to move farther out west, even if there is no farther west to move to.

Henry Geldzahler, *Dale Chihuly: Glass*,
Taipei Fine Arts Museum, Taiwan, 1992

Gilded Ikebana with Ochre Flower and Red Leaf,
1992, 30 x 40 x 12 inches

51

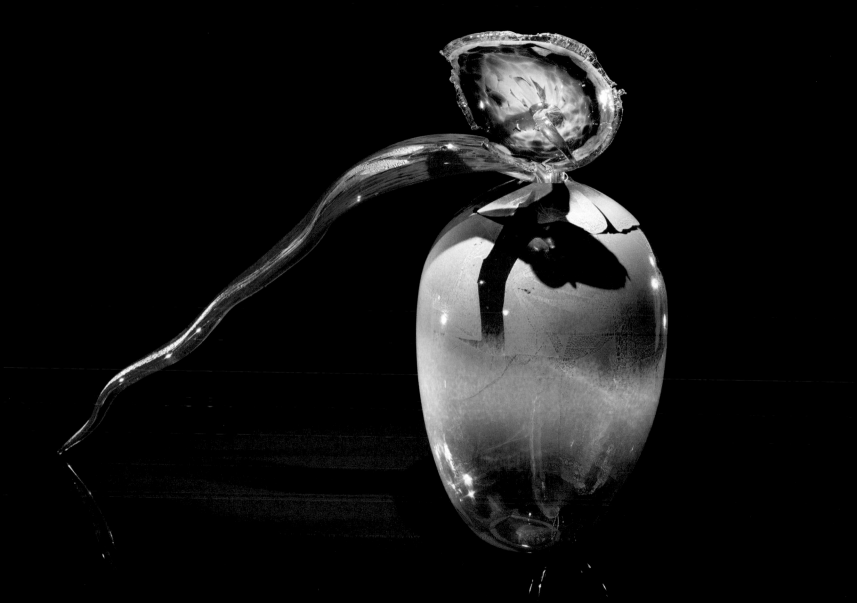

I take thoughts from everybody, ideas from everybody, opinions from everybody. Then, ultimately, I draw my own conclusions. It's just a process, a way of working.

Niijima Float Installation,
1992, 4 x 40 x 15 feet.
American Craft Museum, New York

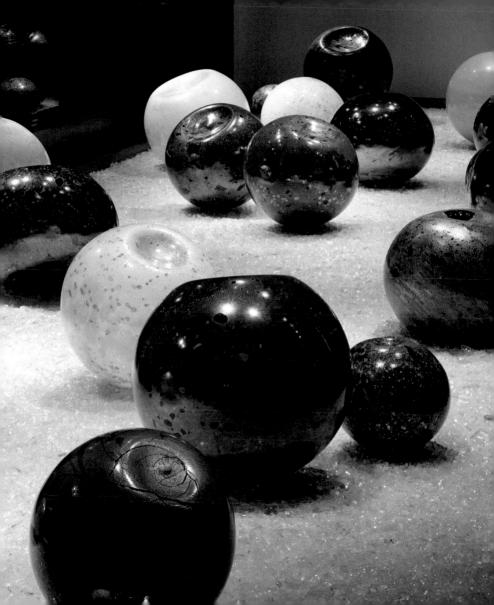

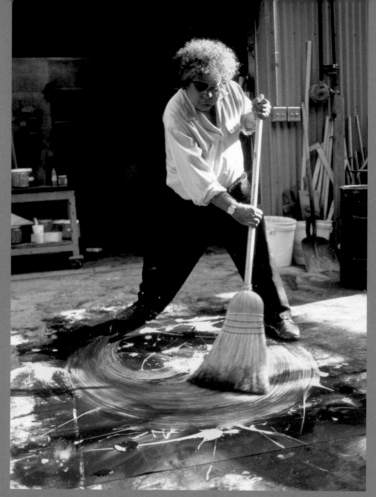

Chihuly drawing, 1992. The Boathouse, Seattle, Washington

If I had to sum up success, I'd say "energy." Without it, you won't be successful.

Niijima Floats and Lemon Yellow Chandelier
with Cobalt Blue Stem, 1992.
Honolulu Academy of Arts, Hawaii

53

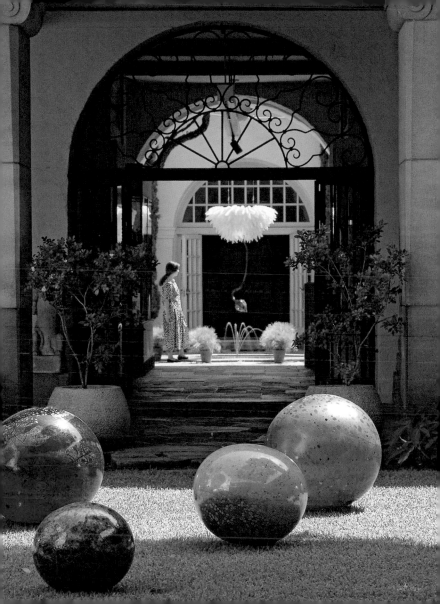

The *Niijima Floats* were named for the island of Niijima in Tokyo Bay, and were inspired in part by the small Japanese fishing floats I used to find on the shores of Puget Sound as a child. These floats are very likely the largest glass spheres ever blown—each is up to 40 inches in diameter and weighs up to 80 pounds.

Niijima Float Installation, 1992.
Honolulu Academy of Arts, Hawaii

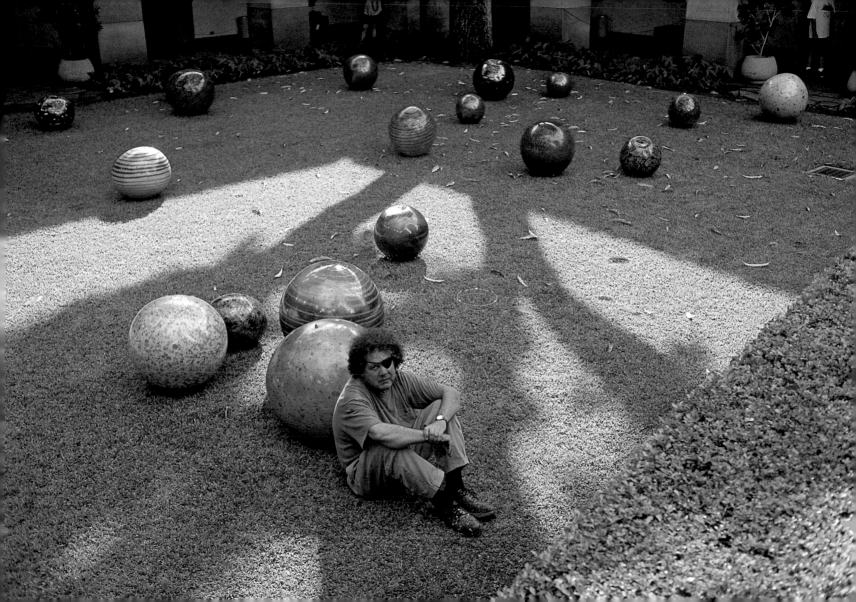

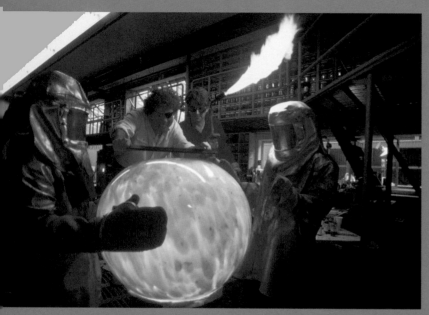

The Boathouse hotshop, 1992. Seattle, Washington

I started the *Floats* in an odd way—as many series begin. I told Rich Royal and the team to blow as big a ball as they could and to put a dimple in the end so we could stick a smaller ball on top. My idea was to make the largest *Venetian* I could—six to eight feet tall. Looking at these balls when they came out of the oven, I decided they looked pretty good on their own.

Niijima Floats, 1992.
Honolulu Academy of Arts, Hawaii

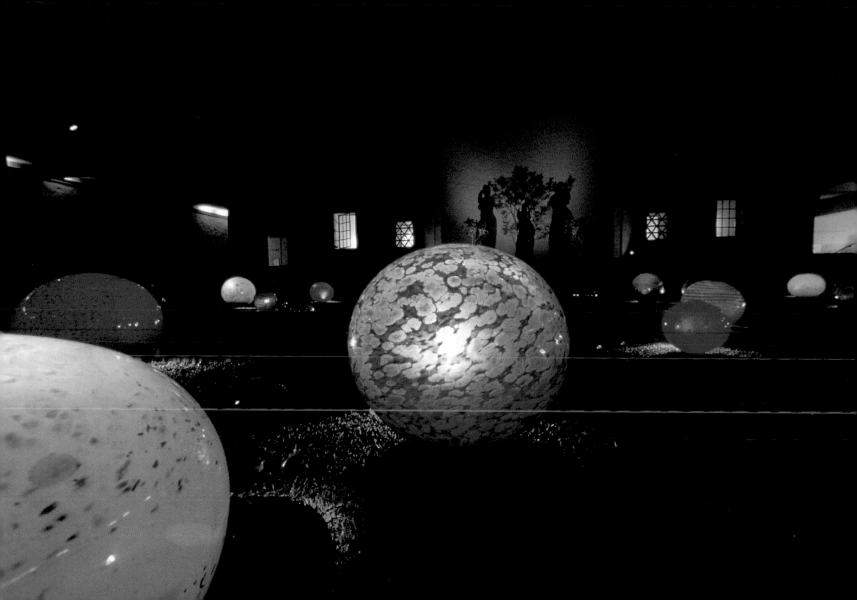

It's interesting that the most difficult series I have ever blown is the *Floats*, considering a sphere is the easiest form to make in glass. It's the most natural form you can blow. But it's not natural at this scale.

Niijima Floats, 1992.
The Boathouse,
Seattle, Washington

56

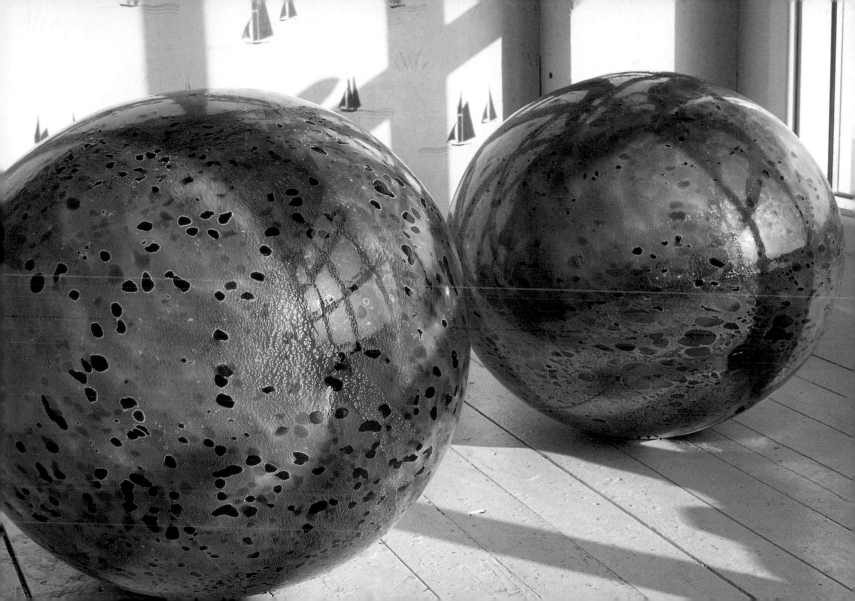

Give the people something to see in a museum
and they will come.

Robin Williams with Chihuly, 1994. American Academy of
Achievement Awards, Malibu, California

Macchia Installation, 1992.
Honolulu Academy of Arts, Hawaii

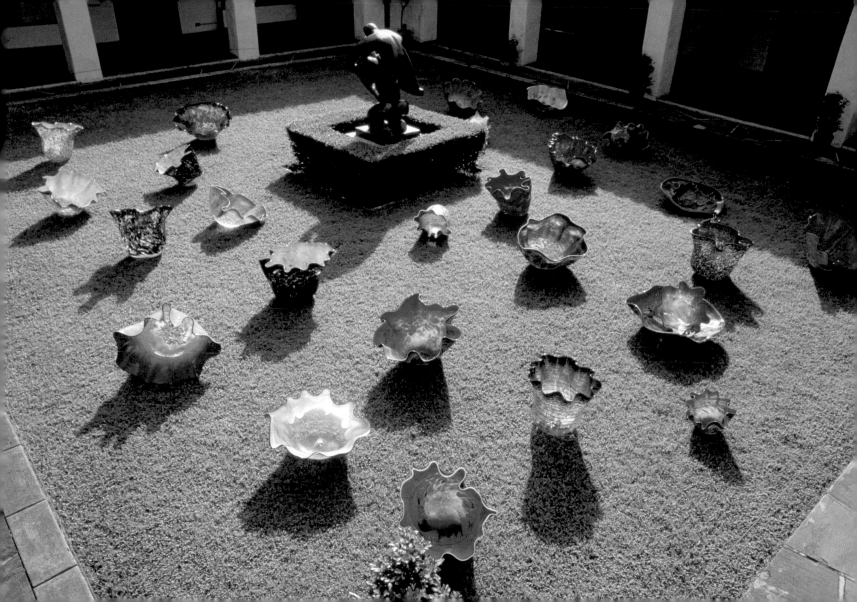

You can more directly sense my energy in my drawings than in any other way, perhaps. And from the very beginning, the drawings were done, as my glass is done, very quickly, very fast.

N.Y. Lino Blow Venetian Drawing,
1992, 30 x 22 inches

A lot of artists can produce things, and a lot of them can be innovative and creative. But probably the real trick is deciding what it is that's good, what's important, how much of you is in the work.

Duratrans, 1992.
Seattle Art Museum,
Seattle, Washington

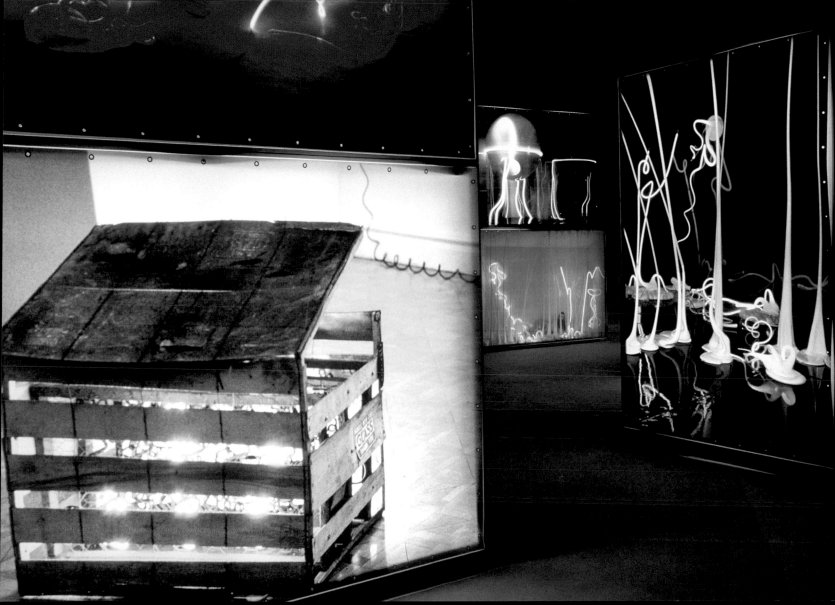

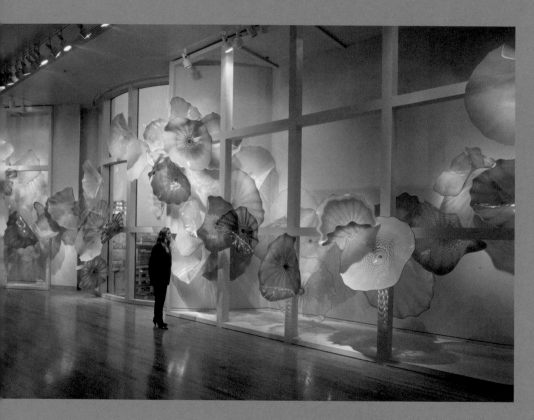

Generally, when people ask me about inspiration, where my work comes from, what inspires me, I can't really answer that question. The ideas just come as they come.

LEFT, RIGHT, AND OVERLEAF:
Venturi Window, 1992,
48 x 16 x 7 feet.
Seattle Art Museum,
Seattle, Washington

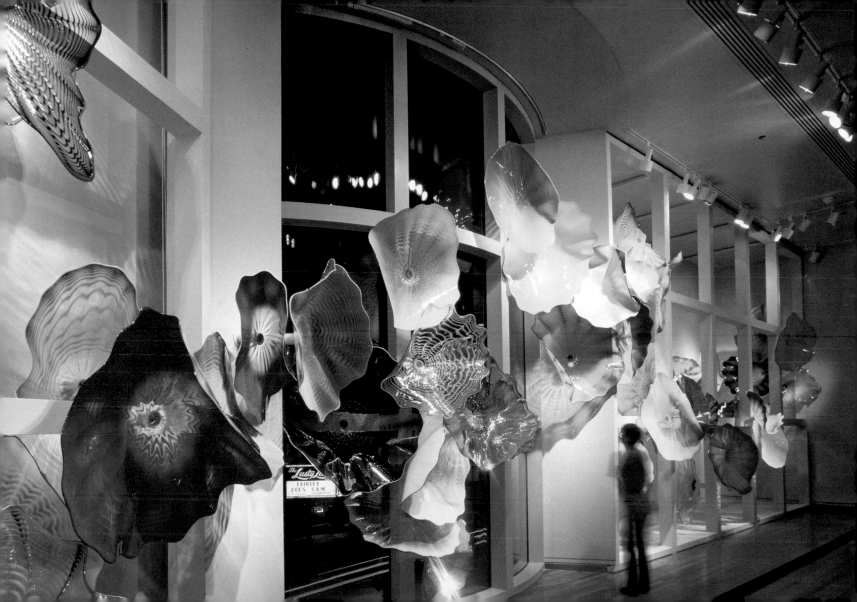

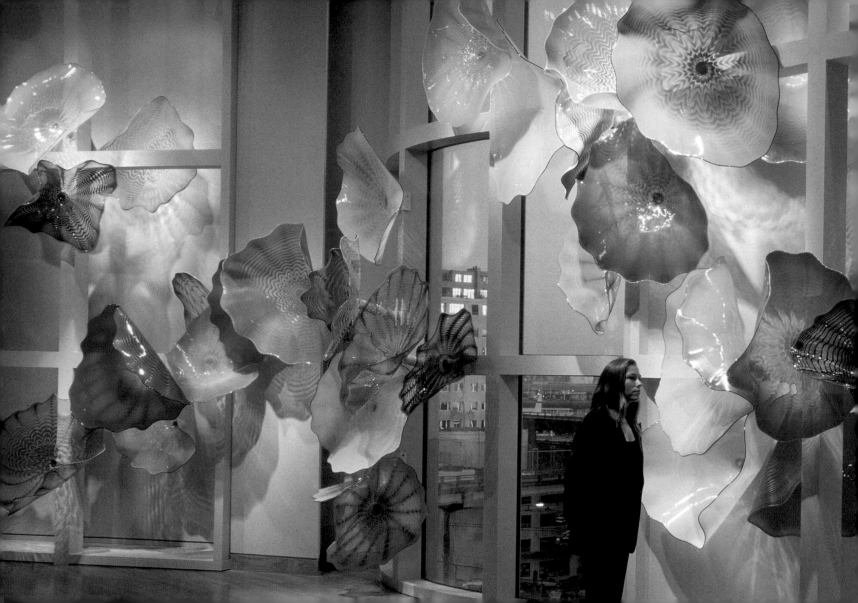

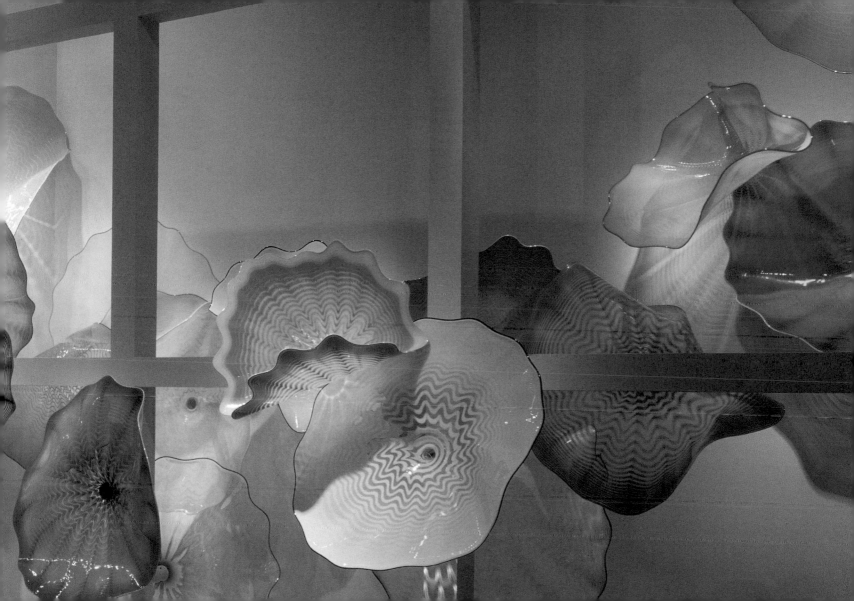

Chihuly studying models for *Pelléas et Mélisande* opera sets

The story of *Pelléas et Mélisande* allowed my imagination to go in many directions, and the ambiguity of the opera gave me great freedom. I began to envision immense glass forms on a black glass stage. A giant glass flower—the garden. A red tube—Golaud's broken heart. A pile of yellow glass—Mélisande's hair that was "longer than she." I wanted to suggest the essence of each scene in a way that was far more visual, visceral, intuitive than conceptual.

Pelléas et Mélisande, 1993.
Opera set, Act 1, Scene 1, The Forest

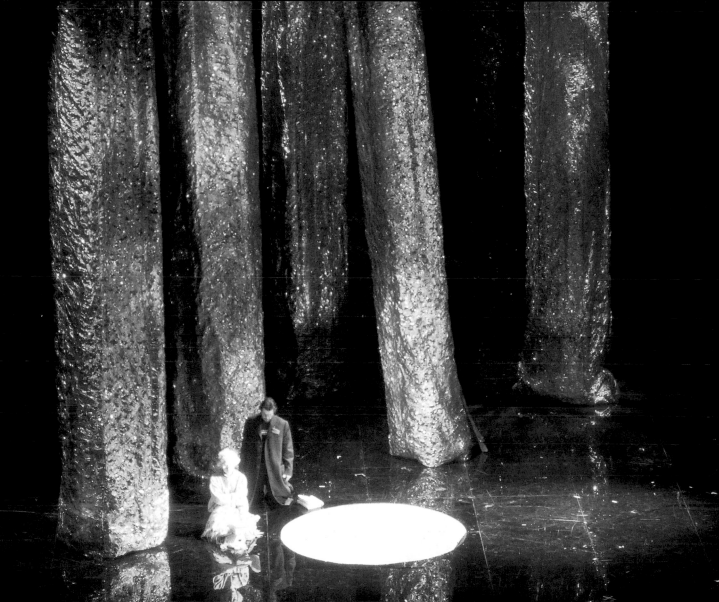

The way that I work is by doing a lot of work. And out of that come ideas, refinement, more work, more ideas.

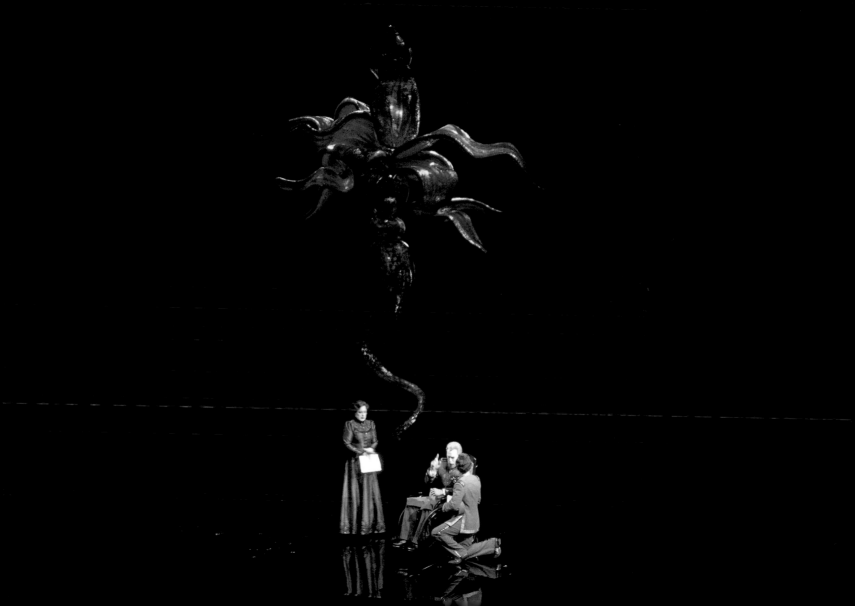

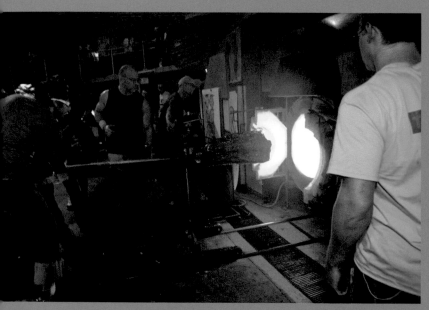

Martin Blank, Robbie Miller, and team at *Pilchuck Stumps* blow, 2006. Museum of Glass, Tacoma, Washington

Using a crude mold and creating iridescent surfaces, I explored an idea generated by the sets I designed for the Seattle Opera's 1993 production of Claude Debussy's *Pélleas et Mélisande*. This was the first time that I used this specific mold-blowing technique.

Forest Green and Silver Pilchuck Stump,
1992, 20 x 10 x 9 inches

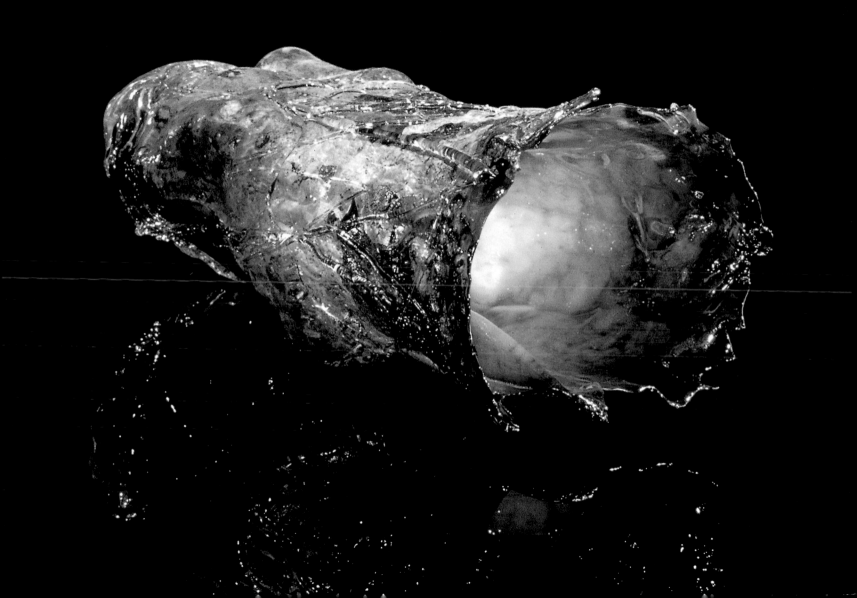

My father came out of the coal mines and became a meat cutter, then a union organizer. My mother was a housewife, and I had, from what I know, a great relationship with both of them, and I was close to my brother, who was six years older than me, who was unfortunately killed in the Navy Air Force when I was fifteen. The next year my father died of a heart attack when he was fifty-two, and that left my mother and me with no money, in debt, and my mother never having worked for all the twenty-five or thirty years that she'd been married. And so my mom went to work as a barmaid, more or less, at a tavern nearby the house.

White and Oxblood Seaform Set
with Black Lip Wraps and
Orange Hornet Chandelier, 2005.
Colorado Springs Fine Arts Center, Colorado

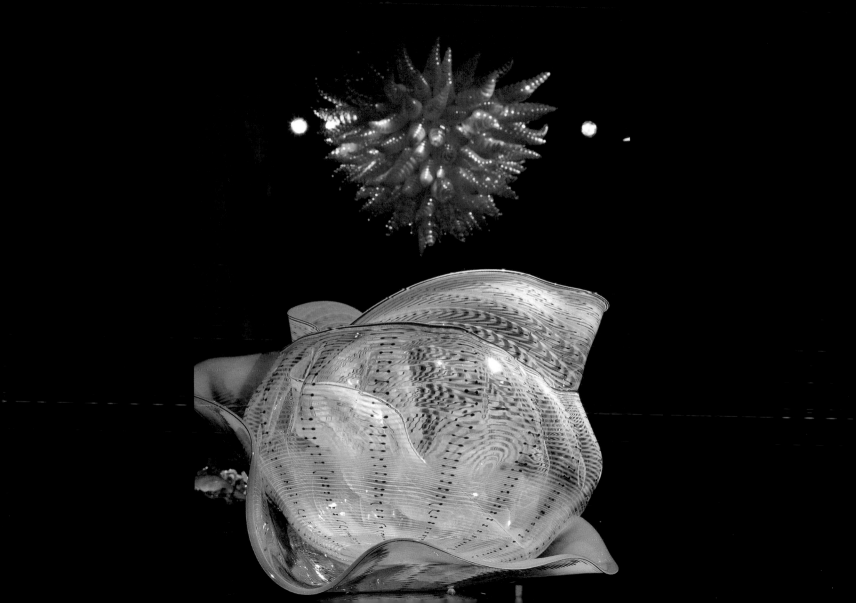

I was only experimenting with the ice-skating rink. I really wanted to freeze neon tubes under the rink, and then have the skaters skate on it. I got permission from the city to use the rink. Then a newspaper picked up on it and kind of pushed me. They insisted that if I was going to be using the civic ice-skating rink, I had better let the public come in and look at it. That made sense. So we did that. I had to change my plan from being experimental to doing something that I had confidence would actually work. If the public was going to come in (and eventually 30,000 people came in that weekend to see it), I wanted to make sure that we could produce something that would have an impact and that people could relate to. I built on an earlier project that I'd done with Jamie Carpenter back in 1971 called *20,000 Pounds of Glass and Neon*, and extended it up to 100,000 pounds. We added a lot of other things. We did some big spheres of ice, forty inches in diameter, that weighed 1,000 pounds. We did some neon *Tumbleweeds* as well.

100,000 Pounds of Ice and Neon, 1993. Tacoma, Washington

65

I wish I could do more with ice and neon, but one has certain limitations. You can only do what you can do. But it is one area that I want to work with more.

100,000 Pounds of Ice and Neon, 1993. Tacoma, Washington

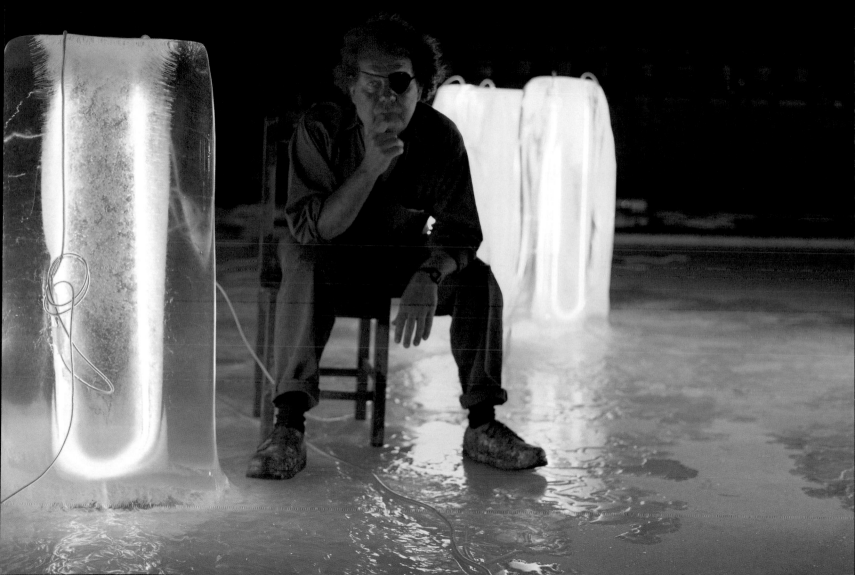

Ice is an incredible material. I mean, it's frozen water. If you really think about it, what a magical thing that is. And then you look at the ice in its many facets and forms, the transparencies and opacity and translucency and crackling and shifting. It changes by the minute.

*100,000 **Pounds of Ice and Neon**, 1993.*
Tacoma, Washington

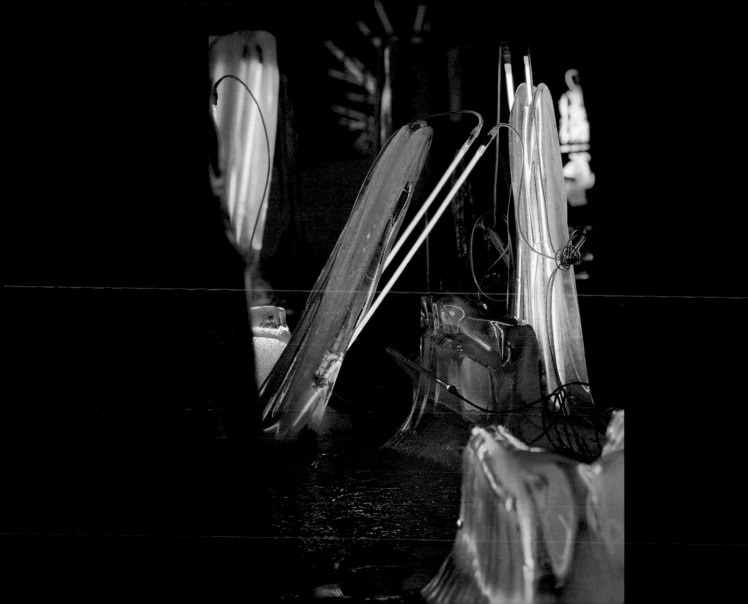

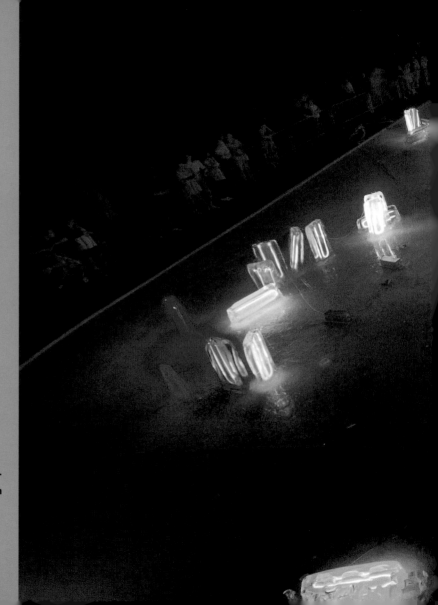

Most artists deal with galleries—galleries do most of the promotion and marketing of an artist's work. Maybe they do an interview or whatever, but in my case I'm very interested in reaching out to the public in other ways. I'm interested in books, I'm interested in movies, I'm interested in television.

100,000 Pounds of Ice and Neon, 1993.
Tacoma, Washington

68

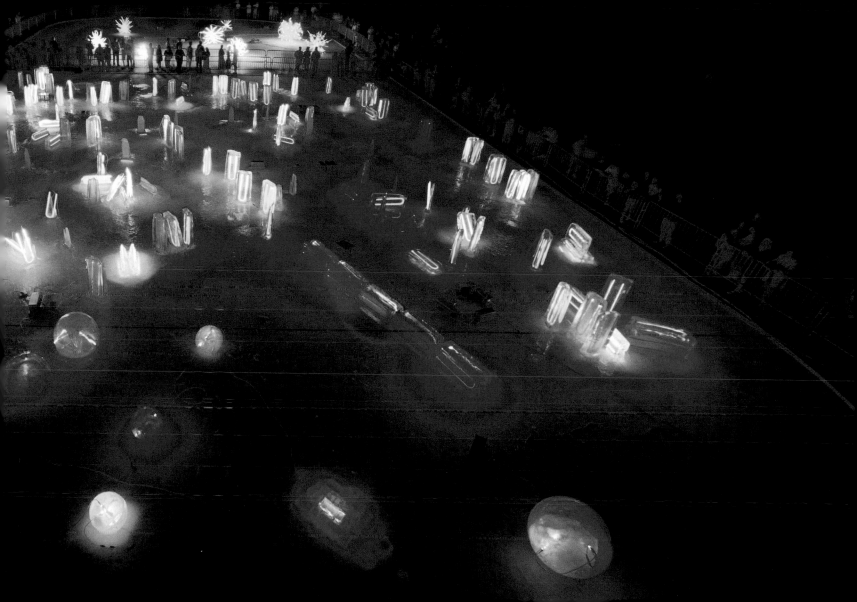

I like it more on the edge. I don't care if we lose pieces. I'm always saying "Push it further, make it bigger." You don't know how far you can go until you go too far.

100,000 Pounds of Ice and Neon, 1993.
Tacoma, Washington

69

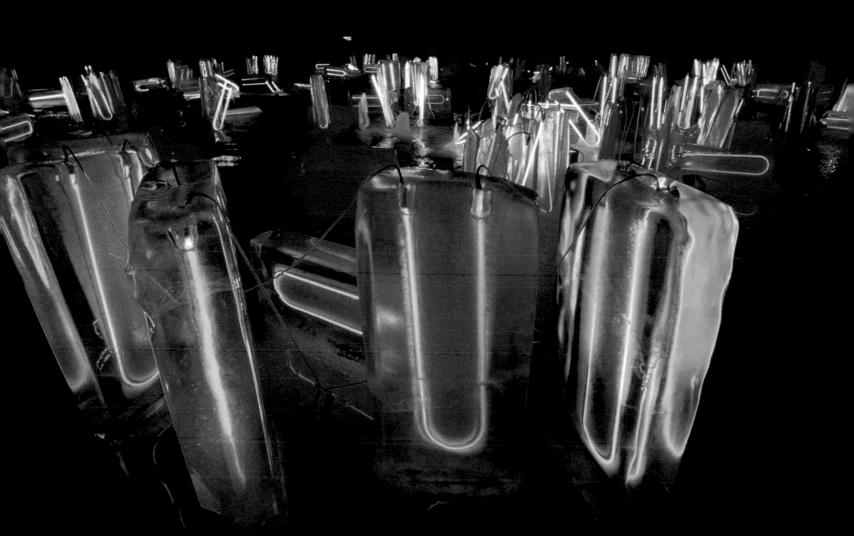

I rolled the dice and quit teaching in 1980. A lot of people tried to get me not to do that. Because I gave up a great shop and a lot of security to do that. I've always been known to roll the dice with things, and that was one of the most important steps in my career.

100,000 Pounds of Ice and Neon, 1993.
Tacoma, Washington

70

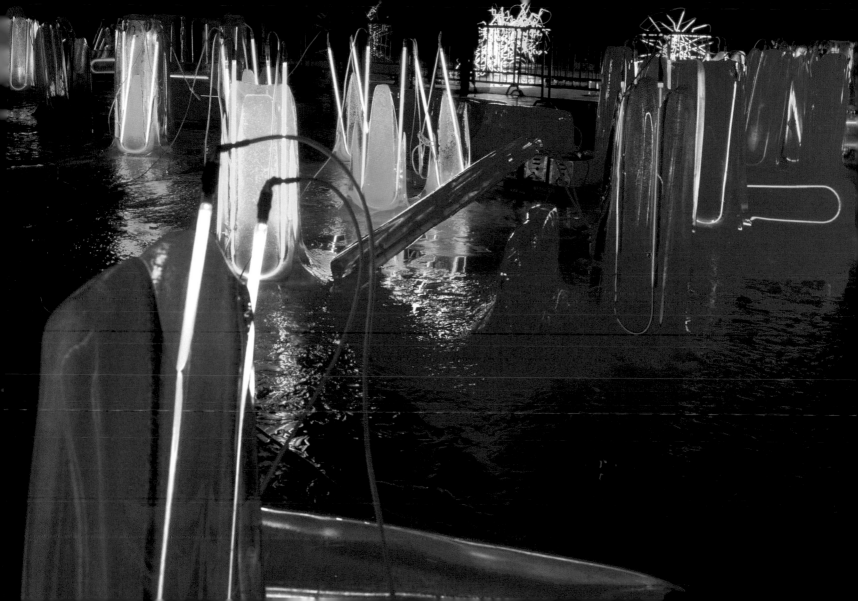

Many people have asked me what I was thinking and why. I guess the answer is that I think from my gut more than my head.

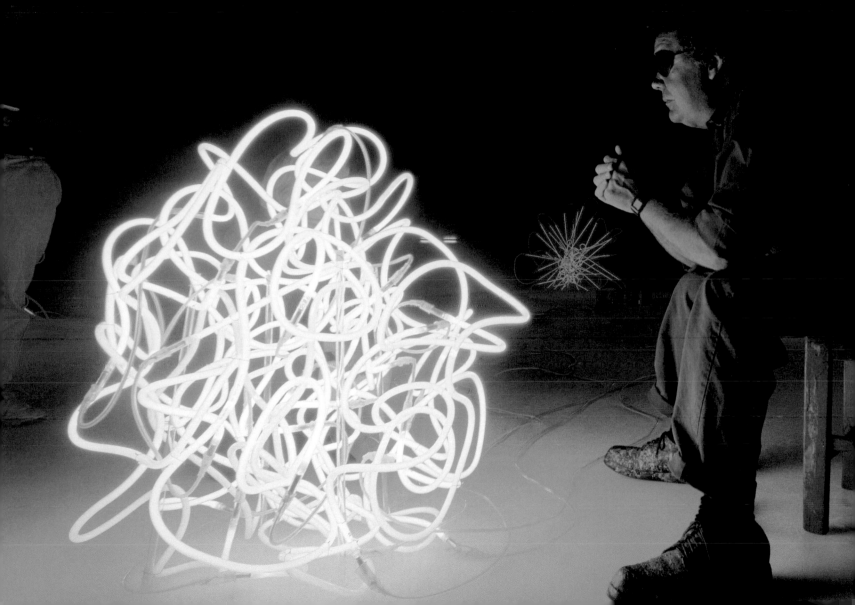

Orange Hornet Chandelier was installed in my old loft space in the Railway Building. One great story is that the color was so intense at night, with the low voltage light on, we used to get calls because people thought the space was on fire. I always liked that one.

Tracy Savage, Savage Fine Art, Portland, Oregon

Orange Hornet Chandelier,
1993, 19 x 7 feet.
Portland, Oregon

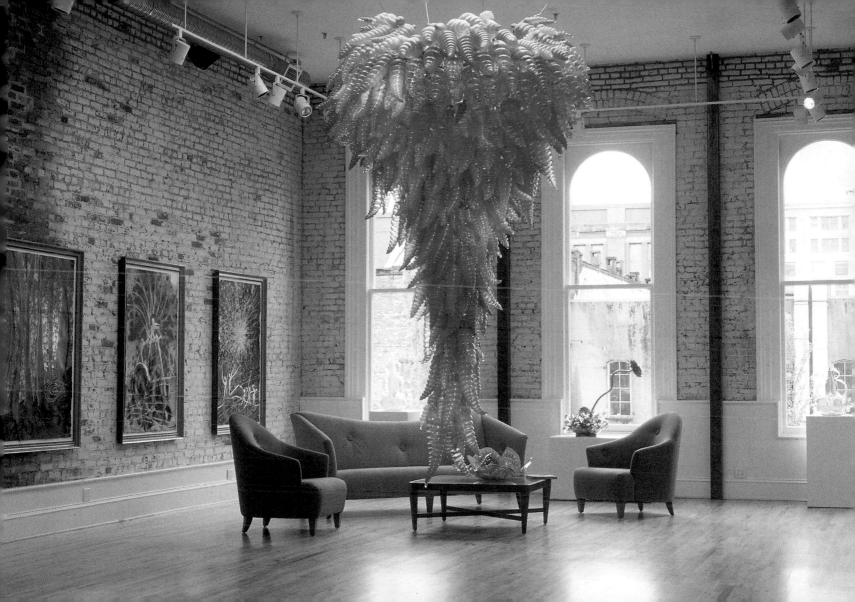

Who knows what's next? You know, when people say, "What are you going to do next?" I always say, "If I knew what I was going to do next, I'd be doing it."

73

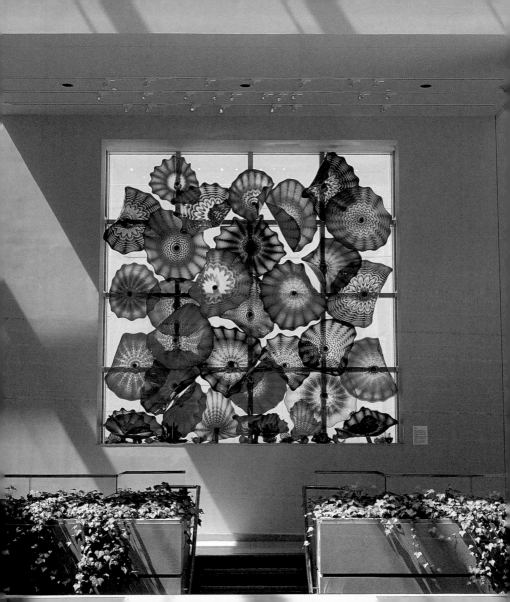

I don't know what it is about glass and me. It's just my material—it's the one I like to work with. There's nothing like it. All you have to do is heat up sand and you get glass. What other material can you really blow human breath into and make a form and then heat it up with fire and move it around and manipulate it with centrifugal force and gravity?

Malina Window **detail**

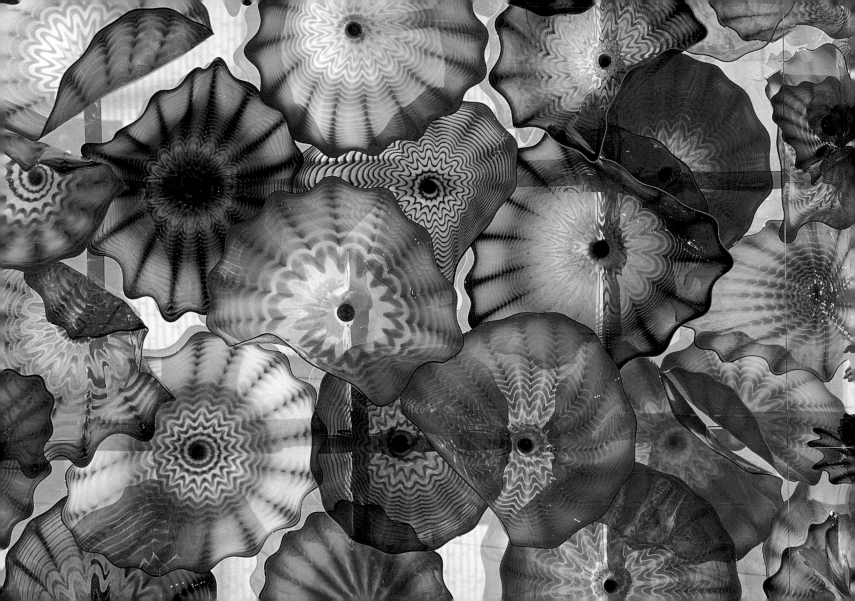

A lot of the work I do is inspired by nature or looks as if it might come from nature, but I don't look at something specific in nature to make a piece. I just sort of have a natural feeling for using glass—trying to take advantage of the color and transparency that glass offers. Also, I'm making use of the ability to take this ancient material, which is blown with human breath—this magical material—to some new place.

Basket **grouping, 1981**

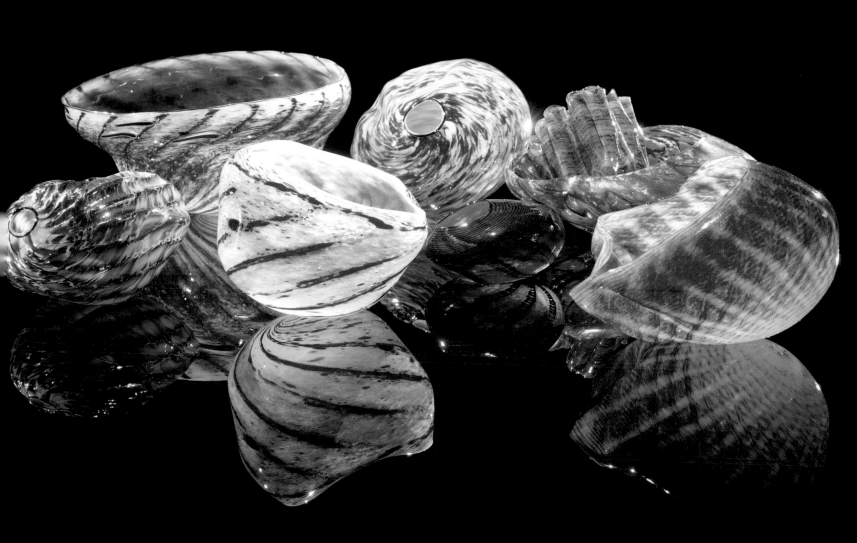

I definitely look for things to inspire me or to get me wanting to do work. It doesn't come all that naturally. The thing that's helped me the most has been figuring out when I could work best. This thing about working best in the morning with nobody around, I figured that out a long time ago. If it weren't for that I probably wouldn't get half as much done.

Sapphire and Ruby Basket Set,
1993, 20 x 20 x 22 inches

Over time I developed the most organic, natural way of working with glass, using the least
number of tools that I could.

Saturn Red Basket grouping, c. 1993

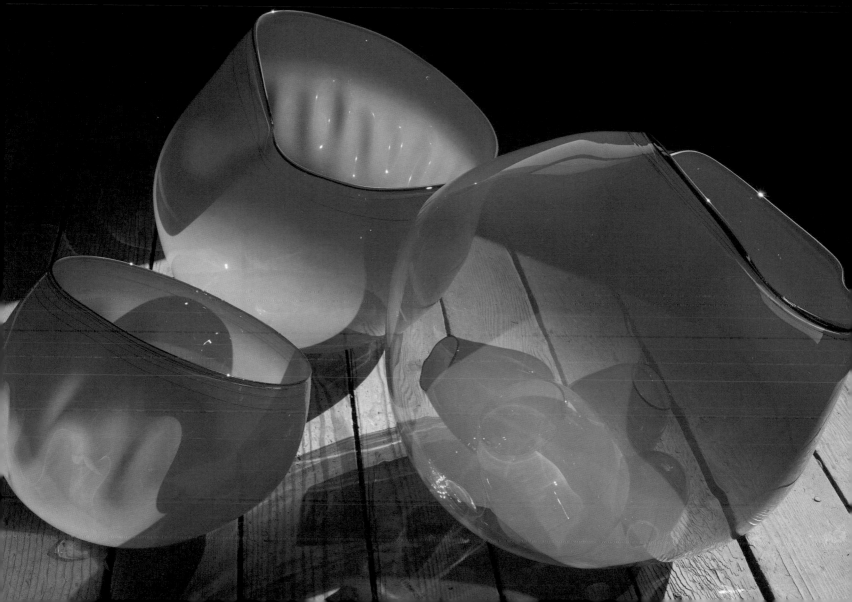

I woke up one morning with the idea that I would work with all the colors that were available to us. We bought color rods from Germany. And I decided I would use all 300 of them. In order to switch to that kind of thinking, I also switched in terms of form and method of applying color. I put one color on the inside, then sort of a translucent or opaque white in the middle, and then another color on the outside. So there are three layers. Sometimes there'd be as many as four or five layers.

Concord and Aubergine Macchia with Variegated Jimmies, **1981, 5 x 7 x 6 inches**

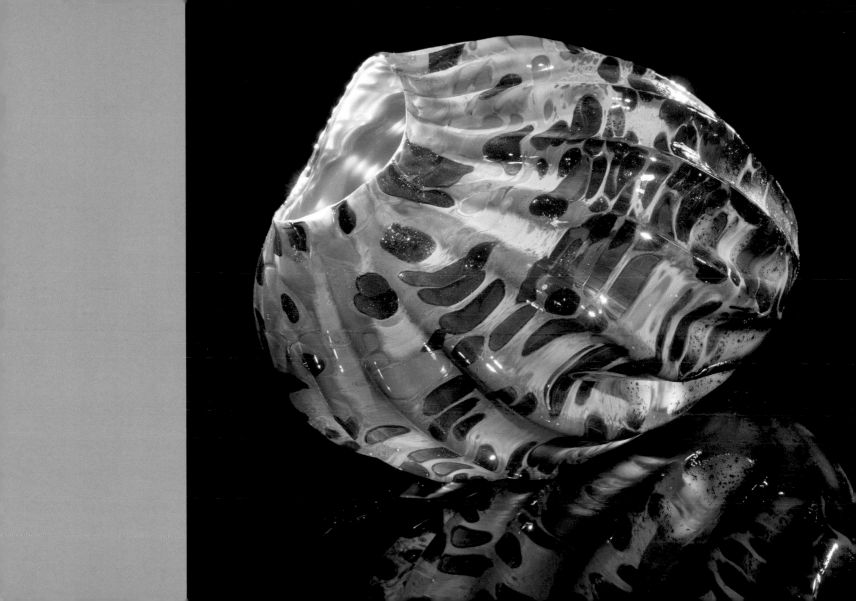

I pushed Billy Morris to make *Macchia* bigger and bigger and bigger. By the time we got done, we were making *Macchias* about three feet high and three feet wide. At the time, that was the largest glass I'd ever made, and some of the largest glass that had ever been made.

Macchia **grouping, 1981**

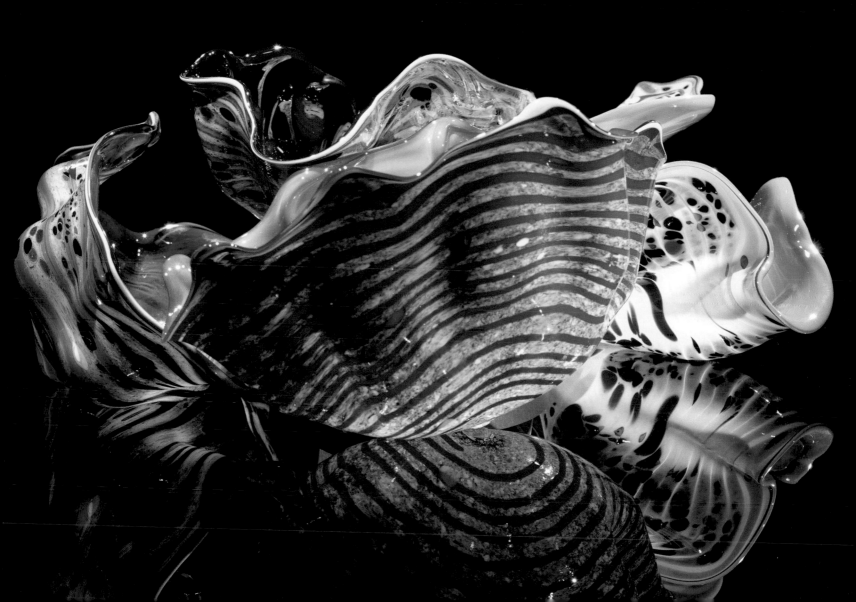

Like much of my work, the series inspired itself. The *Macchia* series began that day I woke up wanting to use all 300 of the colors in the hotshop. The unbelievable combination of colors—that was the driving force.

Rust Spotted Macchia,
1982, 12 x 13 x 10 inches

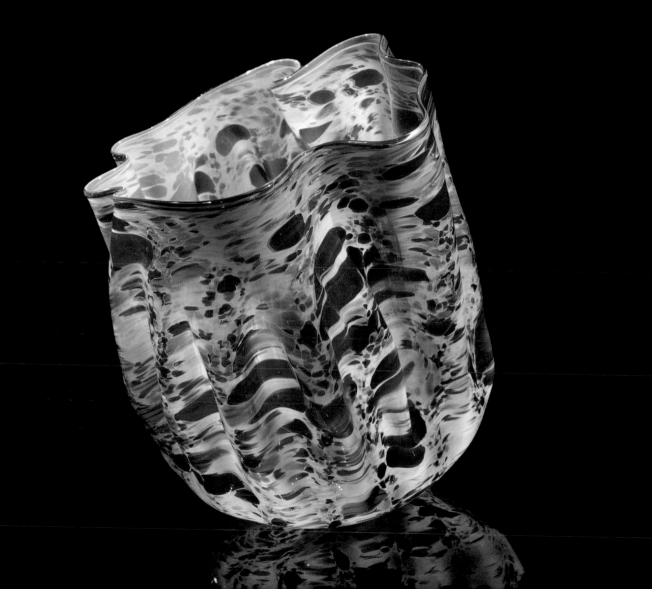

I don't feel like I fit into any category very well, whether it be artist, designer, or craftsman. Yet I can't help feel an affinity with people who had ateliers like Tiffany or Gallé.

Fire Orange Venetian with Ribbons,
1993, 17 x 18 x 18 inches

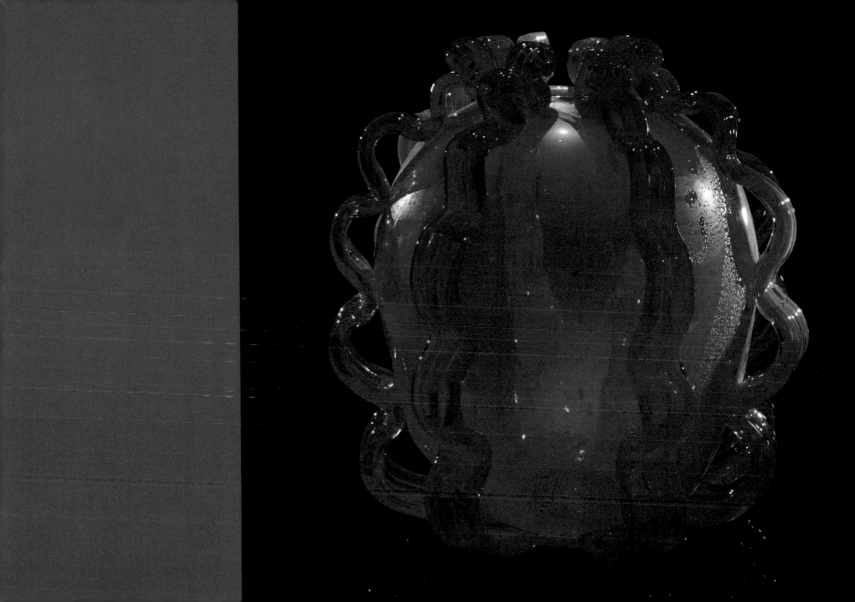

When you're working with transparent materials, when you're looking at glass, plastic, ice, or water, you're looking at light itself. The light is coming through, and you see that cobalt blue, that ruby red, whatever the color might be—you're looking at the light and the color mixed together.

Lime Mist Ikebana with Russet Leaf,
1993, 25 x 35 x 16 inches

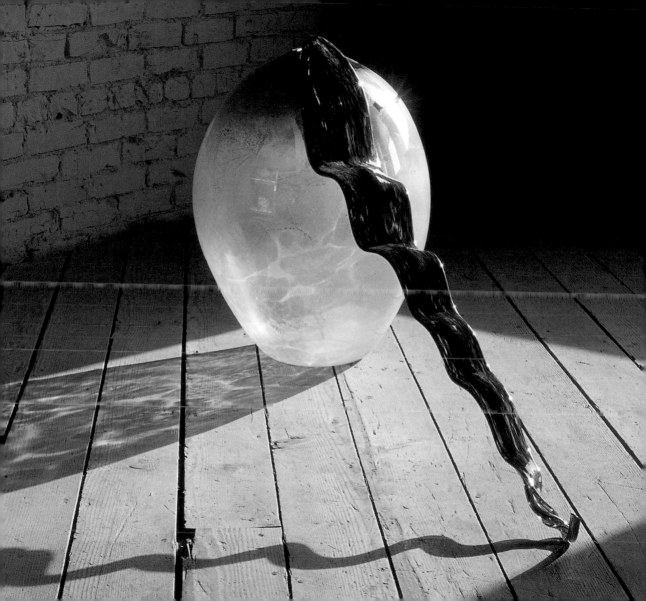

Glass has the ability, more than any other material, to bring joy and a certain happiness to people.

Golden Orange Venetian with Viridian Leaves,
1993, 14 x 8 x 8 inches

83

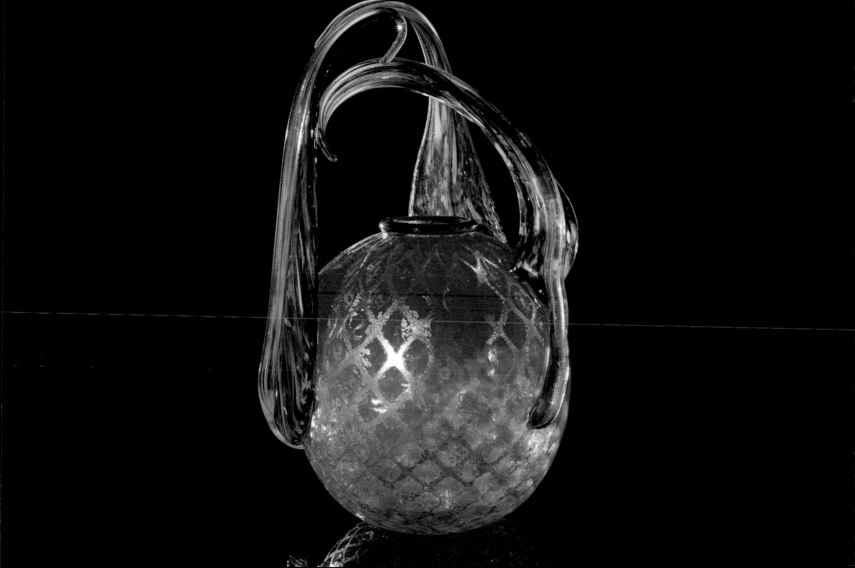

I like the idea of something made for regular consumption that can be an art form.

Violet Soft Cylinder with Yellow Lip Wrap,
1994, 12 x 13 x 11 inches

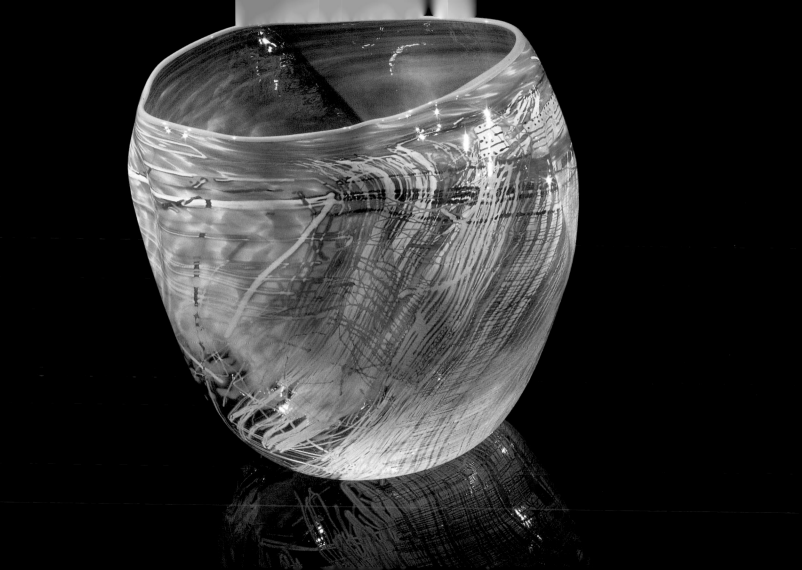

Black Cylinder detail, 2006

I began the *Soft Cylinder* series in 1986, combining the glass pick-up drawing technique from the earlier *Cylinders* with the softer, sagging forms of the *Baskets* and *Seaforms*, and the bright, contrasting colors of the *Macchia*.

**Voula Green Soft Cylinder with
Magenta Lip Wrap, 1994,
12 x 13 x 12 inches**

85

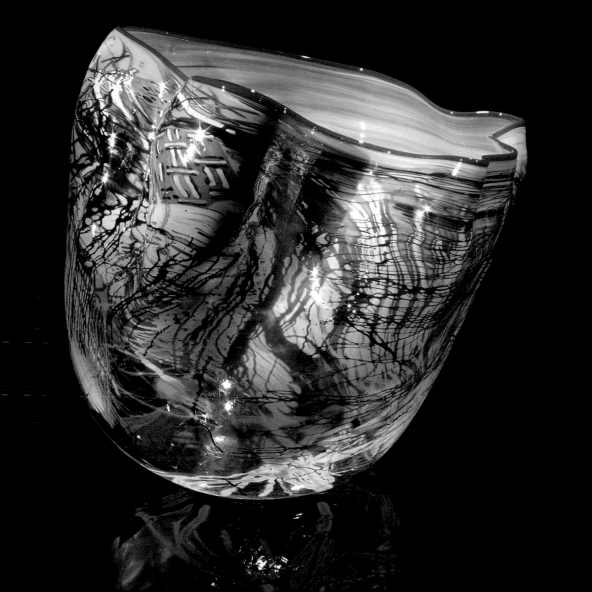

The funny thing is, you don't know when you're at your best. You can wake up with a hangover and then go down and go to work with three hours of sleep and do great work. Or you can be rested up for a week and go down and do lousy work.

LEFT: *Starch Blue Soft Cylinder with Magenta Lip Wrap*, 1994, 12 x 12 x 12 inches

RIGHT: *Butter Yellow Soft Cylinder with Copper Red Lip Wrap*, 1994, 13 x 13 x 12 inches

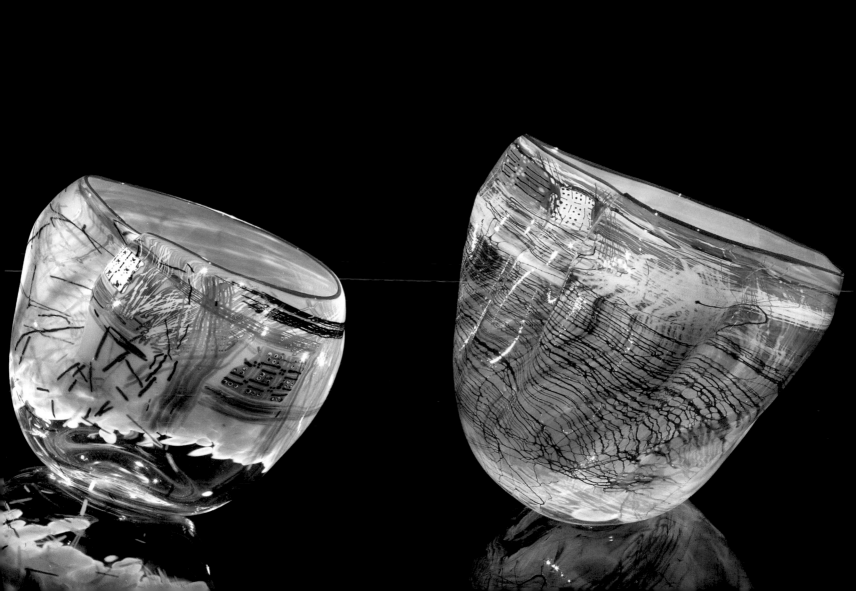

My work is about symmetry, clarity, and the use of subtle color, whereas Dale's approach is obviously the polar opposite. Consequently, working with Dale was always very exciting as we worked the glass hot, loose, and fast. Oftentimes, on the verge of out-of-control.

<div align="right">Benjamin Moore, unpublished biographical sketch</div>

<div align="right">*Basket Cylinders*, 1980</div>

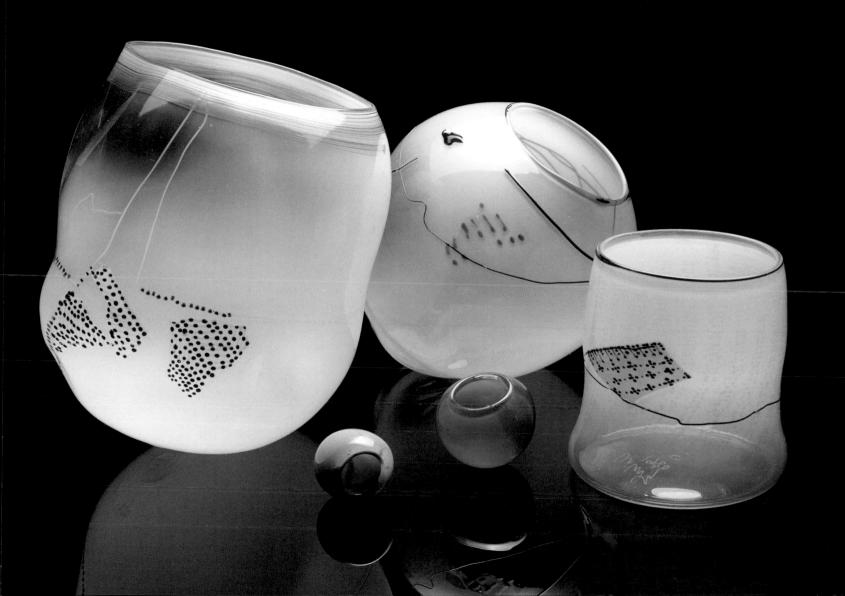

Needless to say, it has been an incredible ride working with Dale, realizing many of his early series. Being there firsthand, seeing Dale's incredible creativity and enthusiasm in making his work, has been truly inspirational. Dale has given me an opportunity to work with the material in a way that I probably never would have on my own.

Benjamin Moore, unpublished biographical sketch

Dove Blue Seaform Set,
1980, 5 x 11 x 11 inches

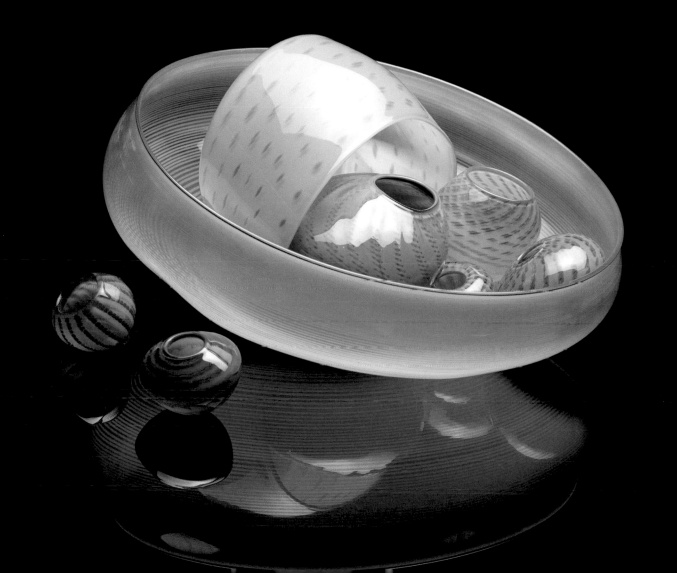

I knew that if I made the *Baskets* thin I could manipulate them more. First I would bang them with a paddle to beat them up a bit. But I soon learned that if I just used the heat of the furnace and the fire, I could get the same kind of movement from the fire itself, and it was more beautiful.

Shell Pink Basket Set,
1988, 9 x 22 x 22 inches

89

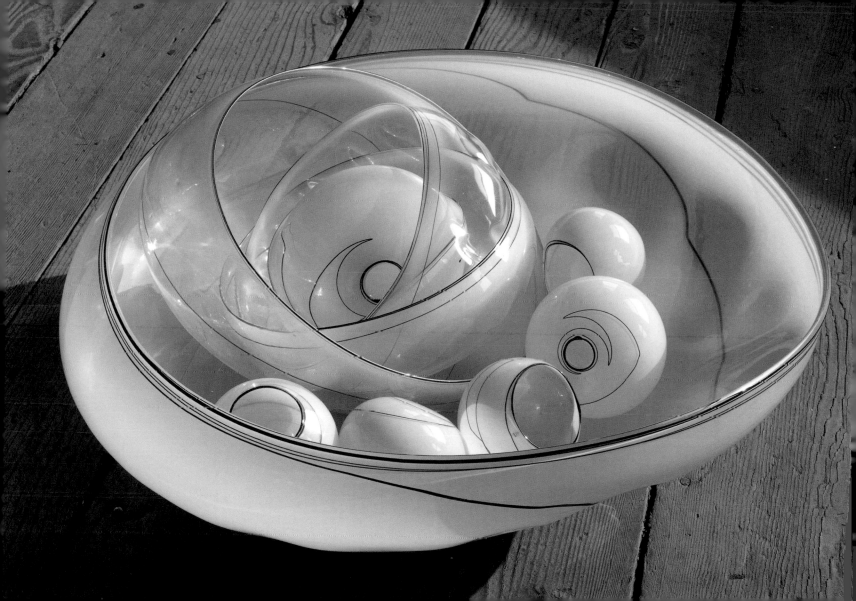

He has an incredible ability to try things almost as a beginner. In other words, he doesn't let any kind of rules about the material of glass hold in his ideas. I think that's why he's the best at what he does and why he's done so many major projects; because rather than be limited because of his knowledge, he's liberated by his knowledge.

Joey Kirkpatrick, *Chihuly at the V & A*,
film directed by Peter West, 2002

Aqua Putti Venetian detail, 1991

90

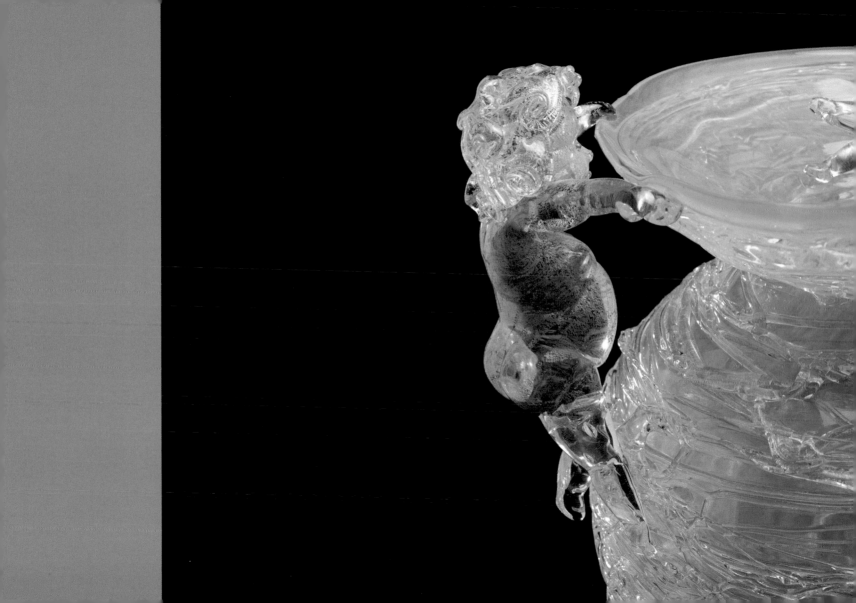

It was easy for me to think that people could learn how to do things. Part of that came about because I lost the sight of one eye and then I had another injury, so I was forced to let people do certain things for me if I wanted to continue what I was doing. That helped, but that wasn't the real, defining aspect of why I became more of a director. We think of most artists as working alone in a solitary way. We have that vision of Van Gogh. But, in fact, if you look back in art history, for example at the Renaissance, a lot of artists had big teams, large ateliers of people working for them. That was partly because there was great demand for their work. In fact, the words *craft* and *art* were interchangeable. We've moved to a situation where we have art and then we have craft. Craftsmen have a hard time having someone make work for them because that's what they are—craftsmen. I really don't know how you would describe me.

Monarch Window, 1994,
40 x 22 x 3 feet.
Union Station, Tacoma, Washington

91

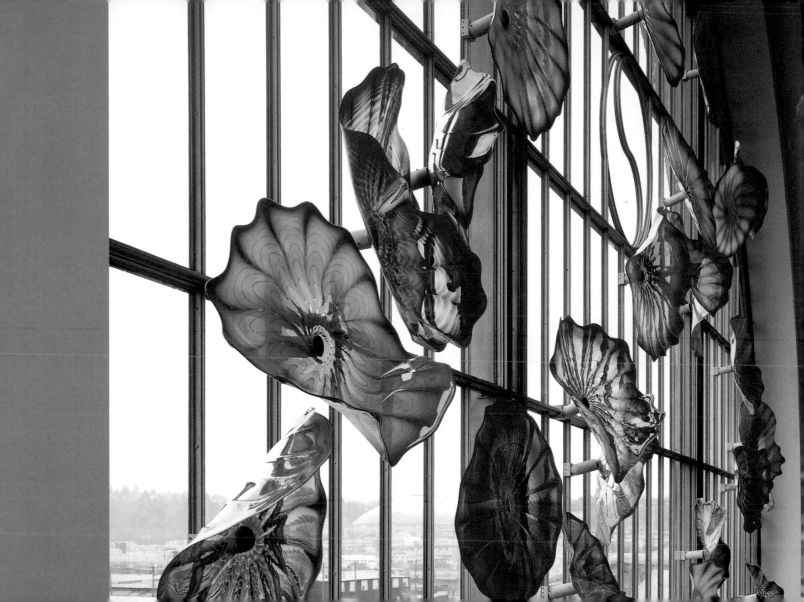

All he lost was depth of vision; he could use the other eye. In a way his career seems to have blossomed from then. He was able to tell other people to make the glass and he stopped being a one-man band and became kind of the leader of the band.

Peter Blake, *Chihuly at the V & A*,
film directed by Peter West, 2002

Union Station, Tacoma, Washington

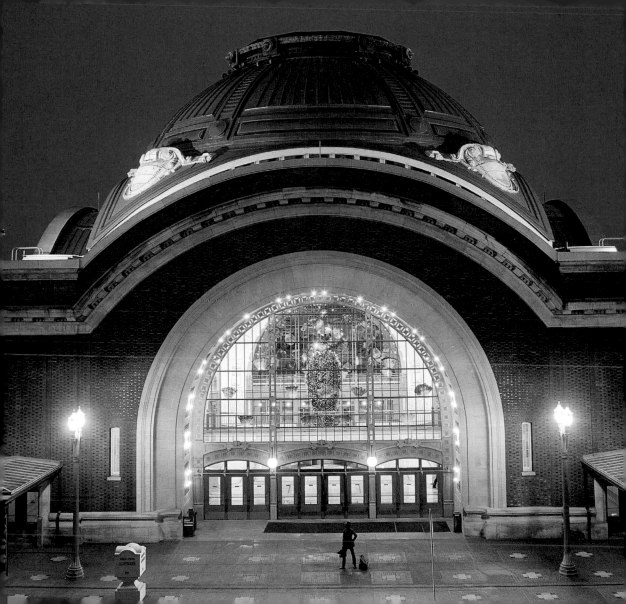

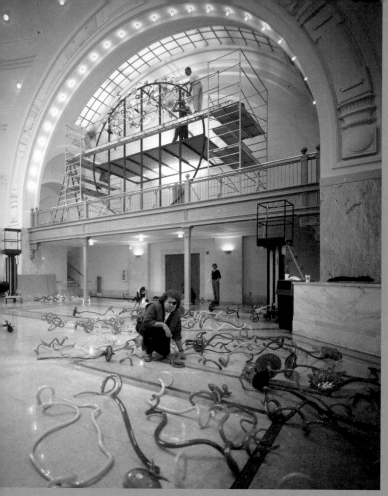

Lakawana Ikebana installation, 1994. Union Station, Tacoma, Washington

The *Chandeliers* range from three to thirty feet in length and can be made up of as many as a thousand elements attached to a stainless steel armature. The parts can be bulbous, long and twisted, short and spiraled, or even frog-toed. Hung together, the many pieces that make up each *Chandelier* create a unified, though complex, composition.

***Cobalt Blue Chandelier and Monarch Window, 1994.* Union Station, Tacoma, Washington**

93

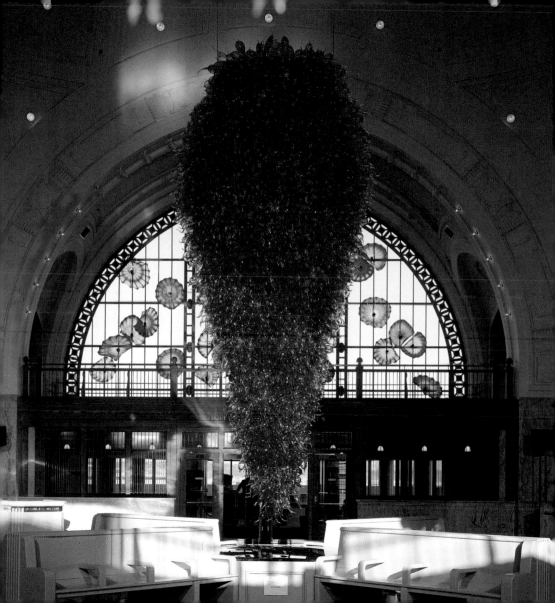

The *Chandelier* doesn't really symbolize anything.

Palm Cobalt Blue Neon Chandelier, 1995,
15 feet 1 inch x 4 feet 6 inches x 4 feet 6 inches.
New York, New York

94

The *Persians*—that's one of the most difficult series to describe. It started off that they were geometric shapes, I think. It was a search for new forms. We worked for a year doing only experimental *Persians*—at least a thousand or more. Sometimes the *Persians* became very *Seaform*-like, or they became very geometric.

Monarch Window, 1994, 40 x 22 x 3 feet.
Union Station, Tacoma, Washington

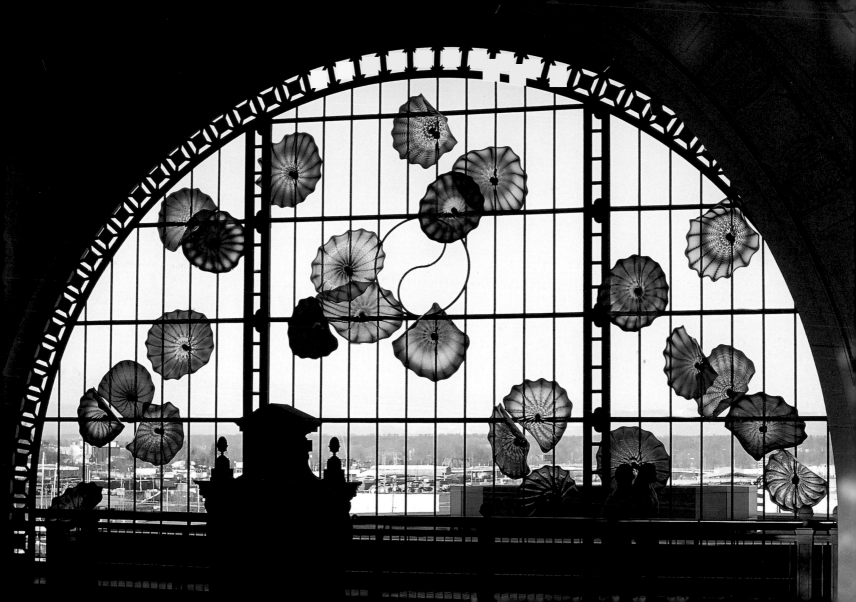

Dale Chihuly, 1998. Tacoma, Washington

You can't blow alone. It's a collaborative process; you develop a common language with the team. I do almost nothing but come up with the ideas.

Cobalt Blue Chandelier and Monarch Window, 1994. Union Station, Tacoma, Washington

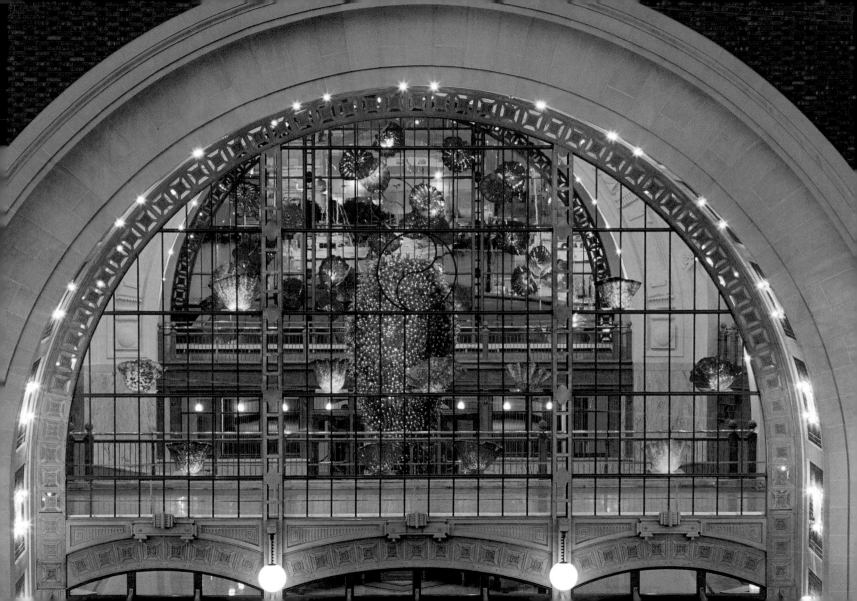

From the very beginning, I would say that the working drawings were superficial to the extent that they were a way for me to use my energy. I was lucky to have found that outlet.

Basket Drawing Window, 1994.
Dallas Museum of Art, Texas

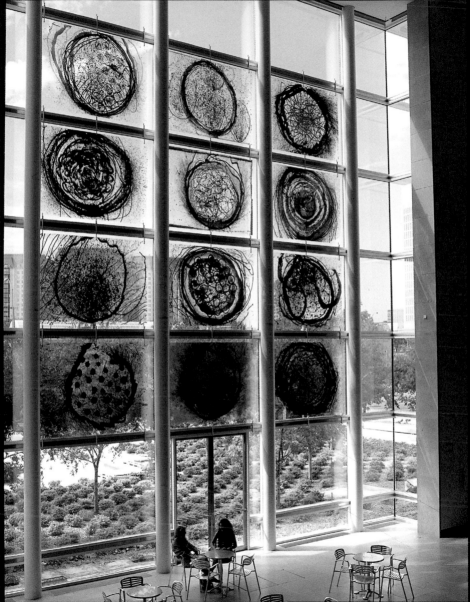

Sometimes you see a great piece evolving, but you may lose it because glass is such a fragile and brittle material. That's the magical beauty of glass.

Persian Wall Installation, 1995.
Palm Desert, California

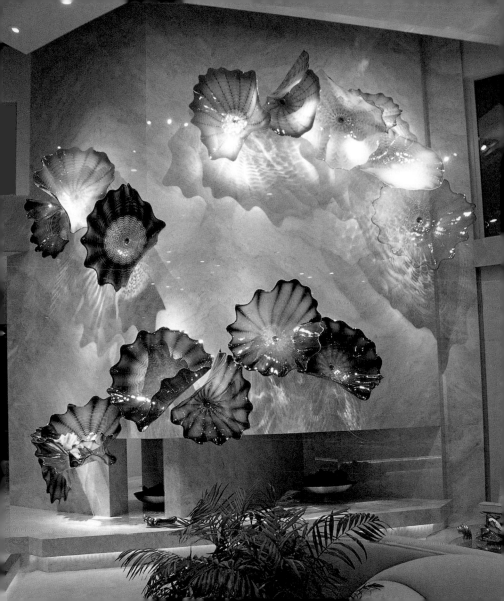

I have found that if all the parts in a piece are good, it doesn't seem to matter how people set them up. I want my works to look like they have been washed up—a random look—and if you think that way, it is hard to arrange them in a way that they will look bad.

Blanket Cylinder **group, 1995**

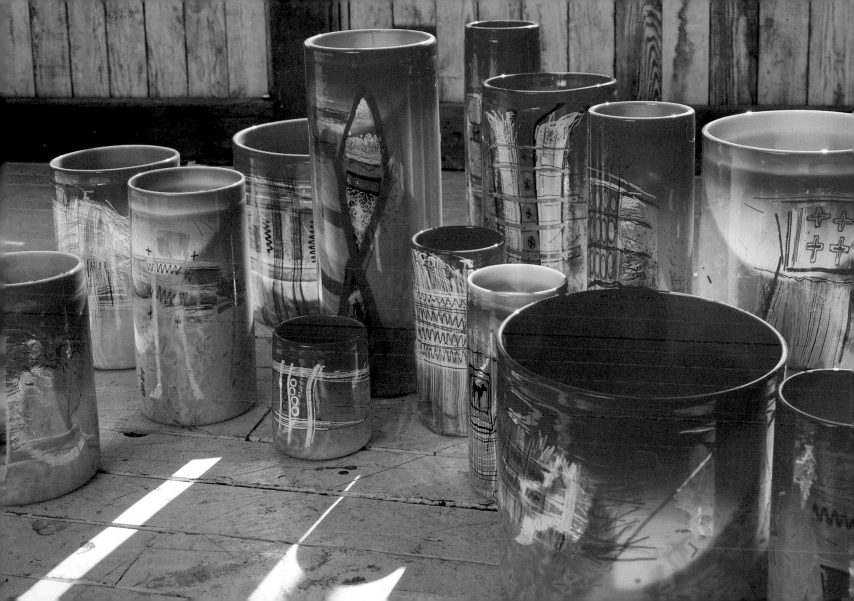

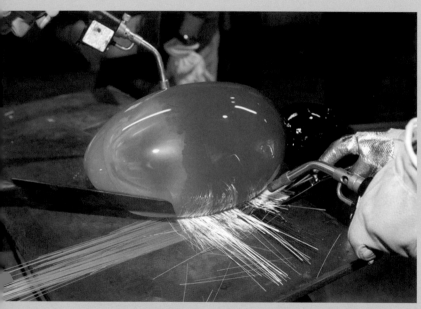

Cylinder process, 2006. Museum of Glass, Tacoma, Washington

I don't know what's more unbelievable, glass or glassblowing.

Peach Cylinder with Indian Blanket Drawing,
1995, 17 x 10 x 10 inches

100

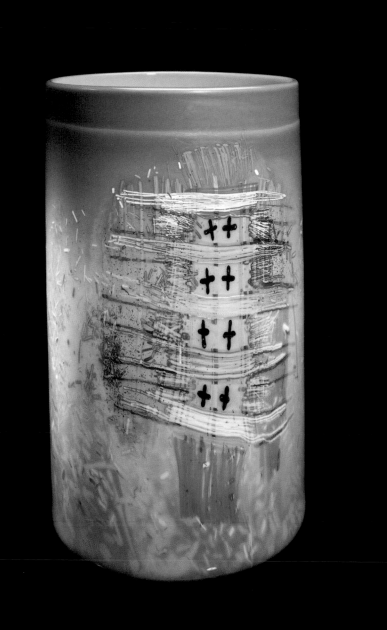

I think of the *Cylinders* as drawings.

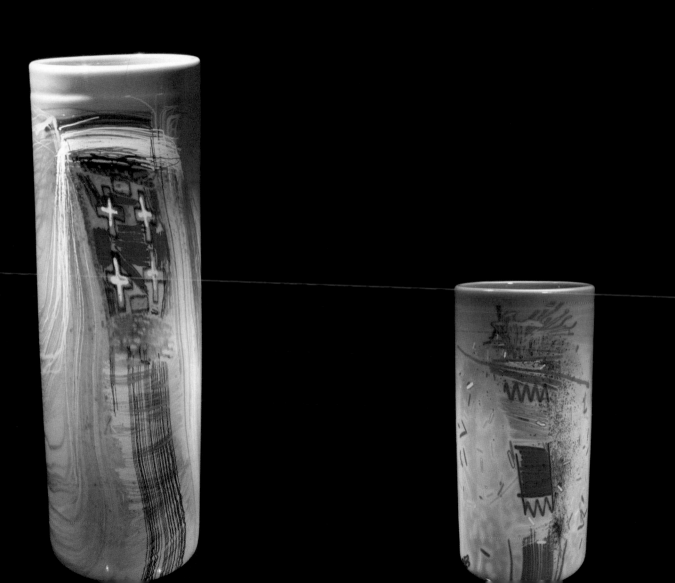

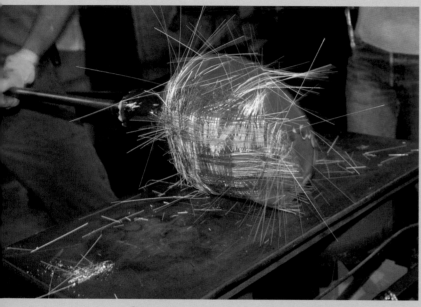

Cylinder process, 2006. Museum of Glass, Tacoma, Washington

The moment the molten glass comes down and fuses onto the rigid glass drawing, everything becomes liquid and fluid—it all takes place in a few seconds.

Peach Cylinder with Indian Blanket Drawing,
1995, 17 x 11 x 11 inches

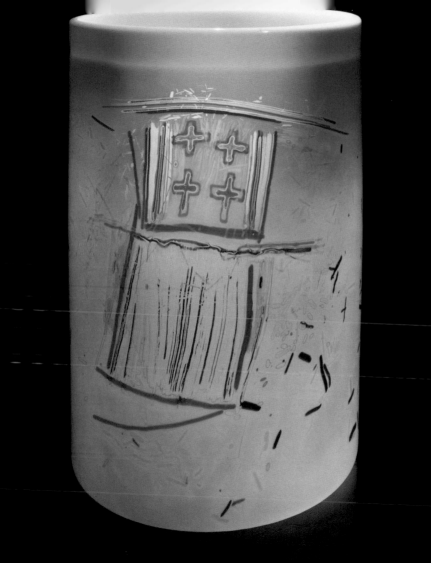

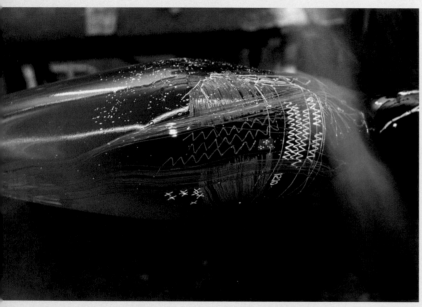

Cylinder process, 2006. Museum of Glass,
Tacoma, Washington

I remember getting a call from Henry Geldzahler, the curator at The Metropolitan Museum—this was in 1976—who said that he had seen some photographs of my work and that he'd be interested in buying some for the Met. And that particular purchase and connection meant a great deal to me, and I remember that probably more than any other single event.

Peach Cylinder with Indian Blanket Drawing,
1995, 15 x 9 x 9 inches

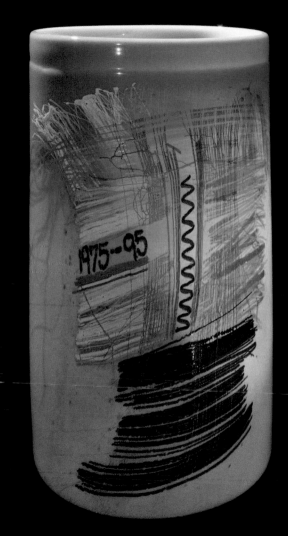

I think artists know quite often when they hit on something. In fact, artists really can't move ahead or go on unless they have that feeling. Sometimes you might have to fool yourself that you're doing something important, but unless you can make something important for yourself, you can't continue.

Peach Cylinder with Indian Blanket Drawing,
1995, 7 x 4 x 4 inches

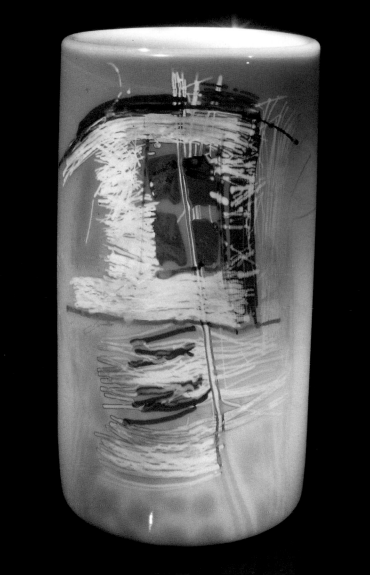

I don't know where the ideas come from. They come from traveling, they come from working—probably from working more than any other single way. They come from talking to people, from looking at things, and I'm just fortunate that so often when one idea runs out there's another idea waiting in the wings.

Paxton's Garden, 1995.
Lismore Castle, County Waterford, Ireland

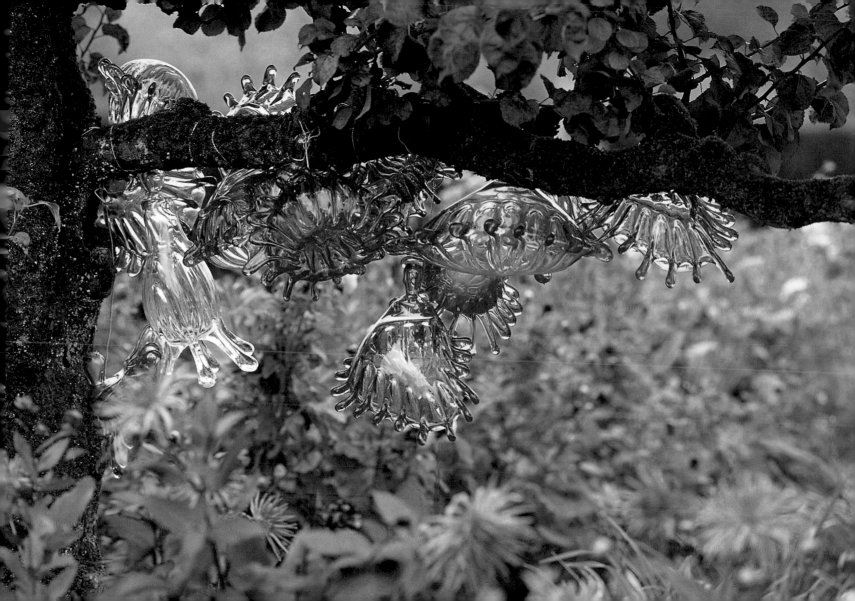

I'd seen a chandelier in a Barcelona restaurant when I was traveling. There was a chandelier hanging at eye level over each table, because the room had a low ceiling. And it was really beautiful. I loved this idea of hanging a chandelier at eye level. It triggered something that said that now I could make a chandelier, because it doesn't have to be functional.

Destruction Room Chandelier,
1995, 10 x 7 feet.
Lismore Castle, County Waterford, Ireland

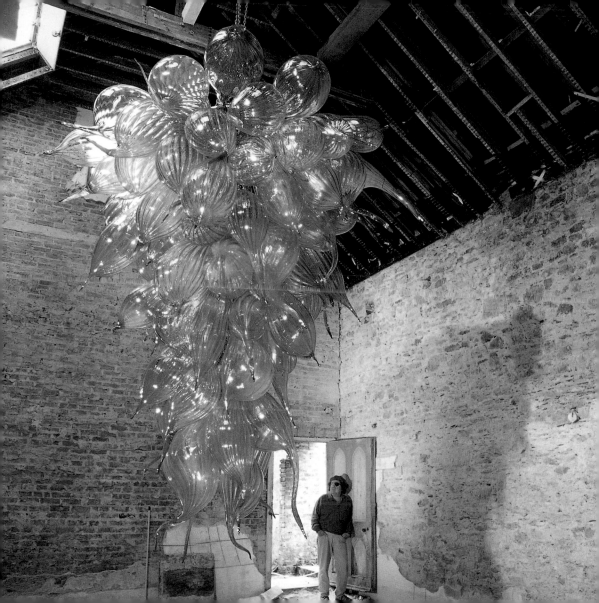

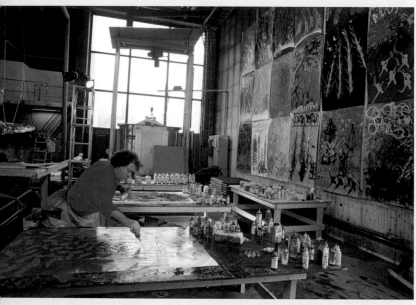

Chihuly drawing, 1996. Vitro Crisa Factory,
Monterrey, Mexico

More and more I began putting things outside
and discovering, as I suspected, that the glass
could take it.

**_Garden Installation_, 1995.
Lismore Castle, County Waterford, Ireland**

107

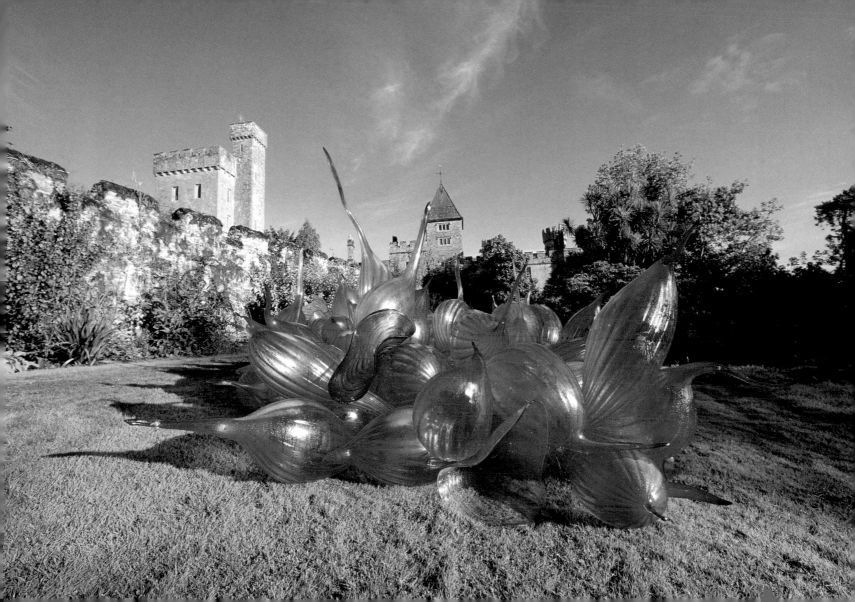

I love to work outside. I love to do exhibitions that have courtyards or gardens of glass. You can see it throughout my work, even from the very beginning.

Garden Installation, 1995.
Lismore Castle, County Waterford, Ireland

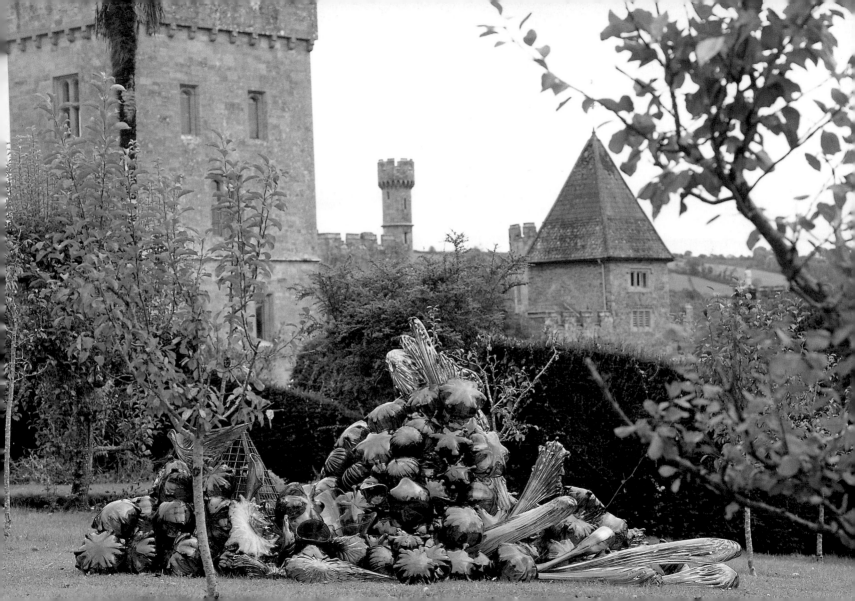

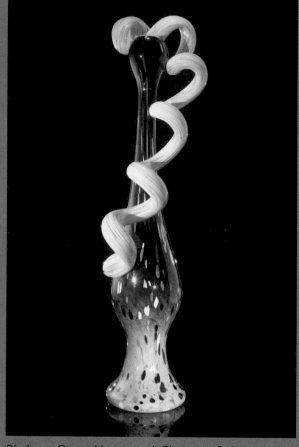

Black over Orange Venetian with Chartreuse Coil, 1991.
35 x 13 x 10 inches

It's a natural thing for artists to want to go as far

as they can.

Mexican Green and Blue Mirrored Chandelier,
1996, 6 x 5 x 3 feet. Vitro Crisa Factory,
Monterrey, Mexico

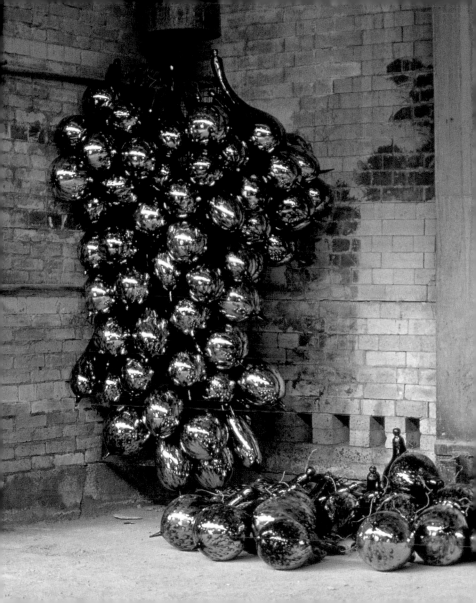

They had never seen so much glass come out of Nuutajärvi Glassworks in Finland. So quickly, in such odd, freehand shapes, and all of us were surprised as well. Using the river and the glass together—it was a surprise. Things just kept flowing. There was an osmosis of hot glass to the river, back to the courtyard, out in front of the factory … it was probably the most intense twenty days of my life.

Charles Parriott, *Chihuly: River of Glass*,
film directed by Michael Barnard, 1997

Tepees, 1995.
Nuutajärvi, Finland

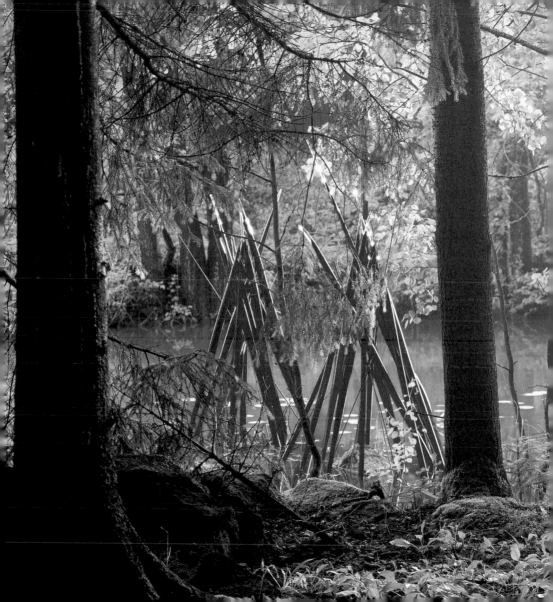

How do you connect a natural, organic feeling to something? I once did a *Chandelier* that was hanging from a branch and the branch gave way and the *Chandelier* happened to go in the water. It was one of the most beautiful *Chandeliers* I ever made because nature played a role. When that happens, when you can go with the flow and get that feeling, then the work looks best to me.

Gourd Chandelier, 1995,
10 x 5 x 5 feet.
Nuutajärvi, Finland

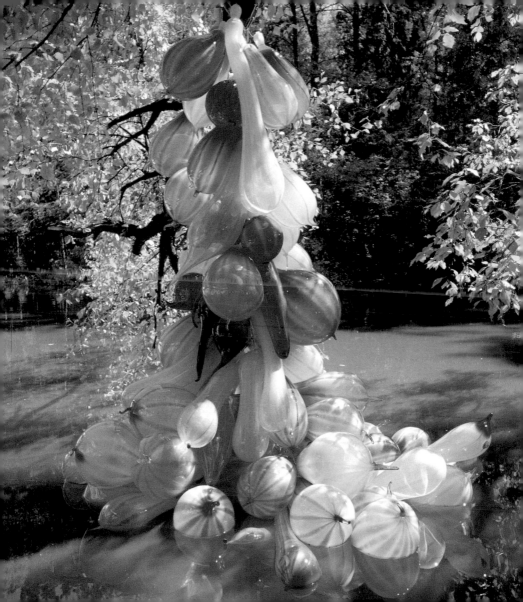

You might ask why Finland and why chandeliers and what's this all for?

Cobalt Blue Chandelier, 1995,
5 x 6 x 3 feet.
Nuutajärvi, Finland

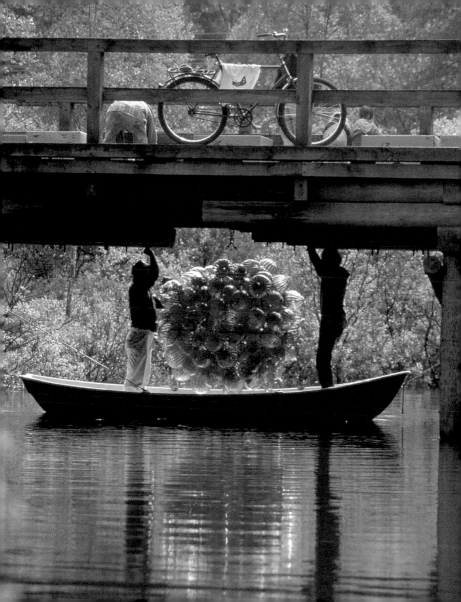

I had an inclination before we came to Finland that I wanted to work on the water. I hadn't really done any installations like this, literally, for twenty-five years. The last installation on water that I can remember doing was about 1971 at Pilchuck. When we first built Pilchuck, we floated some glass on the pond. I think even then, in 1971, it was actually an afterthought. So here we are twenty-five years later, and much of this work that we just did is almost like I picked up where I was in 1971.

Belugas and Seal Pups, 1995.
Nuutajärvi, Finland

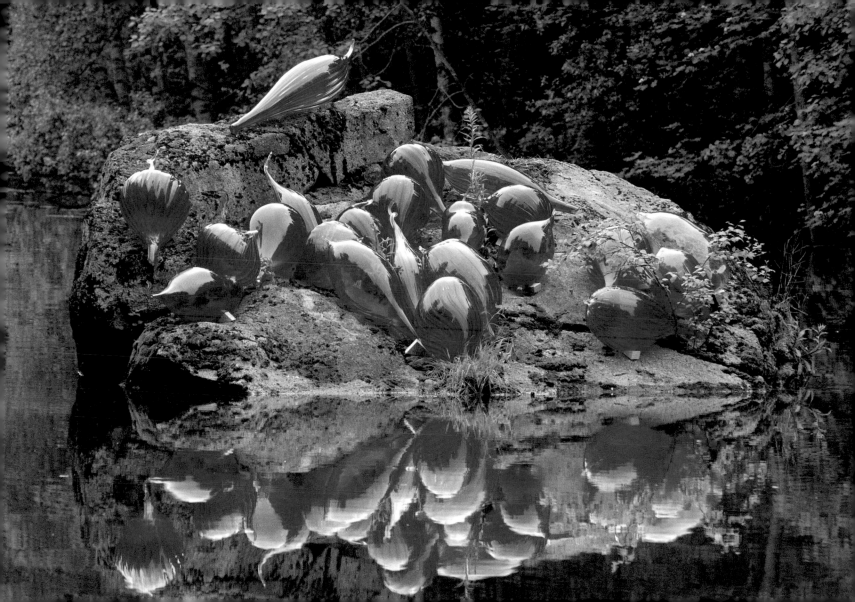

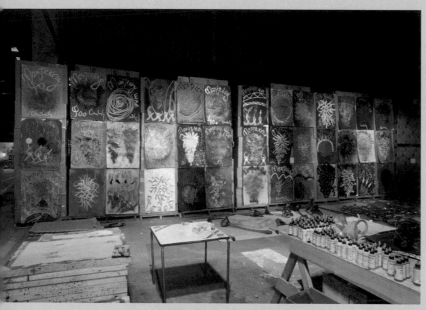

Drawing Wall, 1996. Vitro Crisa Factory, Monterrey, Mexico

I tend to work in countries that have a great glass tradition. I'm always stunned at how differently all these glass masters work, how different the facilities are, the character of the people, whether it be Finland, Mexico, Ireland, the Czech Republic, France, Great Britain. Everybody has their own way of working, and we've learned so much from being able to work with great masters in all these countries.

**Mexican Plaza *Chandelier*, 1996, 10 x 5 feet.
Monterrey, Mexico**

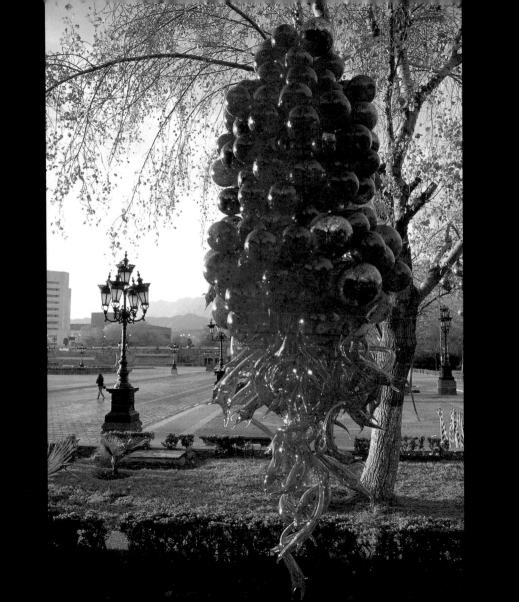

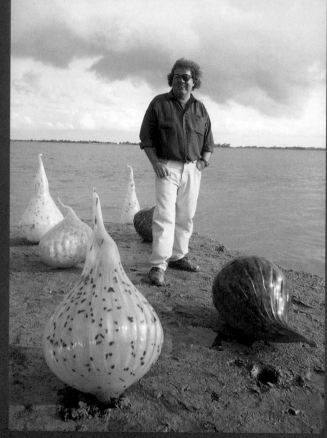

Walla Wallas, 1996. Venice, Italy.

Hang it in space and it becomes mysterious, defying gravity or seemingly out of place— like something you have never seen before.

Isola di San Giacomo in Palude Chandelier, 1996, 8 feet 7 inches x 7 feet 2 inches. Venice, Italy

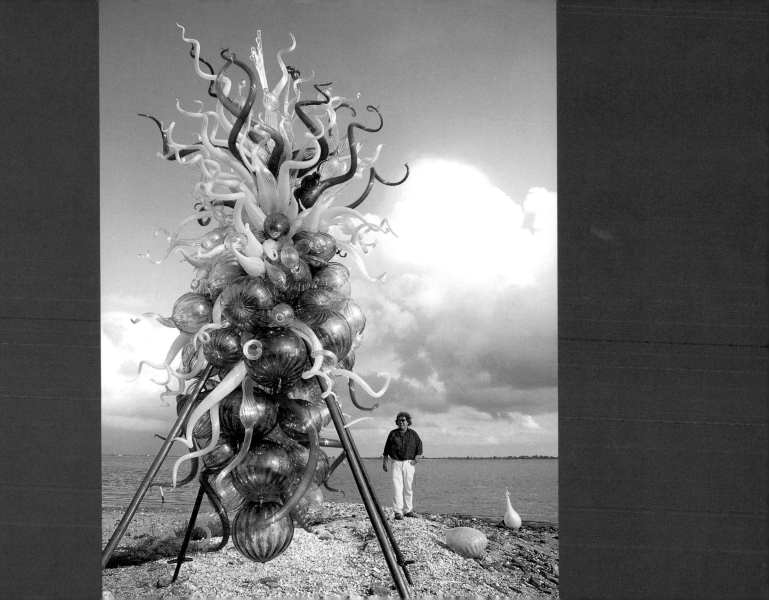

I just couldn't understand why no one wanted the *Chandeliers* because I really thought they worked well in space. So I kept making them in spite of their lack of success—commercial success and probably critical success as well. I try not to read the reviews.

Mercato del Pesce di Rialto Chandelier,
1996, 8 x 5 feet. Venice, Italy

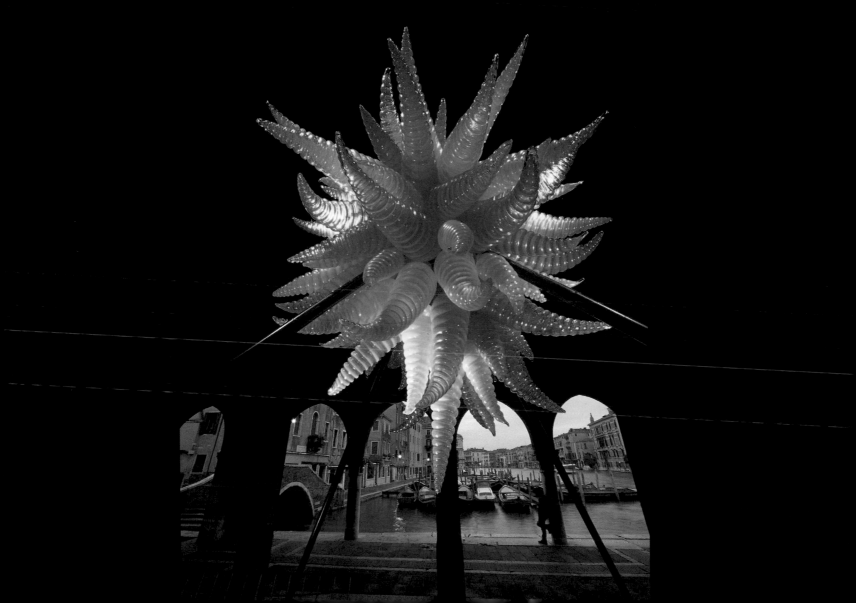

Looking back, I was lucky to connect well in the Venini Factory when I was young. I did some models for them, and I had the opportunity to get to a studio and work with great glassblowers. I was too intimidated to blow glass myself, because I was so lousy compared to the greatest that there were. But I watched, and I learned, and I saw the team in action.

Chiostro di Sant'Apollonia Chandelier, 1996, 5 feet 5 inches x 7 feet 4 inches. Venice, Italy

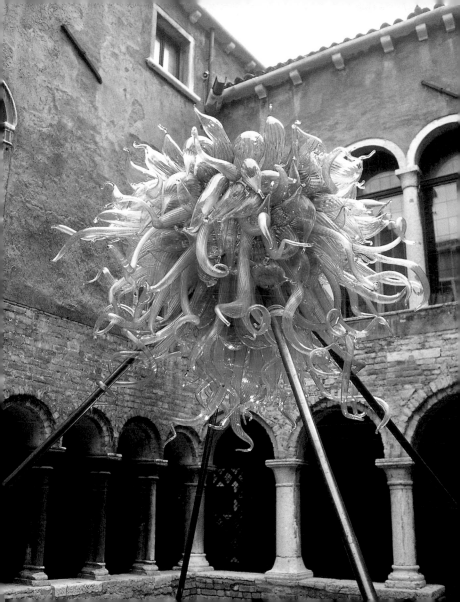

One day I started dreaming about Venetian chandeliers and I started imagining my *Chandeliers* hanging in the little canals of Venice.

Campiello Remer Chandelier, 1996,
12 feet 6 inches x 5 inches x 5 inches.
Venice, Italy

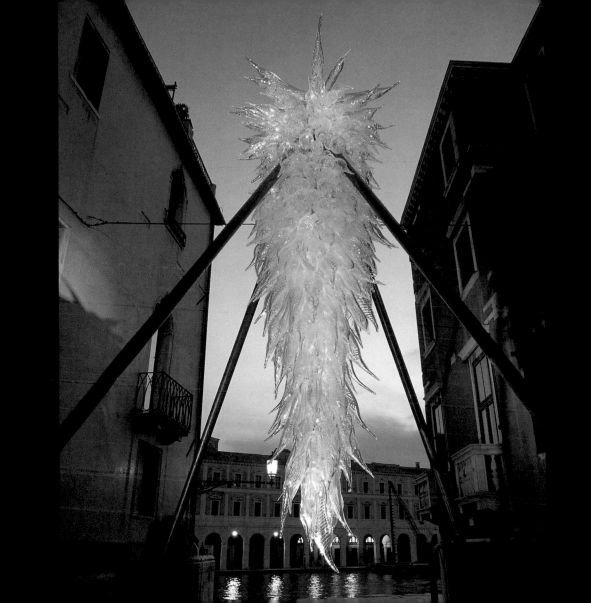

I've been such a nomad all my life. I don't think I'll ever lose the desire to travel to beautiful places—one more archipelago, another ring of standing stones, another glassblowing session in some exotic spot, or just one more trip to Venice to see the full moon over the Grand Canal.

Palazzo Ducale Chandelier,
1996, 9 x 8 feet. Venice, Italy

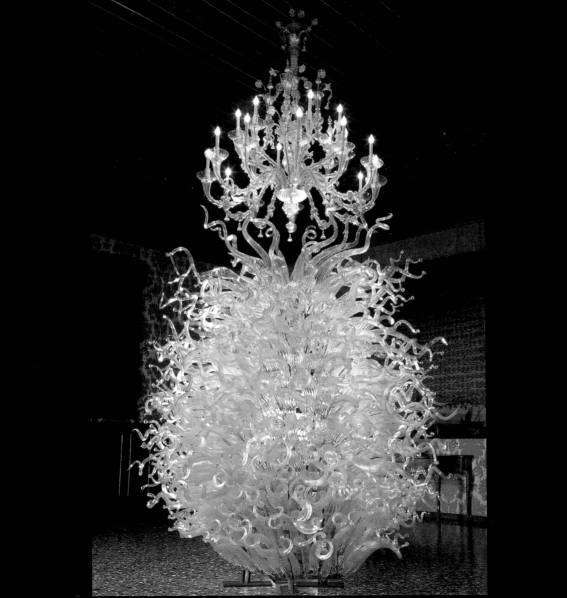

Why did I put the *Chandeliers* on the river? I knew that they would reflect in the river. If I have a choice, I'll work around water whenever I can.

Squero di San Trovaso Chandelier,
1996, 10 x 4 feet. Venice, Italy

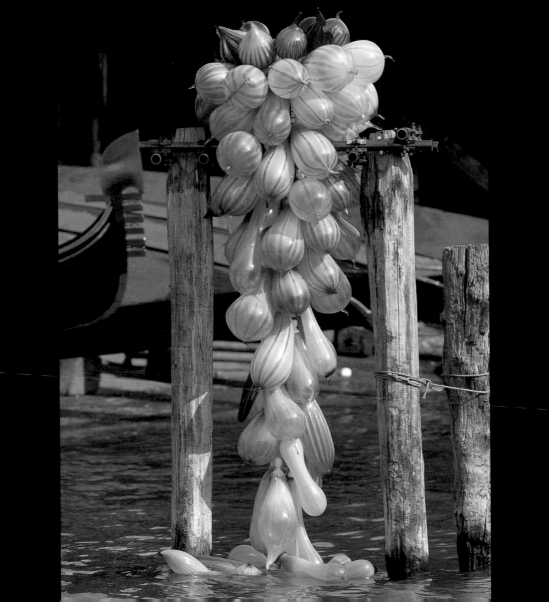

The chandelier is one of the few forms in glass that has scale, is three-dimensional, is vessel-related, is animated by light, is airborne, and is capable of transforming an environment, all of which are important qualities for Chihuly's work, themes that the artist has explored in his *Macchias* and especially in his *Persians* series.

Tina Oldknow, Corning Museum of Glass,
unpublished essay titled "Chihuly Over Venice:
Dale Chihuly's Shining Legacy," 1996

Campo della Salute Chandelier,
1996, 14 x 6 feet. Venice, Italy

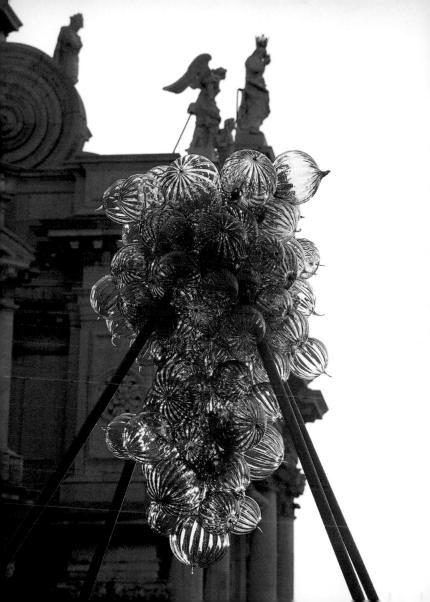

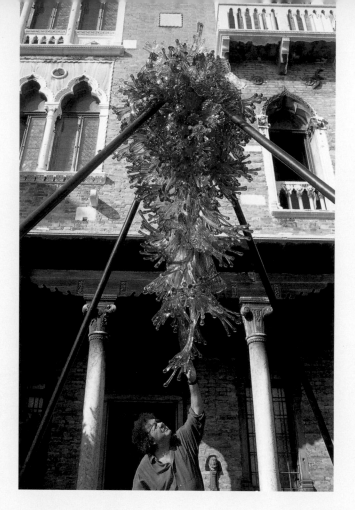

Talk about the twentieth century not being able to live up to its abilities. We've never made a good chandelier—not one that I can think of. And I'll bet that there have been no less than 10,000 different ones designed and built. It's an interesting challenge to try and make something that works.

Palazzetto Stern Chandelier, 1996,
12 feet 6 inches x 5 feet 11 inches.
Venice, Italy

122

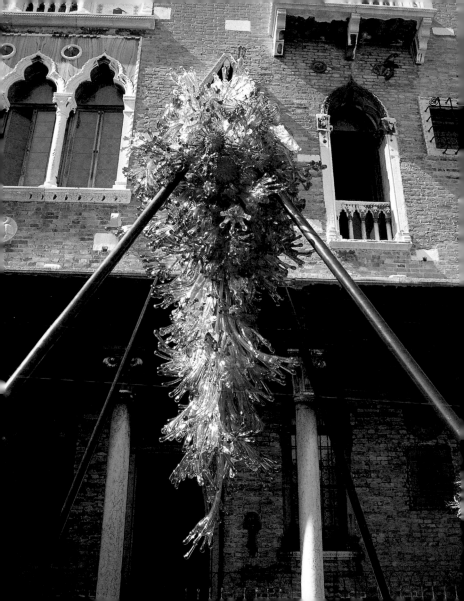

Venice is my favorite city, especially since the automobile has screwed up every other city. In Venice, you have some solace. And water!

"On the Road," in *Chihuly: Color, Glass, Form*,
Tokyo: Kodansha International, 1986.

Ponti Duodo O Barbarigo Chandelier,
1996, 11 x 4 feet. Venice, Italy

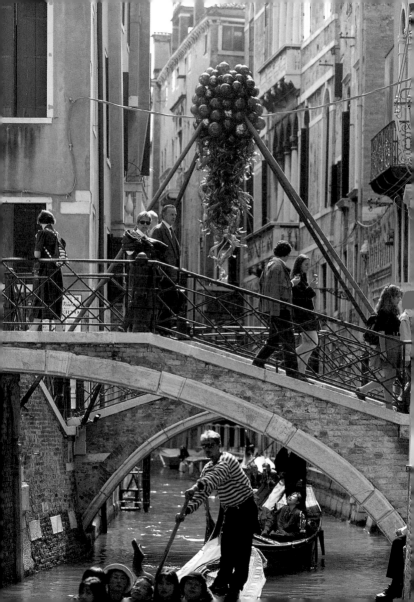

Chihuly, too, has always recognized his own debt to Venice, to the inspiration he has derived from the city itself as well as its glassmaking traditions. *Chihuly Over Venice* was, in one sense, Chihuly's reply to tradition and his thanks to an important mentor. It was also a way of bringing something to Venice that its glass community could delight in, as much as the American glass community has been delighted by Venice.

Tina Oldknow, Corning Museum of Glass,
unpublished essay titled "Chihuly Over Venice:
Dale Chihuly's Shining Legacy," 1996

Rio delle Torreselle Chandelier, 1996,
6 feet 6 inches x 8 feet 2 inches. Venice, Italy

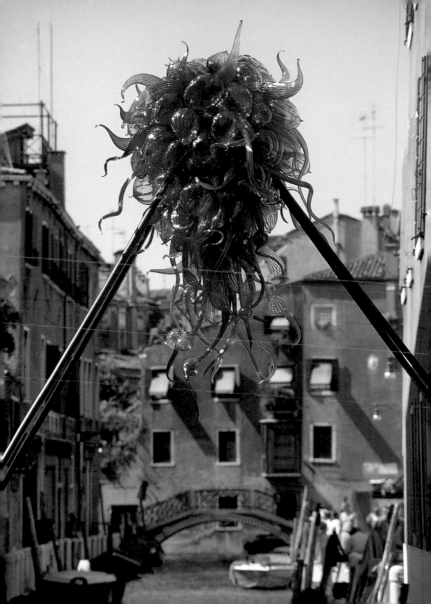

Working with a team is good for me—new people, new ideas, new places. *Chihuly Over Venice* started out with the end in sight—the *Chandeliers* hanging over canals. But the people became more important—all the glassblowers and artisans from different countries working hand in hand with all the Americans.

Palazzo Di Loredana Balboni Chandelier, 1996, 10 feet 7 inches x 6 inches x 6 inches. Venice, Italy

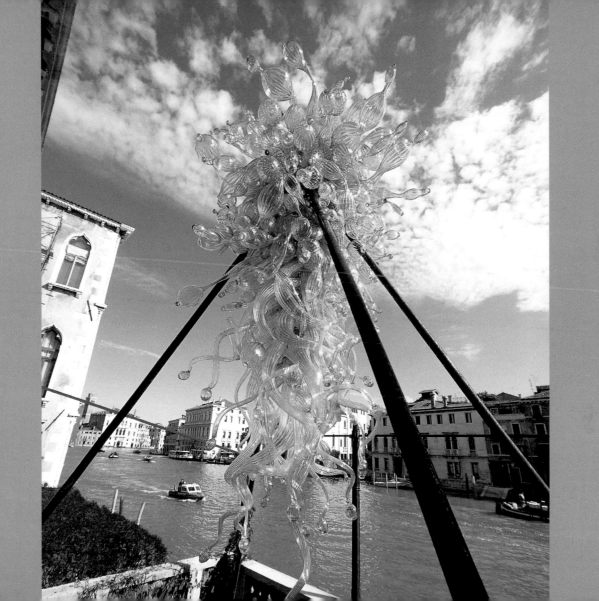

Glass is one of the few materials that light goes through, and colors can be so intense, or so subtle.

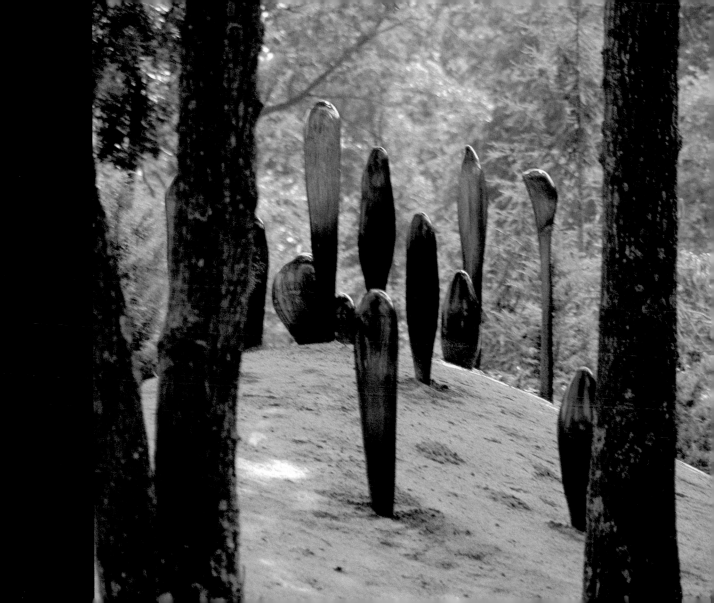

Traditionally, in Italy, you could only be a glassblower if your father was one. Glassblowing is 2,000 years old, and not much in the methodology or the equipment has changed. The Venetians have guarded it jealously. But we have really opened things up a lot. Seattle has become the capital of the glass world on this continent, just as Venice is in Europe. We have sixty or seventy different hotshops and each week we see a new one open. There must be 500 to 1,000 glass artists in the Seattle area.

Fiddleheads, 1996.
East Hampton, New York

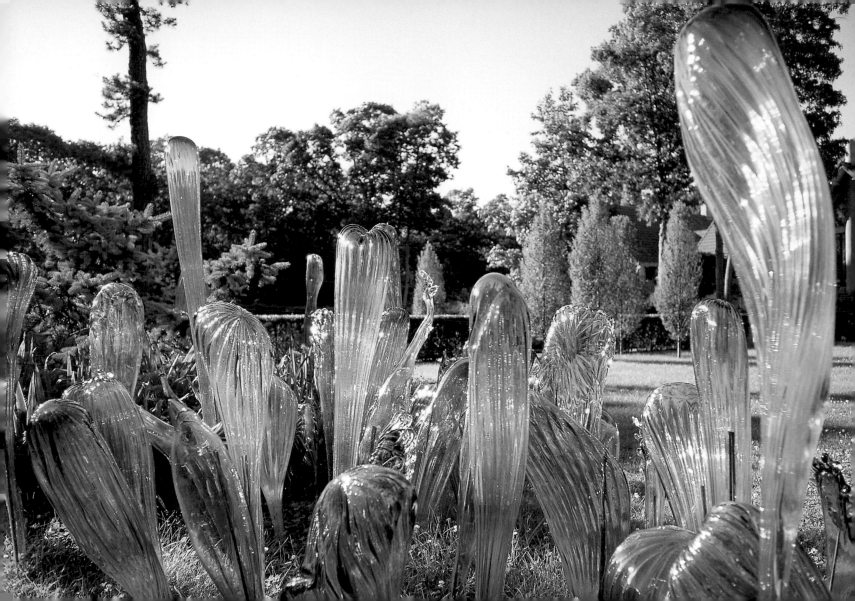

I love baths. I love to walk on the beach, and I love to be around water. There is no doubt in my mind that water helps you be creative and is conducive to thought, which, for the artist, is the important thing.

Walla Wallas, 1996.
Lake Union Ship Canal,
Seattle, Washington

128

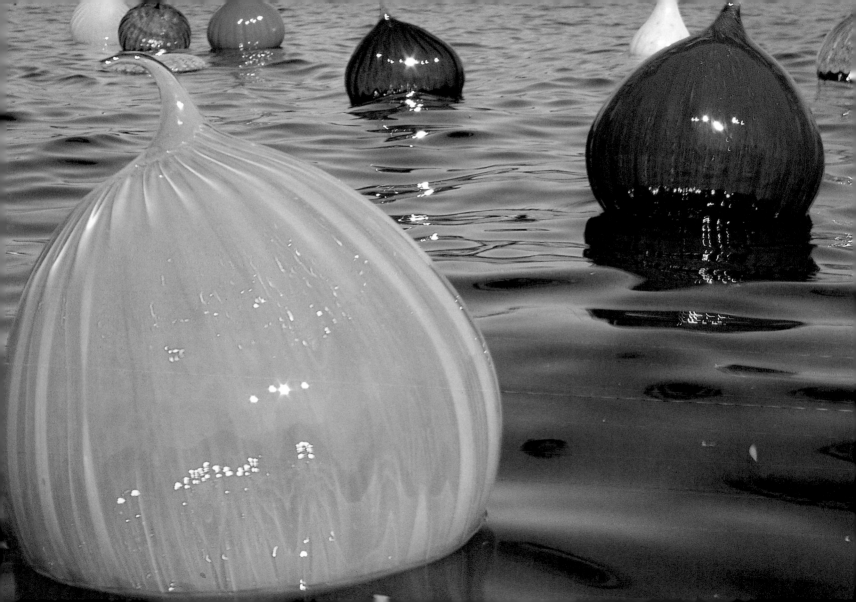

Glassblowing is very athletic, and the more you blow, the better you get. I've been at it for thirty years and I am as infatuated as when I blew my first bubble in 1965 in my basement in South Seattle.

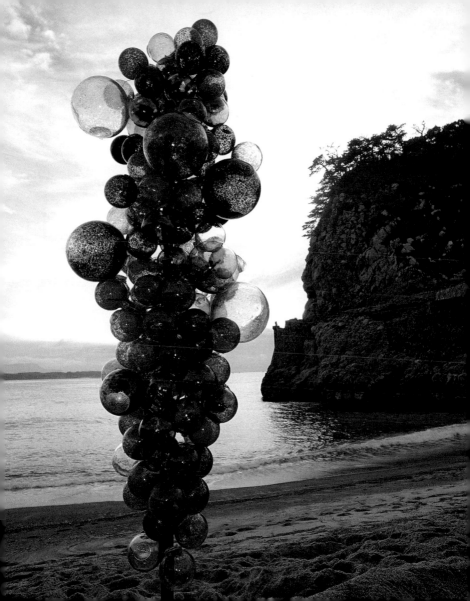

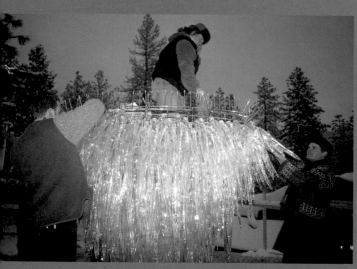

Icicle Creek Chandelier, 1996, 12 x 9 x 6 feet. Sleeping Lady Retreat, Leavenworth, Washington

This was a really unusual piece—it was my first permanent outdoor installation. I was holding off on doing the project for Harriet Bullitt up in Leavenworth, which is up in the Cascade Mountains in the snow country. I think Mount Rainier, in a record year, will have 100 feet of snow on top. The time was up. I needed to get the project going. I'd just come off *Chihuly Over Venice*, and so I thought it would be an interesting time to roll the dice and do the project outside. Harriet's a great client, and she said, "Look Dale, whatever you want to do, go ahead and do it."

Icicle Creek Chandelier, 1996, 12 x 9 x 6 feet.
Sleeping Lady Retreat, Leavenworth, Washington

130

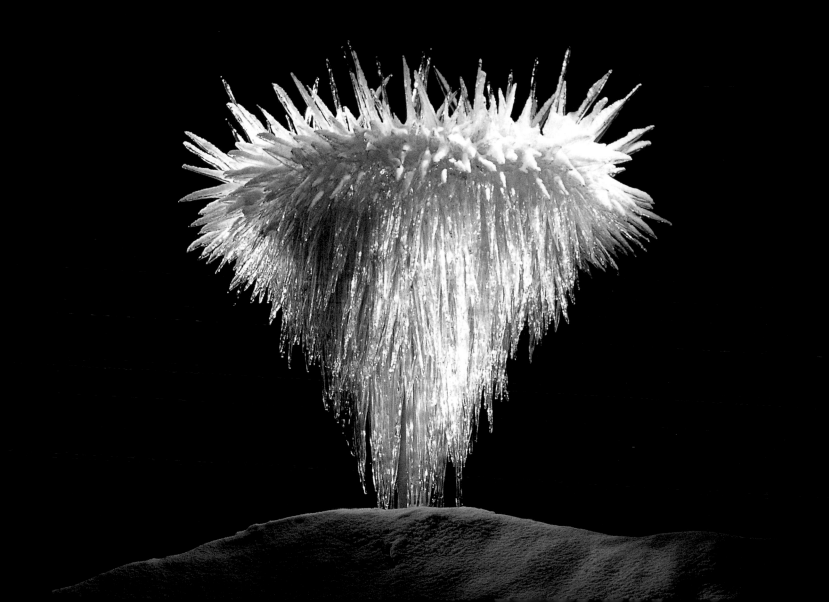

I love to work with people. It inspires me to be working with a group of people on an idea. It's the way things happen for me.

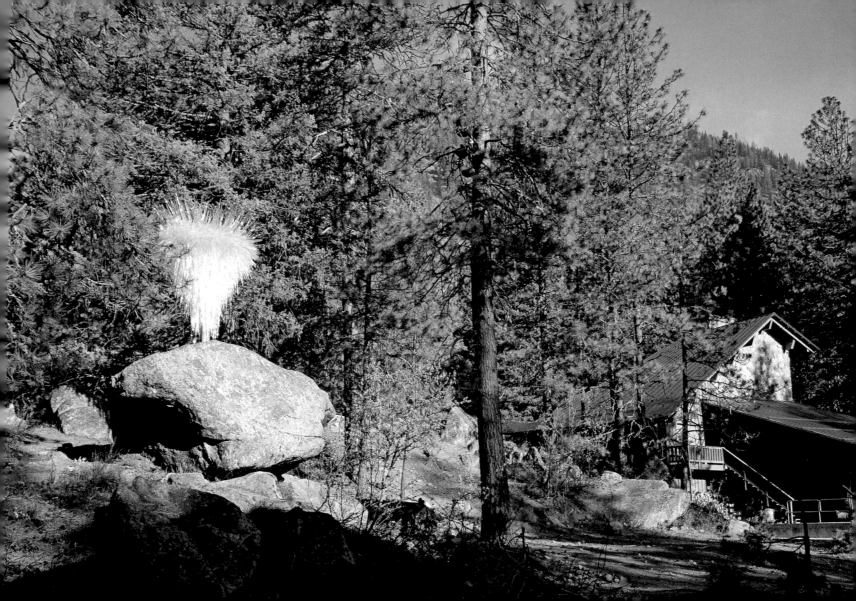

Chihuly's best pieces imply pure movement. It's as if his *[Sea]forms* will surface to the top of the gallery room as soon as night comes. The pieces seem to float, one inside another, delicately tangential, each existing on its own.

Susan Zwinger, "Sea Still Lifes in Silicon,"
The Santa Fe Reporter, November 4, 1981

Deep Purple and Azure Seaform Set,
1997, 14 x 31 x 18 inches

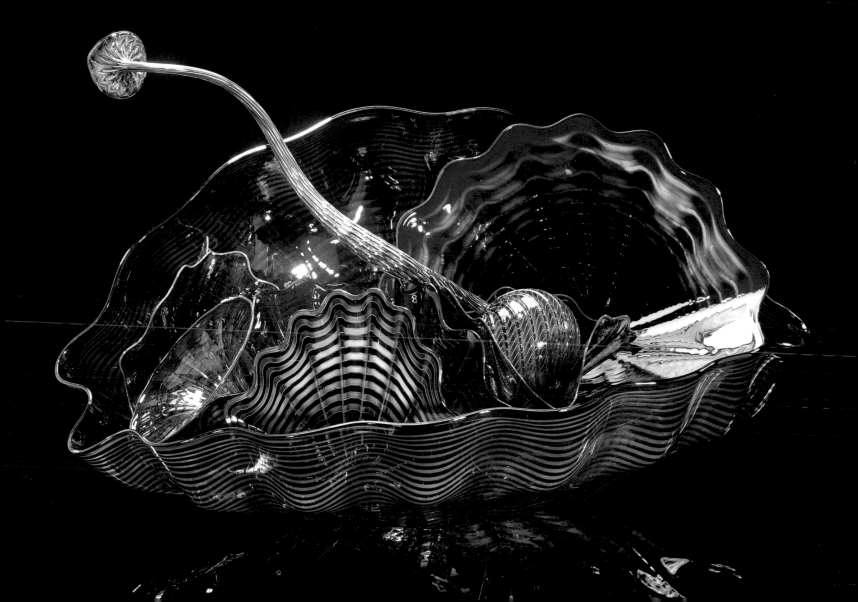

I would not have gone to school by choice. I wasn't a very good student in high school and junior high, because I didn't care about studying. The only reason I went to college was my mother really wanted me to go. I went to college up the street and took a weaving course that first year. I guess that was in 1959.

Sky Blue Seaform Set with
Goldenrod Lip Wraps, 1997,
11 x 35 x 36 inches

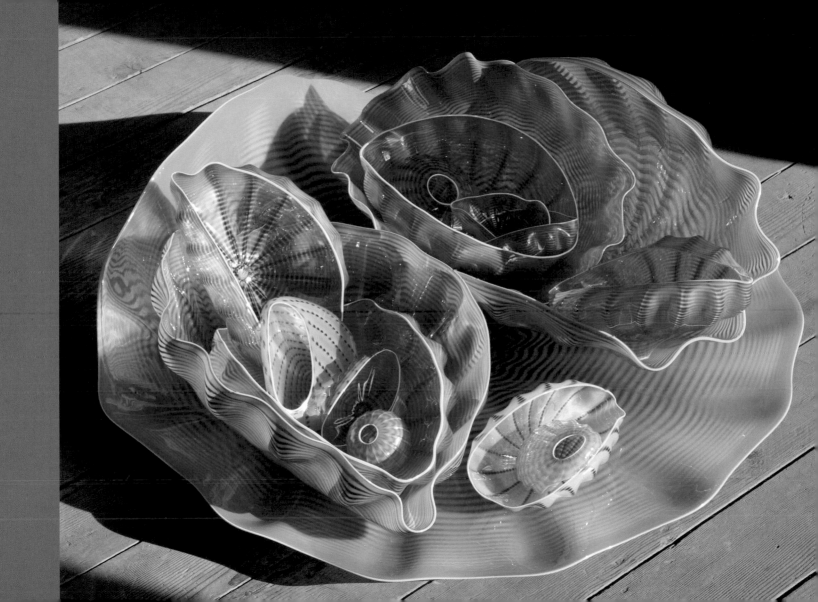

You can't just learn glassmaking skills and forms by making something a couple of times. Many of the things we do, we've had to do hundreds of times in order to make them well. Once you get there, you can then push it to the next stage. That's why the glassblowing goes on constantly. It has to. We hone the skills, develop the methods and the molds. You can only get where you want to be by working and working and more working.

Red Mahogany and Birch Persian Set with Ebony Lip Wraps, 1989, 14 x 42 x 26 inches

134

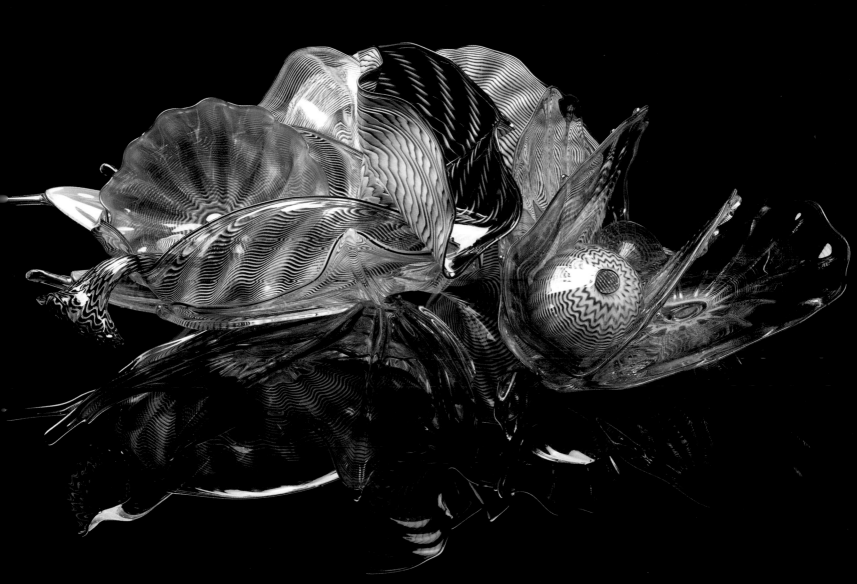

It's a question of timing—you just have to become one with the material and understand its temperature. You can't see it—you have to feel it. Only by working day in and day out, year after year, can a series really develop.

Cerulean Blue Piccolo Venetian,
1998, 9 x 5 x 5 inches

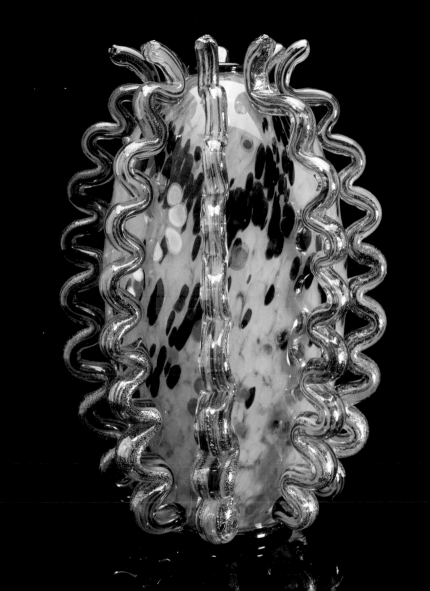

How is this project unique? First of all the scale, and secondly, the number of talented people who make up the team: glassblowers, architects, engineers, shippers, installers, and fabricators—over 100 in all. It took about 10,000 pounds of steel for the armature and some 40,000 pounds of handblown glass—over 2,000 pieces positioned fifteen to twenty-five feet overhead. It also demanded an entirely new type of hardware to attach the glass to the structure.

Chihuly Bellagio, Portland Press, 1999

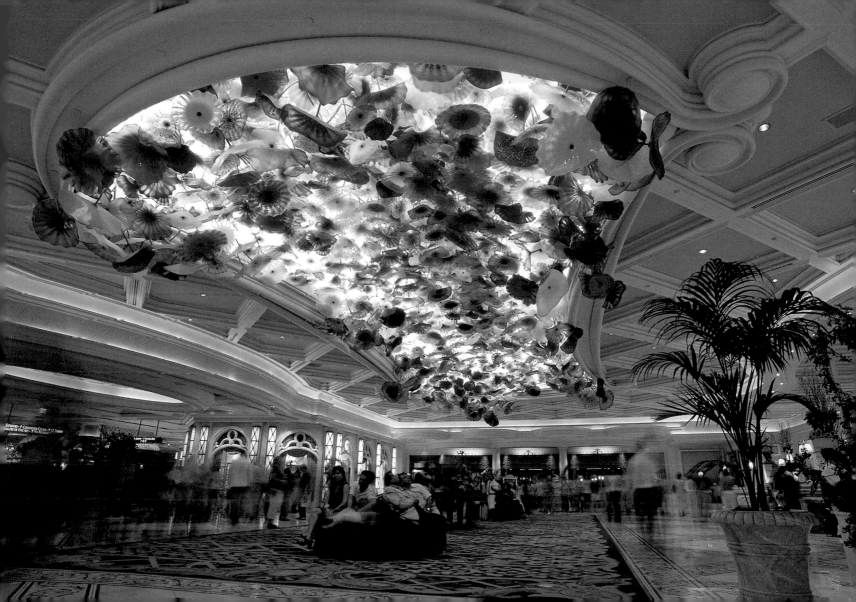

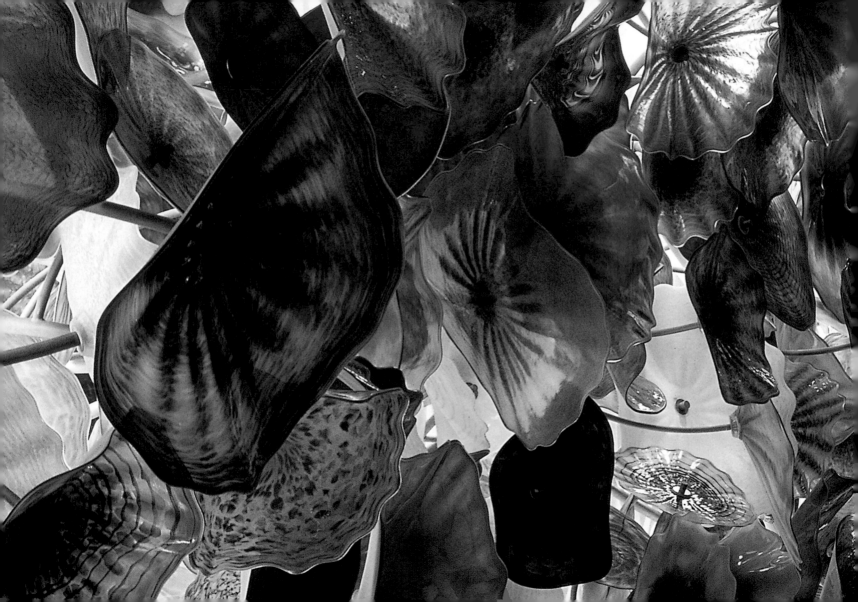

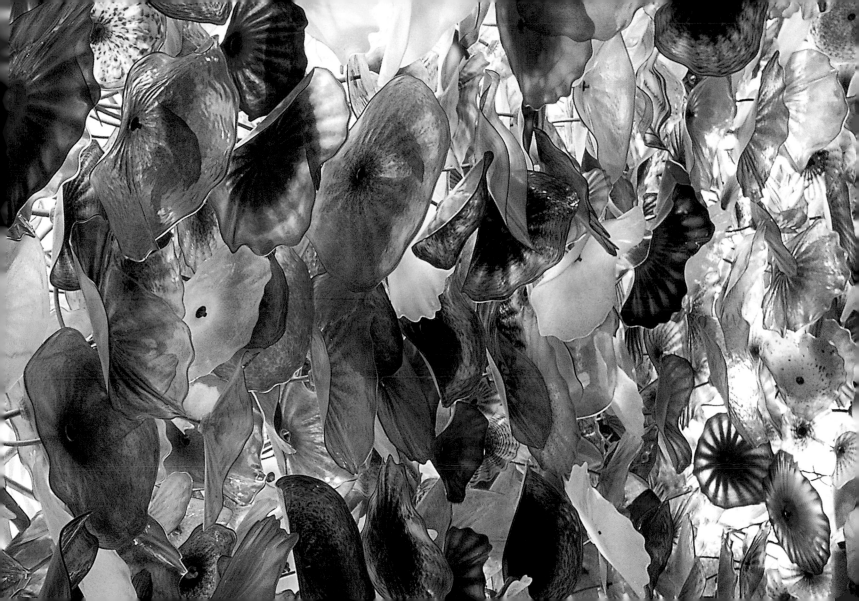

Everything about *Fiori di Como* was new—the scale, the armature, and the glass itself. Color was the most difficult aesthetic challenge, and the structure was the most difficult technical challenge.

Fiori di Como **detail**

137

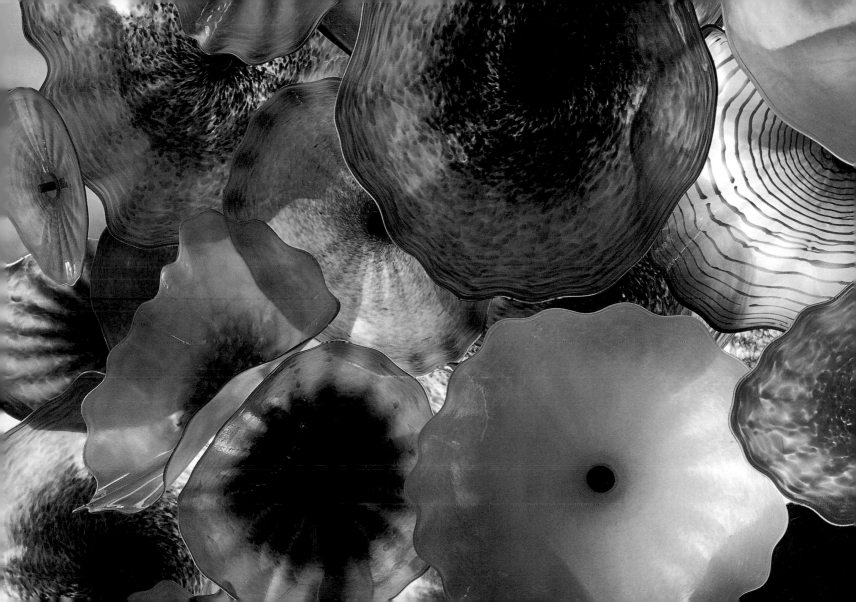

I love working in architectural spaces. In this case it's basically the entire ceiling of a large lobby.

It requires a totally different type of thinking. We're not talking about single objects here; we're

talking about a couple of thousand pieces of glass being used to create one object.

Fiori di Como **detail**

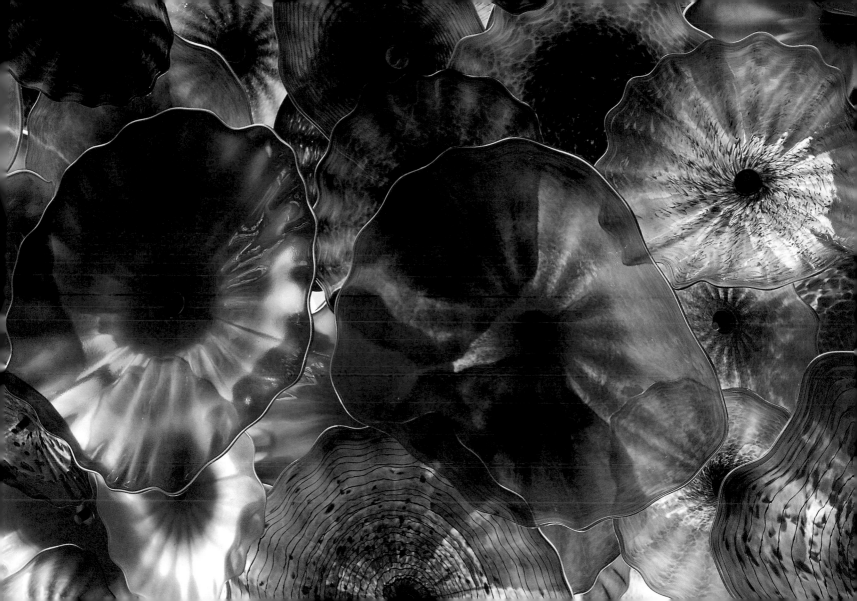

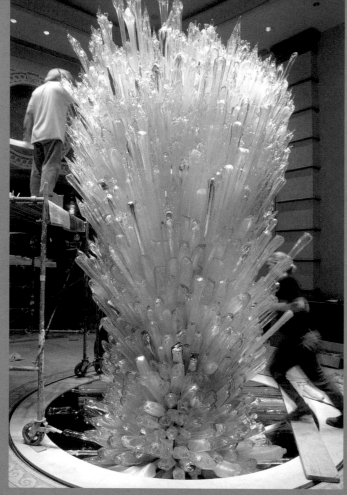

Crystal Gate detail, 1998. Atlantis, Paradise Island, The Bahamas

Any material has an understood set of rules—you can do this with the material, you can't do that with the material. The one thing about Dale is that the more he knows about a material, the less he feels limited by it, I think.

Joey Kirkpatrick, *Chihuly at the V & A*, film directed by Peter West, 2002

Crystal Gate, 1998. Atlantis, Paradise Island, The Bahamas

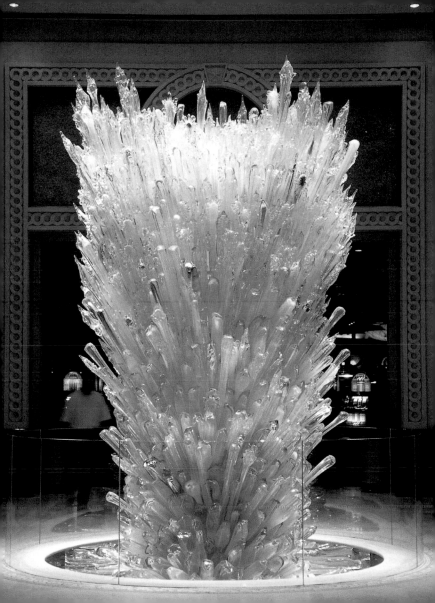

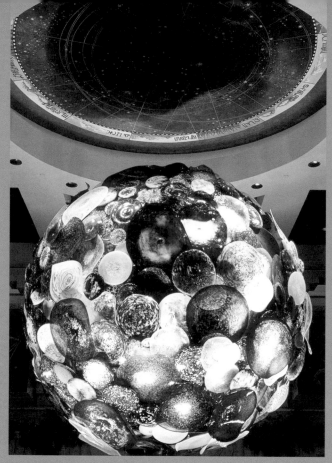

Temple of the Moon, 1998. Atlantis, Paradise Island, The Bahamas

In the glass world, in the museum world, people have a pretty clear idea of how things should look, and Dale challenges taste by not being concerned with it. He knows about color, he knows about forms, and that's what he cares about. And he does go over the top sometimes with pieces that people say, "This is really too much." But it's not. Five years later it's not too much.

Henry Geldzahler, *CBS Sunday Morning*, 1992

Temple of the Moon detail, 1998.
Atlantis, Paradise Island, The Bahamas

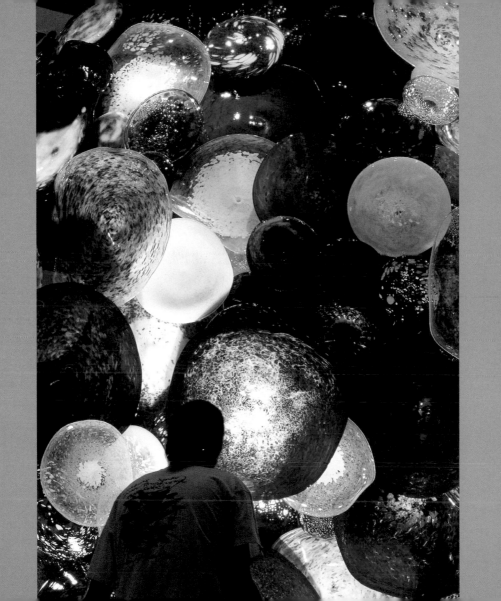

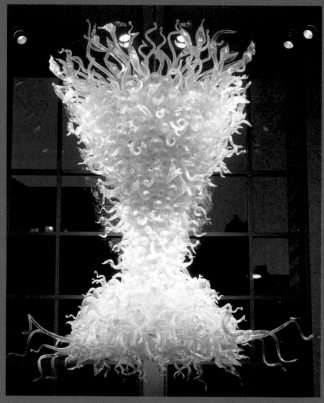

Silver Crystal Cascade Chandelier, 1998, 20 x 10 x 10 feet.
Benaroya Hall, Seattle, Washington

I remember taking walks on the beach as a child and picking up pieces of glass in the sand. And I remember being fascinated by stained glass in church. But I don't think that's unusual. If you go to the poorest neighborhoods, you'll see glass bottles in the window that kids are saving. It's as we get older that we lose the ability to see things.

Gold Crystal Cascade Chandelier,
1998, 15 x 10 x 10 feet.
Benaroya Hall, Seattle, Washington

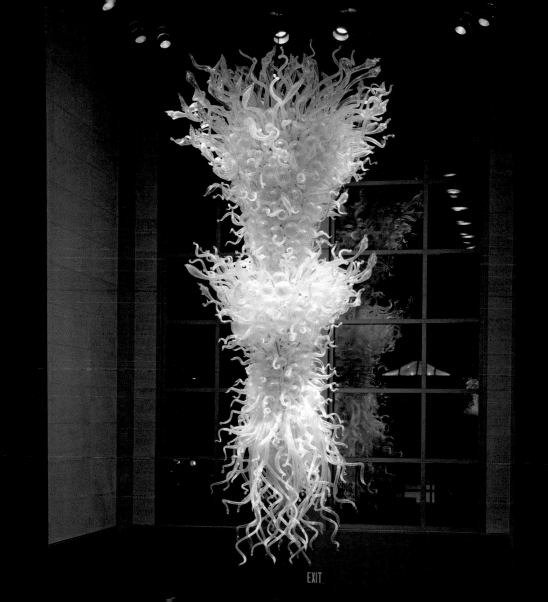

Jerusalem 2000 Cylinder #58, 1999, 34 x 11 x 16 inches

Jerusalem is one of the world's most historic, beautiful, and exotic cities.

Jerusalem 2000 Cylinder Group, 1999

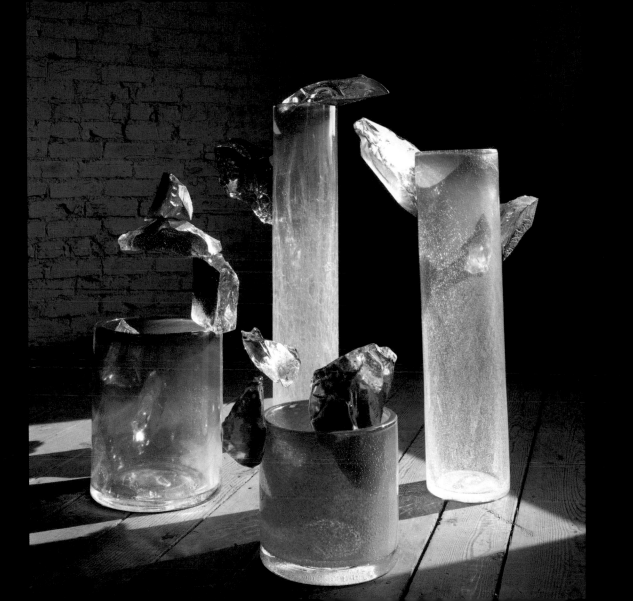

It's very important for me to work regularly, but it's also important to get away from the glassblowing and to travel and to draw. So it's a combination of working and escaping.

Jerusalem 2000 Cylinder #60,
1999, 19 x 17 x 11 inches

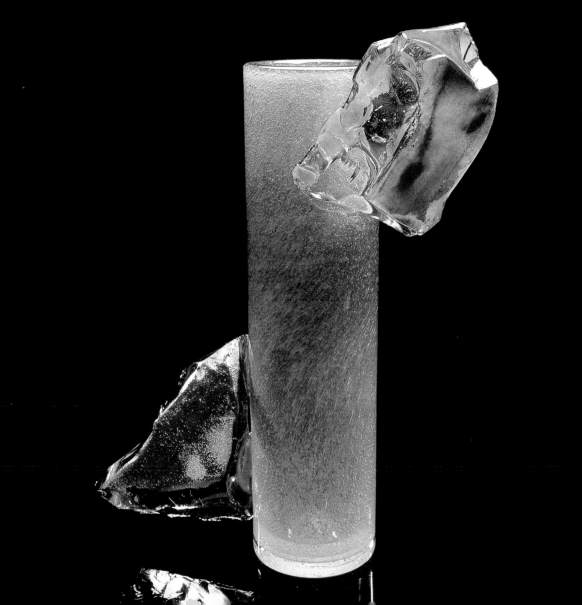

I wandered all through Europe, initially going to Florence to study art, and I studied Italian for a little bit, and thought maybe I could speak it, but I was never very good with languages. So when I got to Florence and I couldn't speak Italian very well, I was depressed. So I went to Paris where I ended up trying to study French, which I wasn't very good at either.

Jerusalem 2000 Cylinder #57,
1999, 18 x 13 x 11 inches

144

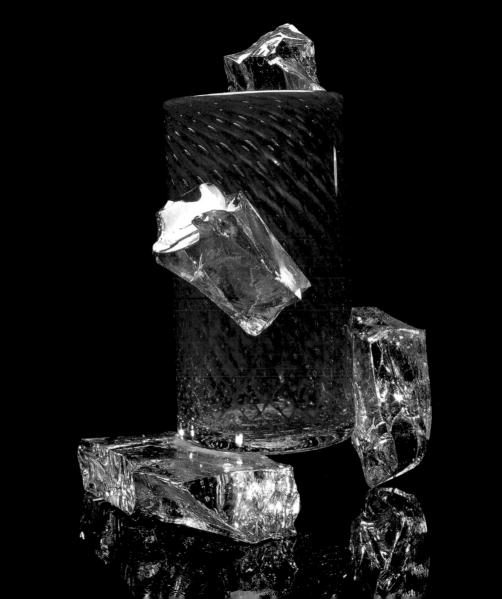

I'm amazed at what people seem to find in my work, and I don't like to limit what they see with a title. For me, titles are very difficult, and I don't usually even think in terms of a theme when I'm creating a sculpture. Once it's finished, I'll come up with a title, but one person might see flowers, another something from the sea or something from a dream.

Jerusalem 2000 Cylinder #105,
1999, 17 x 12 x 18 inches

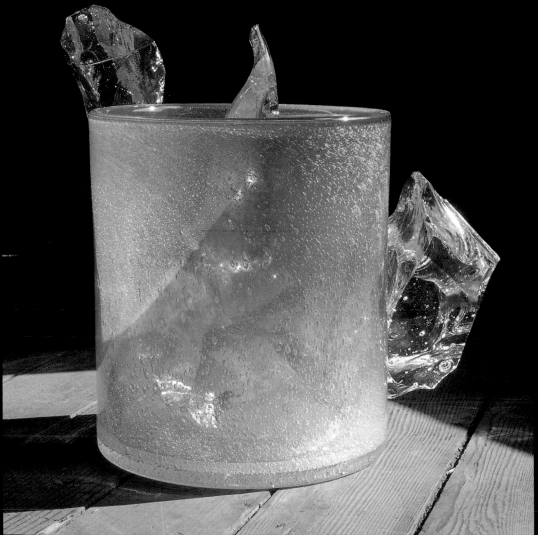

I don't like to second-guess what's good and what's bad. I mostly like to work.

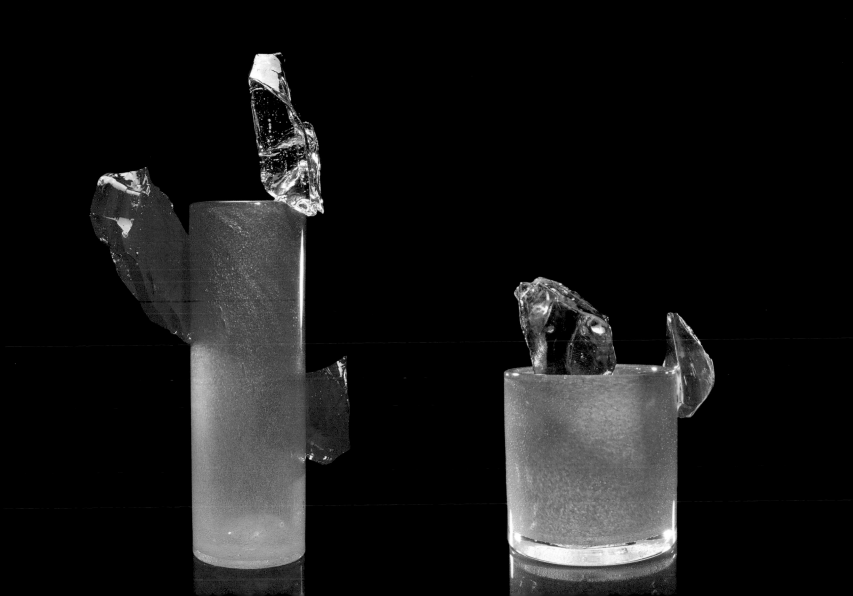

Putting the drawing or the painting down on paper helps me sort of figure out what's in my mind. And the blowing of the glass or the casting or the making of the glass helps bring the idea to fruition.

LEFT: *Jerusalem 2000 **Cylinder #87**,*
1999, 26 x 12 x 11 inches

CENTER: *Jerusalem 2000 **Cylinder #40**,*
1999, 15 x 12 x 11 inches

RIGHT: *Jerusalem 2000 **Cylinder #103**,*
1999, 23 x 21 x 15 inches

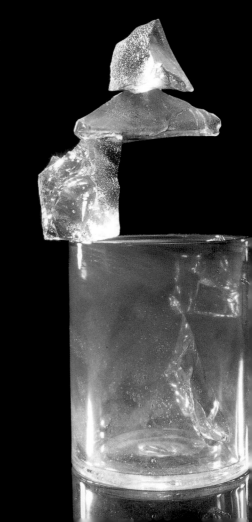

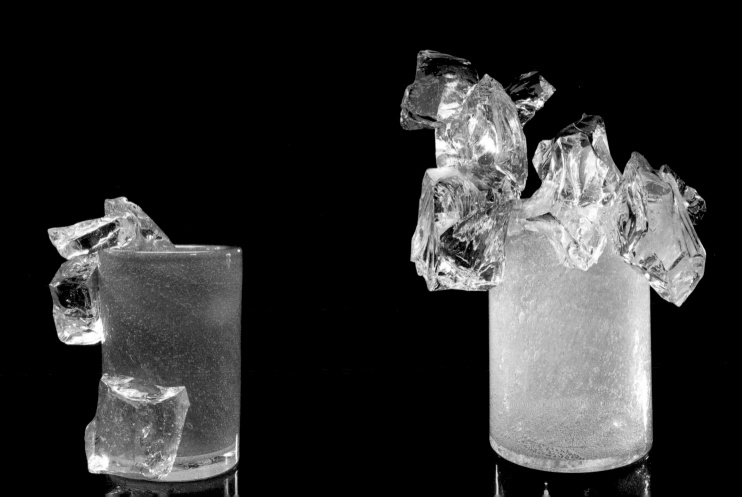

Like so many things I didn't really have control over it—a project just takes on a life of its own.

Jerusalem was like that: It was going to be a smaller project, but it grew and grew. It just grows on

its own.

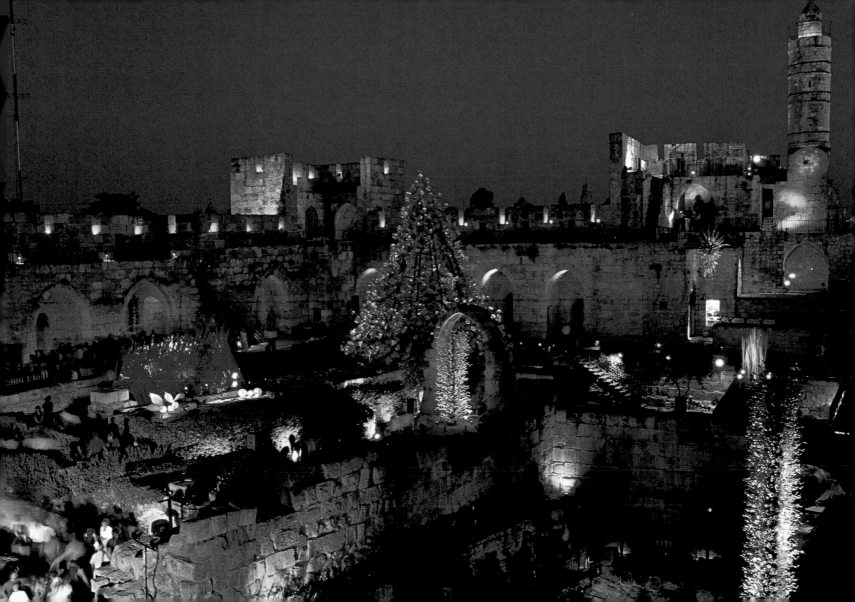

In many ways Jerusalem was a very spiritual experience for me. Each time I returned to the Citadel, I got more involved and the project got bigger and bigger as I became more connected to Jerusalem.

White Tower, 1999, 7 feet 6 inches x 6 feet x 6 feet.
Tower of David Museum, Jerusalem, Israel

One of the most exciting things about the Citadel is the many vantage points for viewing the exhibition. You could see the installations from every level and almost every angle. Totally different from the experience in a museum.

Blue Tower, 1999, 47 feet 6 inches x 6 feet.
Tower of David Museum, Jerusalem, Israel

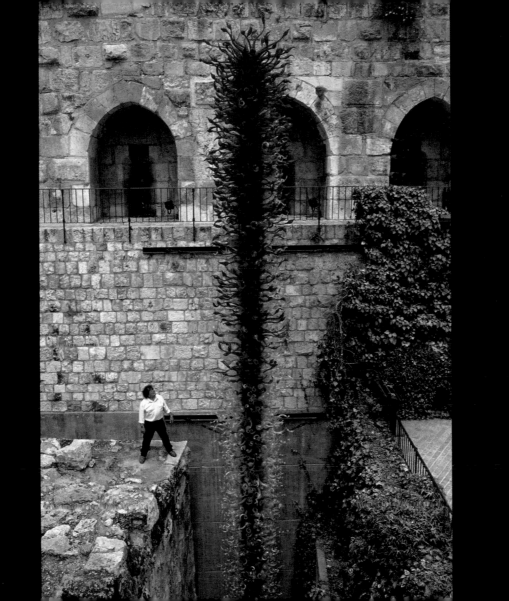

Up until the Six-Day War, the Citadel of the Tower of David was a fortress. It gave me great pleasure to open it up as a place to enjoy art and offer the message of hope and peace. Glass has a healing quality.

Chihuly in the Light of Jerusalem 2000, 1999.
Tower of David Museum, Jerusalem, Israel

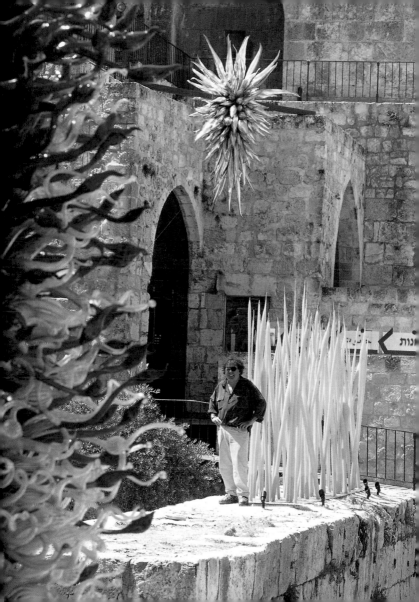

In the Tower of David, I really wanted to take glass to a glorious height—really make something special where the glass could speak to the audience. I was overwhelmed. Could I take on the Citadel? Could I put pieces in there that would hold their own in this extraordinary structure?

Red Spears, 1999.
Tower of David Museum,
Jerusalem, Israel

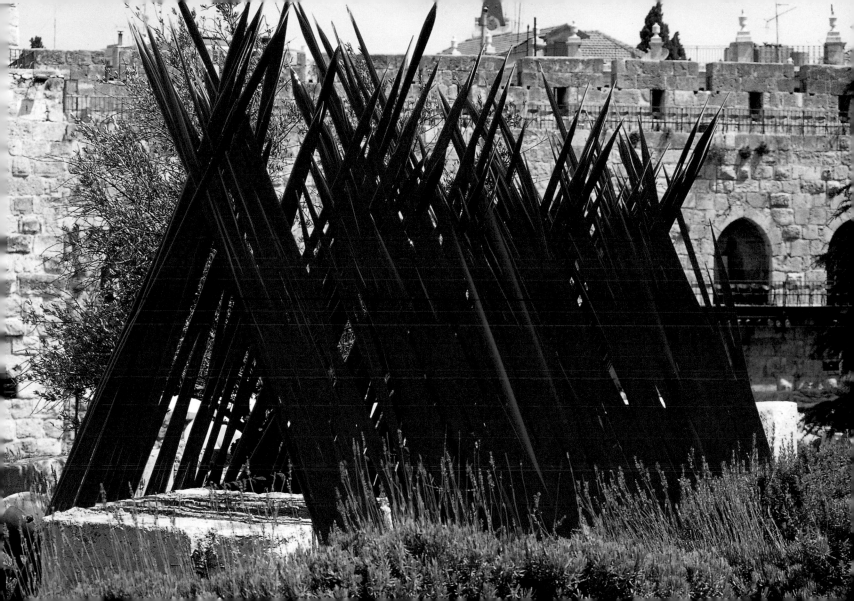

Chihuly drawing, 1992. The Boathouse, Seattle, Washington

What is it about the light in Jerusalem that makes it the City of Light? You can't explain exactly what it is. It's a feeling. It's a look. But it's there. There is this beautiful, golden light that bathes Jerusalem.

Niijima Floats, 1999.
Tower of David Museum,
Jerusalem, Israel

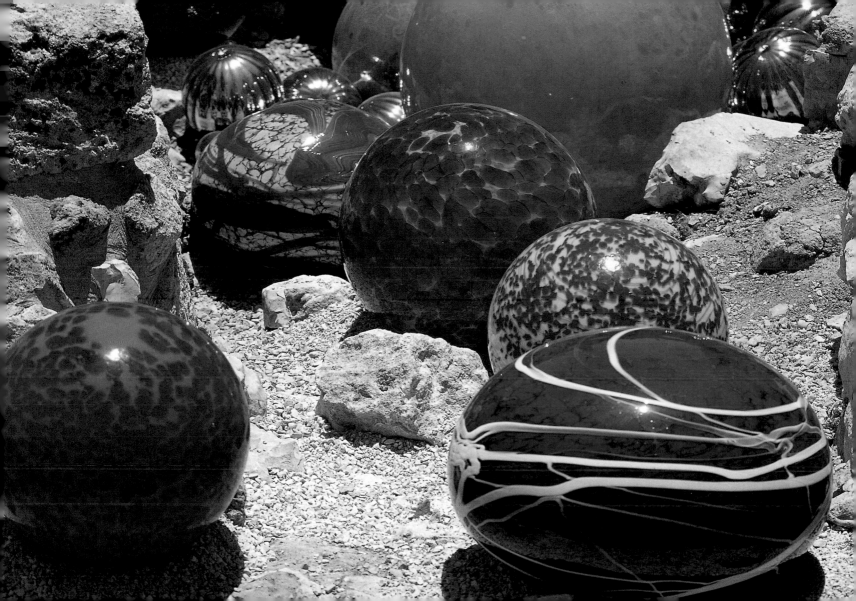

For centuries, people have been fascinated with glass. It's like a gem, but fragile. Glass has history, it has life, it's from the earth.

Cadmium Orange Float, 1992.
28 x 29 x 29 inches

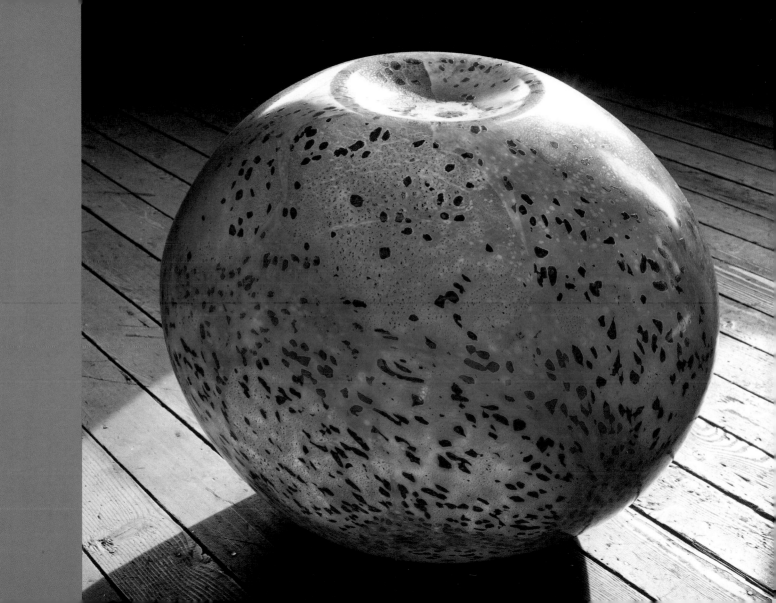

Crystal Mountain, 1999

What am I going to do in here? I don't want to make it too big. I don't want to make it too small. So I decided I would make the *Crystal Mountain,* and I was going to make it out of glass. Don't ask me why I picked pink, but I did.

Crystal Mountain, **1999,**
40 feet 6 inches x 37 feet.
Tower of David Museum, Jerusalem, Israel

155

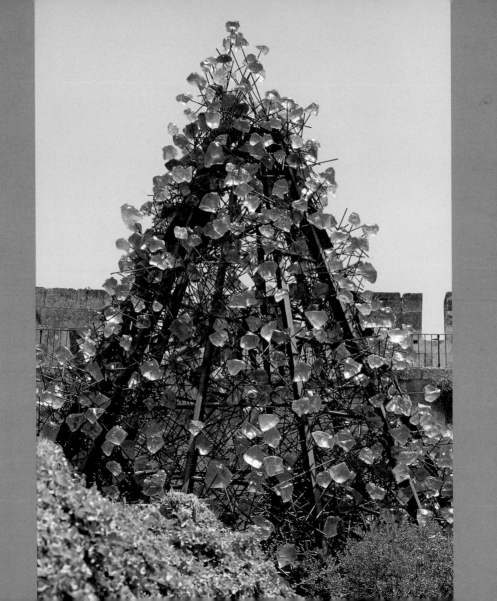

There are many reasons why I went to Jerusalem and the Tower of David Museum to make a major exhibition. First, there was my stay at Kibbutz Lehav in 1962–63. I remember arriving at the Kibbutz as a boy of twenty-one, but leaving as a man in just a few short months. Before Lehav, my life was more about having fun, and after Lehav I wanted to make some sort of contribution to society—I discovered there was more to life than having a good time. It's difficult to explain how this change came about, but it had a lot to do with going on border patrol during the night with guys my own age who had more responsibility and maturity than adults twice their age in the States. After the Kibbutz experience, my life would never be the same.

Chihuly in the Light of Jerusalem 2000, 1999.
Tower of David Museum, Jerusalem, Israel

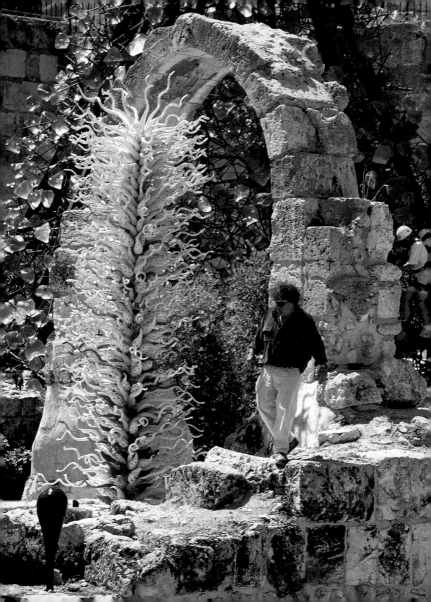

I wanted to give something back to the Jerusalemites for accepting my work in such a heartfelt way. So I brought them sixty-four tons of Alaskan ice in the form of twenty-four blocks—known as "Arctic Diamonds." The idea of taking these huge blocks of crystal from Alaska halfway around the world to Israel was a dream, an idea, but I didn't forget it.

Jerusalem Wall of Ice, 1999, 13 x 54 feet.
Tower of David Museum, Jerusalem, Israel

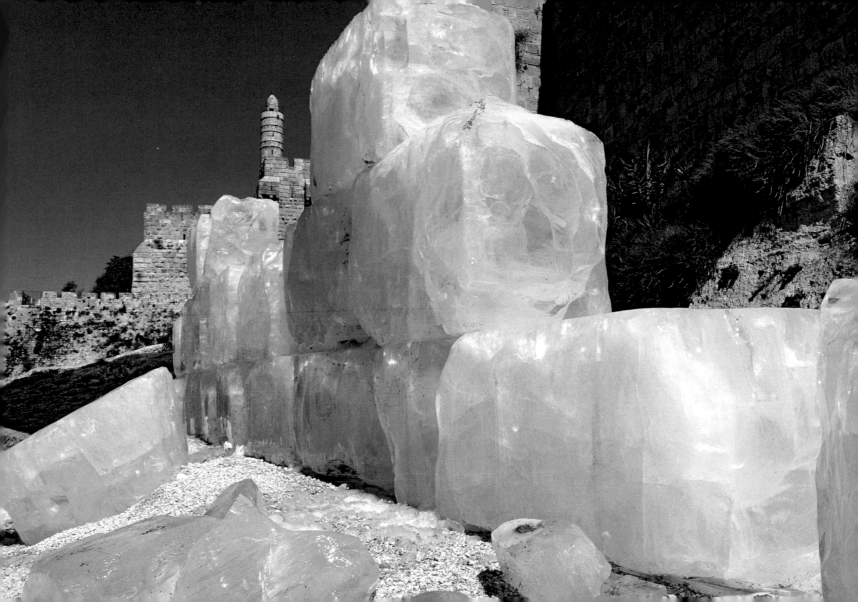

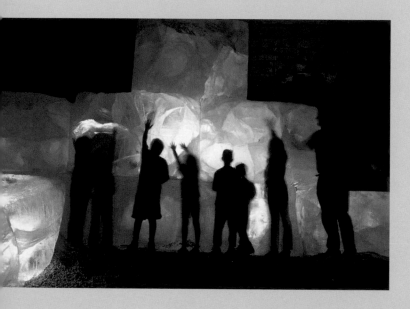

Alaska is about as far away as you can be from Israel. But the ice was unbelievably clear and perfect for this project. I've always liked the idea of ice in the desert. The big blocks were fused together using dry ice. Everything changed—color, form—as the ice melted. The wall was initially transparent, but over time the sun made it more textured, more milky, as the blocks melted, with water running between them. Shooting color through it was as dramatic as neon, in some ways more dramatic. The light seared through the ice in beams, no movement. Just—boom!

Jerusalem Wall of Ice, 1999, 13 x 54 feet.
Tower of David Museum, Jerusalem, Israel

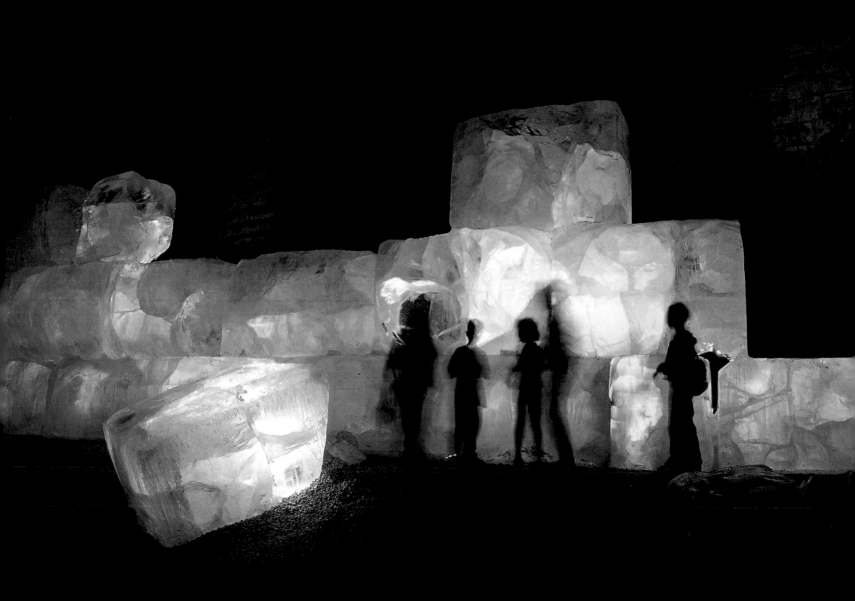

If people saw it as a symbol for the melting of tensions, then that's wonderful. If they came here and just saw it as ice from Alaska, as these great crystal blocks that melt, that's wonderful too.

Jerusalem Wall of Ice, 1999, 13 x 54 feet.
Tower of David Museum, Jerusalem, Israel

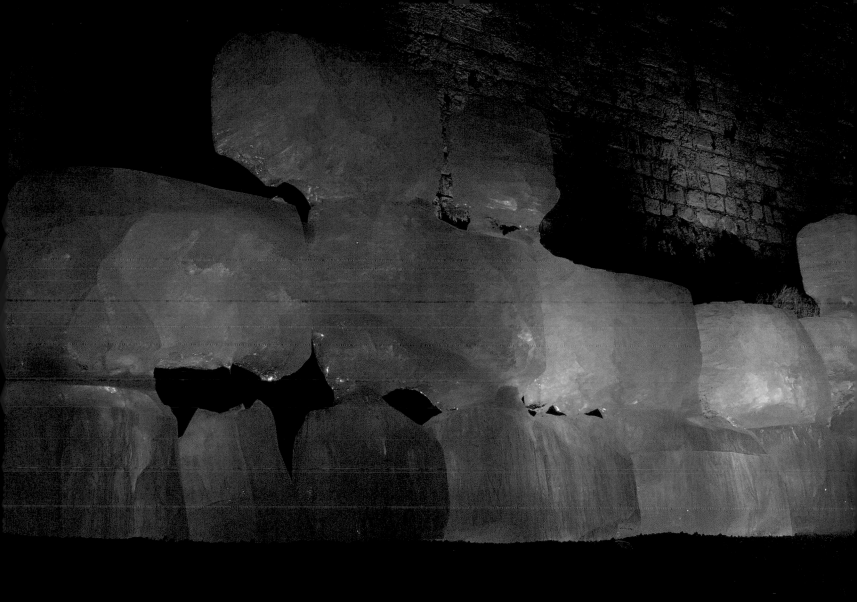

The simplicity of the *Niijima Float* form allows me to concentrate on creating complex surface patterns using layers of colors.

Niijima Floats, 1991. Seattle, Washington

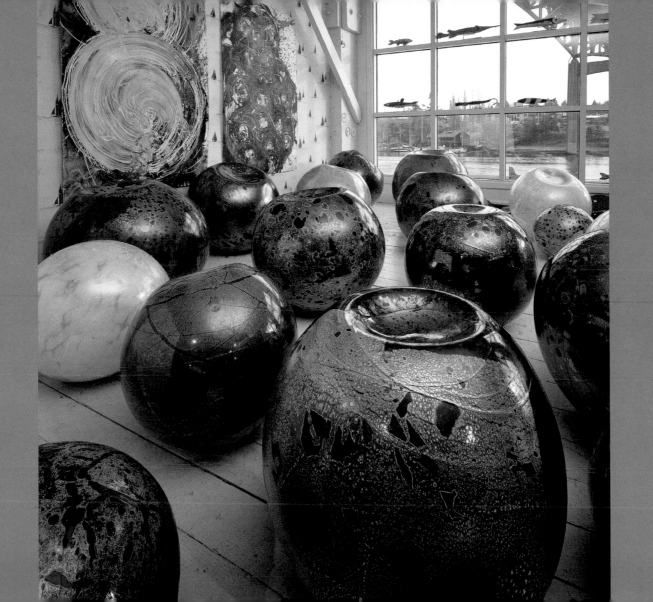

Evelyn Room, The Boathouse, Seattle, Washington

The Boathouse is in a constant state of construction and change. I bought the 25,000-square-foot Pocock Building on Lake Union—originally built to fabricate wooden racing shells—in 1990, and we've been working on it ever since. There's always a new project, like the 88-foot-long table in the Evelyn Room; the Indian Room, built to house my early work, together with a basket collection and several hundred Pendleton blankets; a new Persian ceiling; or a lap pool filled with color.

Evelyn Room, The Boathouse, Seattle, Washington

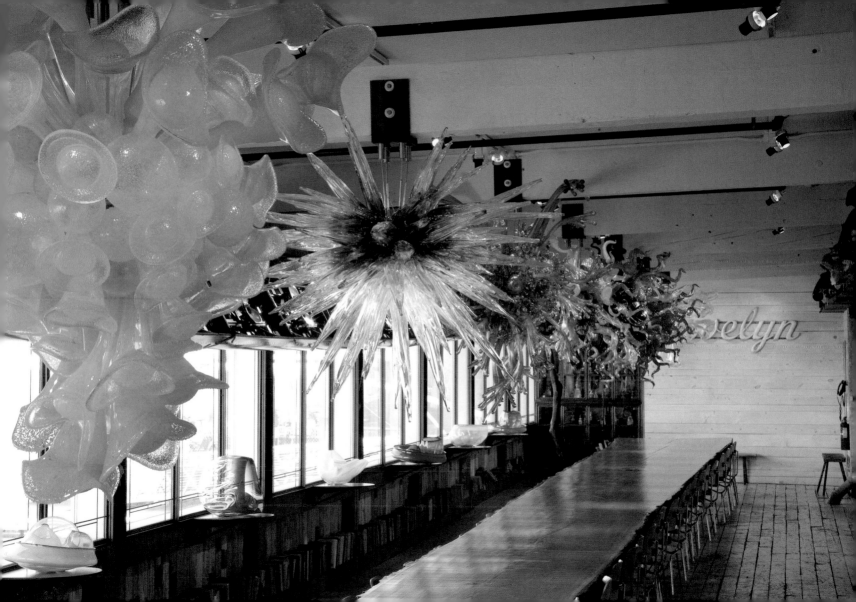

The Boathouse is also, and most importantly, my studio. Glassblowing goes on in the hotshop seven days a week. We do all the experimenting there, and most of my work for the past ten years has been made there. The most notable exception was *Chihuly Over Venice*, when we purposely set out to collaborate with glassworkers in several countries.

Boathouse Persian Ceiling,
1999, 40 x 6 feet.
The Boathouse, Seattle, Washington

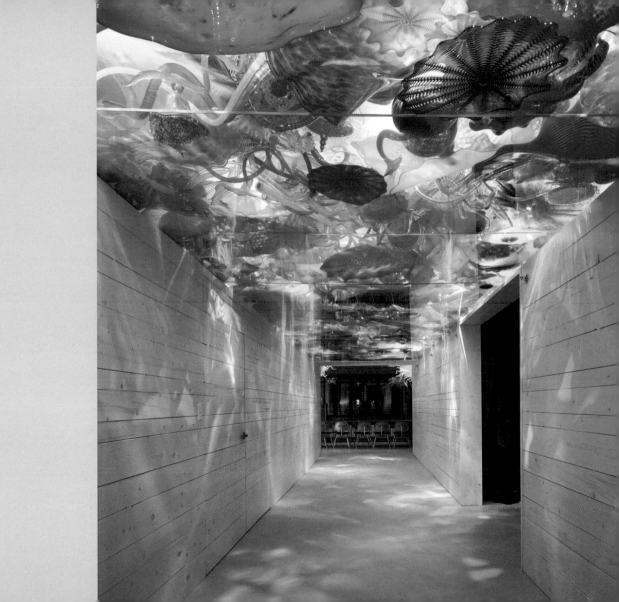

The most interesting thing that's ever happened here at the Boathouse was the making of this glass. All these other things around it—where I get to live and work and design and experience things on the water—that's just all the extras that I get to do to make my environment as creative as possible.

Color rods and sample wall.
The Boathouse, Seattle, Washington

163

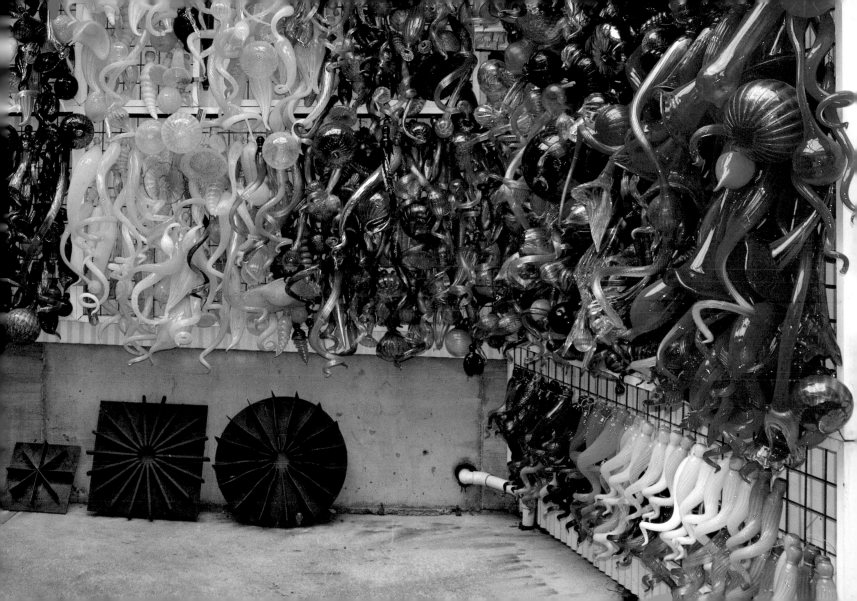

It's important for my creativity to live and be around my work. And also to work and live in spaces that don't feel like a house or like rooms. I love to be on the water. I was very fortunate to get the Boathouse, so if I want to go down and talk to the glassblowers and discuss what's going to happen that day, I can. If I want to walk back up and cook lunch, whatever I want to do, I can do it. I like this connection to where the work is made and where I live.

Boathouse Venetian Window, 2000.
The Boathouse, Seattle, Washington

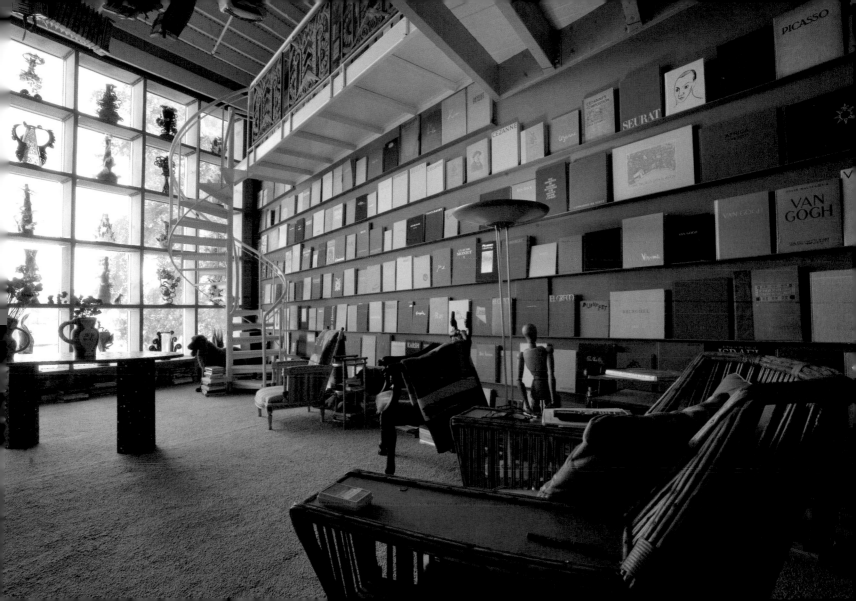

Seattle is surrounded by water on all sides, and what it lacks in architectural history, it makes up for in nautical history.

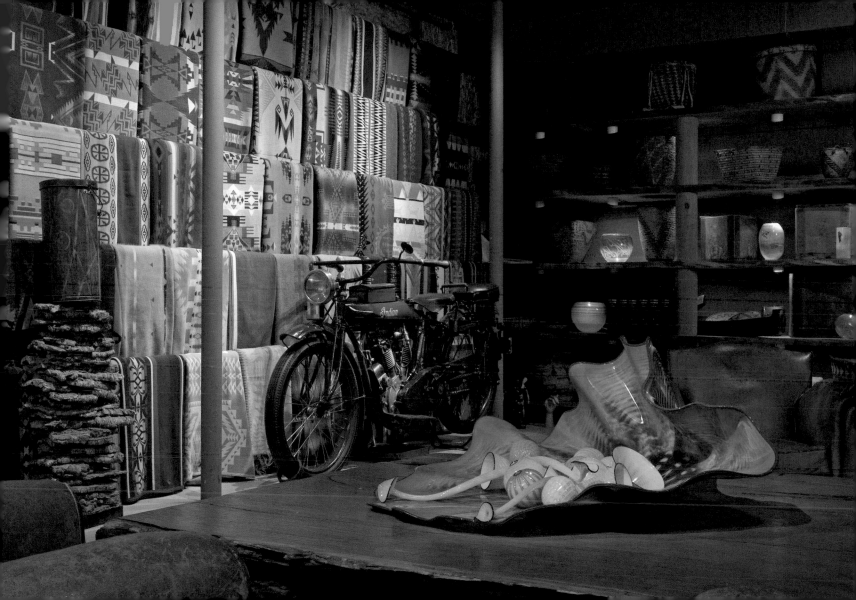

Water is really important to me. I love to be on the ocean, I love baths, I love showers, I love swimming, and I think a lot when I'm in the water.

Boathouse Lap Pool, 1994,
12 x 54 x 4 feet.
The Boathouse, Seattle, Washington

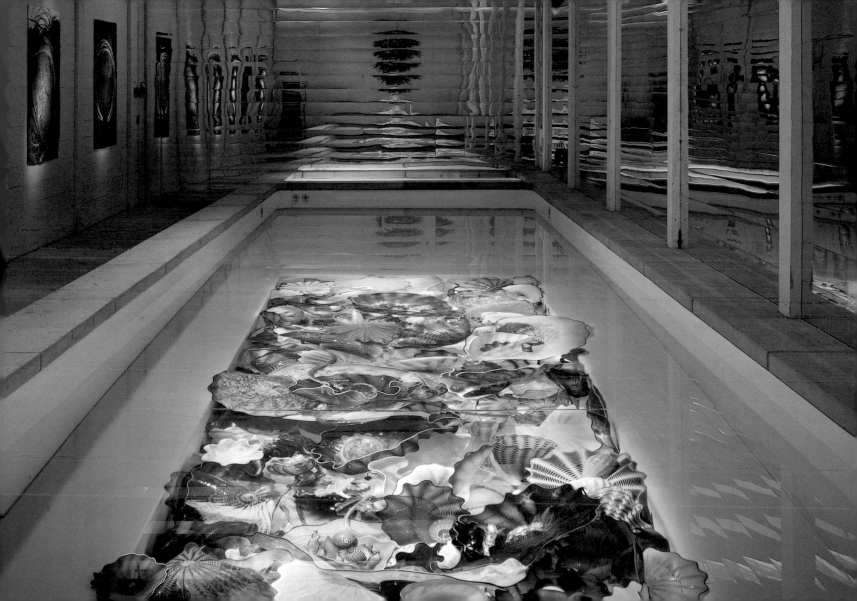

I started dreaming about a glass workshop where I might be able to work with students and colleagues in some wonderful place that was inspirational and beautiful. From the beginning, I never considered anywhere but Washington State. The climate and location were perfect. I liked the idea of students going "out northwest." Someplace that felt new and rugged and didn't carry any excess baggage.

Boathouse Aquarium, 2001.
The Boathouse, Seattle, Washington

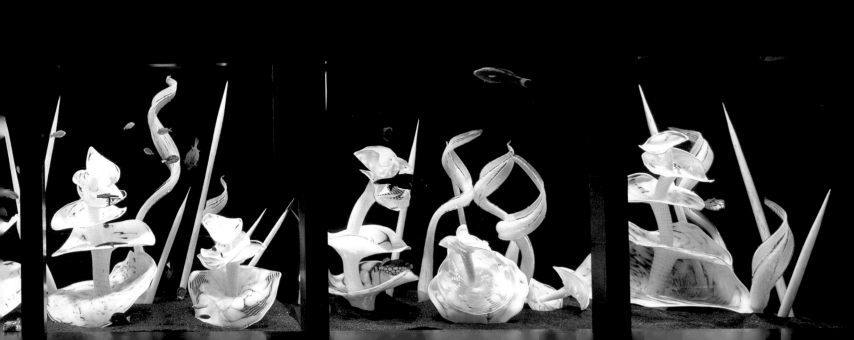

Tug boats and log booms and assorted commercial and pleasure boats go by the Boathouse all day long.

Neon Installation, 1993.
The Boathouse, Seattle, Washington

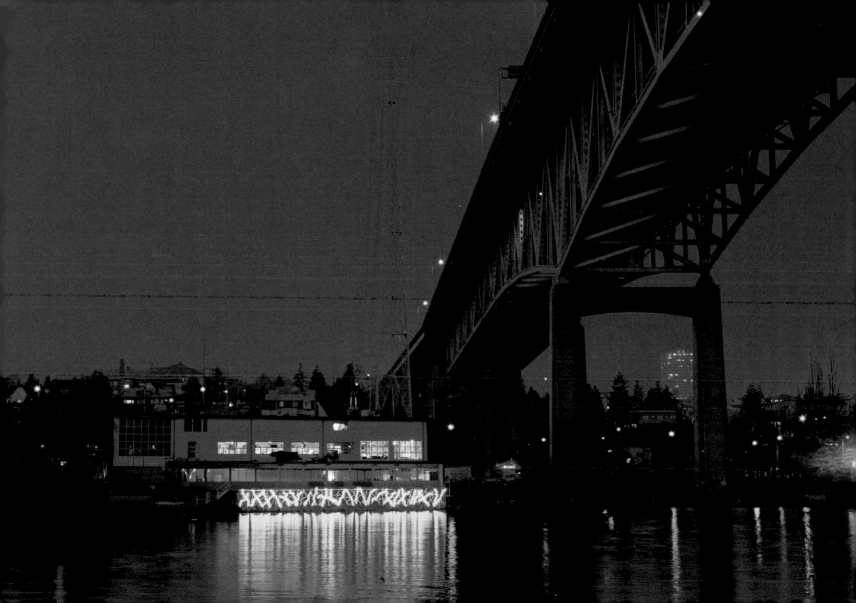

If you have the energy, you'd better figure out where you're going to put the energy—and then put it to good use.

Neon Installation, 1993.
The Boathouse, Seattle, Washington

169

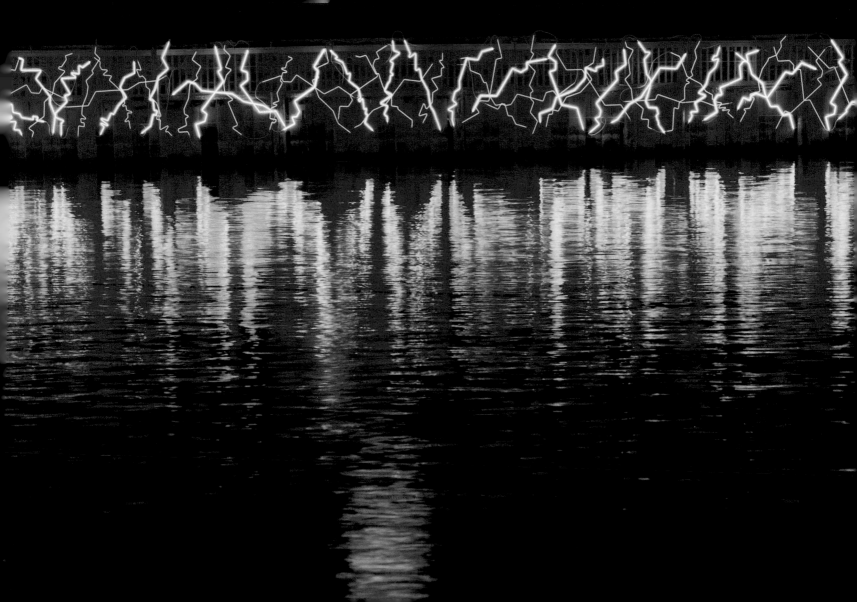

You can help yourself be more creative and I think the people that you're around will influence that. I always told students that the most important thing that they could ever do was to be around artists. Then you begin to understand, as a young person, what the creative process is like.

Green Ferns, 2000. Óseyrarsandur, Iceland

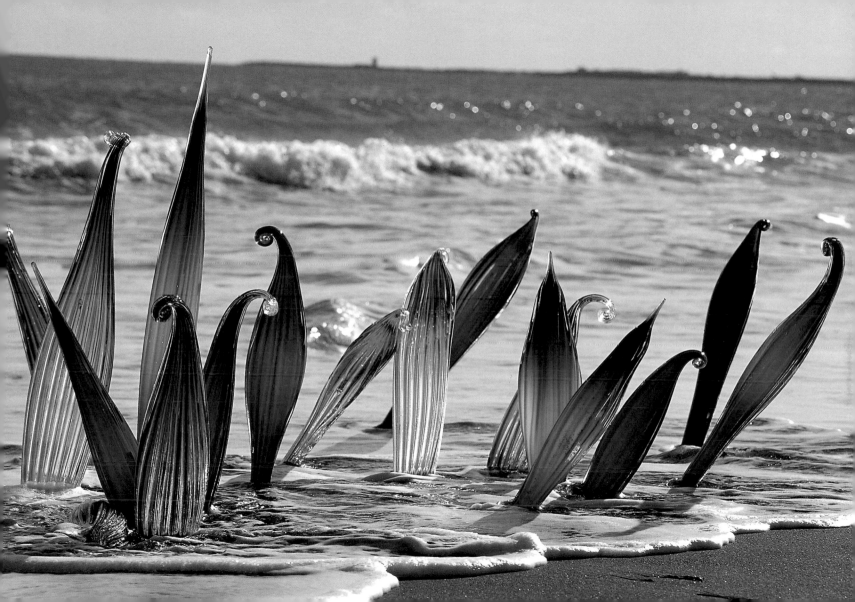

I think of myself maybe more as an explorer than an artist in some ways. Or maybe an artist and an explorer is the same thing. Like an explorer, you don't want to go to places you've already been; you want to go someplace new. On the other hand, you want to develop the idea as much as you can before you leap.

Neodymium Spears, 2000.
Reykjanesskagi, Iceland

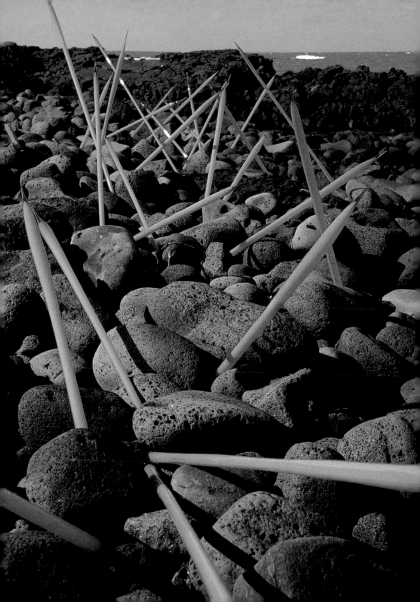

I work on things over and over. If you were to come to my studio, you would see a big team of people working, usually making the same thing all day. So it would be the same thing, over and over and over again. And in that way, you begin to be able to control what's going on.

Black Seal Pups, 2000.
Straumur, Iceland

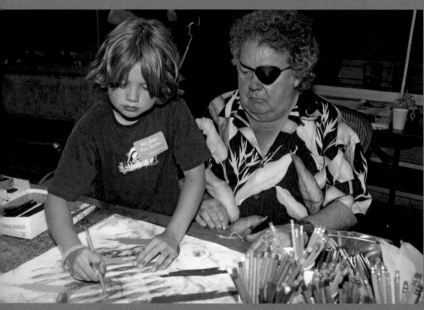

Chihuly and son Jackson, 2006. Museum of Glass,
Tacoma, Washington

While Chihuly's vessels cannot be adequately
described in two dimensions, his drawings
capture their essence: the spontaneity of their
forming and their translucency and vibrancy of
the color through his use of watercolor washes
and other stains including tea, coffee and wine.

Henry Geldzahler, *Dale Chihuly: Glass*,
Taipei Fine Arts Museum, Taiwan, 1992

**Drawing Wall, 2000, 15 x 77 feet.
Joslyn Art Museum, Omaha, Nebraska**

173

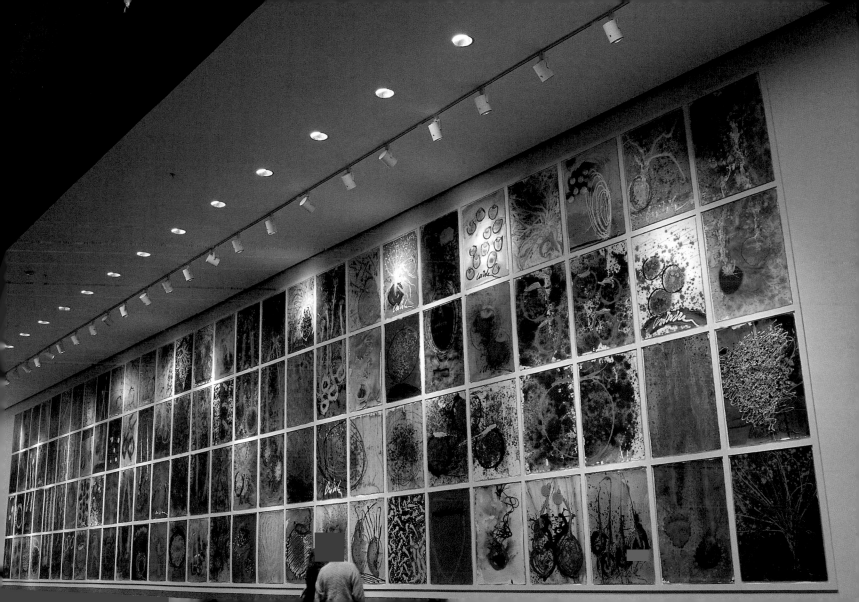

If I could build a house in the San Juan Islands and retire to draw, if that was what I chose to do, then I would do it. But that's not what I want to do. I like to have the shows and develop new work, make another book and start another collection. Who knows what it will be? Whatever it is now, I guarantee you it will be different next year or the year after.

Naples Museum of Art Drawing Wall,
2000, 12 x 60 feet.
Naples Museum of Art
Philharmonic Center, Florida

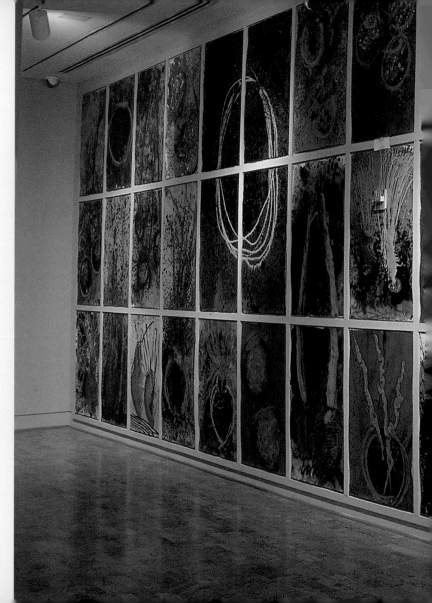

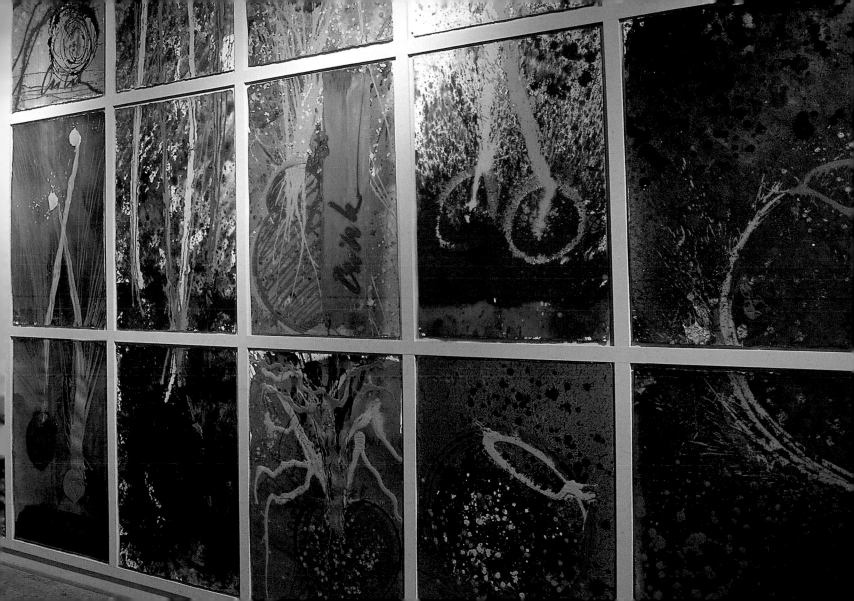

I've done a lot of shows in museums around the world and increased the visibility of glass to the public—showing that a glass form is not, shall we say, just a functional vessel or a little bubble, but it can be many different things to many different people.

Spanish Orange Persian Set with Black Lip Wraps, 1994, 21 x 143 x 33 inches. Joslyn Art Museum, Omaha, Nebraska

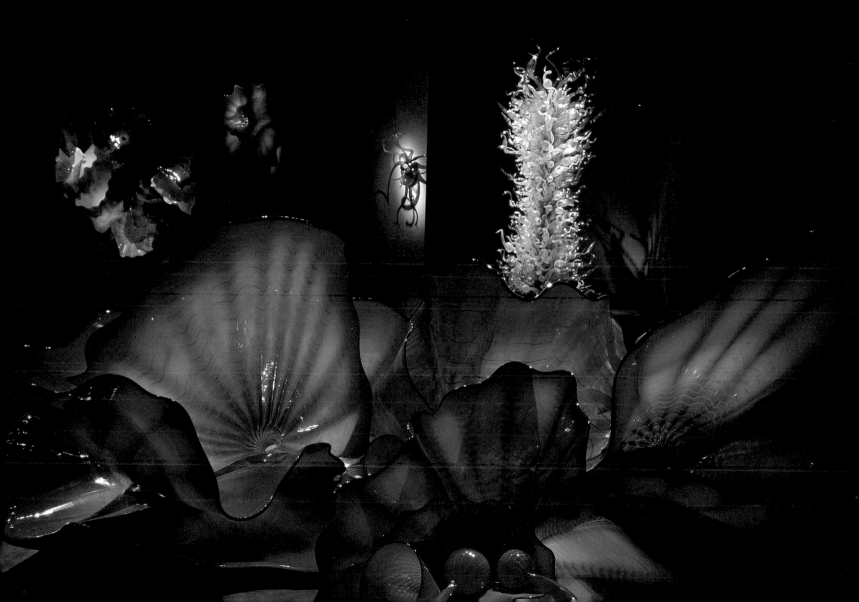

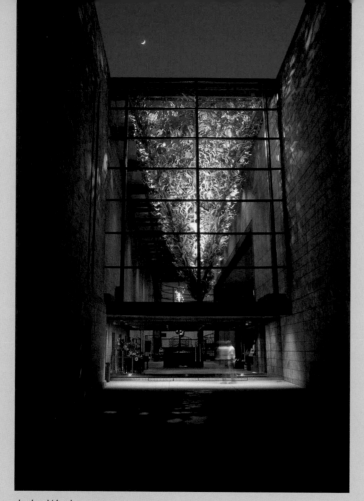

Joslyn Window, 2000.

I'm not interested in doing things that somebody else has done. I'm sure that would be the same for any artist.

Joslyn Window, 2000.
**Joslyn Art Museum,
Omaha, Nebraska**

176

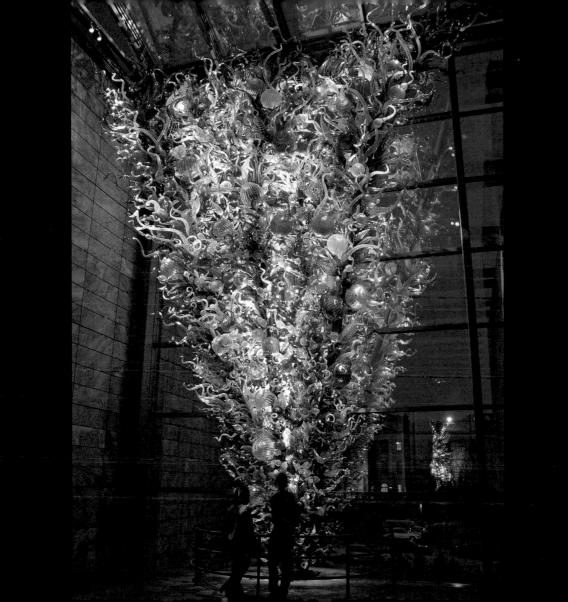

Chihuly drawing, 2000. Joslyn Art Museum,
Omaha, Nebraska

I love to make work and I want to show it in the best possible way. Where's the best possible place to show work? A museum. I can control the lighting; I can control the space. I can get the support from the museum to do what I have to do.

Gilded Silver and Aquamarine Chandelier,
2000, 24 feet 6 inches x 10 feet.
Joslyn Art Museum, Omaha, Nebraska

177

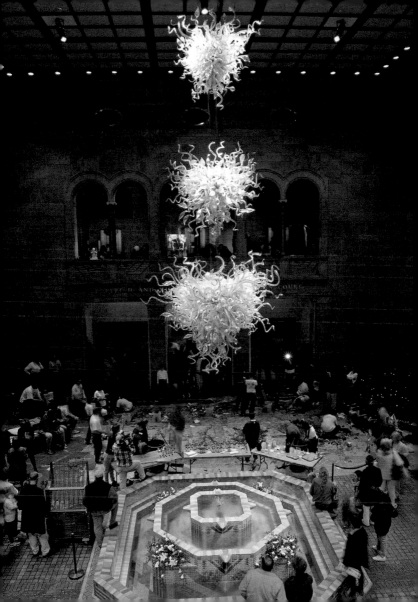

Public installations are my favorites because so many people get to see the work and I'm lucky that my work appeals to such a wide cross section of people. A lot of that has to do with the material.

Gilded Silver and Aquamarine Chandelier,
2000, 24 feet 6 inches x 10 feet.
Joslyn Art Museum, Omaha, Nebraska

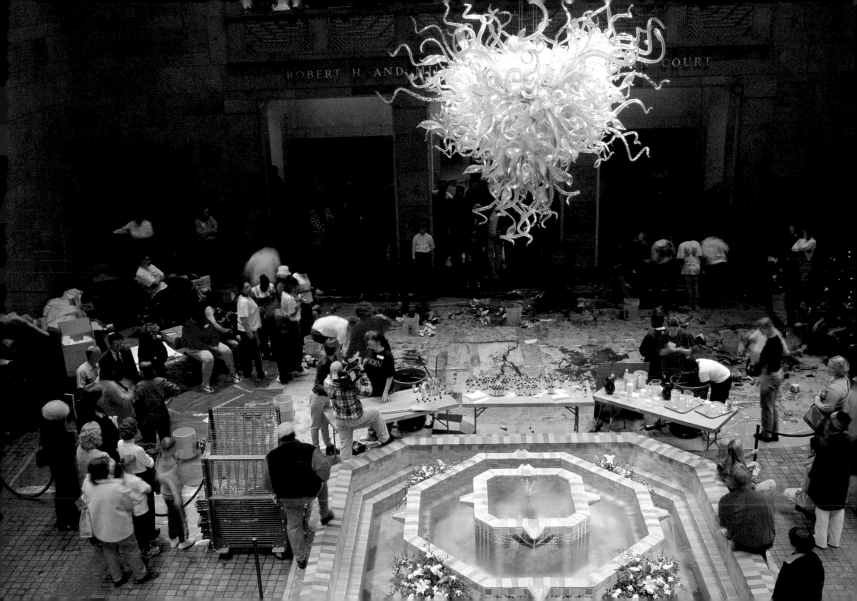

I always worked. Since I was about ten years old, I had had odd jobs. I used to cut lawns and wash cars; I worked in a supermarket. I got a job as a janitor and as a paper boy, and when my father died, they put me in the union, the Meat Cutter's Union. I was only sixteen. I don't think I was supposed to be in the union until I was eighteen, but because my father was a union organizer, I was a card-carrying member of the union. So, I worked nights and went waterskiing every day.

Gilded Silver and Aquamarine Chandelier detail

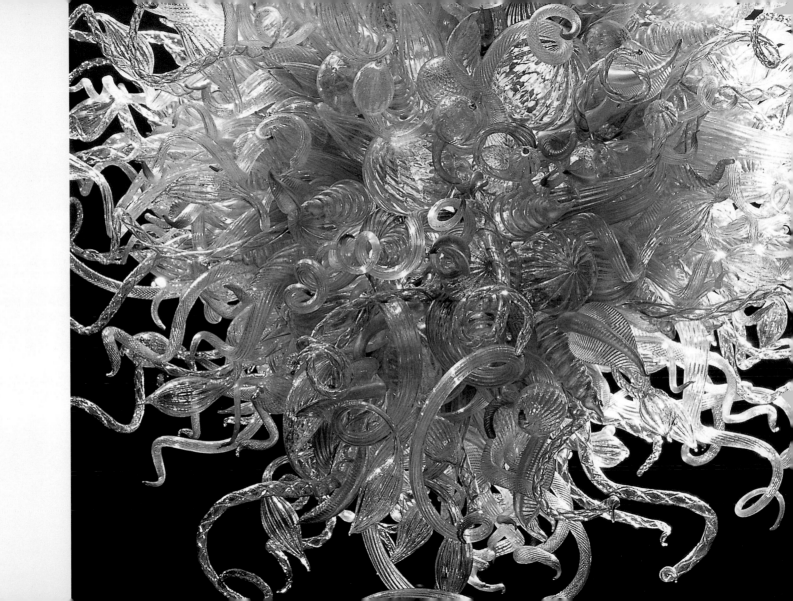

When I first started, I immediately began making these organic, sculptural forms and I really didn't have an art background—I had a degree in interior design. I kind of didn't know what I was doing, but I was pulled in by the material and the blowing process.

Persian Ceiling, 2000.
Joslyn Art Museum, Omaha, Nebraska

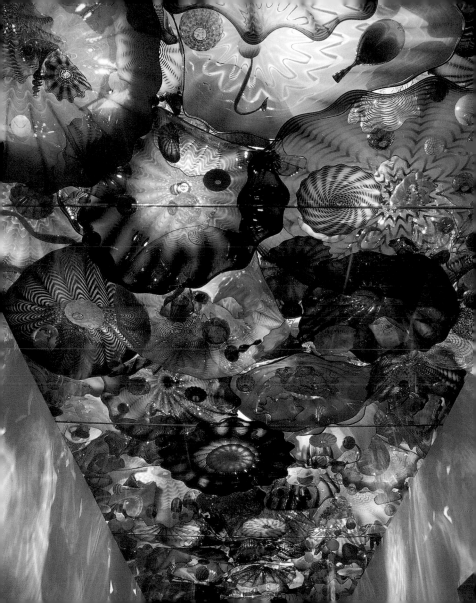

You can't teach art. You either want to do it or you don't—and anybody can do it. Children are so creative when they draw. At a certain age they lose that. I don't know if they get inhibited, or what happens. I started a program called Seniors Making Art about fifteen years ago and we hire artists to go into senior centers. It's amazing. Older people often get that early creativity back, the freedom. I think a lot of people could be artists.

Joslyn Ice, 2000.
c. 150 feet x 30 feet x 14 feet
Joslyn Art Museum, Omaha, Nebraska

181

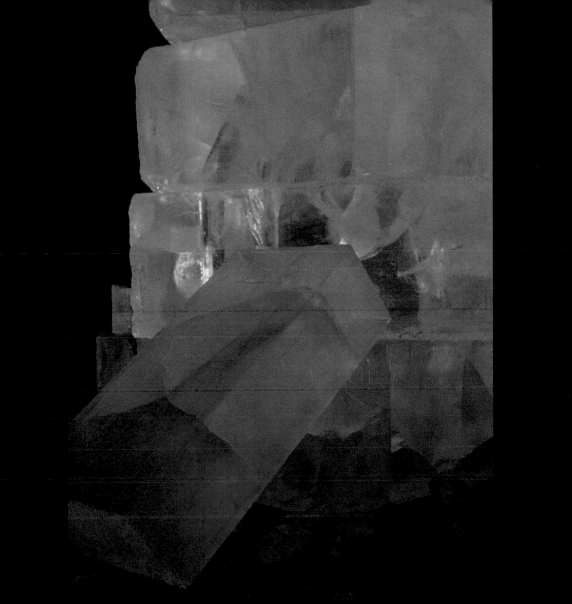

I like to deal with the crowds off the streets who enter public buildings. It's a tremendous challenge and joy to get them involved in looking—to hold their attention.

Joslyn Ice, 2000.
Joslyn Art Museum, Omaha, Nebraska

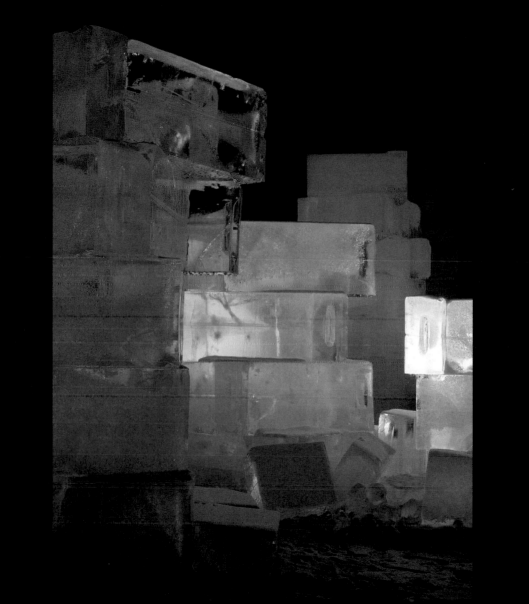

Here was a piece that didn't work. I made the spikes in the Czech Republic. They were green, uranium green. I wanted this beautiful green, which you can't get in this country because of the oxide it takes to make it. Anyway, I get them, but they're just too stiff for me. So I hung them as a chandelier. It was kind of a nice chandelier, but it still didn't work. It was just too spiky. Maybe on a different day I could have made it work. But, at that time and that place, it just wasn't meant to be. So I said, take it down and make some green grass.

Green Grass, 2005.
**Royal Botanic Gardens,
Kew, Richmond, England**

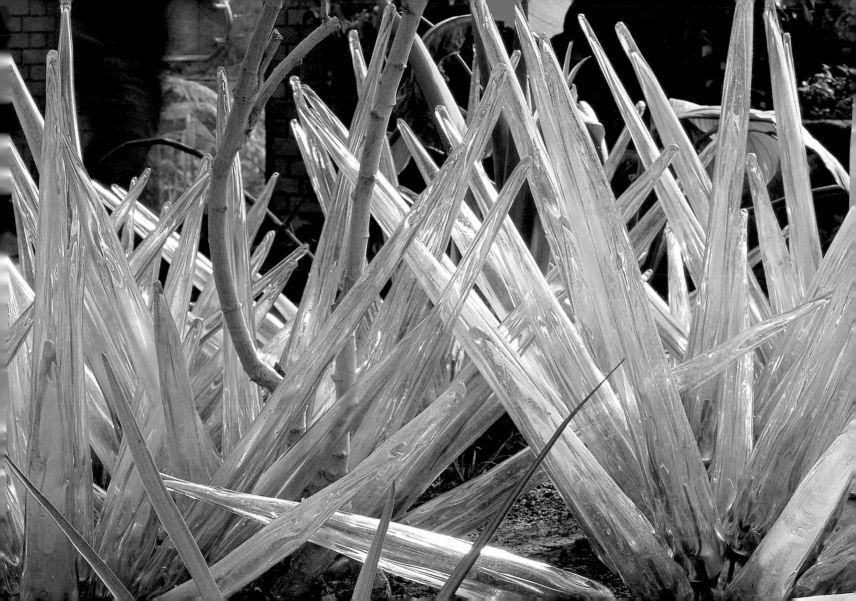

I do believe you have a choice of where you place yourself in the world, and what you do in it. You have your options. You must choose them wisely.

Green Saguaros, 1999.
Palm Springs, California

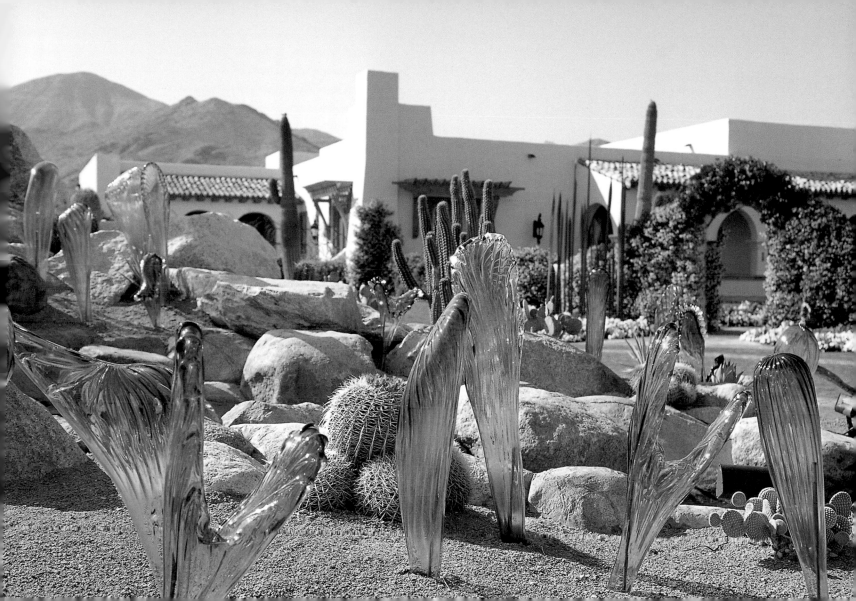

I can't understand it when people say they don't like a particular color. How on earth can you not like a color?

185

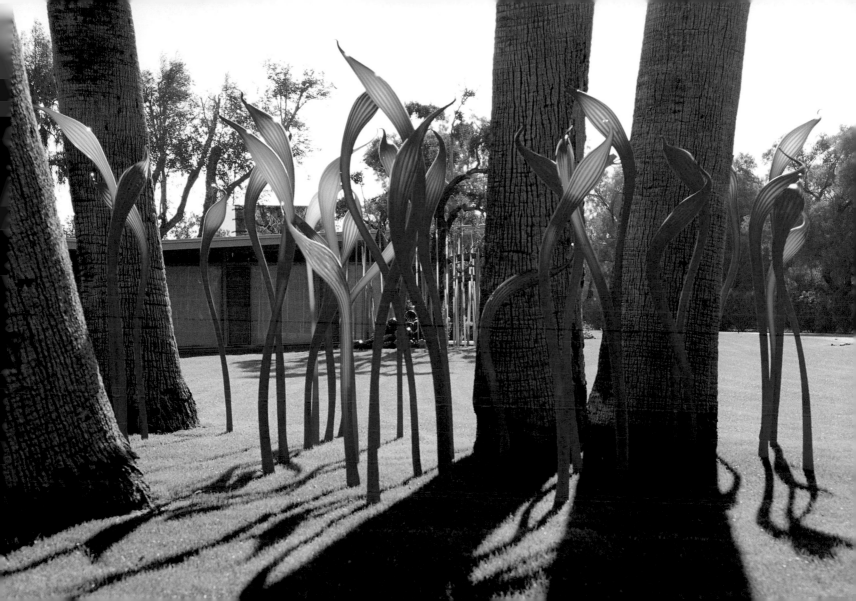

Hotshop. Seattle, Washington

As a little kid walking along the beach, picking up bits of glass and shells, I was struck by the translucency of glass, its transparency, its color.

Goldenrod Persian Wall, 2000,
5 feet 8 inches x 56 feet.
Palm Springs, California

186

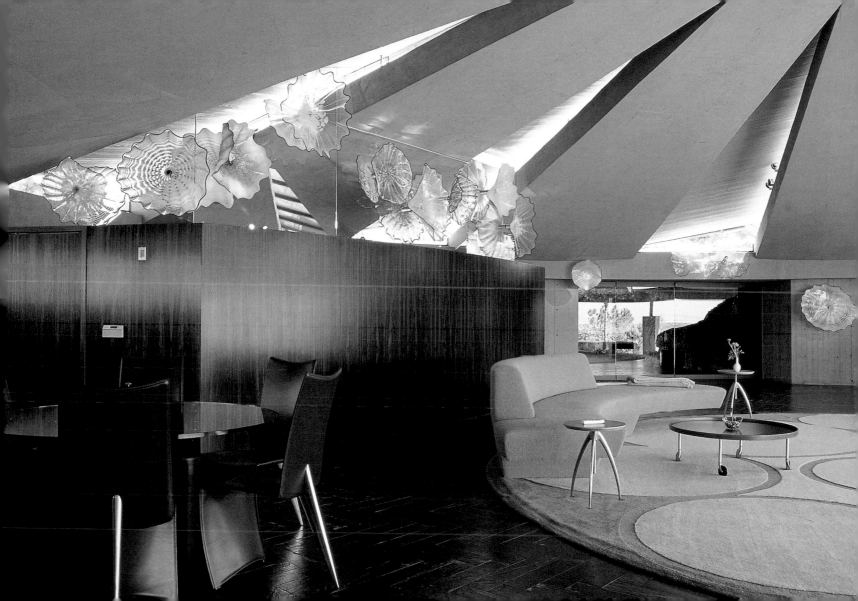

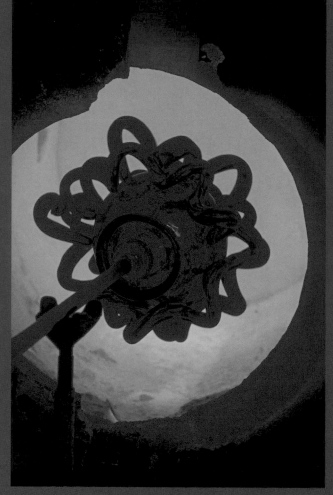

Glory hole

A glory hole is an opening in the side of a glass furnace, which is used to reheat glass that is being fashioned or decorated.

Deep Red Venetian with Flowers and Coils, 2000, 25 x 17 x 17 inches

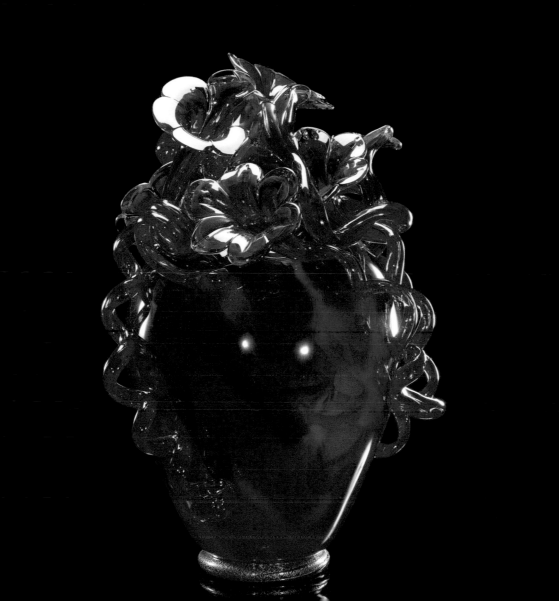

I've always tried to stay away from the tools and to use the natural qualities of the glass and the natural elements of fire and heat to make the forms.

Persian Seaform Ceiling,
2000, 51 x 8 feet.
Naples Museum of Art, Florida

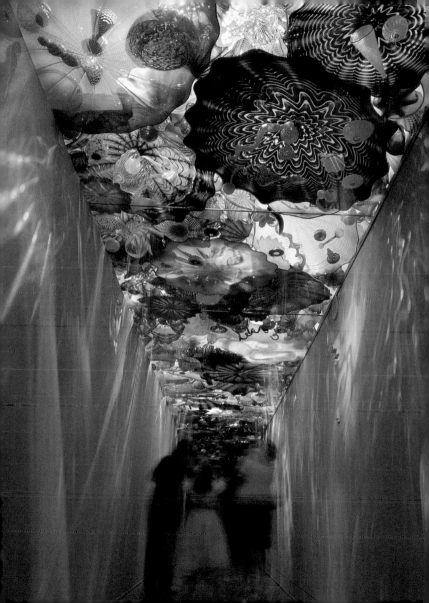

How do you explain where an idea comes from? There are inspirational takeoff points from subjects, but that's not really where they come from. I think those are just the excuses to make things. The important ideas, I think, come from some moment, some outpouring, something that you can't describe.

La Tour de Lumière,
2000, 31 x 13 feet.
Monte Carlo, Monaco

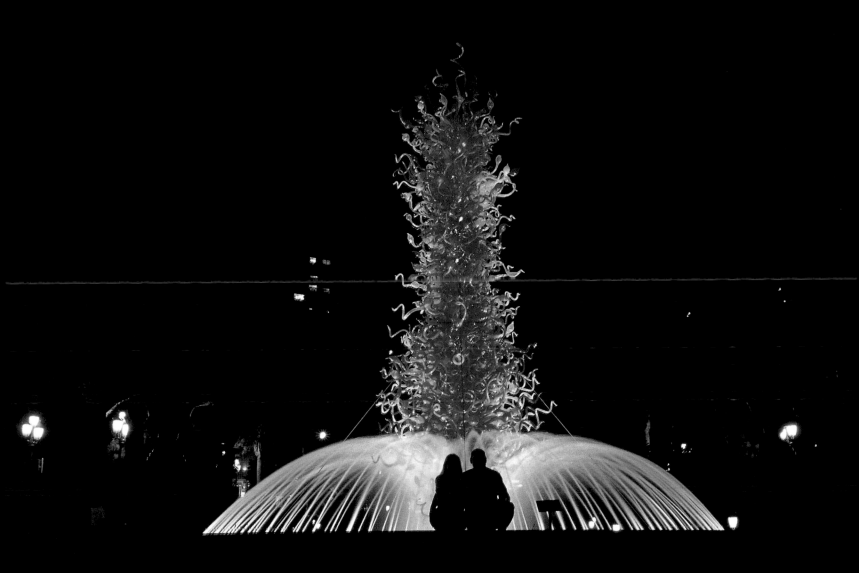

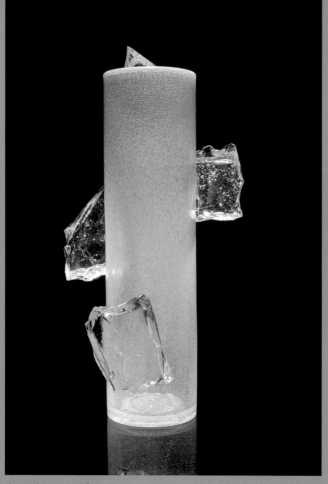

Jerusalem 2000 Cylinder, 2000, 27 x 7 x 7 inches

How far do you experiment with an idea? Then at what point do you decide, "I'm going to really pursue this." And at what point do you decide, "Not only am I going to pursue it, I am going to exhibit it." It is a question of taking chances.

Apple Green Jerusalem Cylinder,
2001, 20 x 21 x 14 inches

190

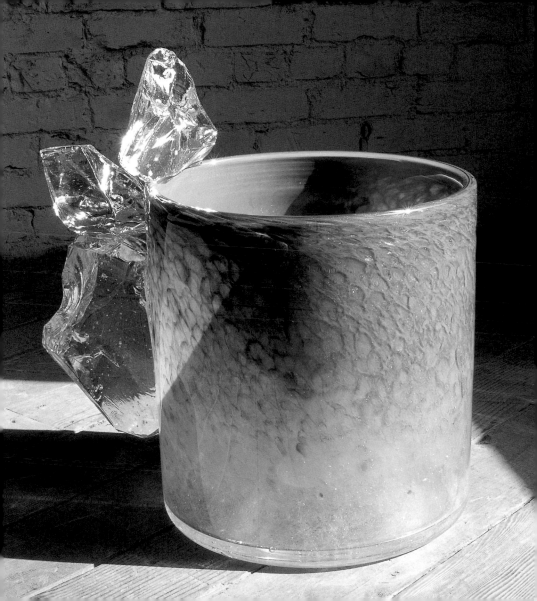

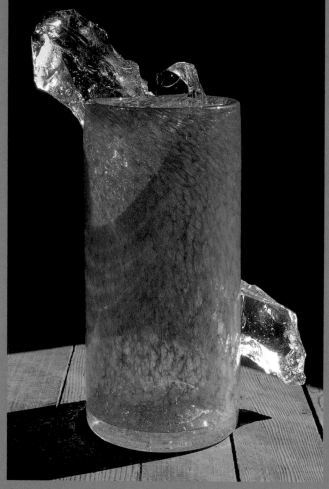

Jerusalem 2000 Cylinder #134, 2000, 22 x 17 x 11 inches

When I was in the pharmacy one day getting a prescription, I had a 93-year-old lady come up to me and tell me how great it was to see a show of mine a couple of years ago. And I can't tell you what a thrill it was to stand there and talk to this old lady, and to see the joy on her face and the smile when she was able to talk to me about seeing this artwork that had brought something to her life.

**Sunburst Orange Jerusalem Cylinder,
2001, 25 x 19 x 14 inches**

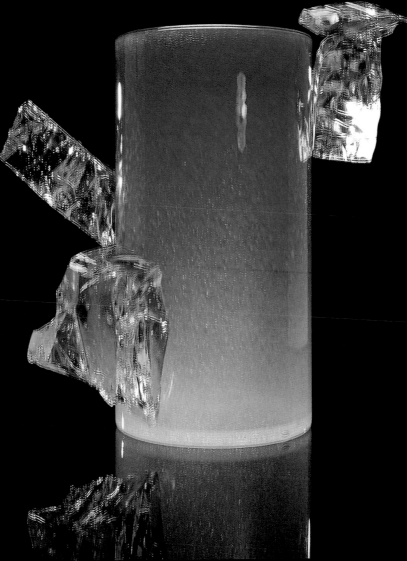

People for centuries have been fascinated with glass, colored or crystal. It transmits light in a special way and at any moment it might break. It's magic. It's the most magical of all materials. People look at the works and just wonder.

What is the use of a Dale Chihuly sculpture? It locates the magic and alchemy inherent in molten glass in gorgeous and permanent materiality. His work stands for change in constancy, highlights on surfaces of permanent fluidity, which cannot help but serve as an ethical standard for anyone who lives with it. One may put oranges or limes in his baskets or dried flowers in his cylinders, but then one can also use a Picasso to cover a hole in the wall.

Henry Geldzahler,

Chihuly: Color, Glass, Form, 1986, foreword

Jerusalem 2000 Cylinder,
2000, 20 x 8 x 8 inches

I work from my gut. I just work, and out it comes. I don't know what it is until it's finished and often I title a piece after it's done. Call it chance, call it fate. There's more than one thing going on.

Ikebana grouping, 2001.
Tacoma, Washington

I want people to be overwhelmed with light and color in some way that they've never experienced.

Ikebana grouping, 2001.
Tacoma, Washington

One of the attractions of being in the Northwest is the rain. If I don't feel good or I don't feel creative, if I can get near the water something might start to happen.

Ikebana Group, 1991.
**The Boathouse,
Seattle, Washington**

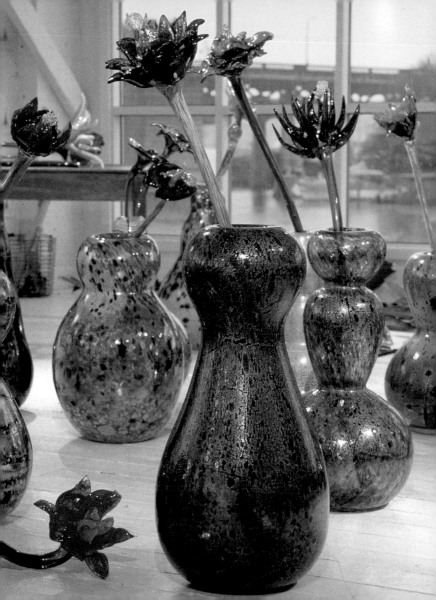

People often ask me why I don't blow glass anymore. I lost the sight of my eye over twenty years ago. It was almost like I was meant not to blow glass, and I was meant to be a director. That position suits me.

Seaform/Basket Drawing, 1989,
mixed media on paper,
22 x 30 inches.

Some artists are more reclusive and they work alone, they're more private. Then there are artists like me who like to work with people, and who like to have people see their work.

Ebeltoft Drawing, 1991, mixed media on paper, 50 x 70 inches.

I don't know what it is about collecting, but I love to collect things.

Basket Forest, 2001.
Garfield Park Conservatory,
Chicago, Illinois

199

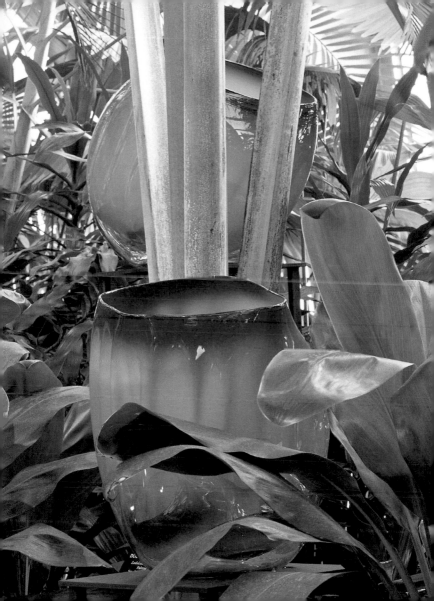

I think it was in 1977 that I visited the Washington State Historical Society with Italo Scanga and Jamie Carpenter. We had just arrived to teach at Pilchuck that summer. We were looking at their Indian basket collection. We were all interested in Native American Indian objects. Looking at this collection, it dawned on me that, hey, wouldn't it be interesting to try to make these baskets out of glass.

Dawn Pink Basket Set
with Flame Lip Wraps, 2001,
24 x 20 x 19 inches

The individual elements in the *Persians* still exude life. The elasticity of each form manifests glass's real character as a frozen liquid, as molecules held in suspension.... The individual elements composing the *Persians* simulate the rhythms and forces of life.... The delicacy and fragility of his glass as well as its tentative placement is an impression of this world: The series is like some wonderful perfume blown across the great central Iranian desert.

Robert Hobbs, "Dale Chihuly's Persians: Acts of Survival,"
in *Chihuly: Persians*, Dia Art Foundation, 1988

Adriatic Turquoise Persian Set
with Red Lip Wraps, 2001,
15 x 37 x 36 inches

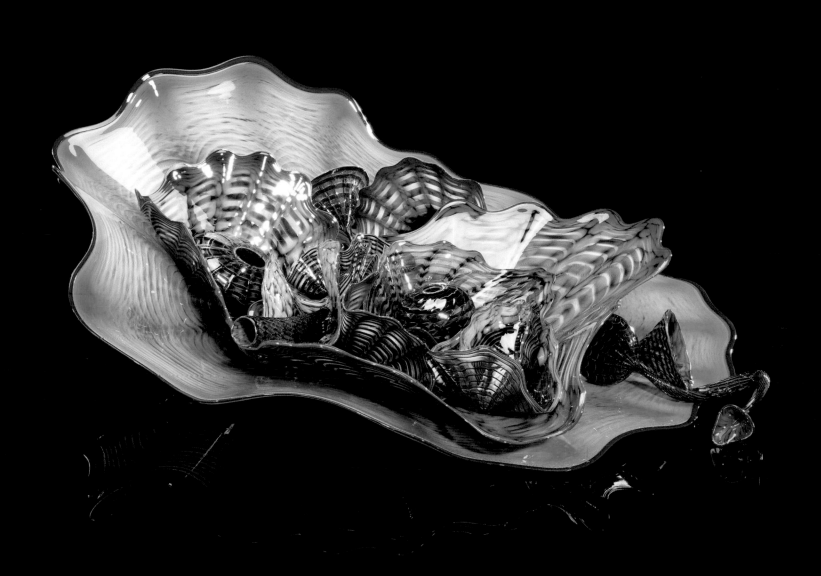

I exhibit widely . . . it gives me great pleasure that probably millions of people get to see my work.

And my work gives people a lot of joy, and that makes me feel like I'm a really lucky guy.

Chihuly with *Reeds*, 2001.
Victoria & Albert Museum, London

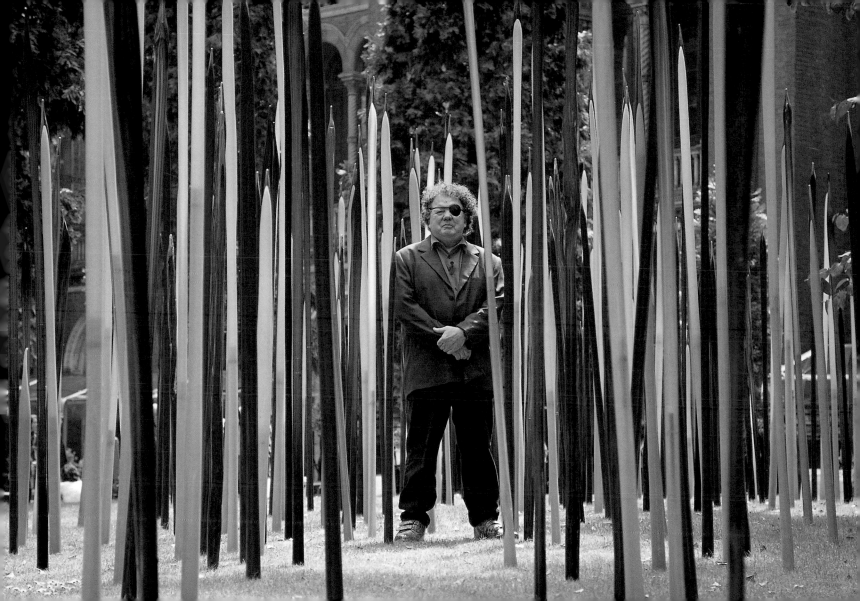

Tower of Light II detail

I tend to do things on a large scale because it's exciting. I like to push things in new and different ways.

Tower of Light II,
2001, 25 x 12 feet.
Victoria & Albert Museum, London

203

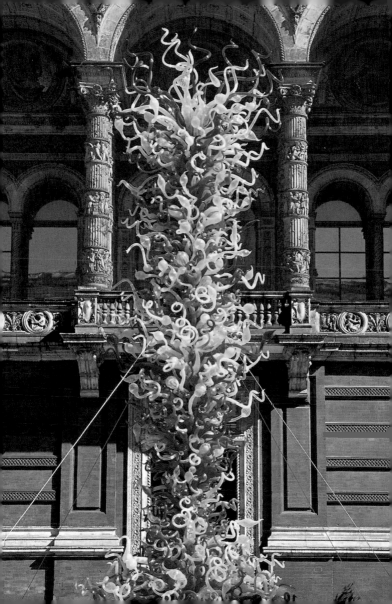

Honestly, I really can't tell you what inspires me. I don't know what it is. You know, I remember thinking there's the head, there's the heart, there's the stomach, and then there's something down even deeper, the gut. That's where it comes out of, I think, for me.

V&A Chandelier installation, 2001,
27 feet 2 inches x 12 feet 4 inches.
Victoria & Albert Museum, London

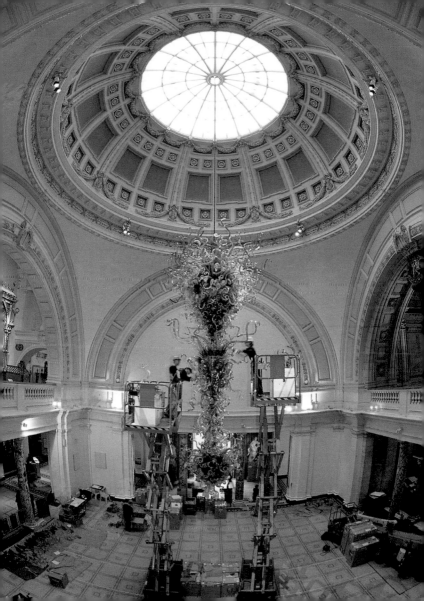

First we blow the glass in the Boathouse, we bring the parts over here (the Ballard Studio, Seattle), we put them together full scale. All the projects are put together full scale here. They're then photographed, taken apart, and then sent to location and then reassembled again. But they're not reassembled in the same way they were the first time, normally. We don't number the parts. Each time it goes up, it goes up a little differently.

B-roll of Salt Lake City Olympic Games,
sculptures and exhibition,
video directed by Peter West, 2002

V&A Chandelier, 2001,
27 feet 2 inches x 12 feet 4 inches.
Victoria & Albert Museum, London

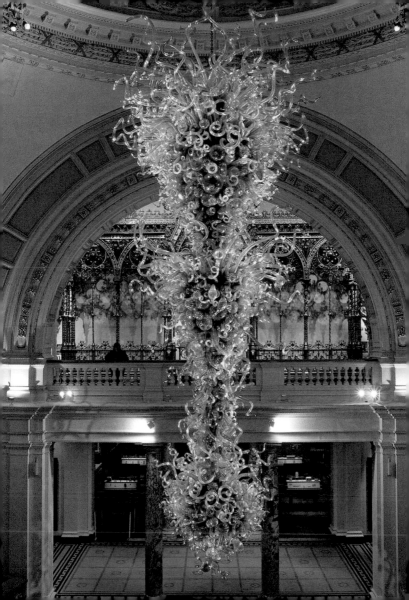

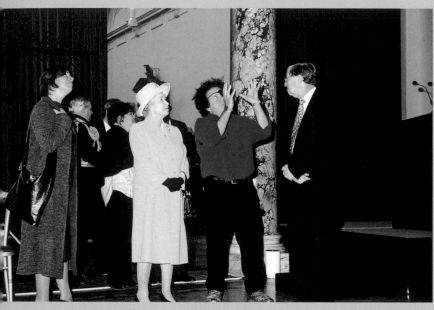

Queen Elizabeth II with Chihuly, 2001. Victoria & Albert Museum, London

What makes the *Chandeliers* work for me is the massing of color. If you take thousands of blown pieces of one color, put them together, and then shoot light through them, now that's going to be something to look at.

V&A *Chandelier* detail

206

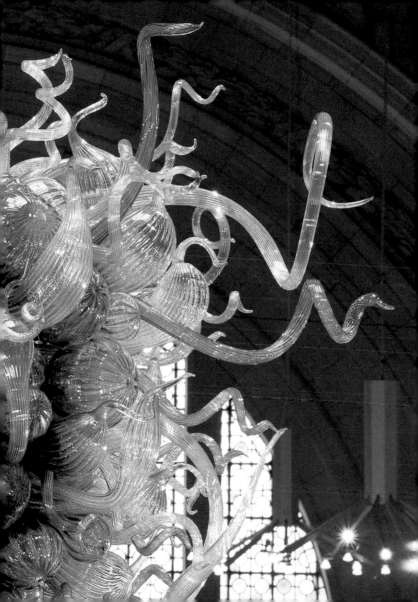

On many installation projects, I have had people help me with the architectural designs. The glassblowing is one side of it, but there is much to be done after the glass is blown. I think I'm the type of person who, no matter what I would have chosen to do in my life, it would have been some kind of collaborative project or process. I'm just not the type to work on my own, by myself. I like to work with people, and I love to work with creative people.

Mayo Clinic Installation mock-up, 2001. Rochester, New York

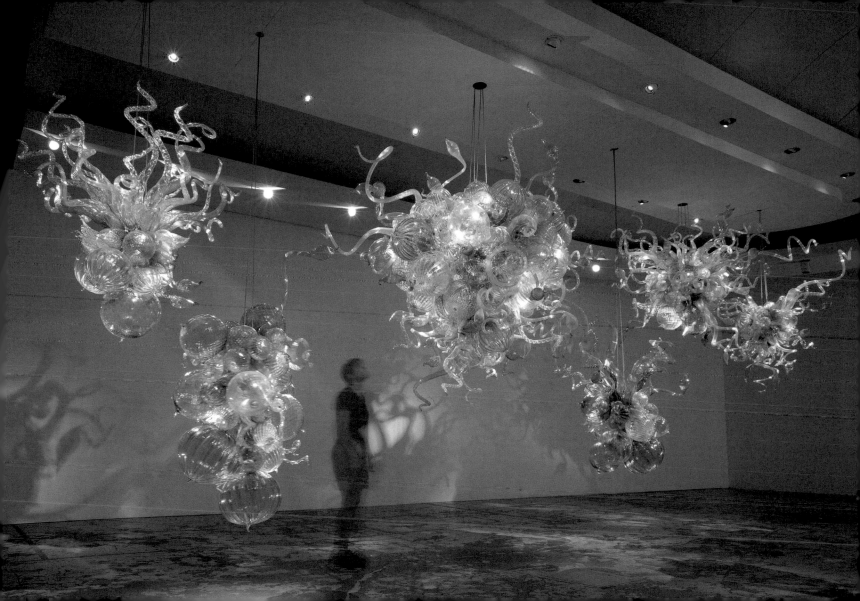

I had the energy to do something, and I was lucky to find something that I could do well.

Hilton Lac–Leamy Chandeliers
and Persian Wall, 2001.
Hull, Quebec, Canada

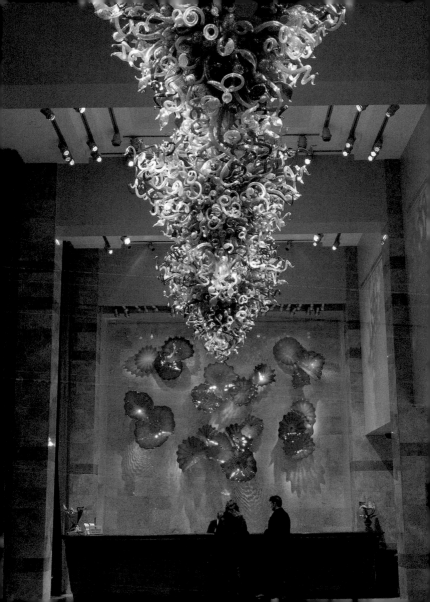

I wanted to show in a greenhouse because I knew that there would be a real connection. My forms are made in a very natural way, so they look like they come from nature. But I don't look at a picture of a plant and say, "Now I'm going to make one that looks like this." Perhaps that's one of the reasons why the pieces work in a greenhouse and work with plants, because they don't really look like the plants themselves but they complement the plants that are there. The greenery also complements my work.

Persian Pond, 2001.
Garfield Park Conservatory,
Chicago, Illinois

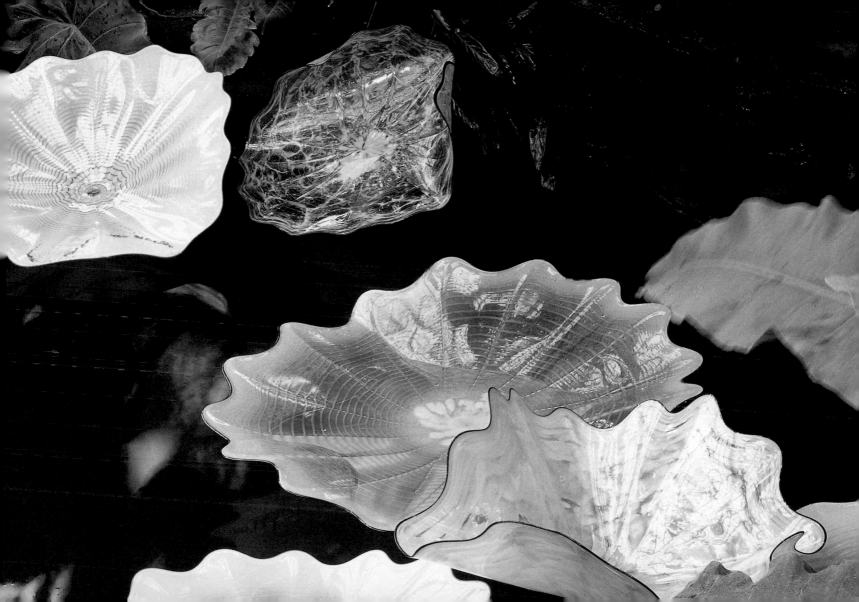

Actually, Garfield Park picked me, and amazingly, this is the first time there'd ever been a glass show in a glass house.

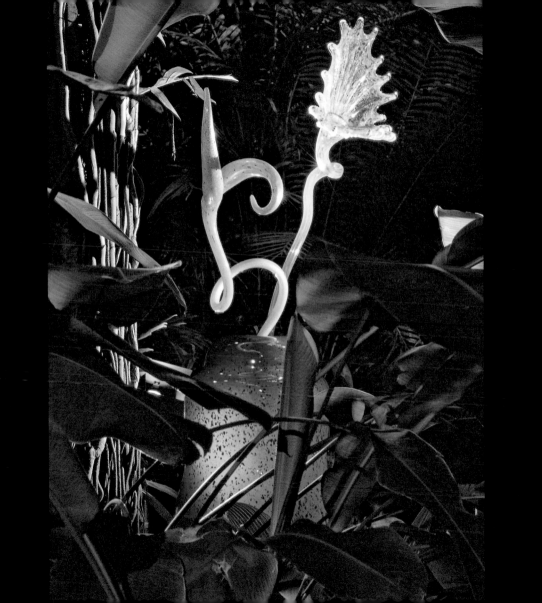

The *Tiger Lilies* were made in Finland from a beautiful ruby red glass. It's a very difficult red formula to melt, and that's one of the reasons I like to work in Finland. All of the different red, yellow, orange, and ambers you see in this sculpture are from the same batch of ruby red. Only glass has this ability to make so many variations from the same exact composition. It's like a gift from the gods.

Tiger Lilies, 2001,
Garfield Park Conservatory,
Chicago, Illinois

211

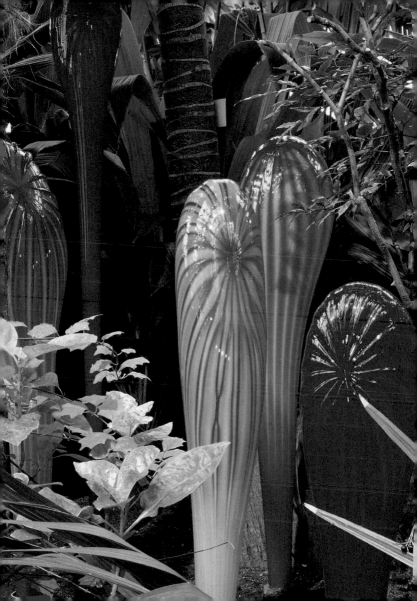

Being in a conservatory is different from being in a museum. If a big show is in a museum, you go from gallery to gallery, and you know there's going to be something around the corner. Here it's much more of a surprise. My work just looks like it's meant to be here.

Tree Urchins, 2001.
**Garfield Park Conservatory,
Chicago, Illinois**

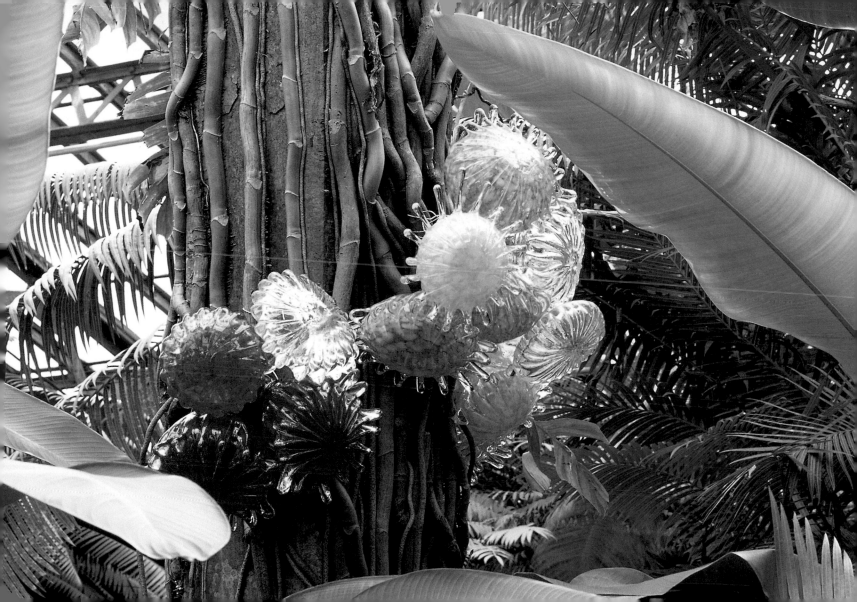

Everybody's going to see the exhibition differently. Some people are going to say it really blends in with nature—it really looks right. Some people are just going to say "Wow." Once they understand that it is an artist's work—although most people going to see it probably already know that—for each person it's going to be a different sort of adventure.

Cobalt Frog Feet, 2001.
Garfield Park Conservatory,
Chicago, Illinois

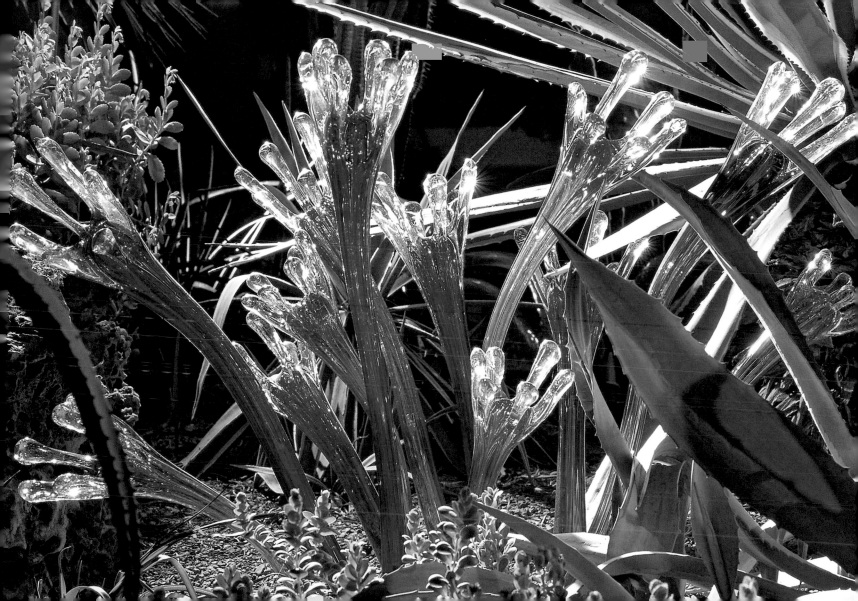

I love the idea that just a single piece of glass could be a sculpture that would command energy
and space and attention.

Garnet Brown Persian with Mahogany Lip Wrap,
2002, 12 x 21 x 13 inches

214

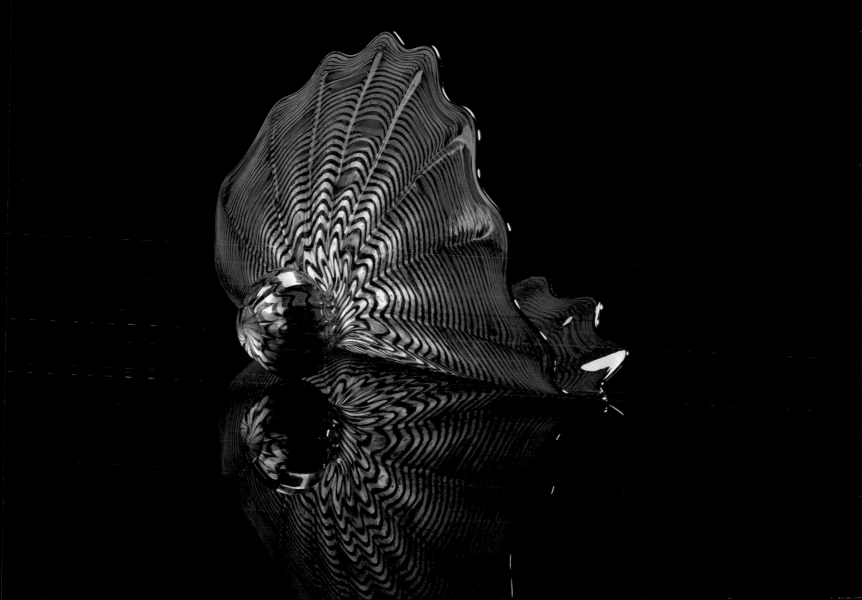

Dale doesn't necessarily plan, Dale responds to what he feels and sees at the moment. I've worked for him for ten years. That's our job: to follow his eye, to follow his wishes. We'll have a dialogue about it, but at the end of the day, it's Dale's work and that's the way he works. That's the process. You're either responsive to that or it's the wrong place for you. That's Chihuly.

Parks Anderson, *Chihuly Over Venice*, film, 1998

Eleanor Blake Kirkpatrick Memorial Tower, 2002, 55 x 8 feet. Oklahoma City Museum of Art, Oklahoma

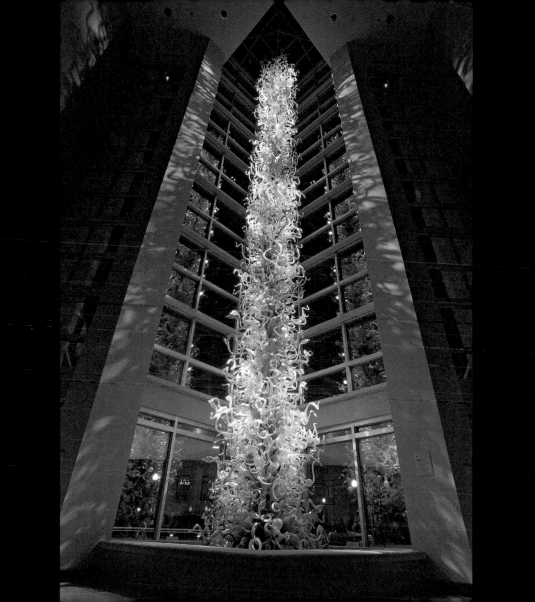

As the ultimate non-artist, I find all art-making magical. One moment there's nothing. And then, with skill and training and determination and vision, there's something wonderful that can change the way we look at the world.

Sister Wendy Beckett, Museum of Fine Arts, Boston: *Sister Wendy's American Collection*; WGBH video, 2001

Anemone Wall, 2002.
Salt Lake City, Utah

216

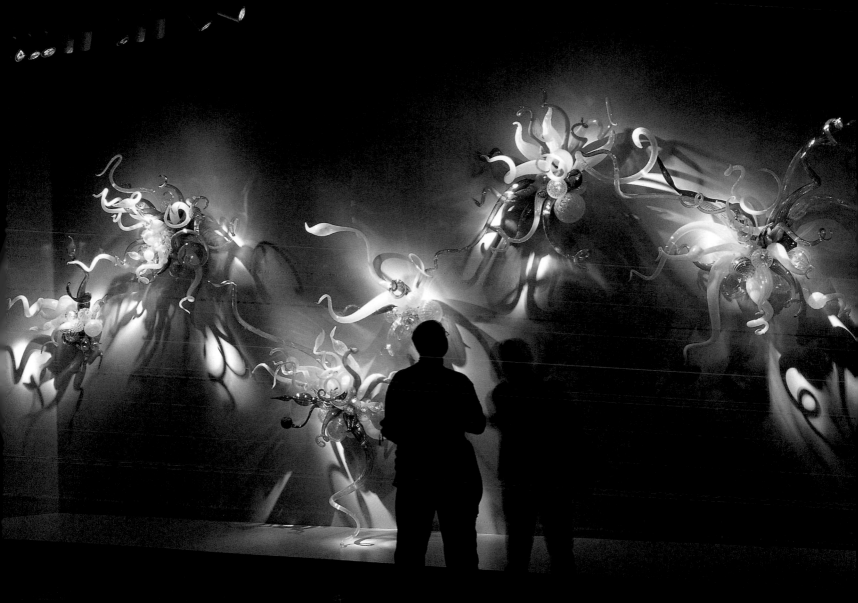

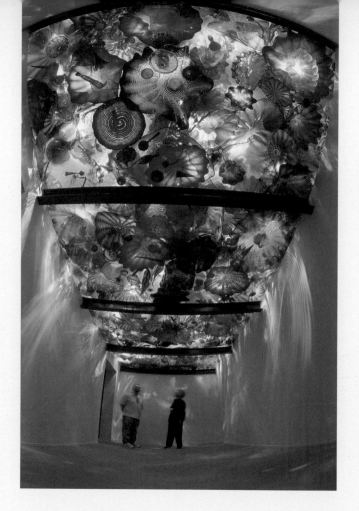

People have asked what inspired me to do the *Mille Fiori*. It wasn't so much trying to replicate plants as it was a way to work with all the techniques we've learned over the last thirty-five, forty years.

Persian Pergola, 2002.
Salt Lake City, Utah

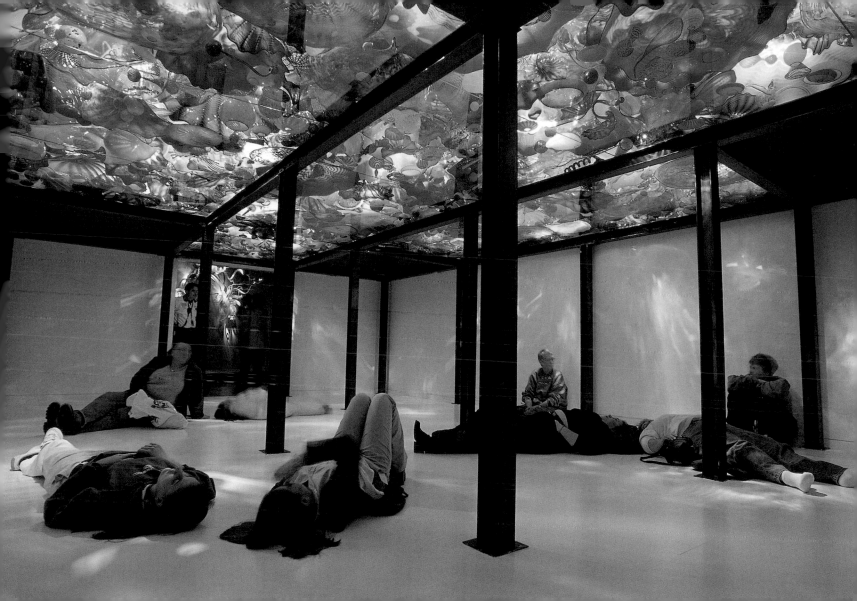

I've worked with and trained some great glassblowers. And, I have been able to attract some of the great European glassblowers as well, that I certainly didn't train—if anything they trained us.

Chihuly Bridge of Glass,
Tacoma, Washington

218

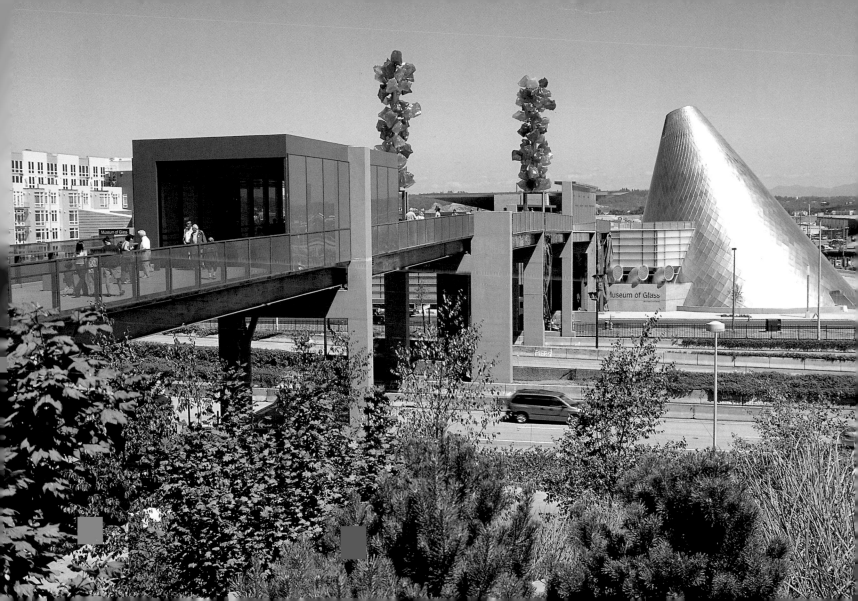

When I'm drawing and blowing glass, I like the music to be on and loud. It's great to work with people, but in order to think, you sort of have to be alone a lot of the time. By pumping up the volume, it cancels out everybody. I think the music helps to keep everything jacked up.

Seaform Pavilion,
2002, 50 x 20 feet.
Chihuly Bridge of Glass,
Tacoma, Washington

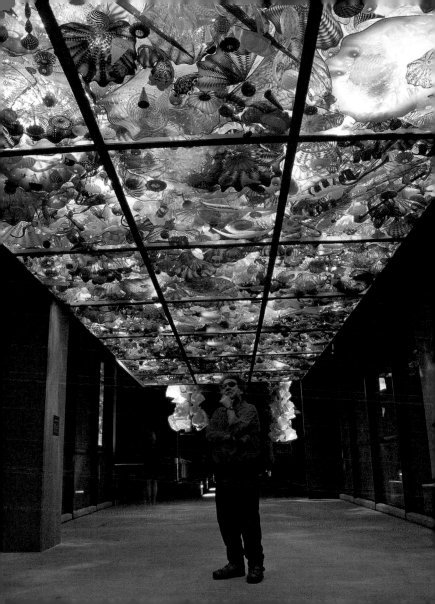

Part of what glassblowers have to learn is how to work with each other, how to help out each other. Also, it's physical, hard work. It helps to be athletic. But mostly you want to be motivated. It's so spontaneous. It's so immediate. Glass inspires almost anybody who works with it—there's a sense of accomplishment and there's danger and excitement. It's all one package.

Venetian Wall,
2002, 12 x 80 feet.
Chihuly Bridge of Glass,
Tacoma, Washington

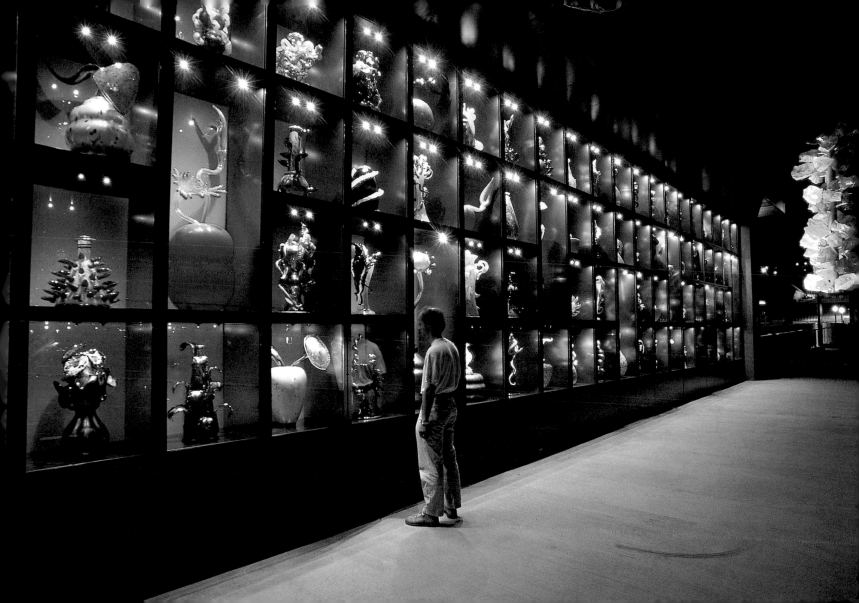

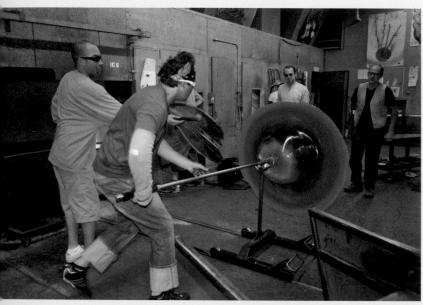

Macchia blow, 2006. The Boathouse hotshop, Seattle, Washington

Traditionally glass has always been done using a team. It's just one of those crafts that demands to be done in a team, and most of the glassblowers that work for me are artists in their own right, and they do their own work for part of the year, then they work for me part of the year.

**Macchia Forest detail, 2003.
Franklin Park Conservatory,
Columbus, Ohio**

221

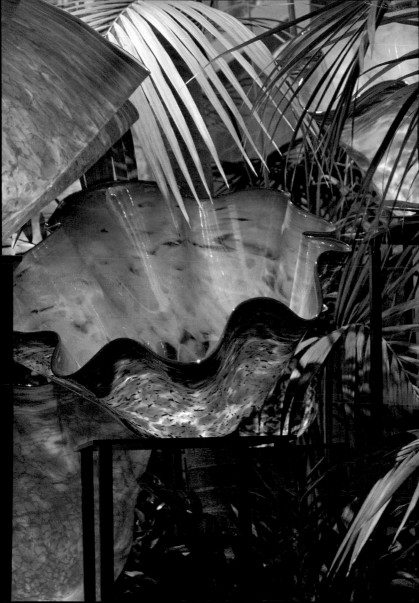

Sometimes Italo says to me, "Relent, Chihuly! Relent! When are you going to quit doing all this stuff? Take it easy. Relax, buy a beach house." But, you know, I can't do that, because I have the energy.

*Tiger Striped Persian Set
with Crimson Lip Wraps,
2003, 18 x 52 x 25 inches*

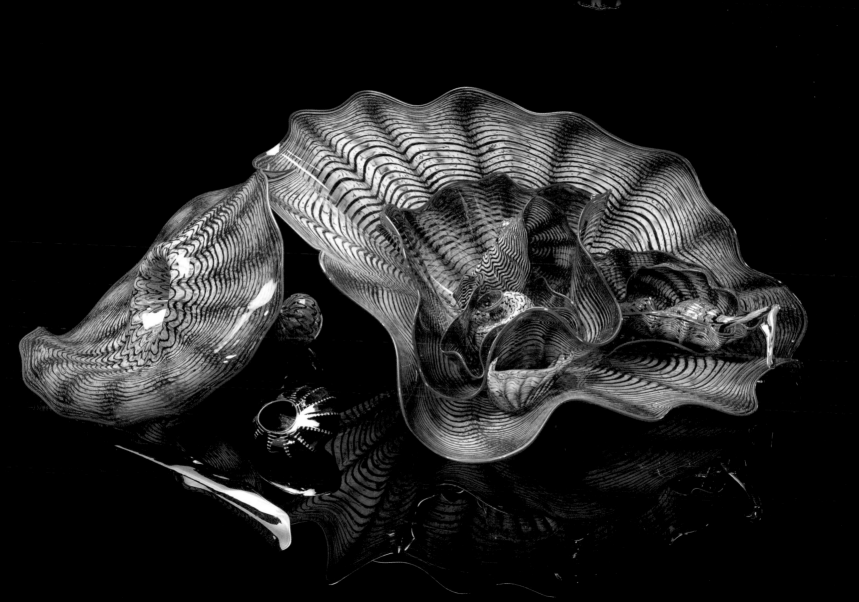

We went to a little island off Tokyo called Niijima. I took about eight of the team over and we worked for two weeks to celebrate the opening of a new glass school there. Back in Seattle a little later, when I started making these big glass balls, I needed to find a name and decided to call them *Niijima Floats*. I remember as a kid walking along the beach and running into these Japanese fishing floats. These spheres really looked like the floats—it was just a name to take off on—and I like the idea of connecting them to the experience of being in Japan.

Polyvitro Floats, 2003.
**Franklin Park Conservatory,
Columbus, Ohio**

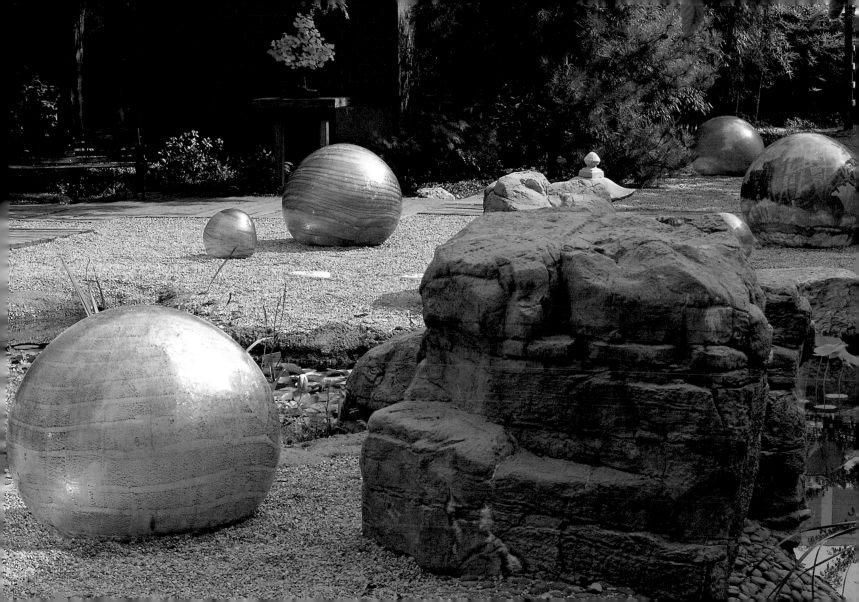

Although Chihuly forms are essentially abstract, they seem nature-based. The undulating sides, swirling lips, and progressively spaced stripes suggest they may have been shaped by eddying water or gusts of wind. Though the scalloped edges are in fact stationary, their apparent fluidity hints at potential movement like the swaying of organisms responding to tidal changes.

David Bourdon, "Chihuly: Climbing the Wall,"
Art in America, June, 1990

Persian Ceiling detail, 2003.
Franklin Park Conservatory,
Columbus, Ohio

224

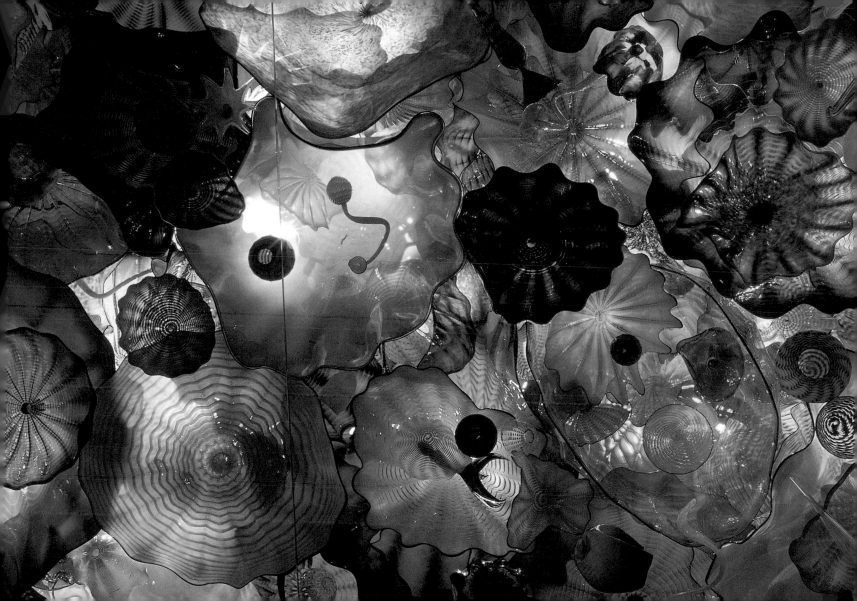

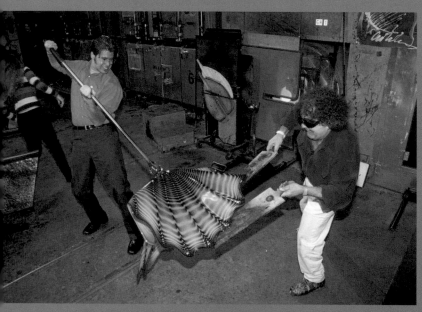

James Mongrain and Dale Chihuly. The Boathouse hotshop,
Seattle, Washington

Boundaries between artists and craftsmen have
melted considerably since the 1960s when I
began exhibiting. Now people use the materials
that suit the ideas they want to express. So,
traditional craft materials like glass, ceramics,
metal, and fabric are included in all kinds of
sculpture.

***Persian Temple**, 2003.*
Franklin Park Conservatory,
Columbus, Ohio

225

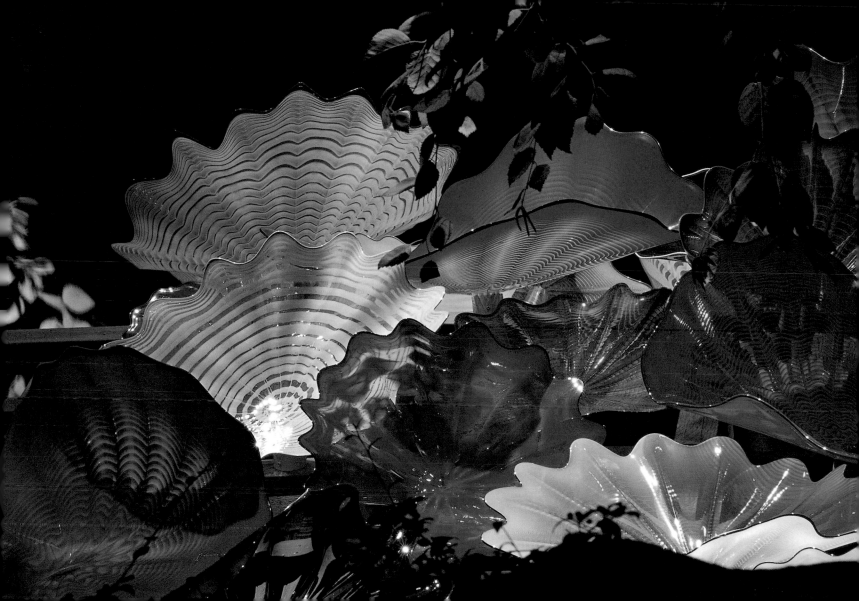

People often ask me how I communicate my ideas to the gaffers. I communicate in different ways with each gaffer. Some of it is drawings, but it's really everything—it's voice mail, it's faxes, it's FedEx, but mostly it's probably looking at the glass itself.

Blue Herons, 2003.
Franklin Park Conservatory,
Columbus, Ohio

226

To me, the best of everything is an art form. If it moves people in some way, that's what's important.

Persian Sealife Ceiling, 2003,
200 square feet.
Norton Museum of Art,
West Palm Beach, Florida

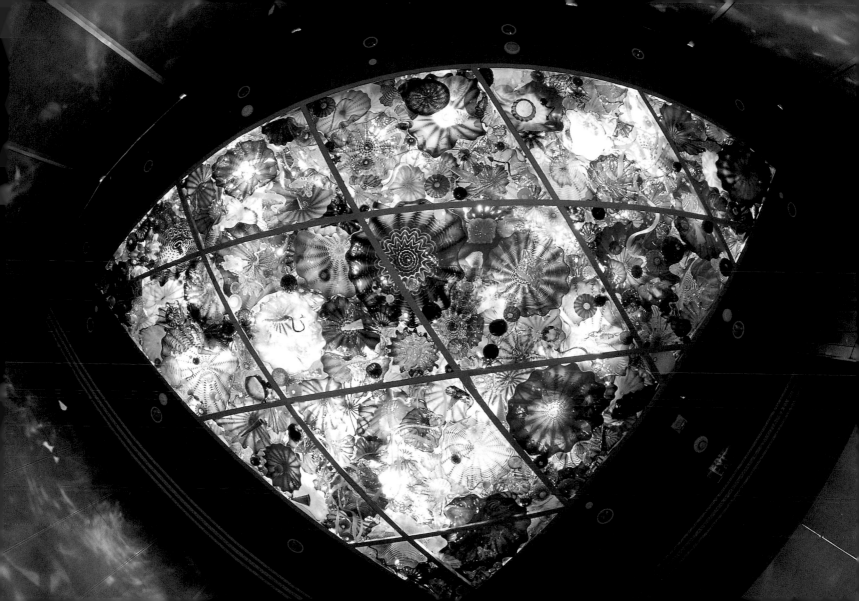

Glass is defined as a super-cooled liquid. And it's transparent, like water. And so the idea that the objects end up looking like they came from the sea is no accident. It is almost like water itself.

Golden Celadon Persian Niche Installation,
2004, 5 feet 1 inch x 5 feet 5 inches.
Orlando Museum of Art, Florida

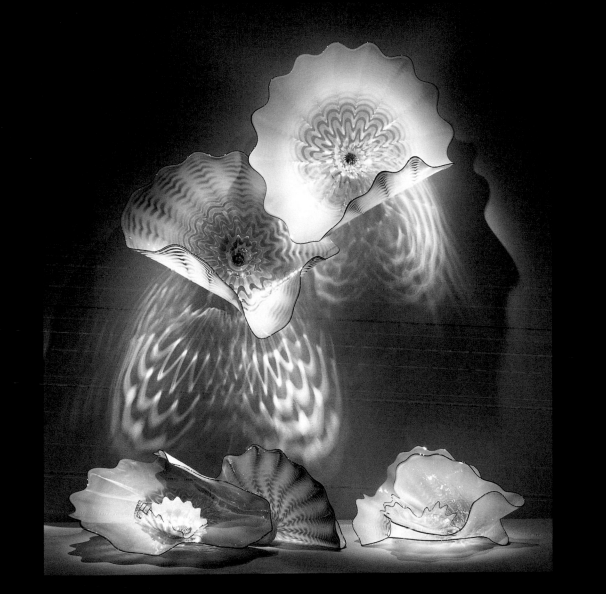

Glass is fragile, but that's one of the reasons why people like to collect it. There's something about its fragility that intrigues you. You move it the wrong way and it's all over.

Spanish Orange Persian Set with Black Lip Wraps, 1994, 12 x 43 x 33 inches. Museum of Fine Arts, St. Petersburg, Florida

229

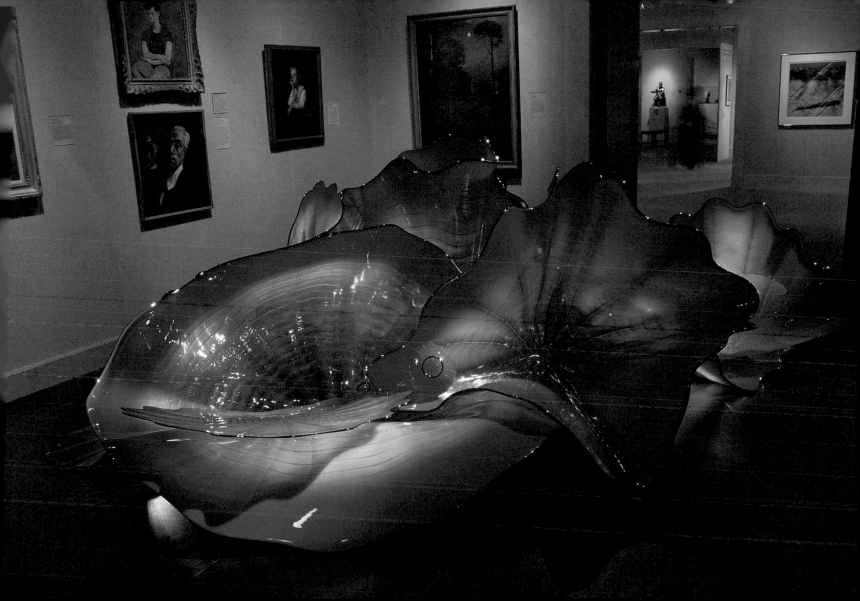

Glassblowing is a very spontaneous, fast medium, and you have to respond very quickly.

Cranberry Red Persian Wall, 2004,
9 feet 4 inches x 41 feet 4 inches.
Museum of Fine Arts,
St. Petersburg, Florida

230

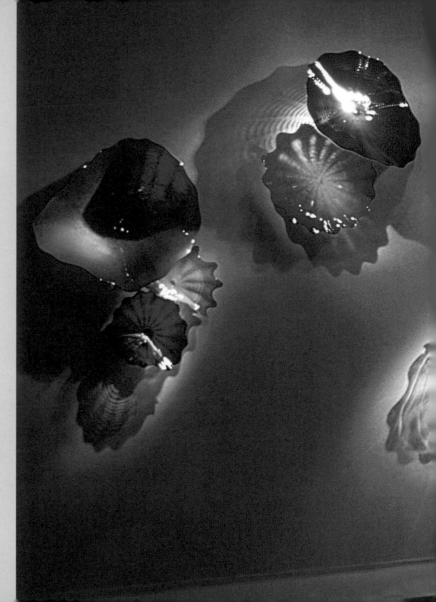

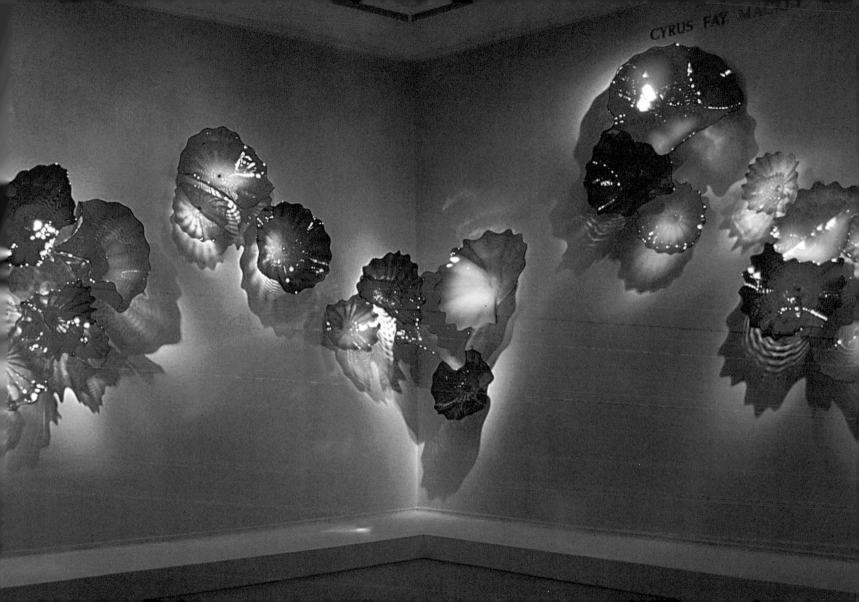

I sort of conceive the next piece as the team is finishing the last one, or sometimes I'm one ahead depending upon my state of mind. My preference is to come up with the next form right after they've finished the last one. I really draw my inspiration from the making of the glass.

Putti Sealife and *Drawing Wall*, 2004.
Orlando Museum of Art, Florida

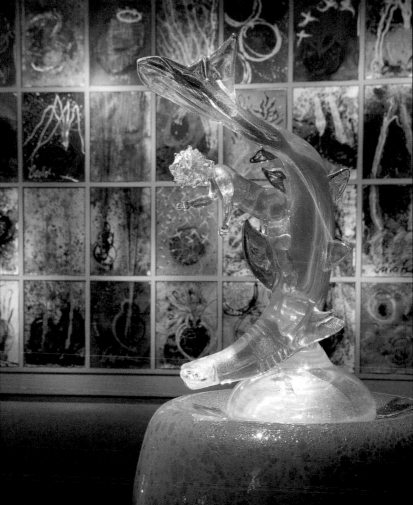

I began to replicate the wavering, woven forms of traditional Northwest Coast Indian baskets in glass after seeing the collection at the Washington State Historical Society in 1977.

Basket Forest, 2003.
Ballard Studio,
Seattle, Washington

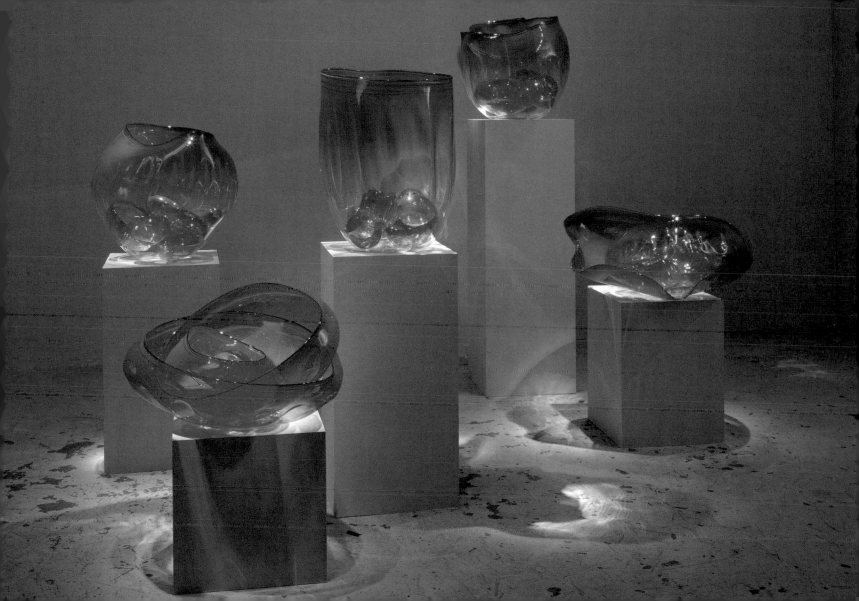

The stacked and collapsing Indian baskets led me to group my *Baskets* together into sets.

Originally, they were earth-toned and red; later, we experimented with more exuberant color.

Basket Forest, 2005.
Oklahoma Museum of Art, Oklahoma

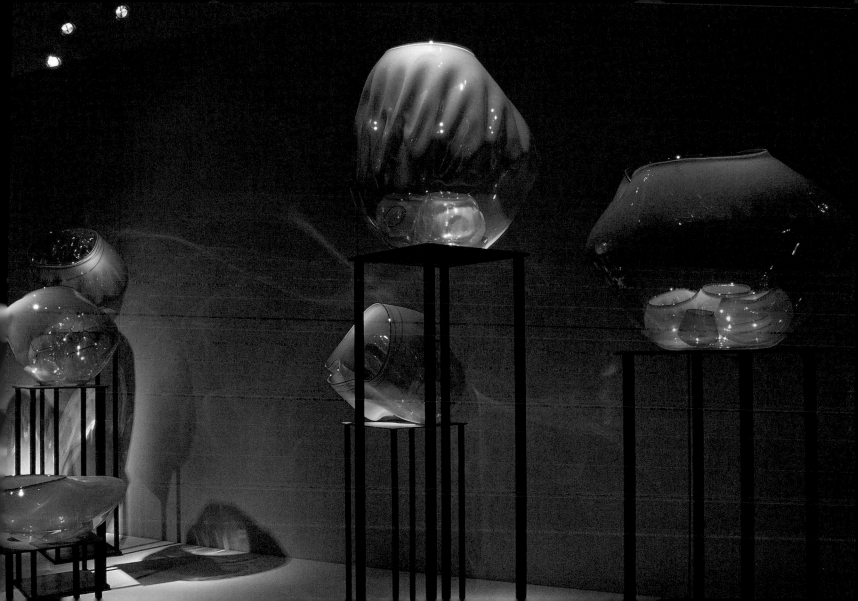

I made the first *Reeds* in 1995 at the Hackman factory, a small glassblowing shop in Nuutajärvi, Finland. Unlike other factories, the Hackman facility had very high ceilings, which inspired me to make these elongated forms.

Neodymium Reeds,
2004, 9 x 14 x 14 feet.
Orlando Museum of Art, Florida

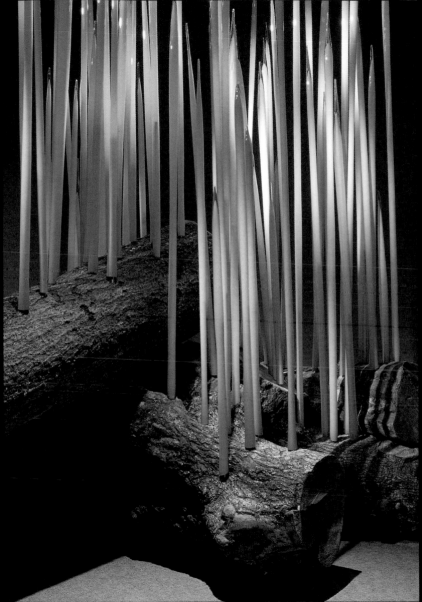

I sometimes use the analogy of myself as a filmmaker. First of all, I come up with a concept, which might be like a script. I don't work on the team itself but make drawings while the team is working. The whole process is a very exciting and inspiring one.

Palazzo Ducale Tower, 2004,
17 feet 2 inches x 6 feet 5 inches x 6 feet 5 inches.
Museum of Fine Arts,
St. Petersburg, Florida

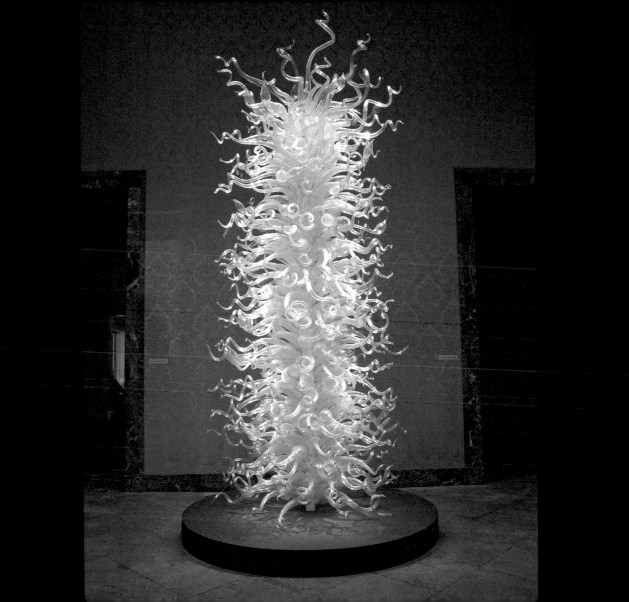

My work to this day revolves around a simple set of circumstances: fire, molten glass, human breath, spontaneity, centrifugal force, and gravity.

Howell Fountain Tower, 2004.
Atlanta Botanical Garden, Georgia

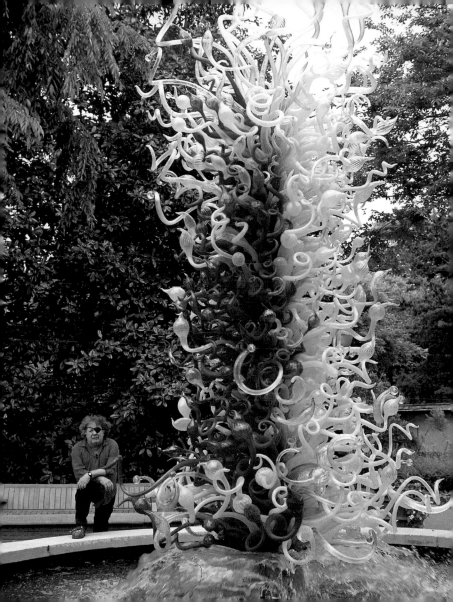

Glass was always one of the most collected of materials since it was first made. The Egyptians valued it as much as precious jewels.

Persian Pond, 2004.
Atlanta Botanical Garden, Georgia

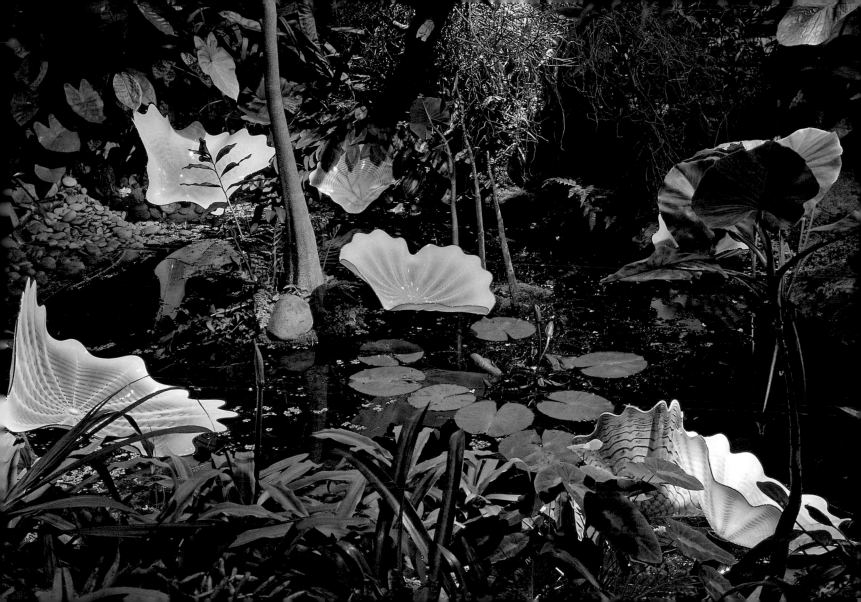

The best way to get a job done well is to have a few more people around than is absolutely necessary.

238

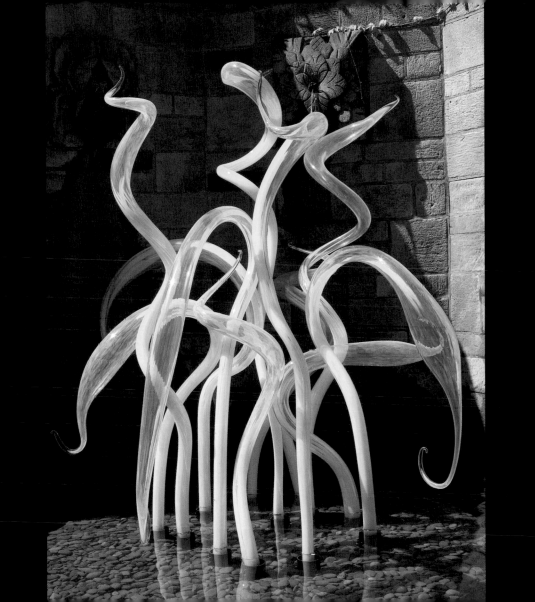

Isn't it unbelievable that the most fragile of materials, glass, is also the most permanent material?

Neodymium Reeds, 2007.
Phipps Conservatory and Botanical Gardens,
Pittsburgh, Pennsylvania

239

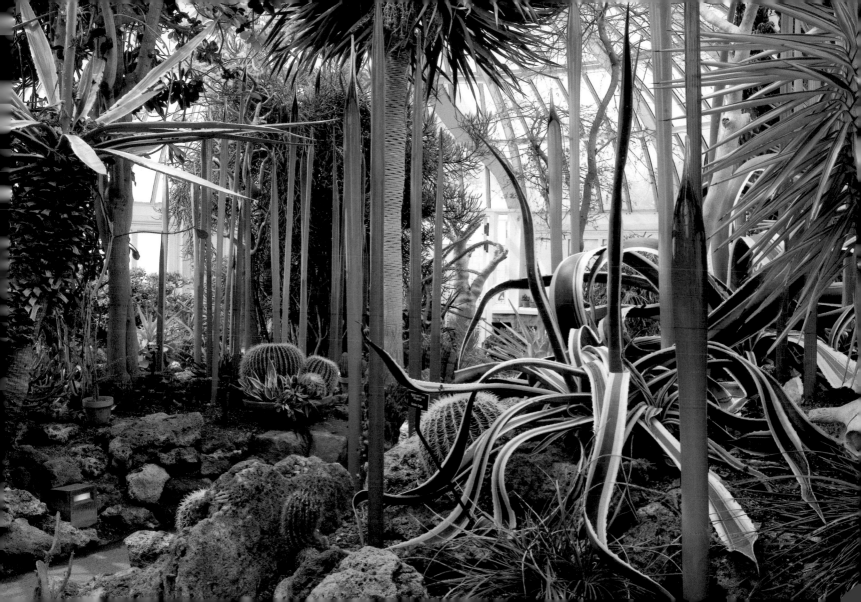

I love to juxtapose the man-made and the natural to make people wonder and ask, "Are they man-made or did they come from nature?"

Trumpets, 2005.
Royal Botanic Gardens, Kew,
Richmond, England

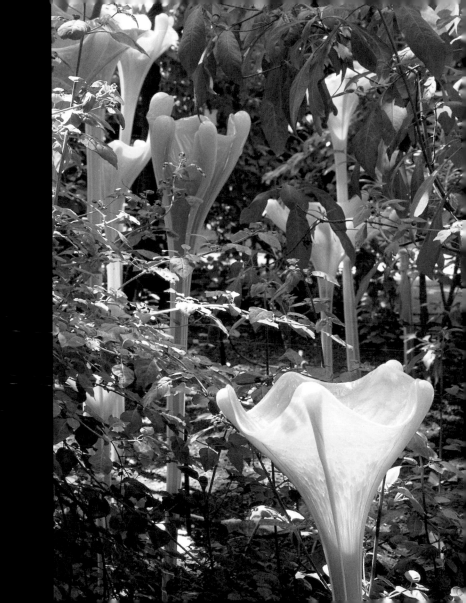

In 1964, I took the train from Vancouver to Montreal on my way to Russia. During the sixty-hour ride, I decided I would mix as many colors as I possibly could from a complete set of Winsor Newton watercolors. Three thousand miles later, I had an album filled with thousands of color samples. This was not unlike the thinking behind the *Macchia* series.

Macchia Forest **detail, 2004.**
Atlanta Botanical Garden, Georgia

Call it art, call it craft. I don't care what they call it. Somewhere down the line, long after I'm dead, someone will figure out what it was and how important it was. In the meantime, I get my kicks out of people seeing the work.

Parterre Fountain, 2004,
60 x 92 x 98 inches.
Atlanta Botanical Garden, Georgia

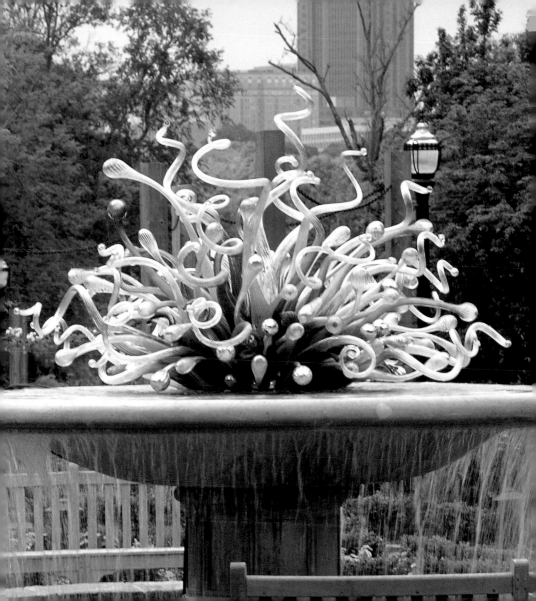

Glass itself is so much like water. If you let it go on its own, it almost ends up looking like something that came from the sea.

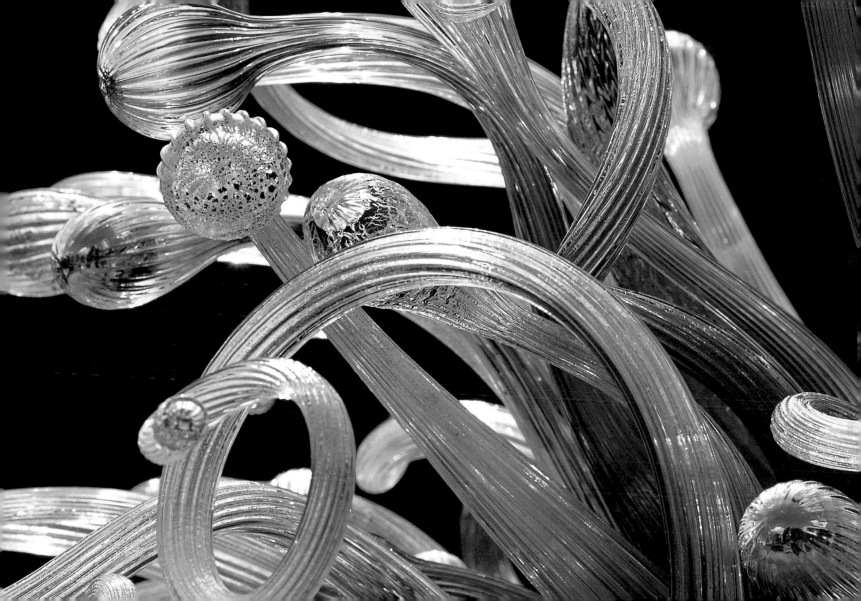

When people go into a museum, it's the perfect environment. They already feel they're in a special place looking at special things. If the lighting's just right, the situation's just right, it can be very powerful. When people go into a museum, it's a sacred place. Museums are almost like the cathedrals of our time in some respects.

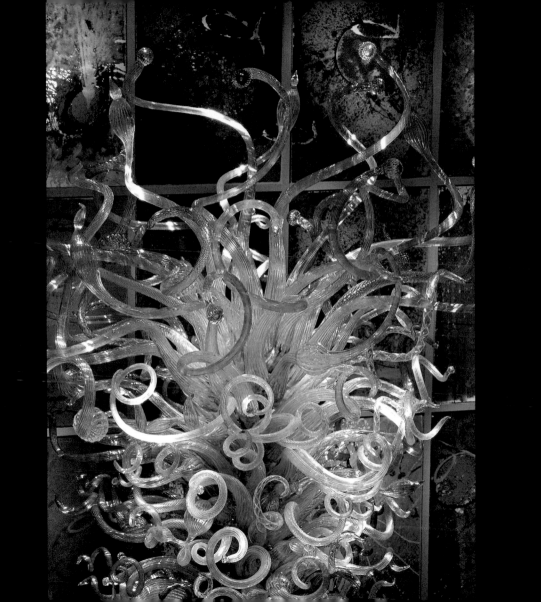

Drawing workshop, 1998. Taos, New Mexico

It's amazing how much art affects people's lives. For those who are interested, and go to museums, it really can be quite an altering experience. It gives me a lot of pleasure to realize my work makes people feel good for the most part. It gives them a lot of joy and I also like the fact that with my work you don't really have to be educated in art to get something from it.

Lapis and Chartreuse Tower, Drawing Wall, Persian Table Installation, 2004. Frederick R. Weisman Museum of Art, Pepperdine University, Malibu, California

245

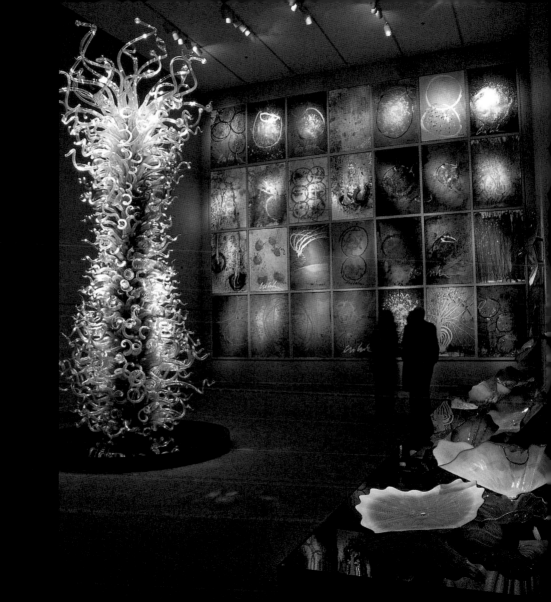

Drawing workshop, 2000. Montezuma, New Mexico

My canvas covers a section of a deck, which overlooks the water. My shoes seem to soak up every spill and splash. I paint with a squirt gun, a mop, anything but a brush. Consequently, my shoes become more colorful every day.

Mille Fiori, 2004,
9 x 16 x 40 feet.
LA Louver Gallery, Venice, California

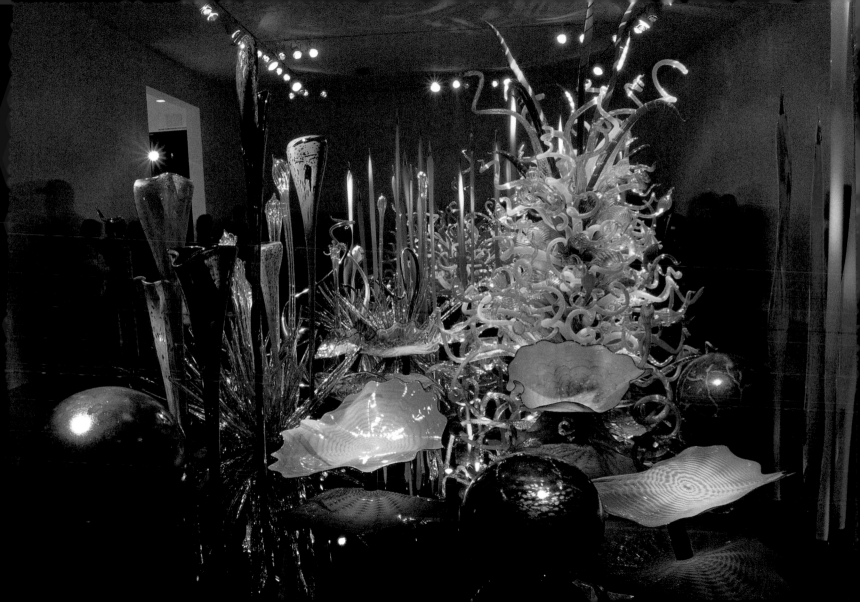

At one time we would bring together anywhere from twelve to eighteen glassblowers and try to do the most extreme pieces that I could ever imagine and that they would be willing to do. The teams kept getting bigger and wilder, and the pieces became more extreme. Well, one thing led to another.

Rising Sun, 2004,
7 feet 7 inches x 13 feet 4 inches x 13 feet 4 inches.
Orlando Museum of Art, Florida

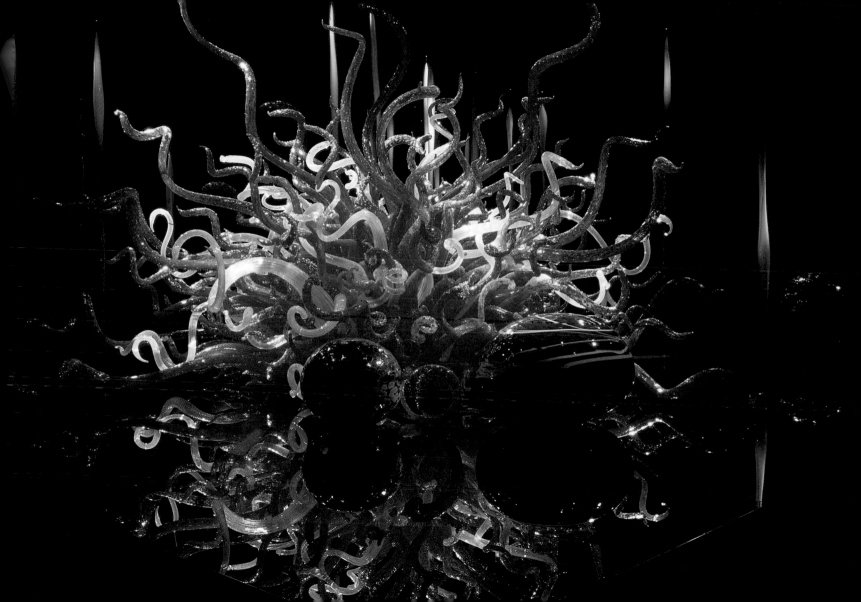

I'll conjure up some crazy idea that the team gets behind and says, "Well if that's what Chihuly wants to do, that's what we'll do." Often it's something that none of us quite knows what it will be until it happens.

Rising Sun detail

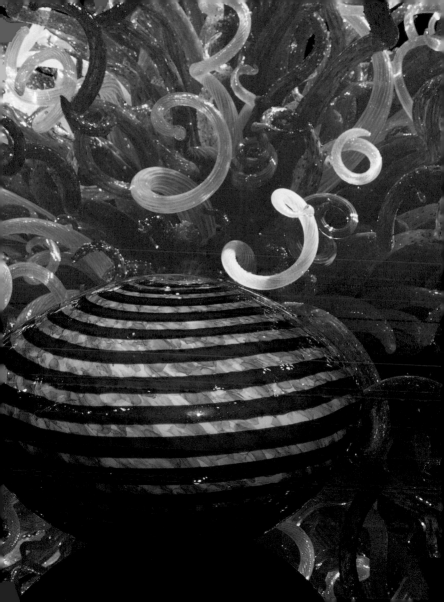

There's no way that anything about my studio remains the same. It's constantly evolving and changing. Even the buildings change. I'm even moving walls and changing the shop. Everything about what I do is an evolving process. The car I drive changes. How I work changes. It's just like the day changes.

Red Finnish Boat, 2004,
19 feet 2 inches x 8 feet.
Orlando Museum of Art, Florida

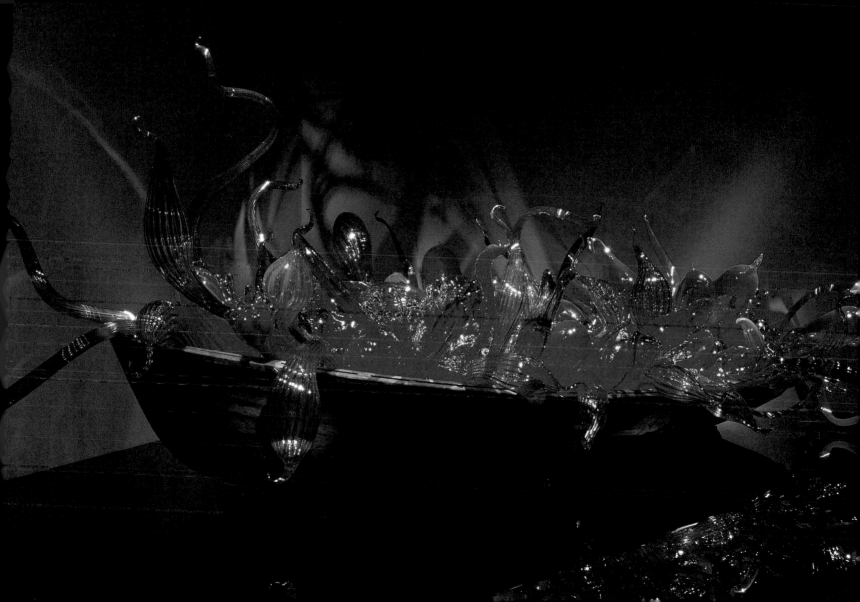

Anyone who has worked with Dale knows that he is so generous. With his time, with himself.

Benjamin Moore, unpublished biographical sketch

Mille Fiori detail, 2004.
LA Louver Gallery,
Venice, California

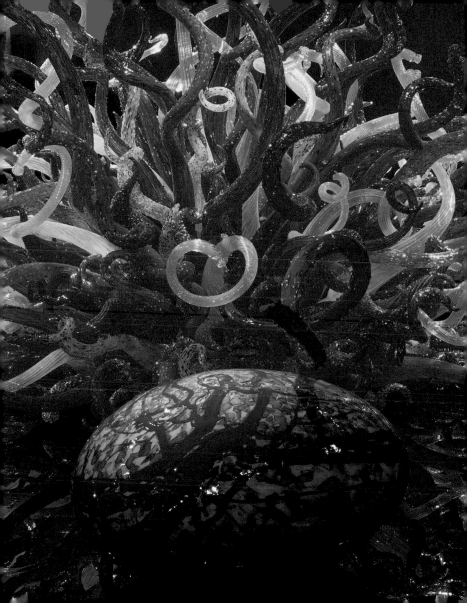

I don't try to please the art world. I care about getting my work out where people can see it, whether it's in a museum, a public building, a resort, or whatever. Whether people think it's art or craft is not important to me. If it gives people pleasure, if it makes them feel good, that's what counts.

Niijima Night Floats, 1995, 15 x 110 feet.
Museum of Glass, Tacoma, Washington

251

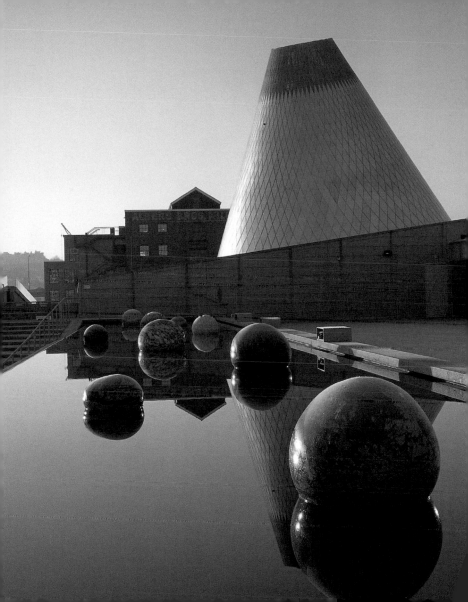

What is most important when I'm making my work? I guess, to wake up in the morning with an

idea, and then to have a great team to execute it. That's what's important to me.

Ma Chihuly's Floats, 2006.
Tacoma Art Museum,
Tacoma, Washington,

252

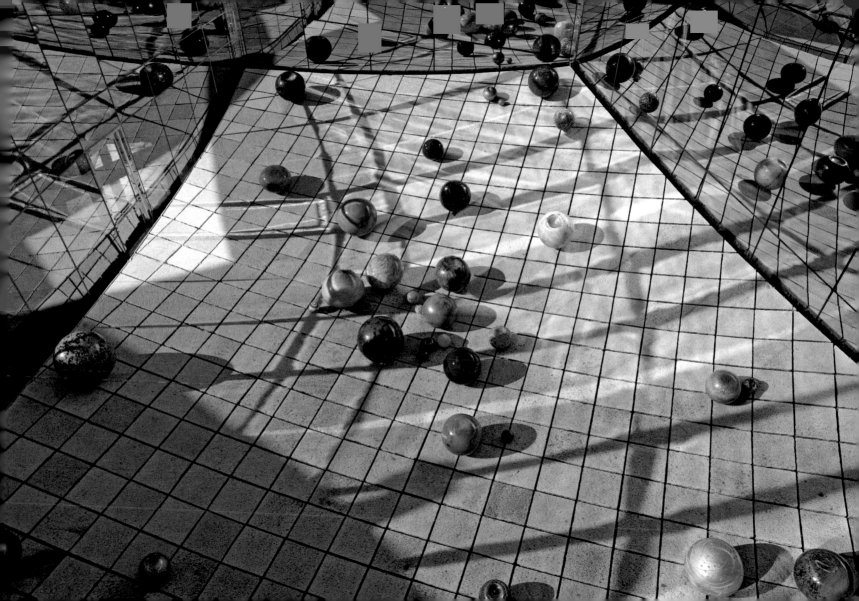

Polyvitro is a name that I coined for a type of plastic. Of the hundreds of thousands of materials in the world, glass and plastic are the only two materials of any scale that are transparent, other than water and ice.

Blue Polyvitro Crystals, 2005.
Royal Botanic Gardens, Kew,
Richmond, England

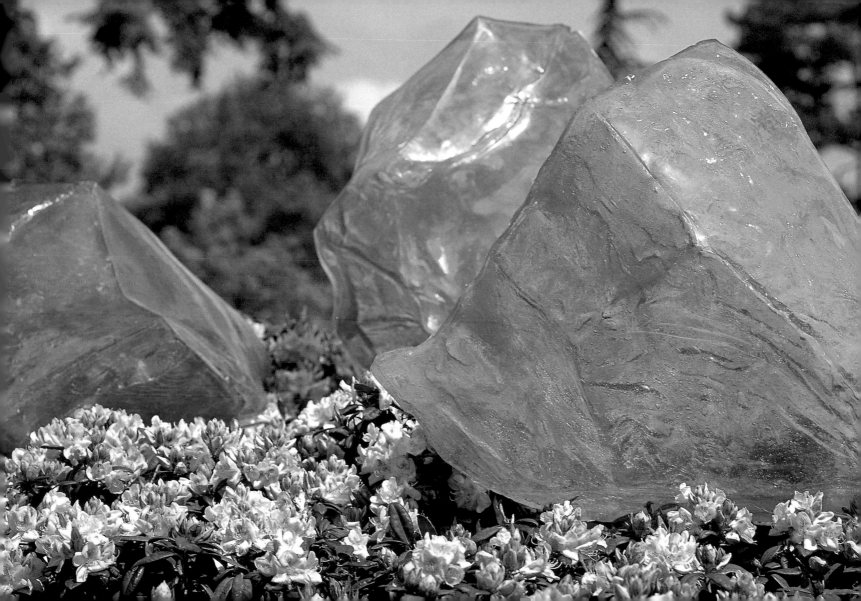

My mother had a big garden and I've always had an interest in gardens and conservatories.
The idea of being able to bring my work more or less inside but still in nature at the same time is
really great.

Sibley Fountain Herons, 2004,
4 feet 8 inches x 11 feet x 6 feet 8 inches.
Atlanta Botanical Garden, Georgia

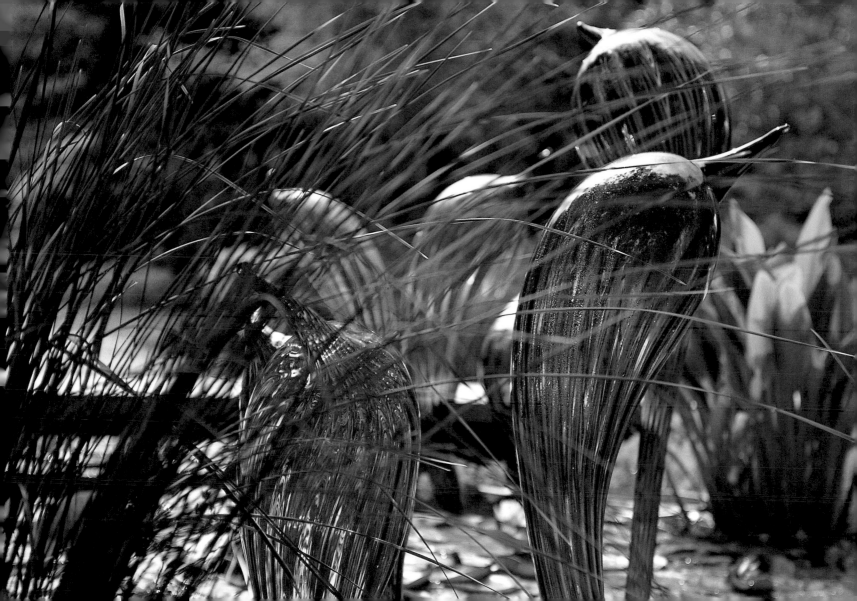

It gives me a lot of pleasure to give people pleasure. It's unbelievable. Probably other than making the work itself, having people enjoy the work is one of the nicest things about what I do.

OPPOSITE:
Blue Herons, 2005,
5 feet 6 inches x 12 feet 6 inches x 6 feet.
Royal Botanic Gardens, Kew, Richmond, England

OVERLEAF:
Niijima Floats, 2004.
Atlanta Botanical Garden, Georgia

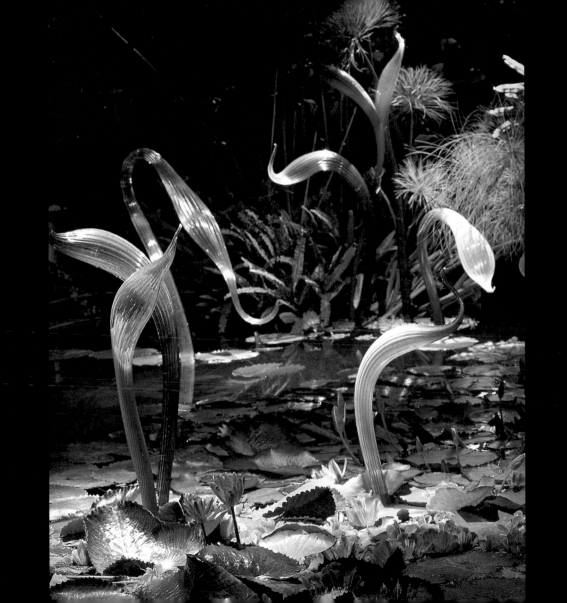

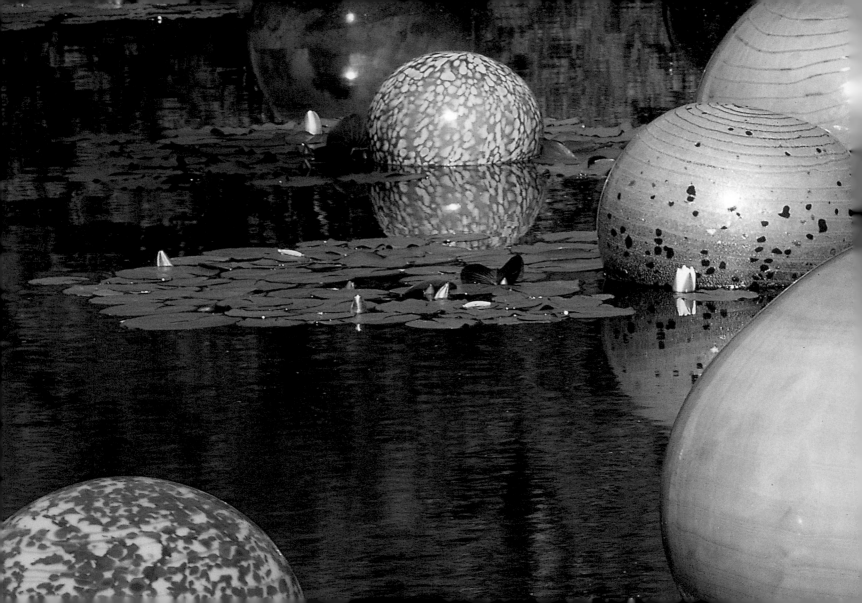

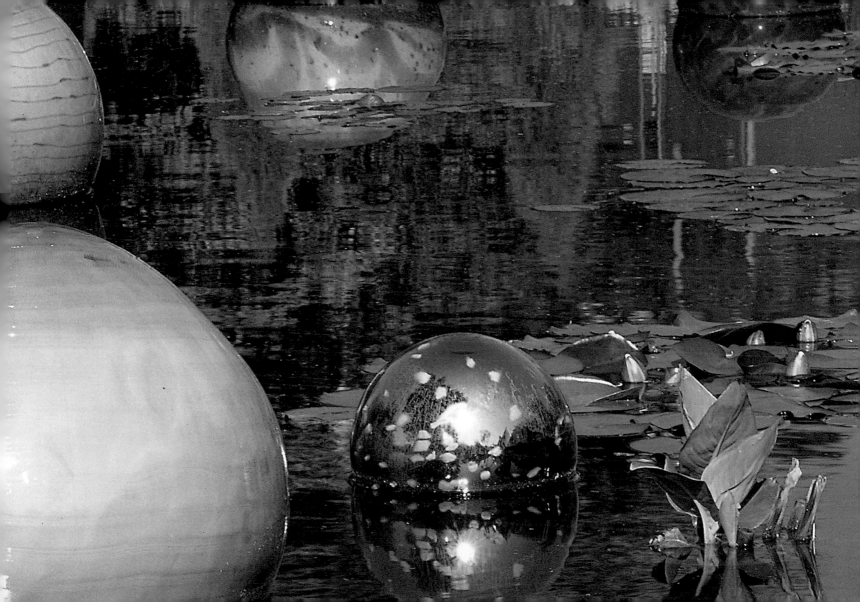

Leslie Jackson and Dale Chihuly, 2005. Royal Botanic Gardens, Kew, Richmond, England

I teach kids they can use any color, any size paper, work any way they want to. There are no boundaries, there are no rules...they don't have to be able to draw a horse or a bicycle.

Palazzo di Loredana Balboni Chandelier, 2005, 10 feet 2 inches x 7 feet 3 inches x 6 feet 4 inches. Royal Botanic Gardens, Kew, Richmond, England

257

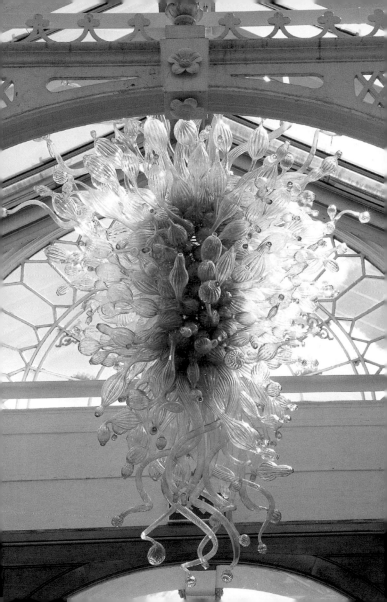

Other people find things by thinking. I find things by working.

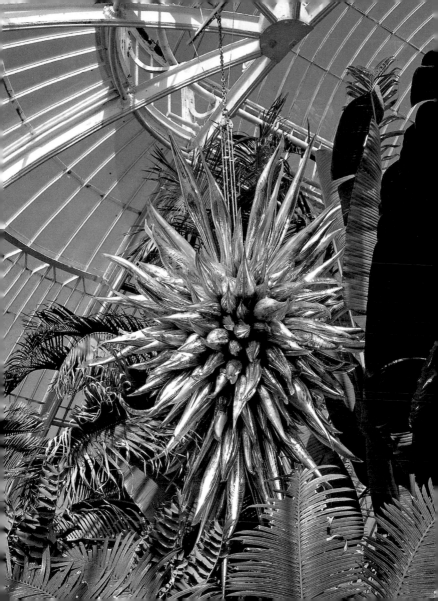

I'm obsessed with color—never saw one I didn't like. I don't know if something can be too colorful.

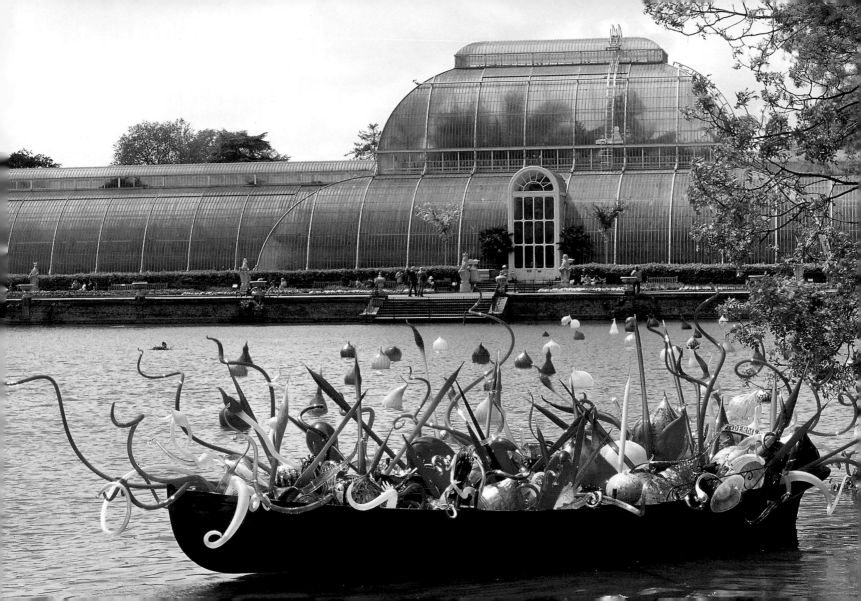

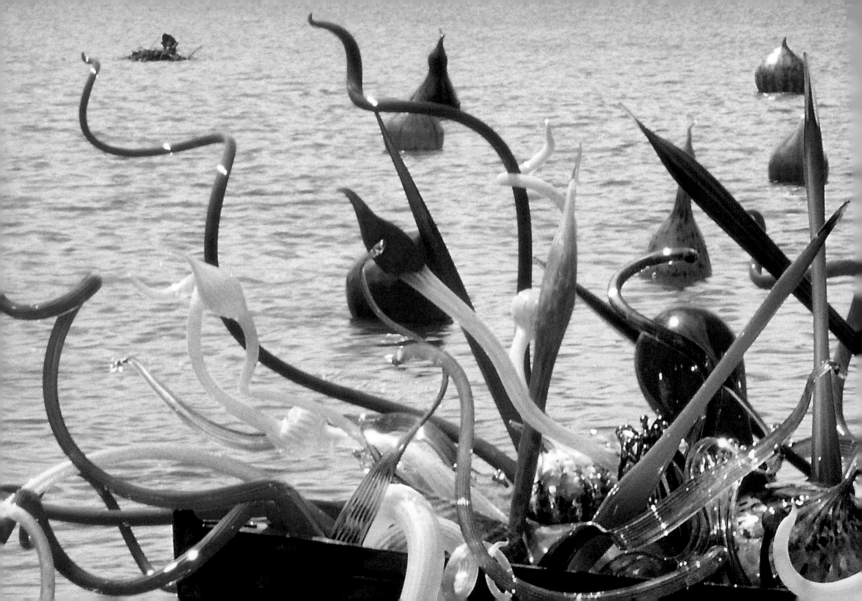

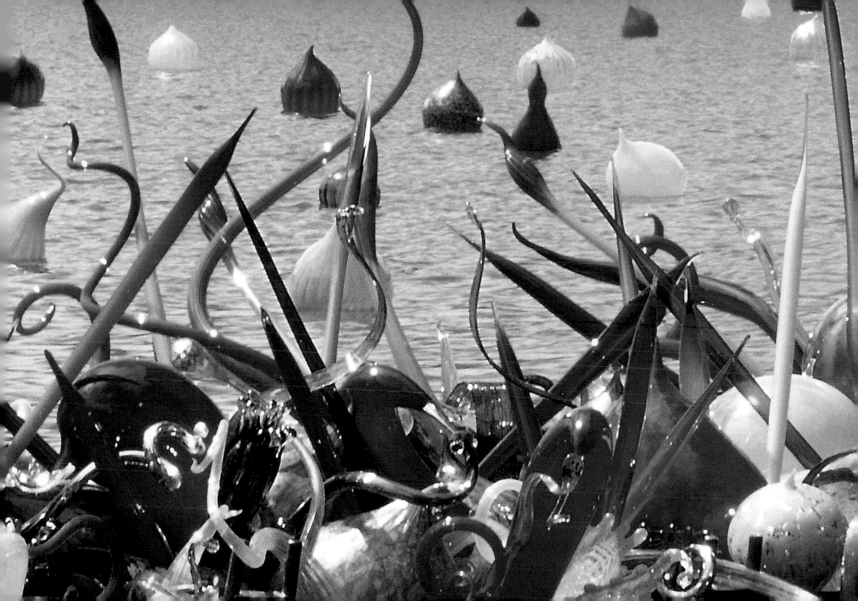

I know if I go down to the glass shop right now and work down there, I'm going to make something that has never been made before. That in itself is an inspiration.

The Sun at Kew Gardens, 2005,
14 feet 7 inches x 13 feet 6 inches x 13 feet 6 inches.
Royal Botanic Gardens, Kew,
Richmond, England

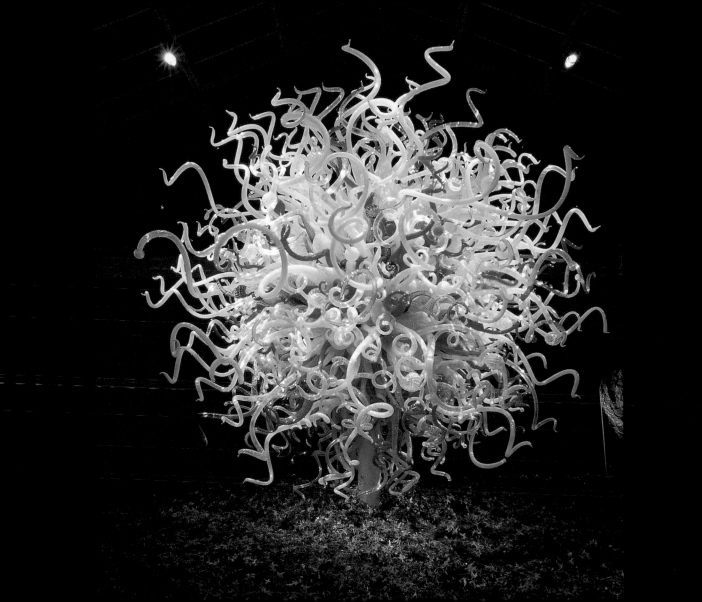

Dale Chihuly, 2005. Royal Botanic Gardens, Kew, Richmond, England

Chance is a crucial ingredient—the unpredictability of the glass, of the colorist, of the gaffers.

Princess of Wales Conservatory Reeds, 2005.
Royal Botanic Gardens, Kew,
Richmond, England

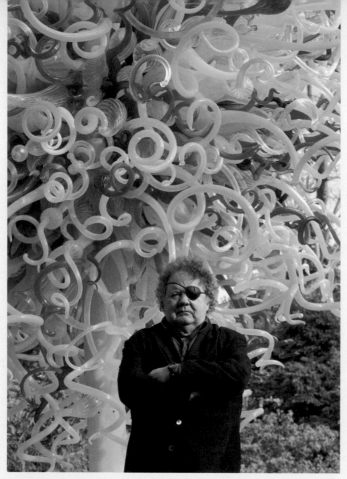

The Sun, 2006, 14 cubic feet. Fairchild Tropical Botanic Garden, Coral Gables, Florida

It's always a question for artists: to know what they're doing and to decide how important it is. So in the way that I work, I try new things periodically. My work doesn't evolve that much. Well, I can't say that my work doesn't actually develop. My work does so many different things. As an artist, I don't think about what I'm going to make, I just work. Things just come out, and I'm just lucky that they just keep coming.

Scarlet, Gold, and Citron Tower, **2005,**
10 feet 8 inches x 5 feet 4 inches x 5 feet 4 inches.
Colorado Springs Fine Arts Center, Colorado

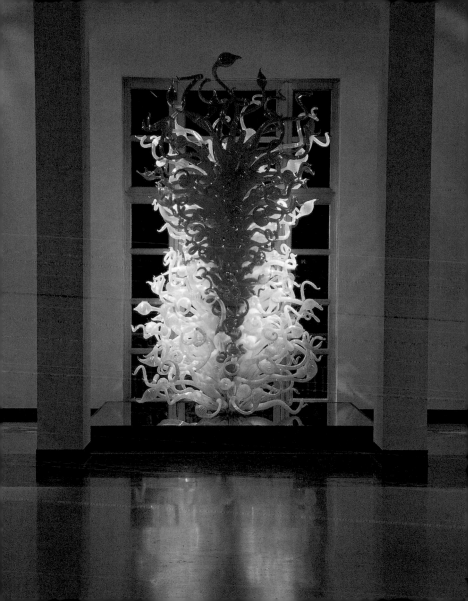

The lighting issue is as important as anything. It's only as good as the light.

Niijima Floats, 2005.
Colorado Springs Fine Arts Center, Colorado

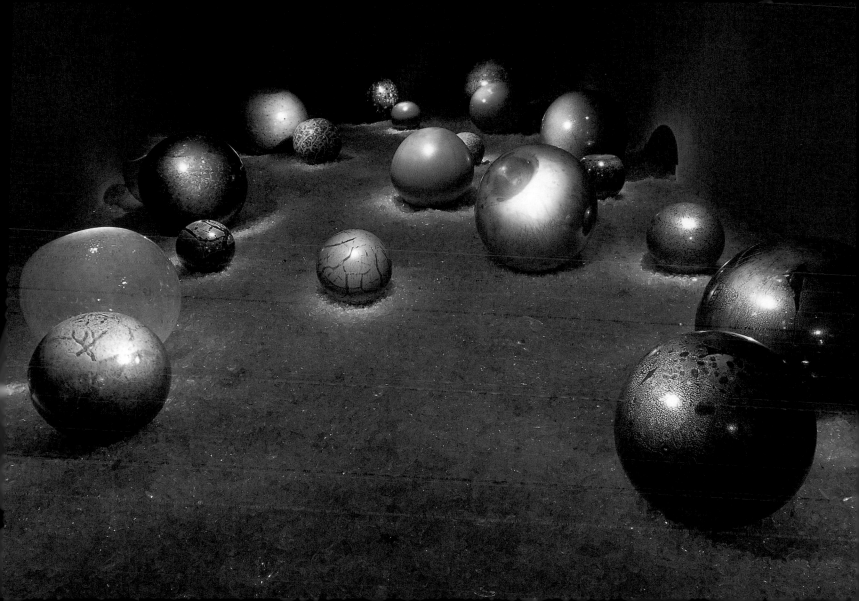

We worked for two weeks. And by the time the two weeks were over, the series had taken on a life of its own—calling on forms, techniques, and aspects of glass from throughout history. It became a creative series totally unlike anything I'd ever done before.

Basket Forest **and** *Cypress Green Chandelier.*
Colorado Springs Fine Arts Center, Colorado

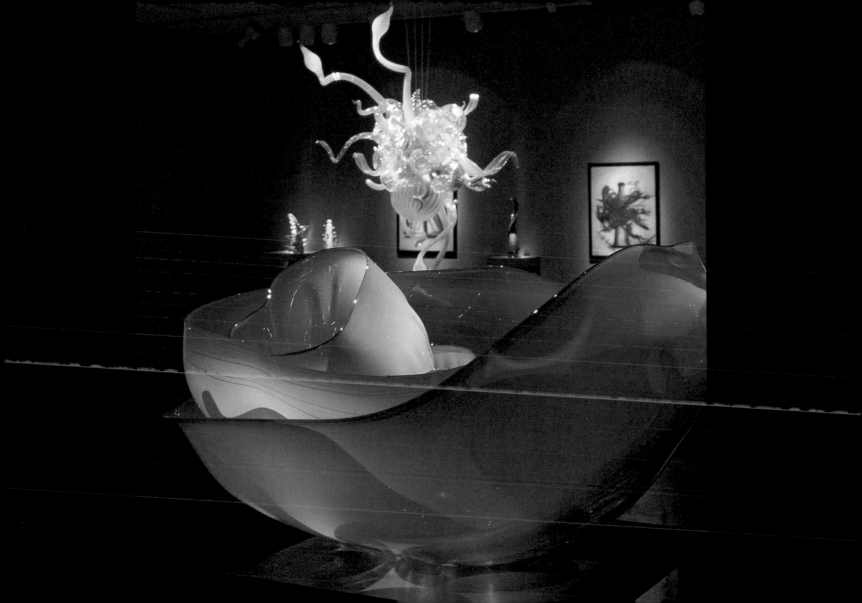

I'm very interested in plastic because it's really the only other material besides glass that does what glass does and transmits light in a similar way. The pieces in plastic couldn't have been made out of glass, because they have a shape that's too difficult to do in glass. We made hundreds of plastic forms, but this is the first one I really like.

Blue Polyvitro Crystals, 2005.
Union Bay, Seattle, Washington

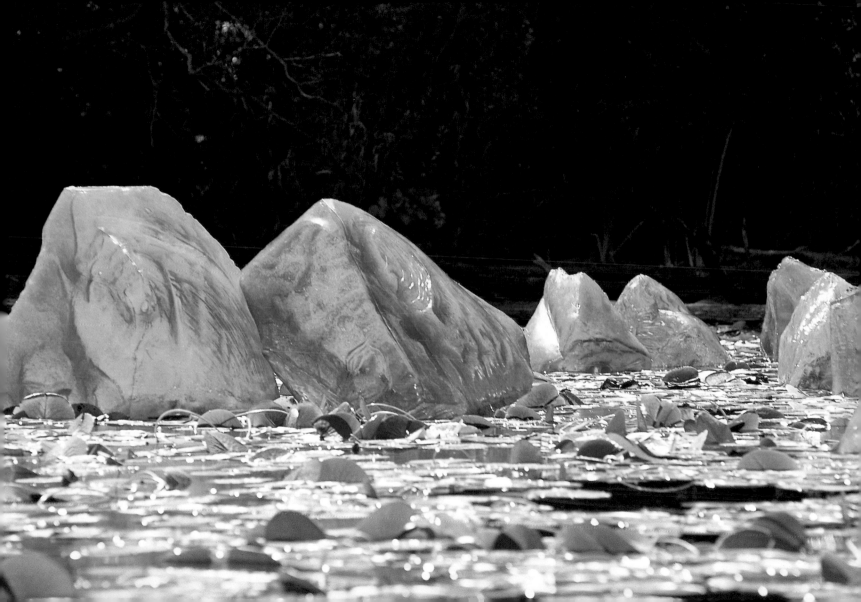

Being in the water, being in the bathtub, being in the hot tub, being in the shower—it's all great. I was even crazy enough to make up a plastic clipboard with a wax pencil so that I can write while I'm in the shower, or even underwater if I want to write something down.

Japanese Bridge Chandelier,
2006, 56 x 98 x 86 inches.
Missouri Botanical Garden, St. Louis

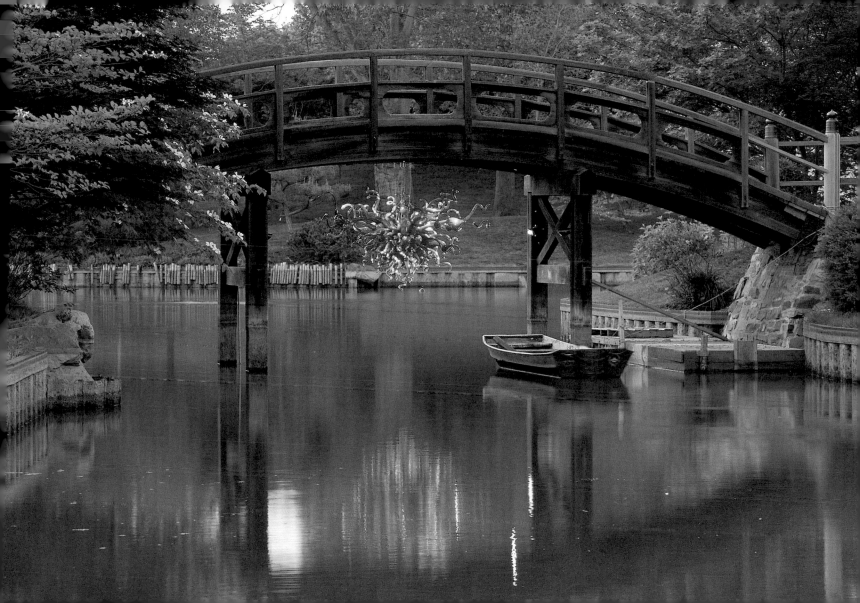

Suppose a child comes upon some beach glass with sun on it. The little kid will drop everything to get that. Maybe I'm that little kid.

Boat, 2006,
6 feet 4 inches x 8 feet 3 inches x 17 feet 1 inch.
Missouri Botanical Garden, St. Louis

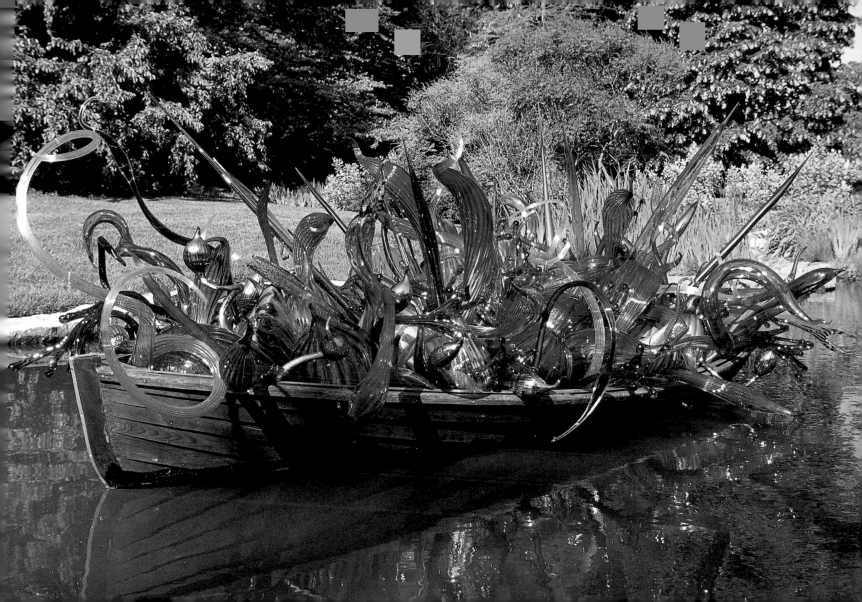

I think his best pieces rival things that Tiffany did 100 years ago.

Henry Geldzahler, *CBS Sunday Morning*, 1992

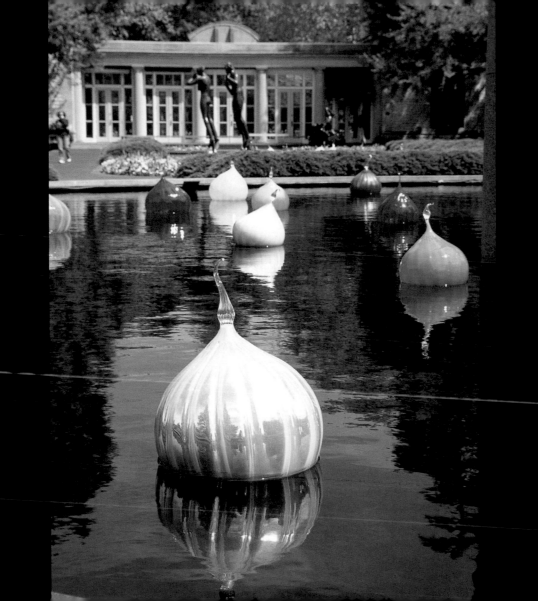

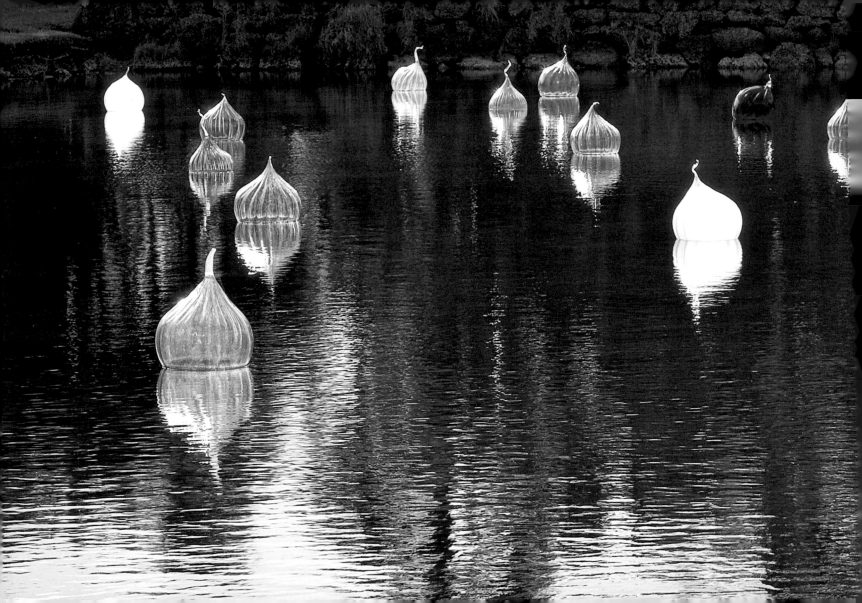

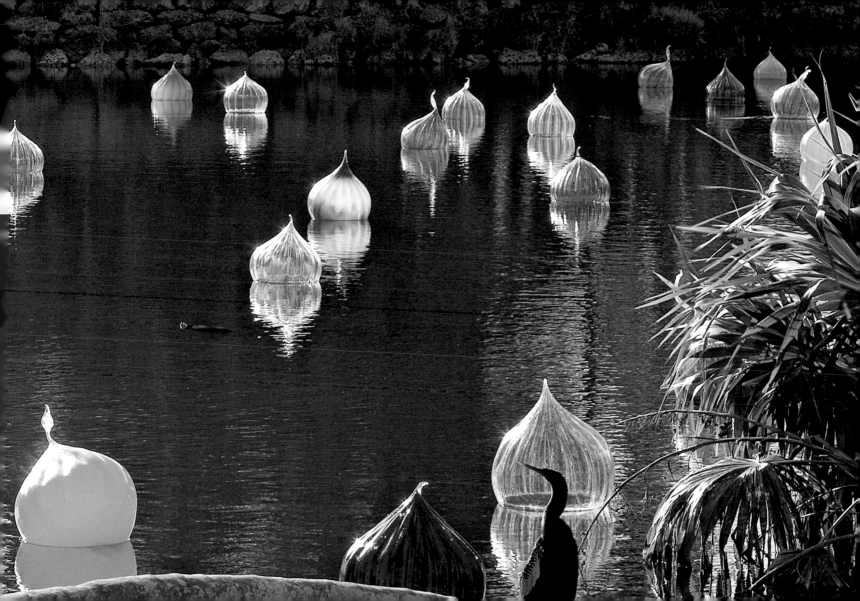

We could make the *Venetian* vases only so high and only so complex. The only other thing we could do was to make separate parts and add them to the pieces. That's really where the term *Ikebana* comes from.

Mottled Bronze Ikebana with Apricot and Chartreuse Stems,
2006, 68 x 28 x 14 inches.
Missouri Botanical Garden, St. Louis

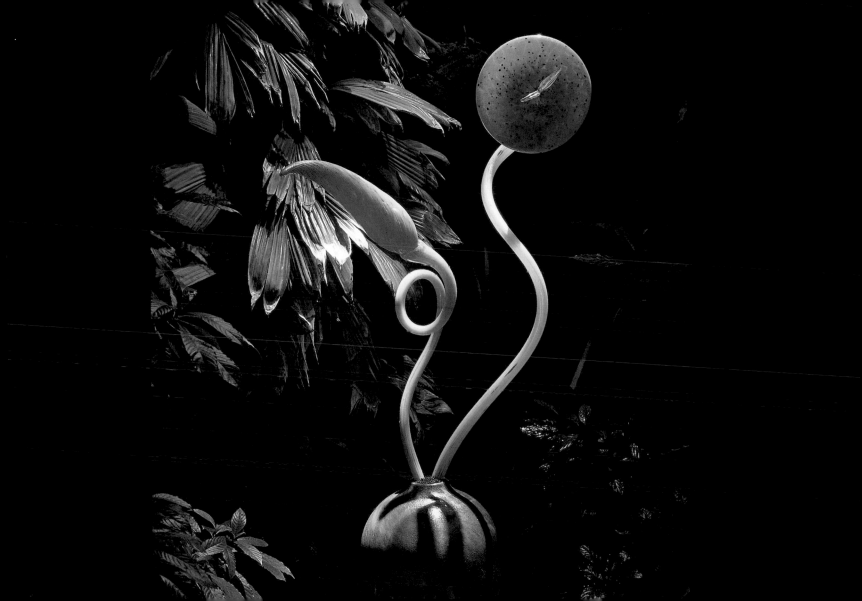

If I don't feel it lives up to what I feel is important, then I can't do it. I have to have the feeling that it's a vital part of me, something that's coming out of me that no one's done before.

Sunset Herons, 2006.
Missouri Botanical Garden, St. Louis

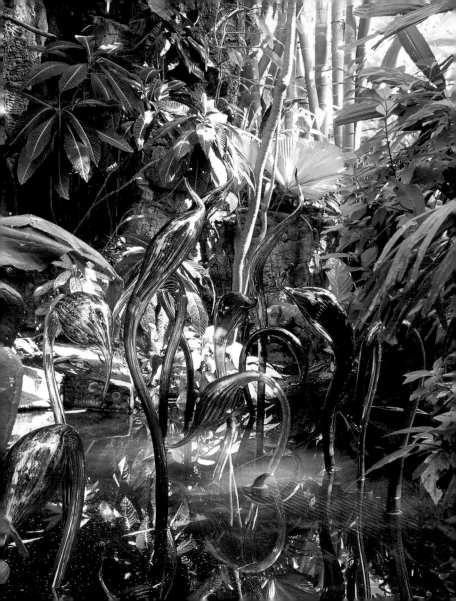

It's one thing to think about something, to have an idea. It's another thing to do it. That really separates the doer from the thinker. You have to have both. You have to be able to think about it and you have to be able to do it.

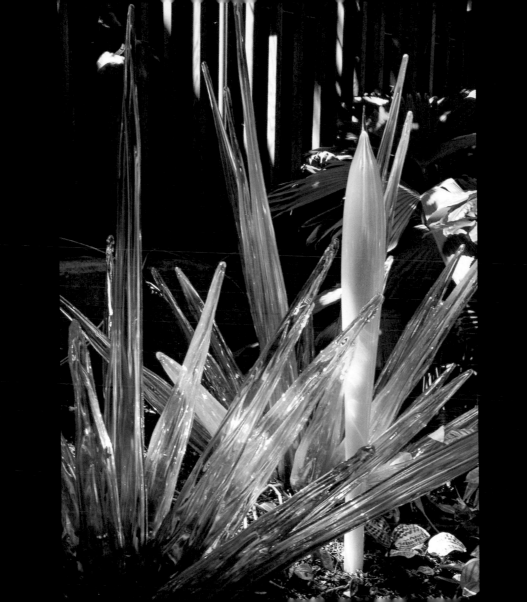

In order to be satisfied as an artist, you're probably going to have to come upon something that's deeply personal. You might as well start searching for that as soon as you can.

Saguaros, 1996.
**LongHouse Reserve,
East Hampton, New York**

273

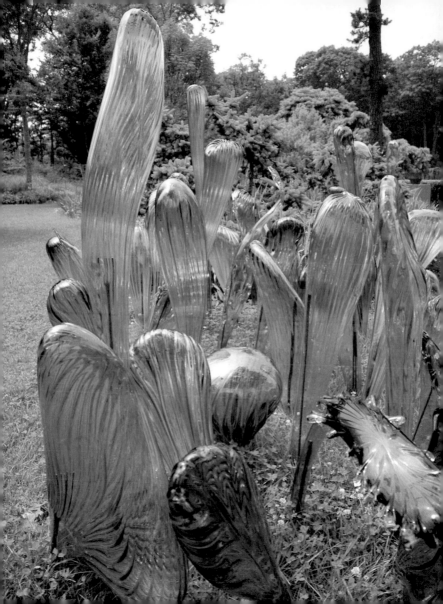

As a teacher, I insisted that all work be photographed, so that I never looked at actual work. All critiques were given from slides. Twice a semester, we would meet—very often in a conference center at a hotel, banquet room, or something—and all day long show slides of student projects. By the time people that worked with me had gone through the Rhode Island School of Design, their work was fully documented, and they were able to talk about their work, and usually have a fairly personal style of their own.

Tumbleweed III, 2006,
77 x 70 x 70 inches.
Missouri Botanical Garden, St. Louis

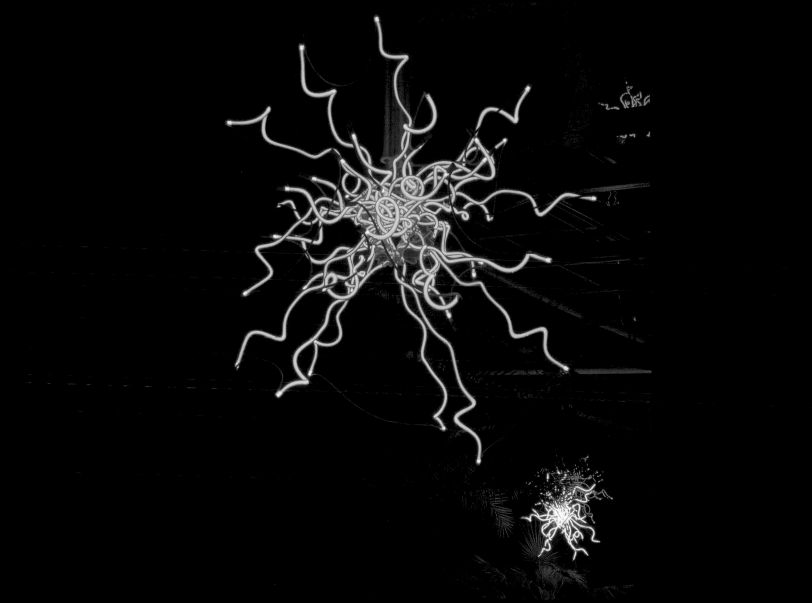

I had the ancient stones of the old fortress in Jerusalem in mind when I developed the idea of using large crystals as forms for outdoor sculptures. The first solidly cast plastic crystals were taken from molds of cullet—the broken chunks of glass retrieved from the bottom of a furnace.

Polyvitro Crystal Tower, 2006,
height 17 feet 6 inches.
Missouri Botanical Garden, St. Louis

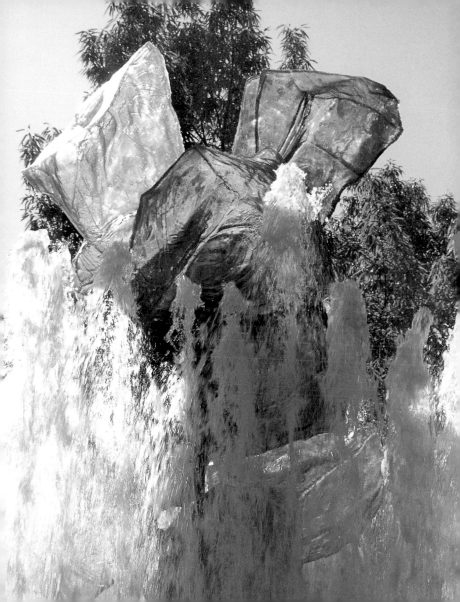

I was lucky to find out, somewhere along the line, that what I wanted to do was to be an artist.

Mirrored Hornets, 2006.
Missouri Botanical Garden, St. Louis

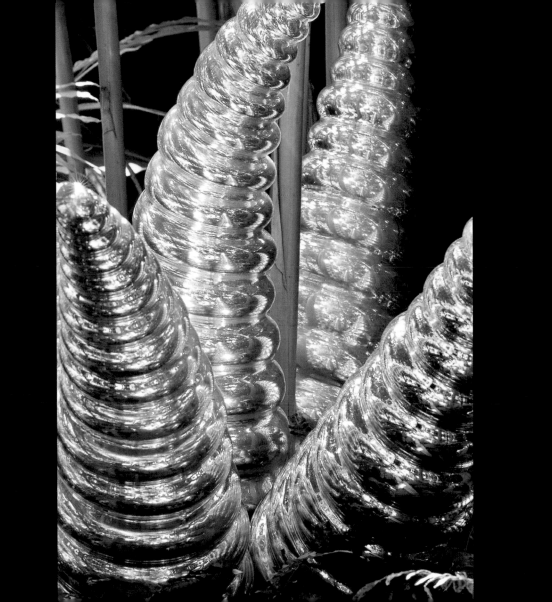

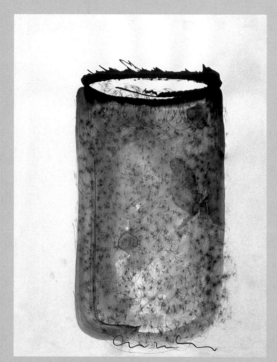

Cylinder Drawing, 2006, 30 x 22 inches

One of the first things I do is start to make a drawing, and then I have several students come up and I say, "Now, pick your least favorite color from the table." And they'll each give me a color that they don't like. And then I'll make a drawing with all the colors they don't like . . . and they end up liking the drawing.

LEFT: *Clear Cylinder #8*, 2006,
16 x 6 x 6 inches

RIGHT: *Clear Cylinder #3*, 2006,
15 x 7 x 7 inches

277

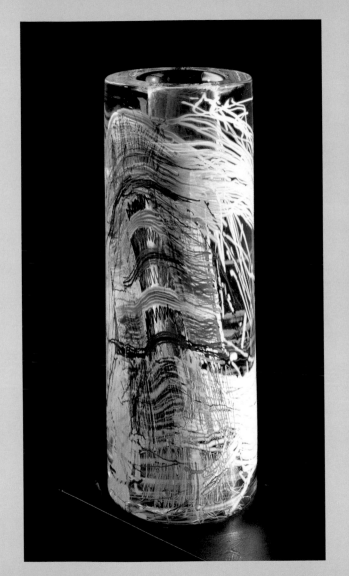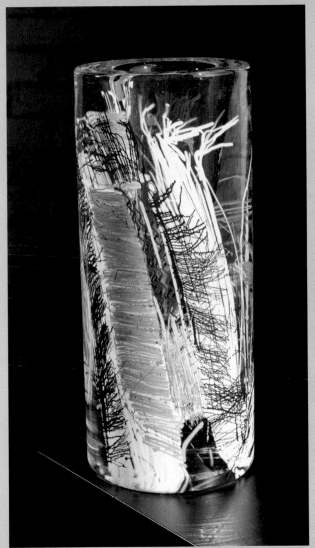

I have found that if you approach glassblowing with some degree of confidence, you usually get much better results.

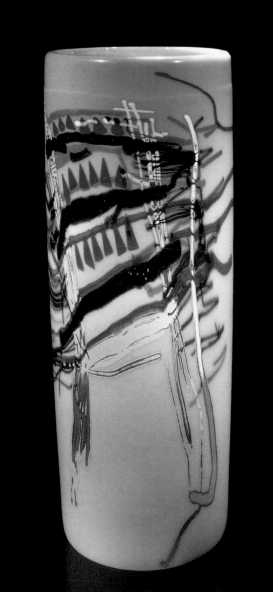

There'll be a cook around to make people food while they are working. But I never like to take a break. I like to work a straight eight hours. That's really important to me, because as soon as you stop to eat, you never get the momentum back. Often the best work comes at the end of the session. But if you stop it in the middle and have lunch, you never reach that peak of working.

Black Basket with Chartreuse Lip Wrap,
2006, 14 x 32 x 32 inches

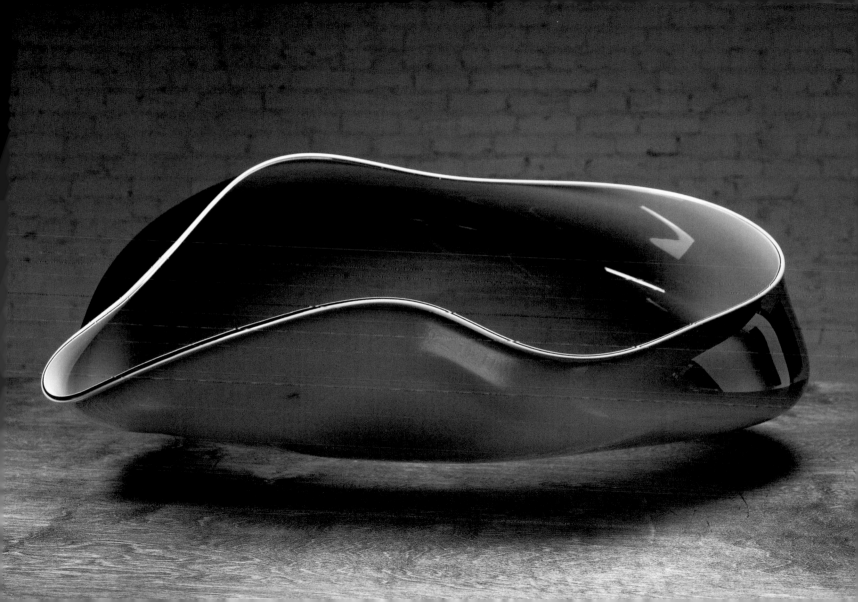

The *Baskets* were the first series that I did that really took advantage of the molten properties of the glassblowing process.

Black Basket Set with Olive Lip Wraps, 2006, 17 x 44 x 34 inches

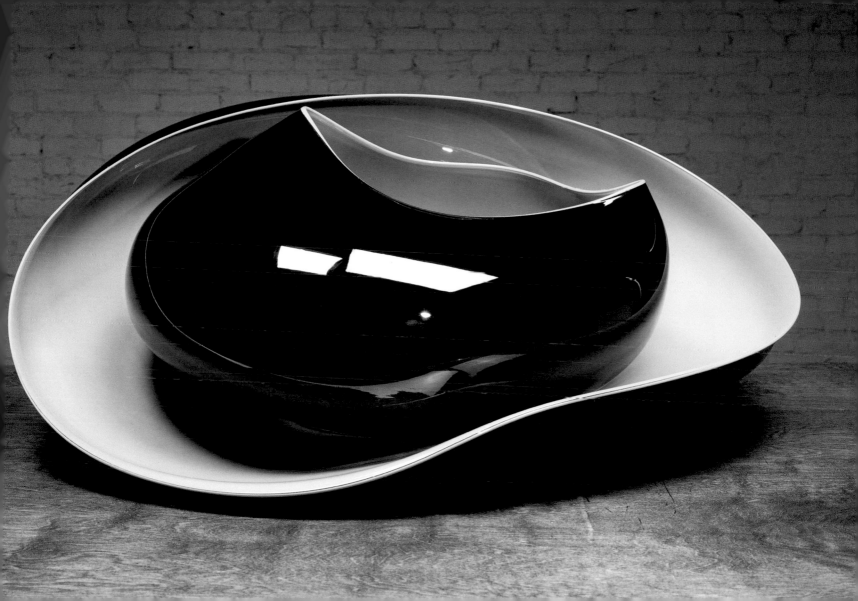

With *Baskets* or *Seaforms*, my concern was with the form and developing ways to work with fire, gravity, and centrifugal force—to stretch and blow the glass to its edge. With the *Seaforms* came the use of the ribbed optical molds, which added strength, allowing us to blow even thinner.

Black Basket Set with Maize Lip Wraps,
2006, 19 x 40 x 35 inches

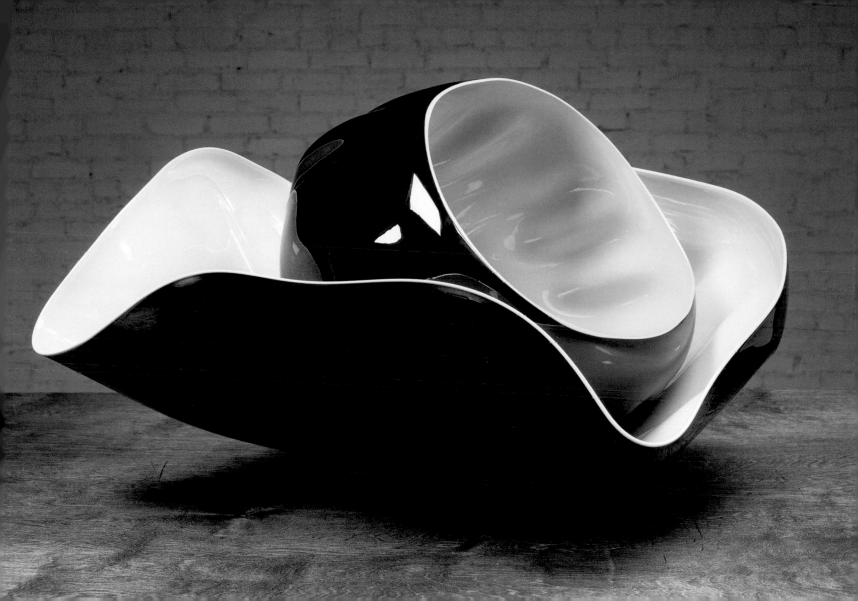

Black Yellow Soft Cylinder with Deep Blue Lip Wrap
detail, 2006, 22 x 19 x 20 inches

A lip wrap—a contrasting color used to delineate the sinuous line of the opening of the vessel—is a device that I've used in many of my series.

**Black Cobalt Soft Cylinder
with Goldenrod Lip Wrap,
2006, 21 x 18 x 19 inches**

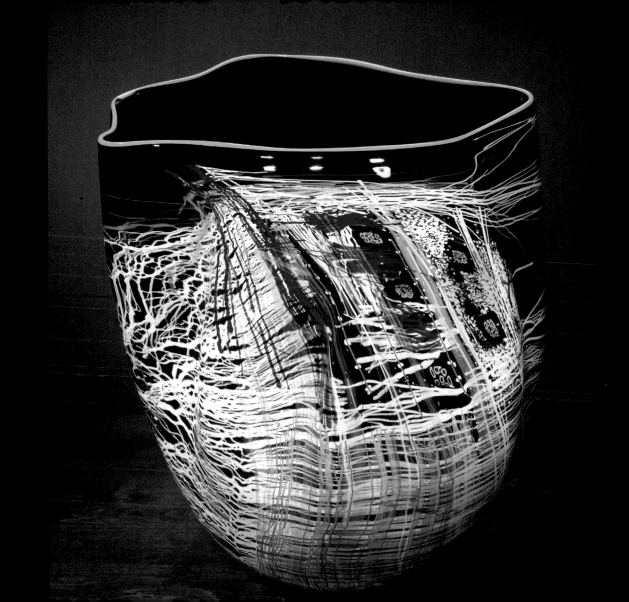

Much of the surface threading on *Baskets* and *Seaforms* came directly from what I had learned from making the *Navajo Blanket Cylinders*.

*Black Tangerine Soft Cylinder
with Chartreuse Lip Wrap,
2006, 25 x 26 x 24 inches*

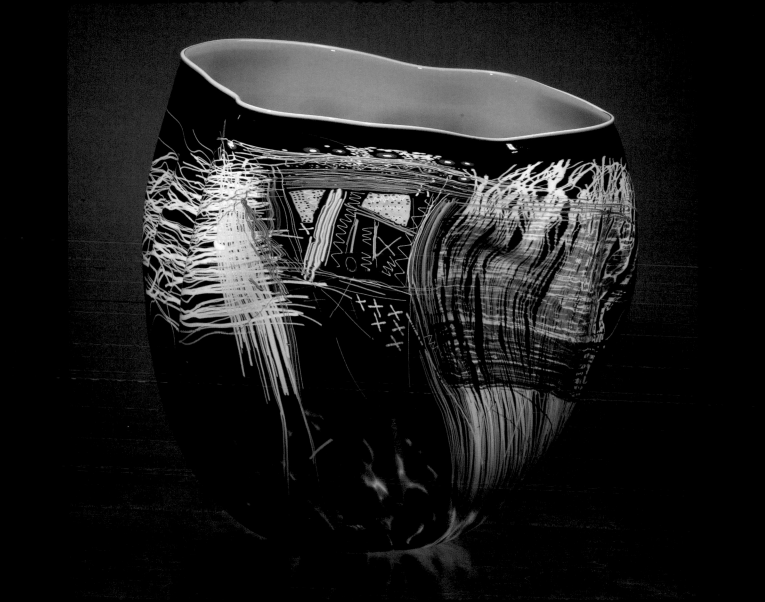

My installations are singular in scale, composition, and form. At times they sit peacefully in nature; sometimes they hang from the ceiling or spring forth from walls. In any setting, the color, form, and light unite to create something magical.

Fireworks of Glass, 2006,
10 feet 10 inches x 10 feet 10 inches x 10 feet 8 inches.
Children's Museum of Indianapolis, Indiana

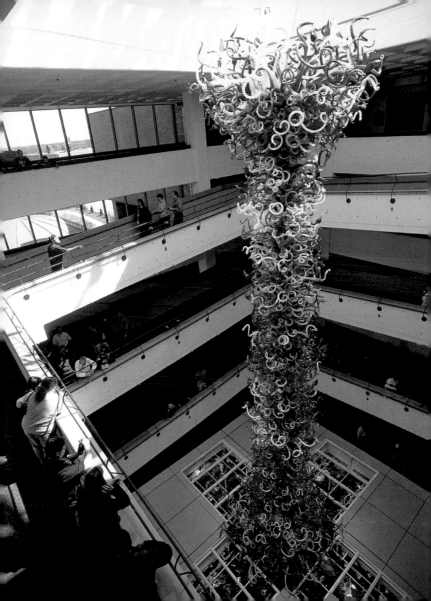

I kind of get the credit, but it's really a team effort. Like making a movie.

Fireworks of Glass ceiling, 2006.
Children's Museum of Indianapolis, Indiana

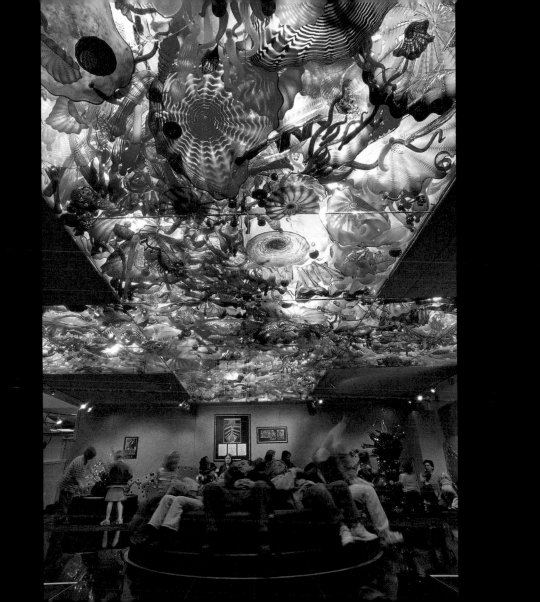

I wanted to see what it was like to have half a mile of neon and a funny tumbleweed form with 560,000 volts of energy going through it. At night it kind of lights up the whole area. It's like a green daylight out there.

286

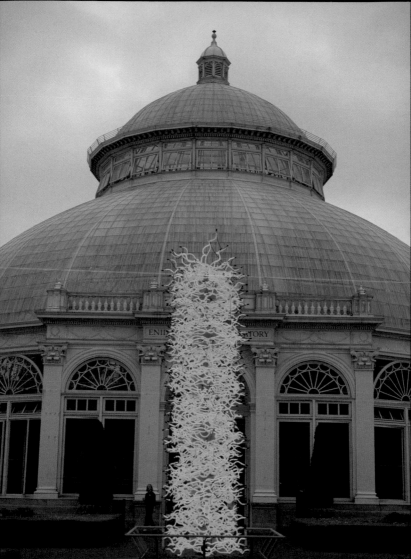

My hope is that it gets people who are interested in gardens and greenhouses to become interested in art and vice versa. Lots of people are missing out by not going to conservatories—the majority of people probably—but once they get inside one, it's another world.

The Sun, 2006,
14 feet 6 inches x 13 feet 6 inches x 13 feet 6 inches.
New York Botanical Garden, The Bronx, New York

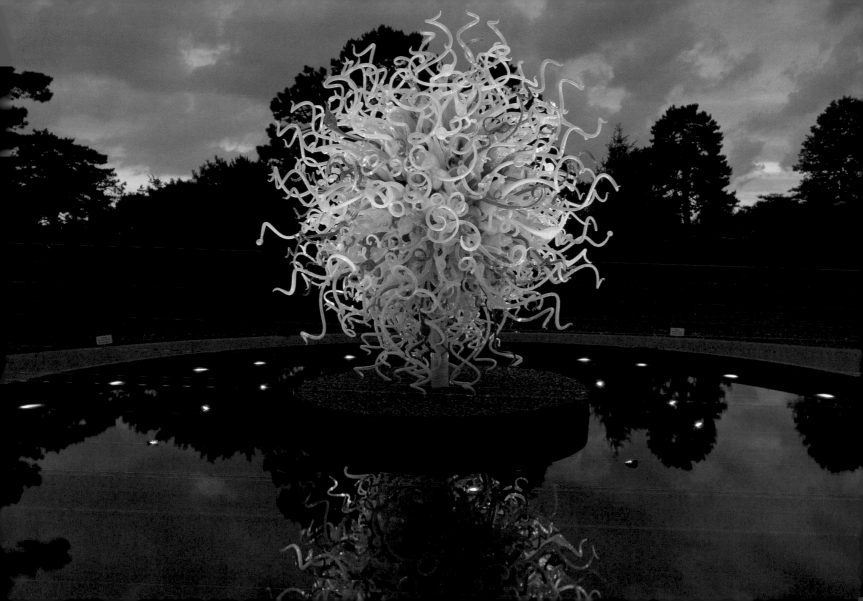

I'm fortunate that a lot of people can relate to my work—that they don't really have to have a background in art to understand it.

Red Reeds at night, 2006.
New York Botanical Garden,
The Bronx, New York

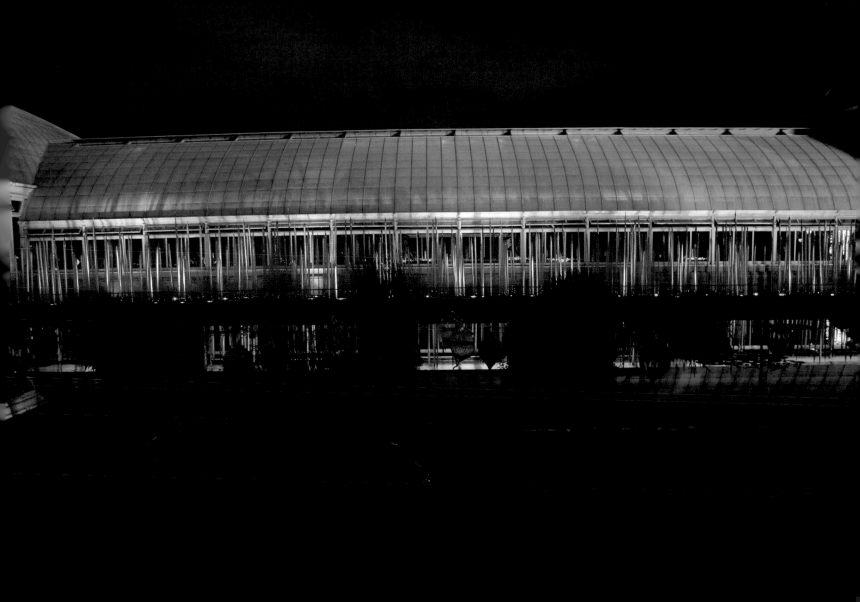

The life of an artist can be a very solitary one, but I like to be around people and to work with them. So the essence of my work is in two things: collaboration and spontaneity.

Amber Herons and *Cattails*, 2006.
New York Botanical Garden,
The Bronx, New York

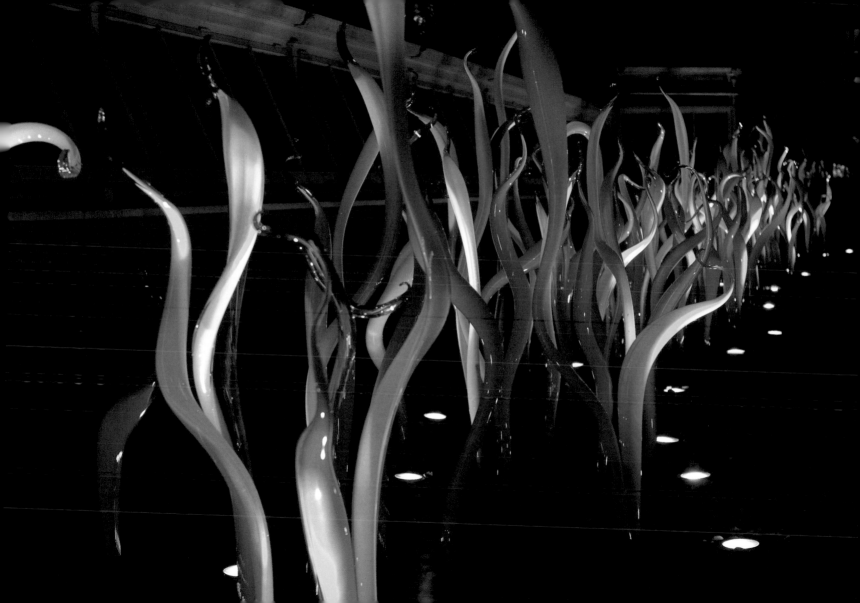

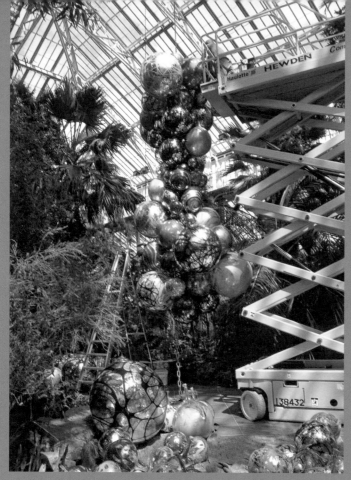

Installing the *Polyvitro Chandelier*, 2006. New York Botanical Garden, The Bronx, New York

I think the problem people have with plastic is that it has no history. Glass breaks, and that's the attraction—that at any moment it can disappear.

Polyvitro Chandelier, 2006, 16 feet 8 inches x 7 feet x 7 feet. New York Botanical Garden, The Bronx, New York

290

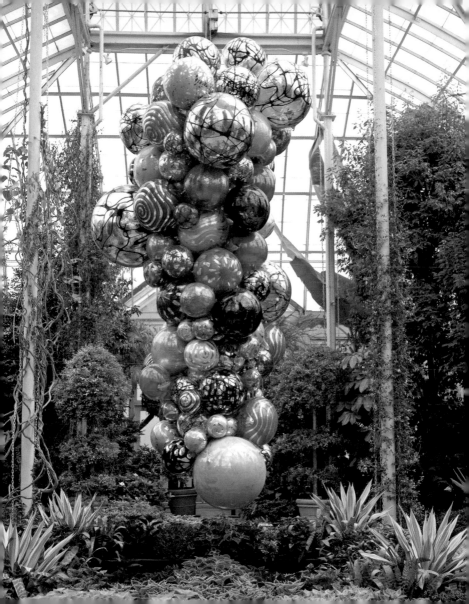

Installing *Walla Wallas* in Washington Park Aboretum, 2005

They are colored light made visible—a rapturous expression of freedom and joy. It was remarked that when people look at works by Chihuly, they always smile. They smile because of the pleasure the forms give, but I think they also smile with amazement.

Sister Wendy Beckett,
Sister Wendy's American Collection,
New York: Harper Collins Publishers, 2001

Walla Wallas, 2006.
Hardy Pool, New York Botanical Garden,
The Bronx, New York

291

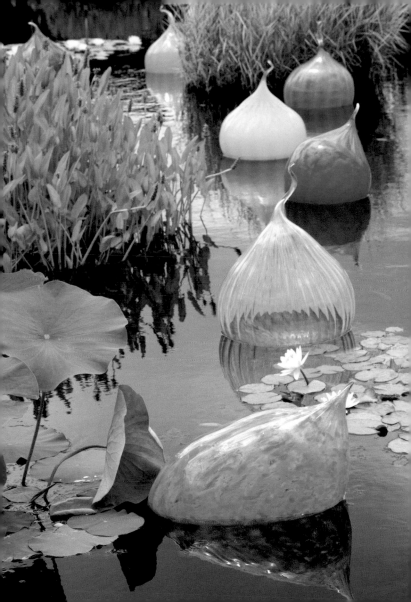

I have to say that it gives me great satisfaction that I am often able to bring members of the public into a museum, who don't normally go to museums, and that the membership increases. So a new type of person is brought in to see my work, and not only my work, whatever else is in the museum at that time.

Neodymium Reeds, *Neodymium Twisted Reeds*,
Green Grass, and *Niijima Floats*, 2006.
New York Botanical Garden,
The Bronx, New York

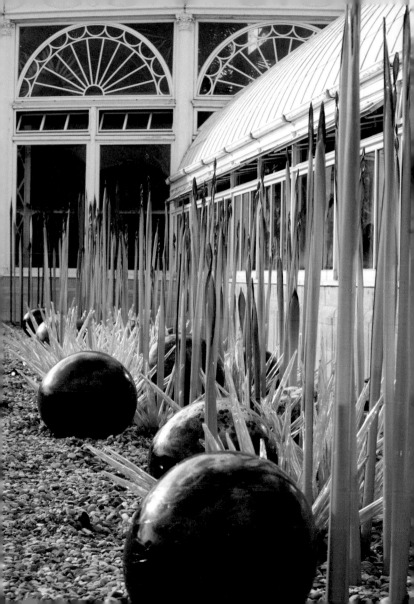

Q: Do artists need the skills of a CEO in order to be successful today?

Chihuly: The important comparison between the CEO and the artist is that both are creative. In my mind, creativity is creativity, whether you're making art or running a company. Anybody who does anything well is an artist.

Sheila J. Gibson, *Robb Report*, June 2000

Blue Herons, 2006.
New York Botanical Garden,
The Bronx, New York

293

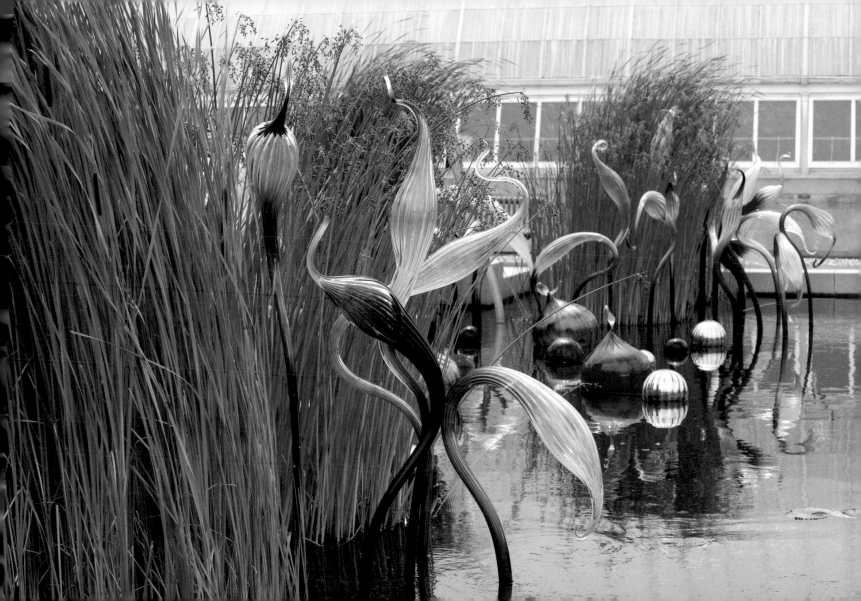

I've done installations starting back in 1966, when I went to the University of Wisconsin. Back then, the installations were more experimental, using plastics and neon and ice and glass. That was a time when all these materials were being discovered by artists.

Yellow Boat, 2006,
4 feet 9 inches x 7 feet 2 inches x 21 feet.
New York Botanical Garden,
The Bronx, New York

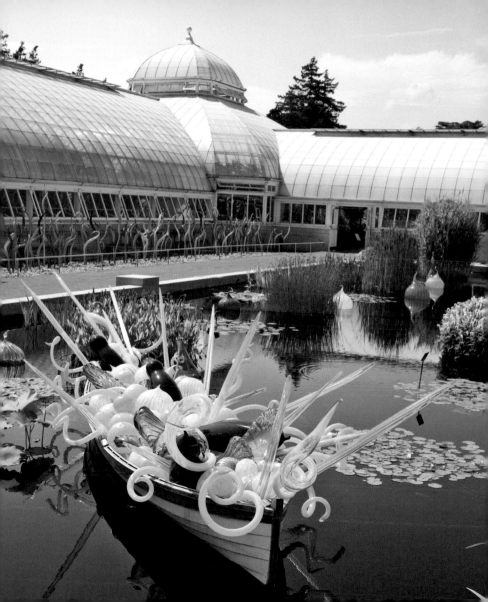

What I'm trying to do is not so much copy the glass in plastic, but see what the plastic itself can do. The elements on the pieces were done in a completely different way from glassblowing. The motif is done while it's flat, then it's folded over, heated up, and then blown. It's a quite different process.

Blue Polyvitro Crystals, 2006.
New York Botanical Garden,
The Bronx, New York

295

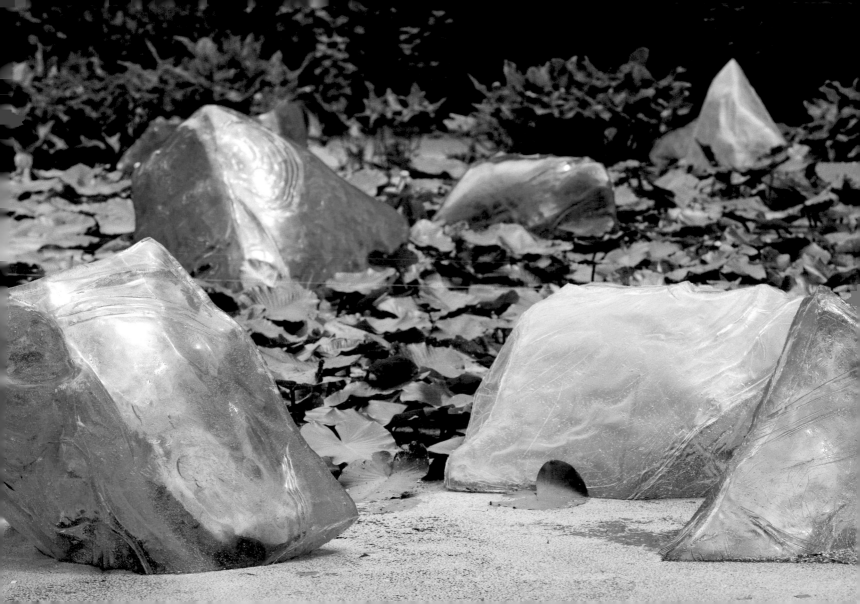

I think it's very difficult to figure out where things come from. The only explanation I'm ever able to give is in one word. That is "energy." Sometimes it's destructive. Sometimes it's beautiful, more creative, more rarified.

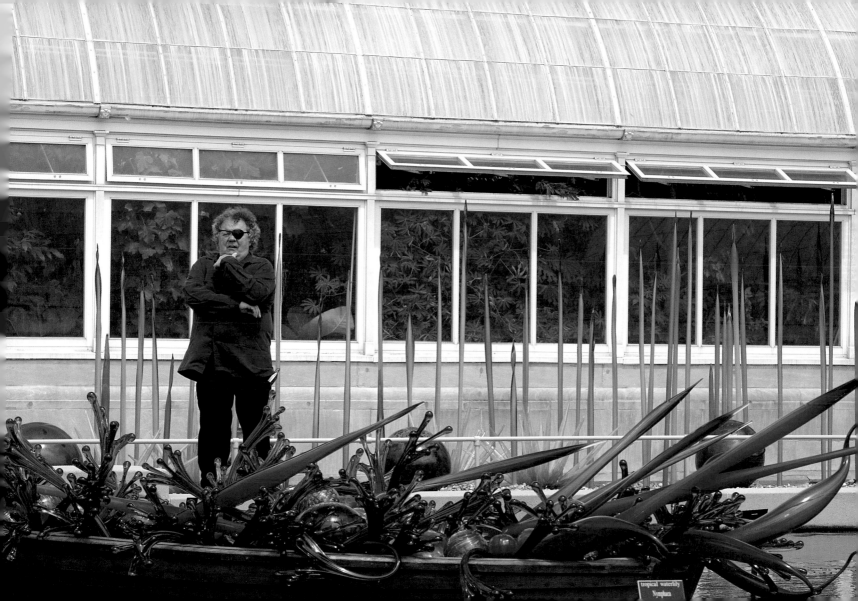

Chihuly's glass is purely about the creation of form, given the reality that glass is liquid when hot and that gravity is a fact of life.

Henry Geldzahler, *Dale Chihuly: Glass*,
Taipei Fine Arts Museum, Taiwan, 1992

Blue and Purple Boat, 2006,
4 feet x 22 feet 7 inches x 4 feet 1 inch.
New York Botanical Garden,
The Bronx, New York

297

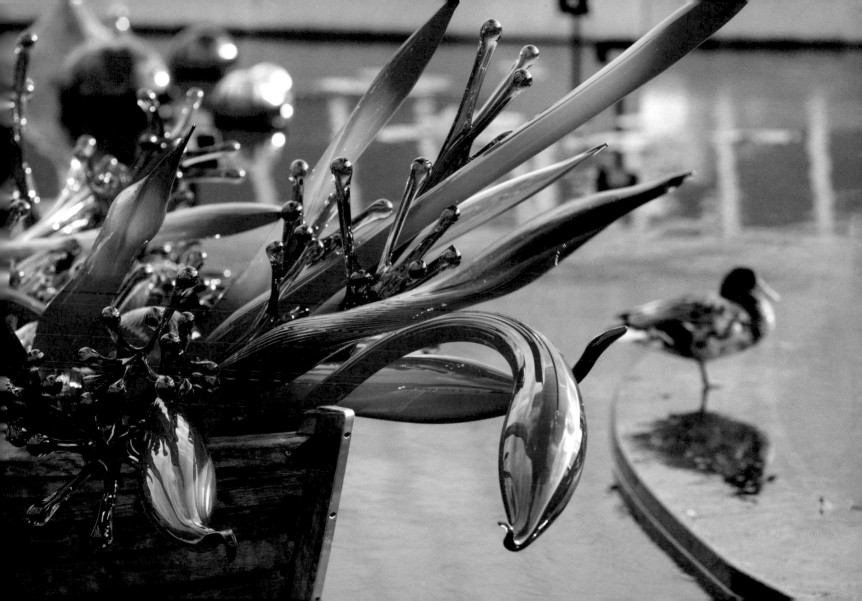

I'm a little less particular than you'd think about the placement of things. One of the reasons is that I like it to seem that things sort of happened by nature and were not put there by man. If it gets too organized, then it's too uptight for me. I get a kick out of having other people do things, because they might do them differently—and even if they're a little awkward, I like it. I strive to have it seem as if the waves from the ocean scattered the pieces and that it would happen differently every time the waves came in.

Paintbrushes, 2006.
New York Botanical Garden,
The Bronx, New York

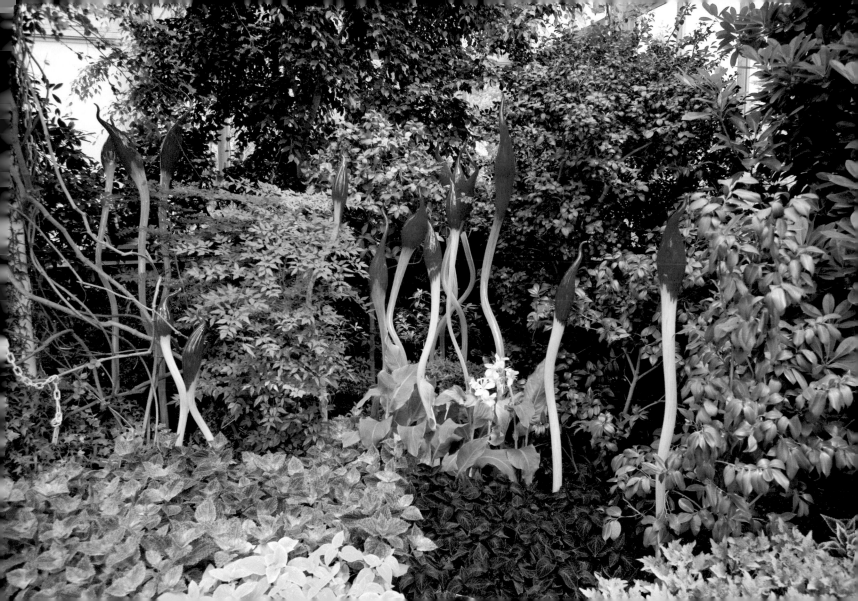

New equipment and new ways of working meant Rich Royal was able to take the *Macchia* even larger. So the *Macchia* became like big objects in themselves. And if you put a *Macchia* on the table and you walked into a room, it really held its own in the room.

Macchia Forest, 2007.
Phipps Conservatory and Botanical Gardens,
Pittsburgh, Pennsylvania

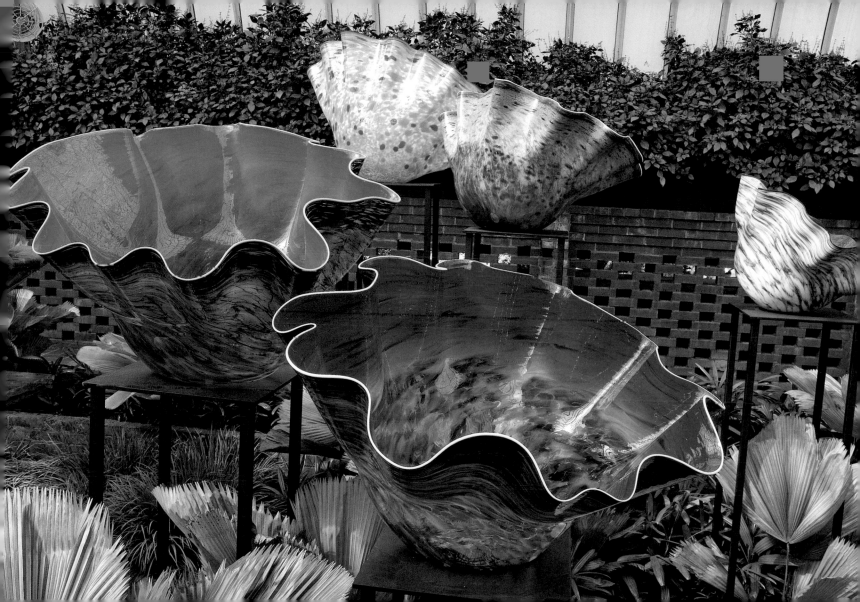

Macchia—"spotted"—was a good word. The splotches of color were the basic motif of the series, but how to enhance color was also of utmost concern.

Macchia Forest, 2006.
New York Botanical Garden,
The Bronx, New York

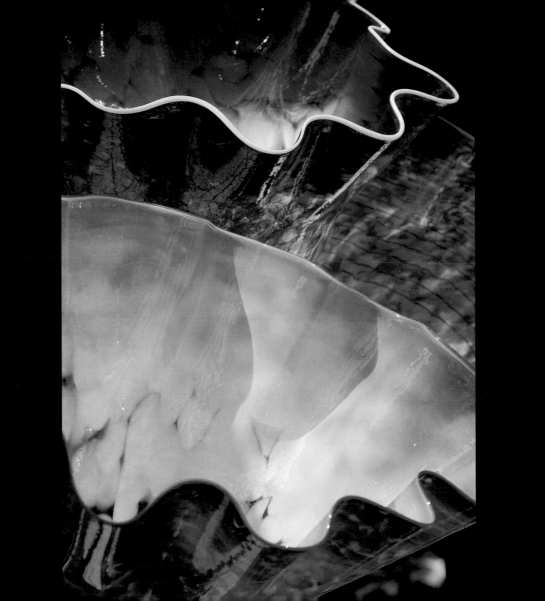

People say, "How do you do all these things? You've got a hundred people doing all these things for you. How are you possibly creative? How can you do anything anymore with all your responsibilities, obligations, going to this show and that installation, and having interviews?" It just gets down to an idea. Give me an hour or two a day when I can think and get an idea. All it takes is looking at this plastic pin and saying to myself, hey, plastic is permanent. Plastic is beautiful. Plastic is something that I want to work with. It only takes that thirty-second thought and I can put it in motion.

Polyvitro Chandelier, 2006,
16 feet 8 inches x 7 feet x 7 feet.
Bowman Garden, Medina, Washington

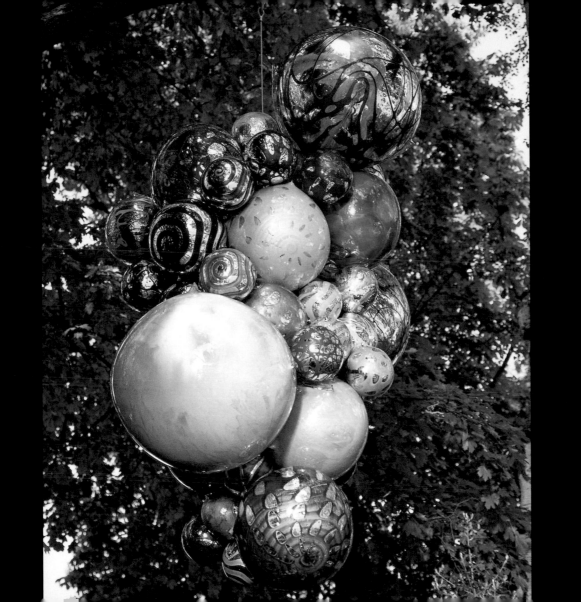

I'm a risk taker. It wouldn't interest me if the work were not a major challenge. I find it hard to understand people who want to be comfortable, who want to be normal.

Orange Tumbleweed and
Aquamarine Tumbleweed, 2006.
Bowman Gardens, Medina, Washington

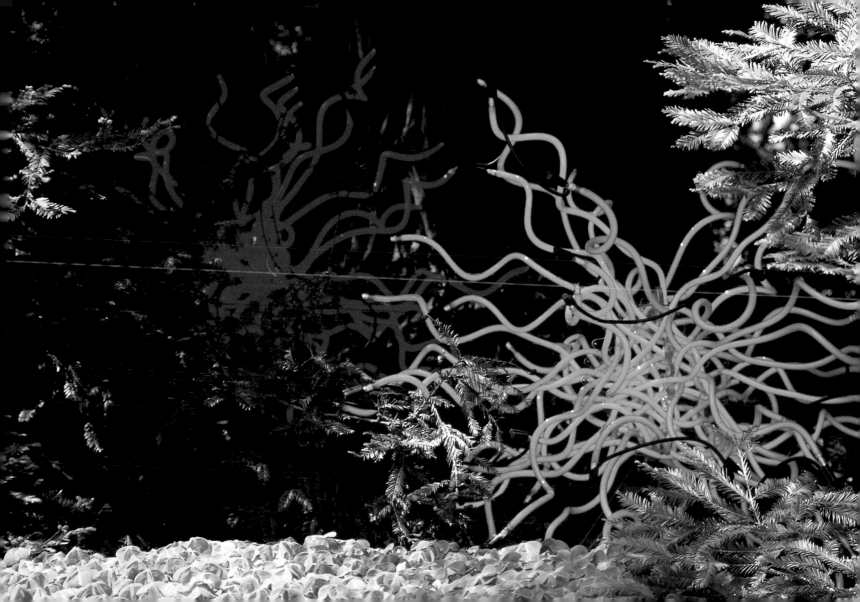

Black Soft Cylinder blow, 2006. The Boathouse, Seattle, Washington

The gaffers bring tremendous creativity to this process, bringing parts and forms, and colors and textures, to completion. Then another group of people take those forms and assemble them into more complex forms. There's a whole group of folks that bring their individual talents and creativity to make these things happen. I think an important part of his genius is his ability to motivate and draw people around him to create what is really a theatrical art form.

Chihuly, *Atlantis*, film, 1999

Black Soft Cylinders, 2007

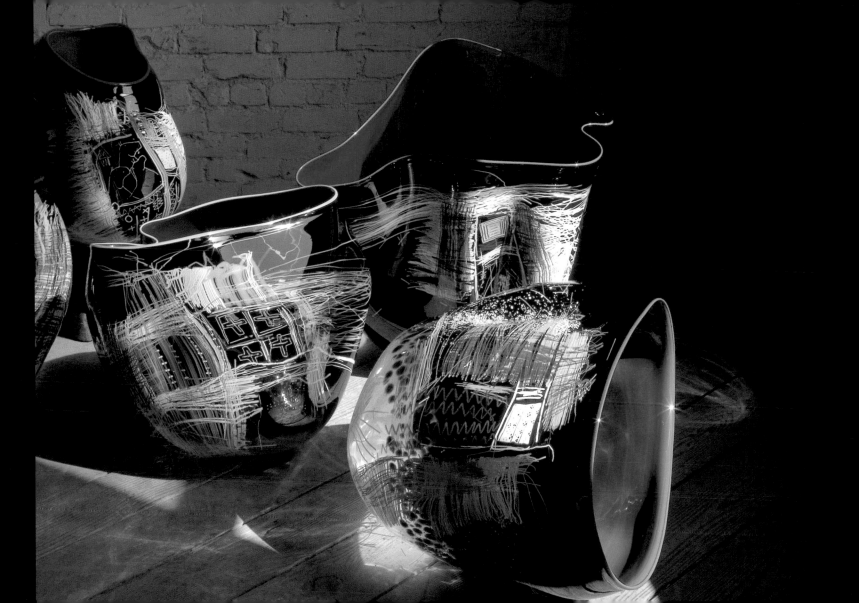

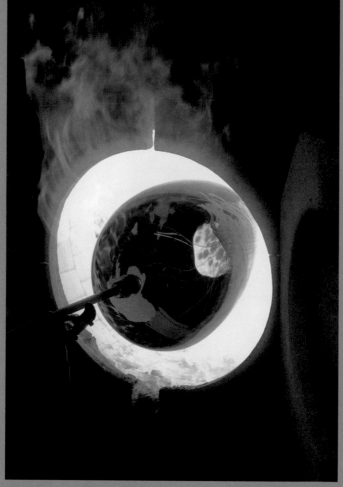

Black Soft Cylinder blow, 2006. The Boathouse, Seattle, Washington

American Art Glass Quarterly: You have an artistic idea. How do you communicate the image you want to create to the people that are working with you?

Dale: I never have really figured that out. It seems to sort itself out naturally.

Black Ruby Soft Cylinder
with Bright Sun Lip Wrap detail,
2006, 22 x 19 x 20 inches

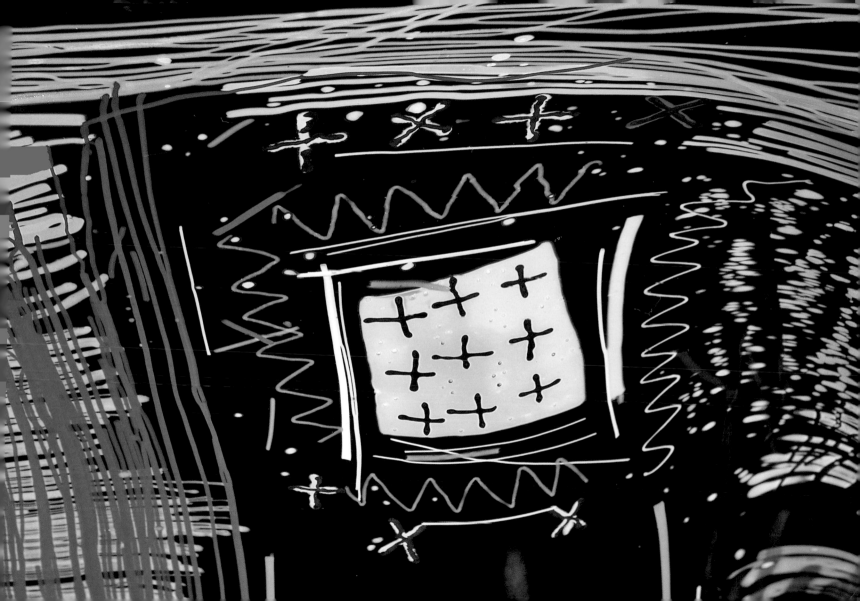

I go through different phases about collecting my own work. I do collect key things from different series and put them away. And sometimes those pieces mean a lot to me and sometimes they don't. What I've never gotten tired of are the photographs of my work. It's the 4 x 5-inch transparencies that probably, in a funny way, mean more to me than the objects themselves. I think that's because I can refer to them and look at them very easily.

Dale Chihuly: Inside, video by
Burnhill Clark and Gary Gibson, 1991

Black Scarlet Soft Cylinder with Leaf Green Lip Wrap,
2006, 21 x 18 x 17 inches

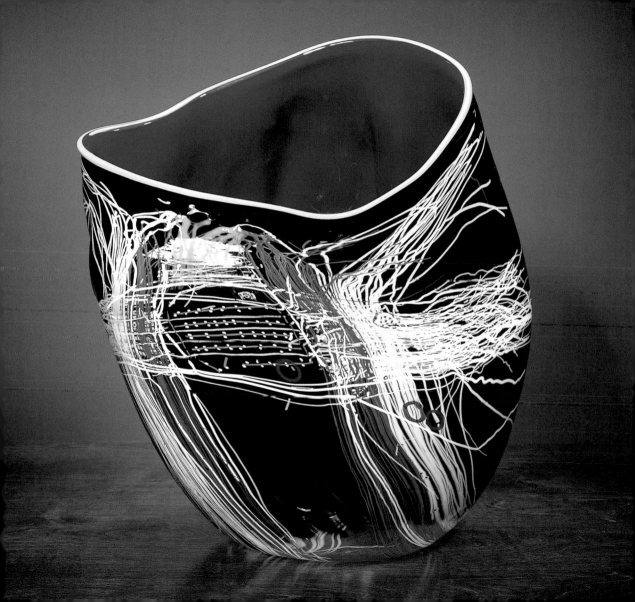

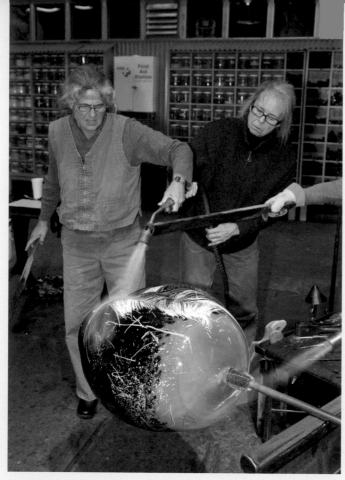

Black Soft Cylinder blow with Joey Kirkpatrick and Flora Mace, 2006. The Boathouse, Seattle, Washington

The *Seaforms, Macchia,* and *Soft Cylinders* all came directly from the style of blowing that I had developed for the *Baskets.* This blowing technique was the result of my trying to make the forms appear as natural as possible, using as few tools as I could. This meant letting glass find its own form, so that the pieces could appear very fragile and natural.

Black Lapis Soft Cylinder with Lemon Lip Wrap, **2006, 26 x 28 x 21 inches**

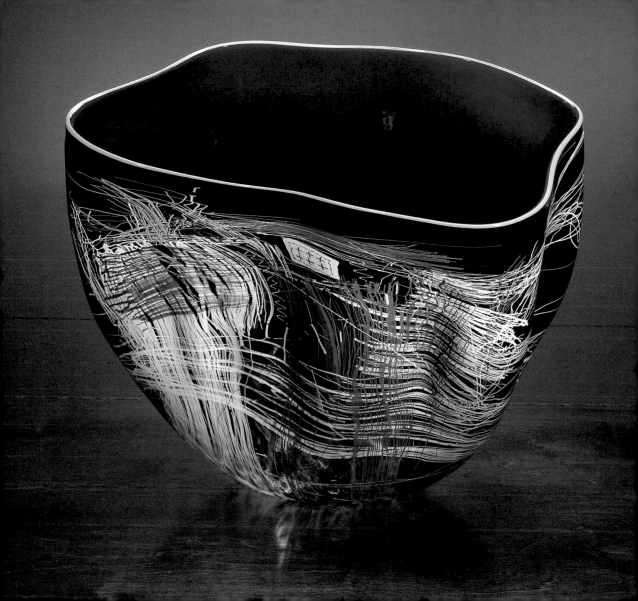

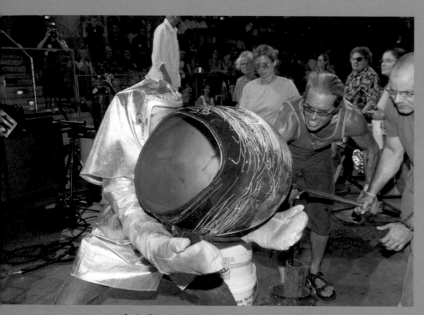

Soft Cylinder blow, 2006. Museum of Glass,
Tacoma, Washington

When liquid, glass wants to fall, to droop, to sag.
Chihuly takes all that and makes it work to his
own ends, leaving out all the incidentals that, I
think, make much contemporary glass too cute,
too twee, as the English say.

Henry Geldzahler, *Dale Chihuly: Glass*,
Taipei Fine Arts Museum, Taiwan, 1992

**Black Marine Blue Soft Cylinder
with Carmine Lip Wrap**, **2006**,
20 x 21 x 18 inches

307

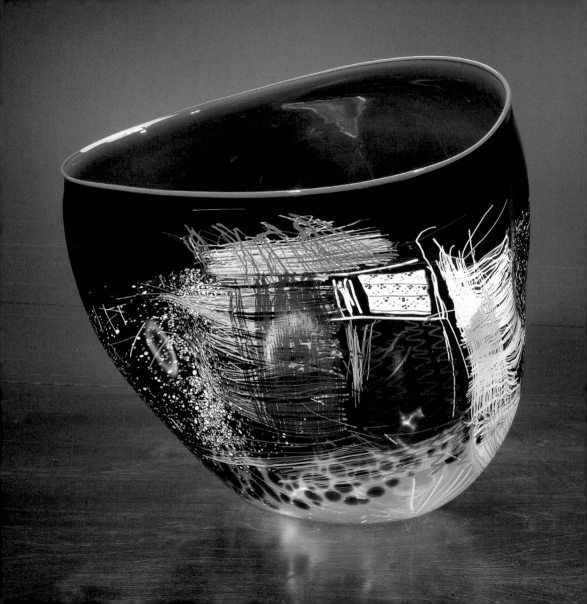

Anybody that knows me realizes that I like to work fast and that the faster it is, the more energy it takes and the better I like it. I know the work is going to turn out better if it's done quickly. If I try to rework things, they never come out as good.

Black Spectra Yellow Soft Cylinder
with Royal Blue Lip Wrap, 2006,
20 x 20 x 21 inches

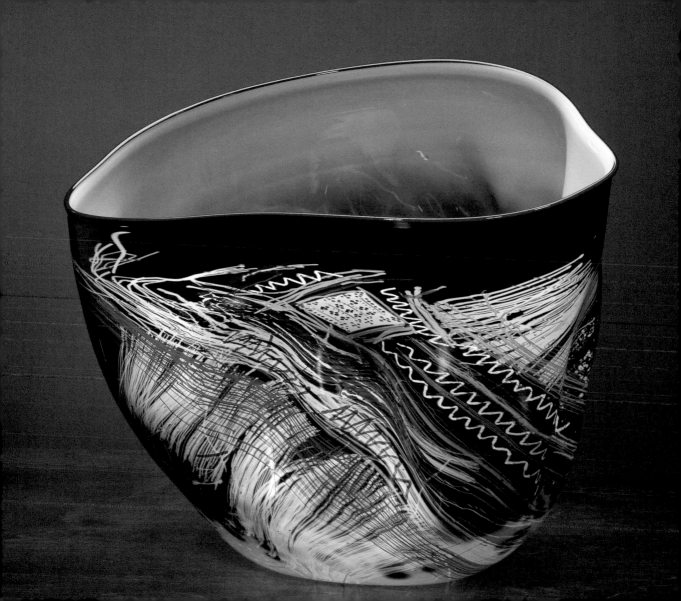

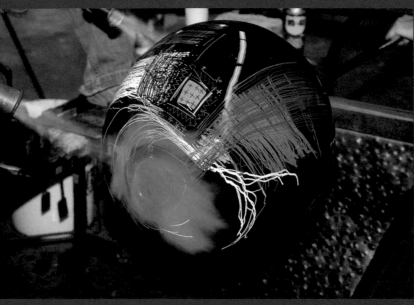

I like my work to be very fluid—it's always been that way. If pieces are geometric, they usually have really fluid additions.

Black Soft Cylinder blow, 2006. The Boathouse, Seattle, Washington

Black Citron Soft Cylinder with Royal Blue Lip Wrap,
2006, 22 x 20 x 16 inches

309

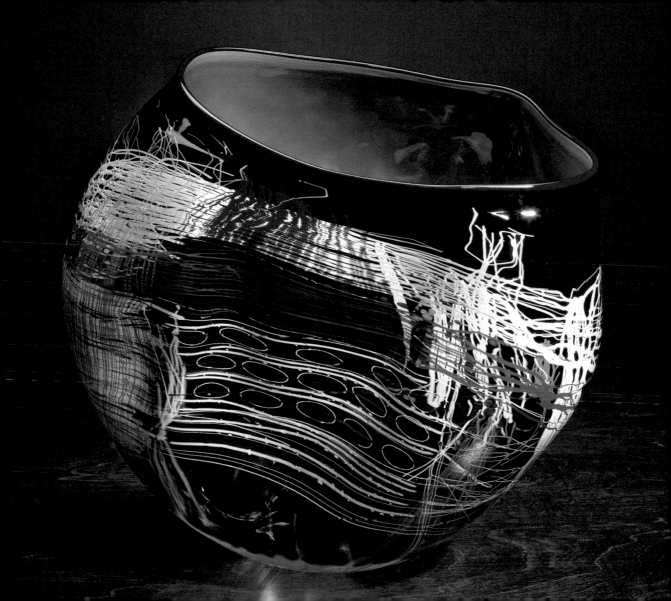

I like things to be spontaneous and I like them to be molten—maybe that's the difference between my pieces and post-modernist glass. Most post-modernist glass is very stiff.

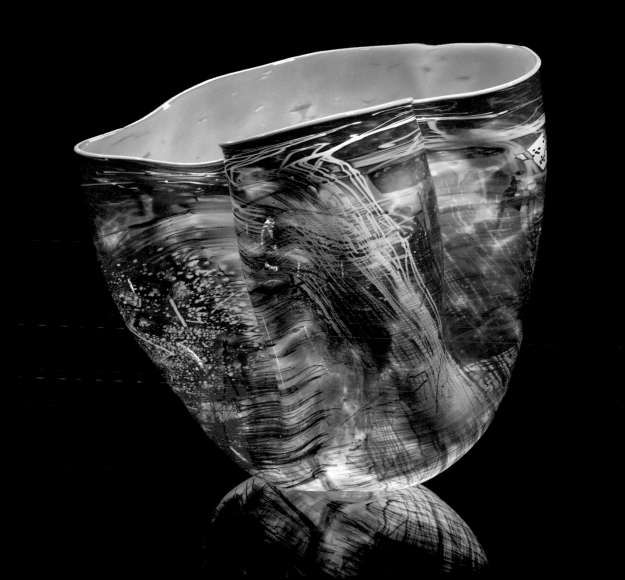

Spontaneity is probably important to almost every art form. When I work, most of the important decisions are really made in about the last fifteen to twenty seconds.

Yellow Hornet Chandelier
with Cobalt Blue Ikebana,
1993, 84 x 55 x 53 inches.
William Traver Gallery,
Tacoma, Washington

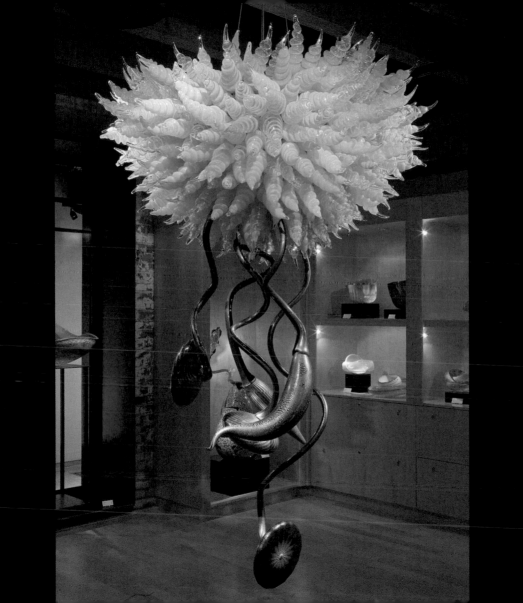

Part of the process of completing a glass object is to cool it slowly. This is done in an auxilliary part of the glass furnace, and it's very important, because if the glass cools too quickly, it will be highly strained by the time it reaches room temperature and may break either as it cools or at some later time.

Buddha Red Ikebana with Yellow and Scarlet Stems,
2001, 55 x 45 x 20 inches.
Fairchild Tropical Botanic Garden,
Coral Gables, Florida

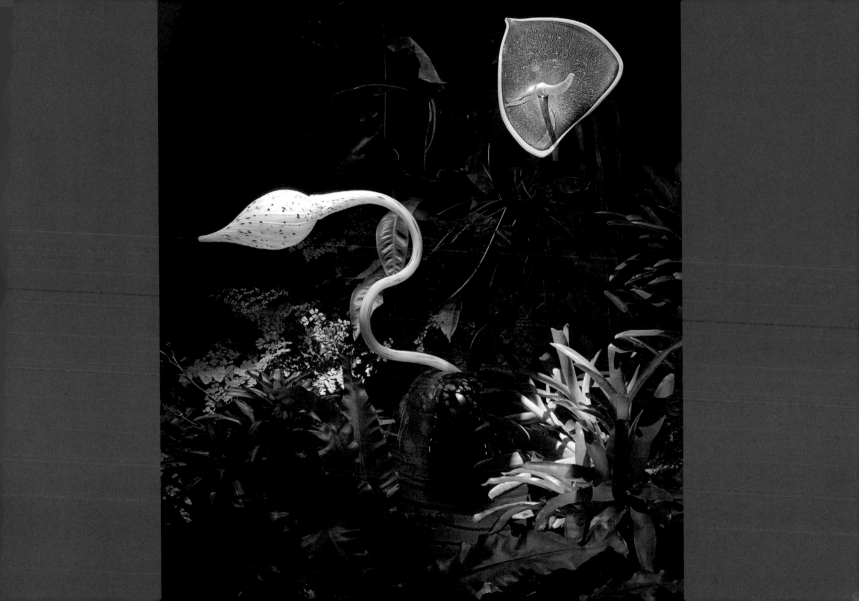

Imagine entering Chartres Cathedral and looking up at the Rose Window. You can see a one-inch square of ruby red glass from 300 feet away.

Tiger Lily and *Tumbleweed*, 2005.
Fairchild Tropical Botanic Garden,
Coral Gables, Florida

Rather than the plants washing out the art, or vice versa, the unusual pairing seems to enhance both.

Teresa Schmedding, "Palatine Natural Setting,"
Chicago Herald, March 7, 2002

Tiger Lilies, 2005.
Fairchild Tropical Botanic Garden,
Coral Gables, Florida

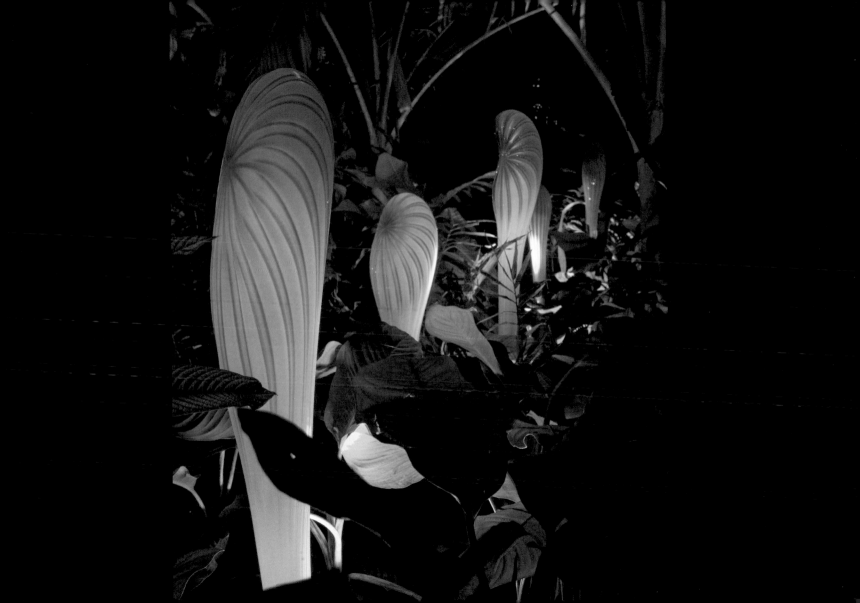

Chihuly at the Fairchild Tropical Botanic Garden,
Coral Gables, Florida

A dominant presence in the art world, Dale Chihuly and his work have long provoked considerable controversy as part of the art/craft debate. However, with projects such as his recent garden installations in Kew and New York, there can be little doubt that his lasting contribution to art of our times is an established fact.

Davira S. Taragin, Director of Exhibitions and Programs, Racine Art Museum, Wisconsin, 2002

***Glade Lake Walla Wallas*, 2005.**
Fairchild Tropical Botanic Garden,
Coral Gables, Florida

315

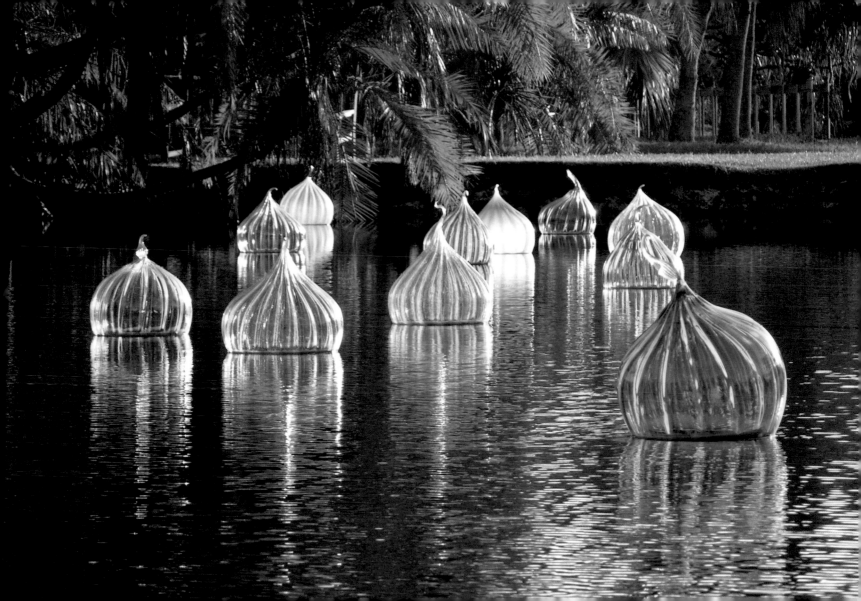

It's such a compelling craft, if you can get excited about what you're doing and pass that on to somebody else. If I can help kids get past some hurdle, there's a lot of enjoyment in that. I don't know how it affects my own work. I'm sure it does. Everything you do affects your work.

Blue Herons, 2005.
Fairchild Tropical Botanic Garden,
Coral Gables, Florida

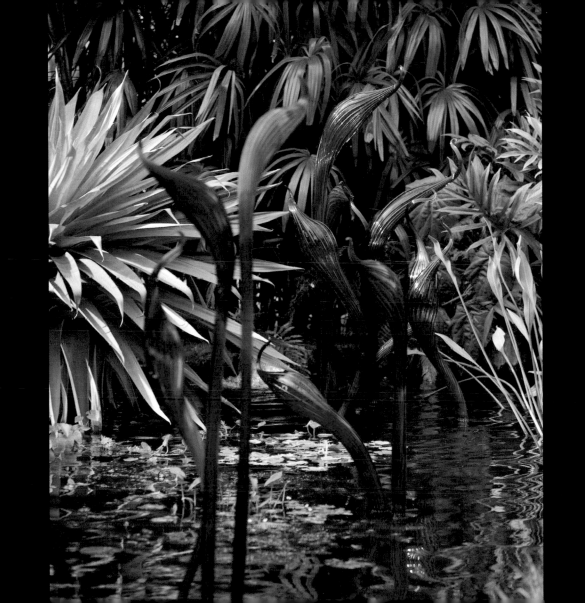

At the Rhode Island School of Design, I concocted a simple but effective teaching philosophy: Motivate students to work hard, to immerse themselves totally in the medium, and then interesting—sometimes even astonishing—results will inevitably follow.

White Tower, 2005,
90 x 72 x 72 inches.
Fairchild Tropical Botanic Garden,
Coral Gables, Florida

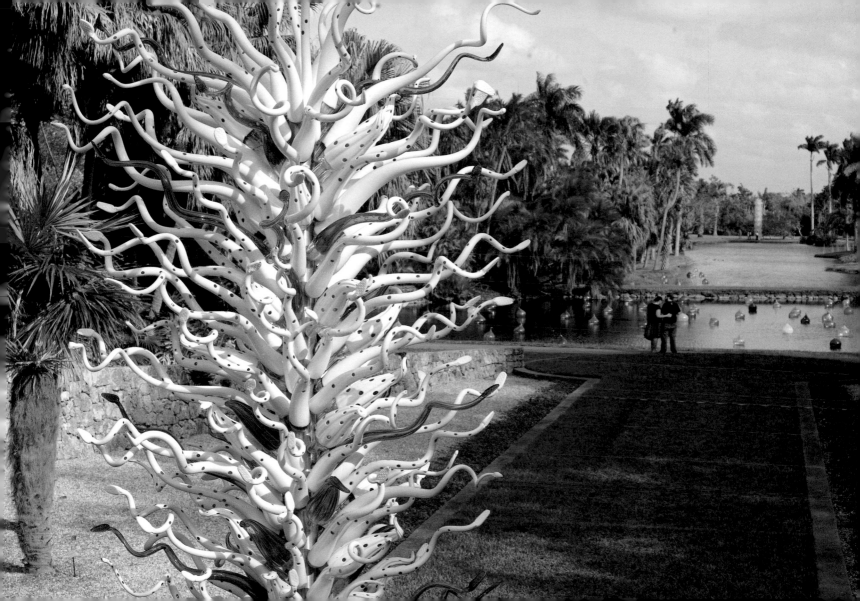

Maybe having lost my father when I was young and my only sibling, my brother, when I was young and then almost getting killed myself—these had an impact. Maybe it makes you realize how short life can be and so I probably took a lot of risks that other people might not. It's very essential for an artist to be a risk taker. I don't think you become a very good artist if you can't.

Citron Green and Red Tower detail, 2006,
14 feet 4 inches x 6 feet 9 inches x 7 feet 6 inches.
Fairchild Tropical Botanic Garden,
Coral Gables, Florida

318

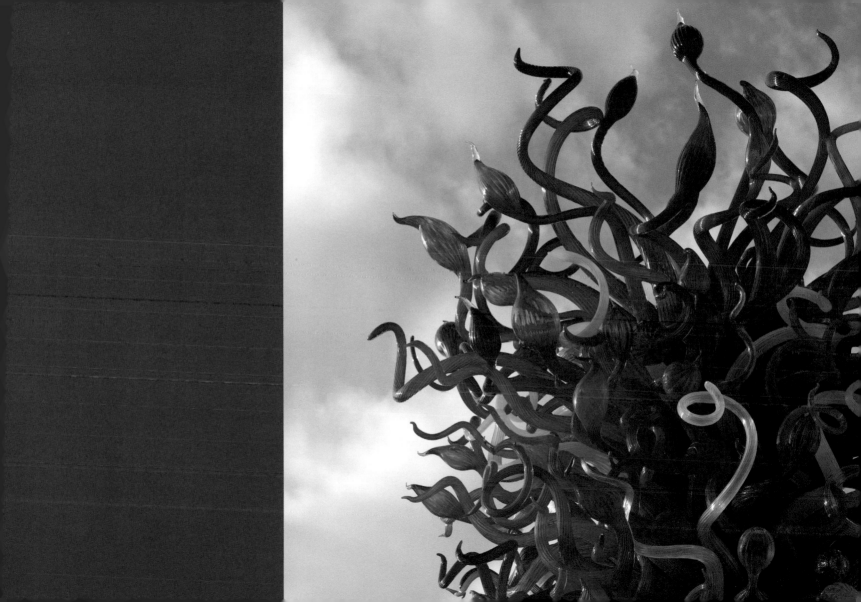

Dale has created a unique thing: abstract art accepted by people not in the art world.

Barry Rosen, quoted in Anna Rohleder
"Glass Act," *Forbes*, April 18, 2001

Saffron Neon Tower, 2006,
27 x 5 x 5 feet.
Fairchild Tropical Botanic Garden,
Coral Gables, Florida

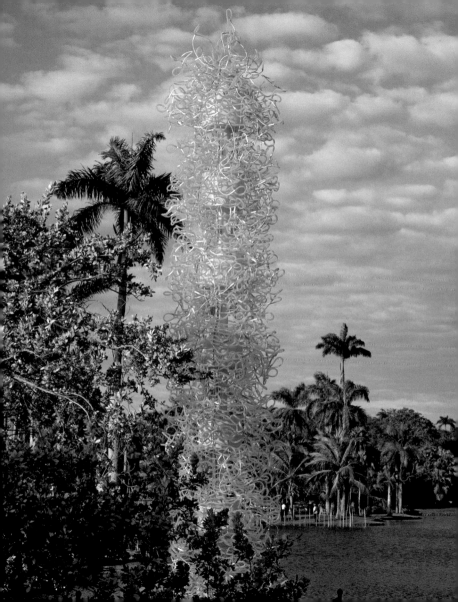

What really concerns me is the end product. It's the object itself when I'm done. Sometimes I miss the glassblowing process because I used to be the gaffer on the team. So there is a certain satisfaction you get from the physicality of making it. But I prefer standing back, in the way I do, and watching and observing. Coming in and working with them and talking to them when it's necessary. And, of course, by watching them that's where I get most of my ideas. I think better watching than I do actually working.

Dale Chihuly: Inside, video directed by
Burnhill Clark and Gary Gibson, 1991

Saffron Neon Tower **detail**

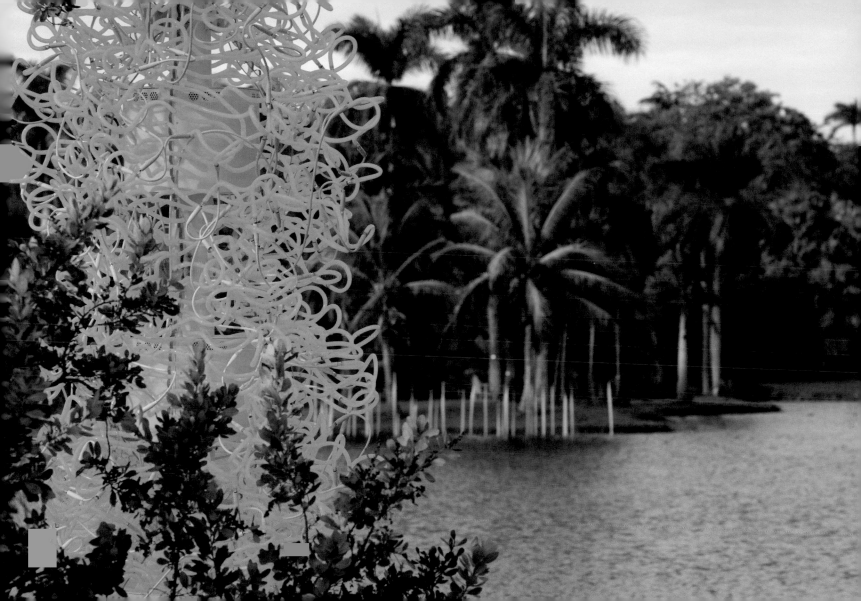

Popularity can work against you. But who's the most prolific artist of the twentieth century? Picasso. And who's the second most prolific? Warhol.

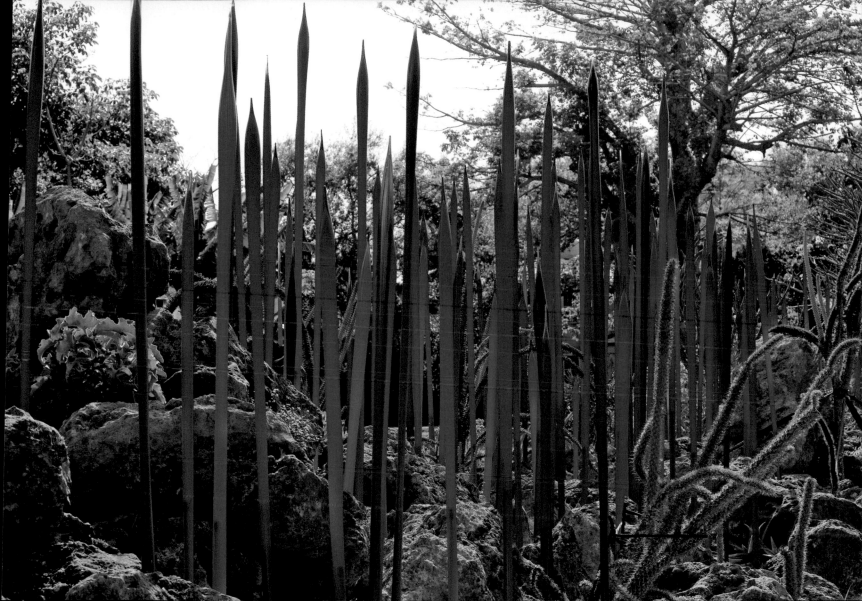

Dale has managed to weave together very, very strong traditions into something that doesn't look like anything else. But you don't have to be smart or art-historically sophisticated to understand these—they are merely beautiful.

Henry Geldzahler, *Chihuly: Installations*, KCTS/9, Chihuly Special, 1992

Succulent Garden Red Reeds, 2007.
Fairchild Tropical Botanic Garden,
Coral Gables, Florida

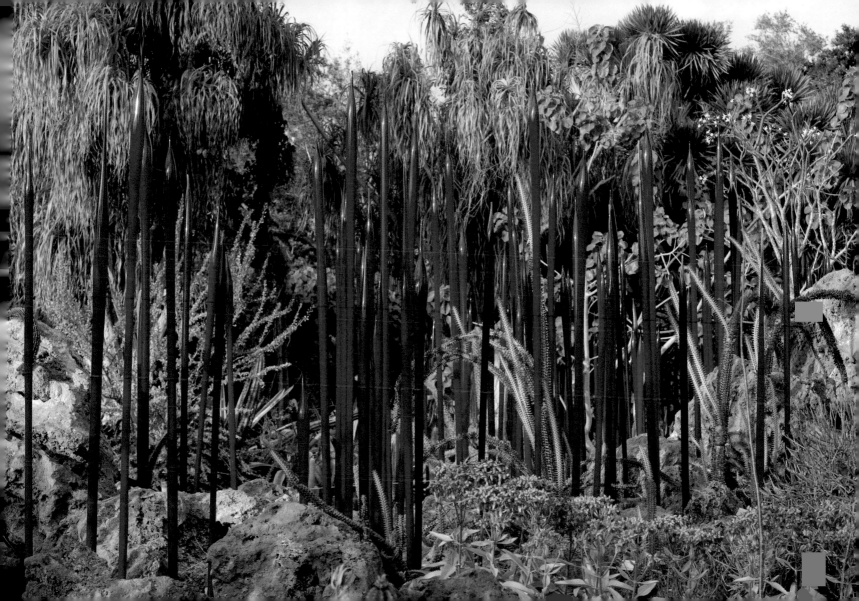

The idea of the *Niijima Floats* was not only to make them big, but to use a lot of color in different ways.

Niijima Floats, 2005.
Fairchild Tropical Botanic Garden,
Coral Gables, Florida

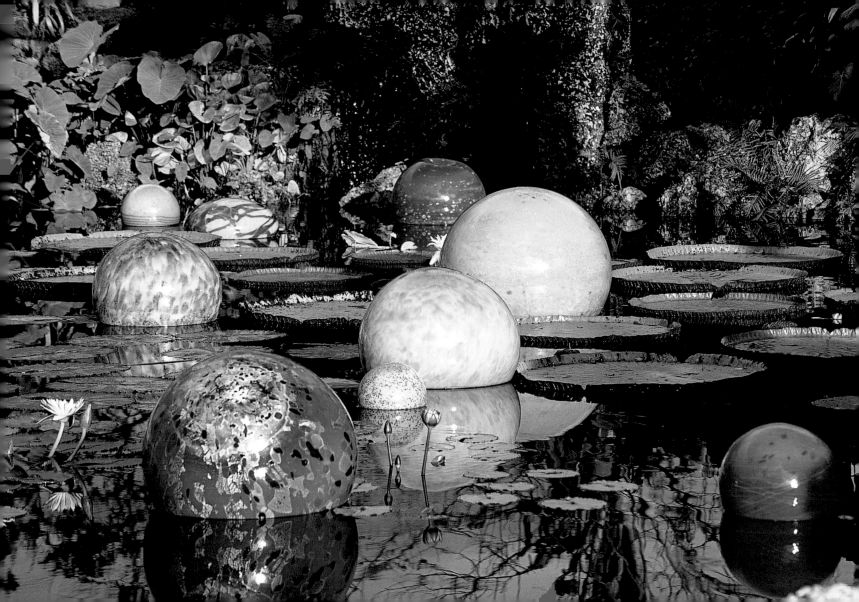

The studio glass movement as we know it started in the early 1960s. Then we started Pilchuck in 1971. People came from all over the world and pretty soon they started living in this area and moving to this area. Now the Puget Sound area has more glass shops than anywhere else in the world beside Venice.

Niijima Float, 2005.
**Fairchild Tropical Botanic Garden,
Coral Gables, Florida**

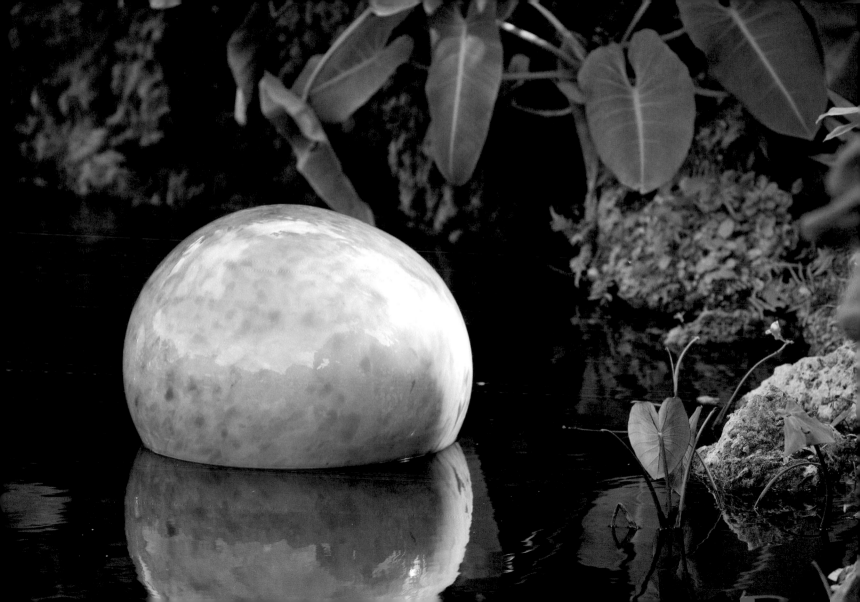

I have no favorite way of working. My students' work was pretty varied too—I don't have much influence on what my students do. If they want to make classical vases or work conceptually or whatever, I like it all.

Speckled Red-Orange Ikebana with Moss Green and Gold Stems, 2001. Garfield Conservatory, Chicago

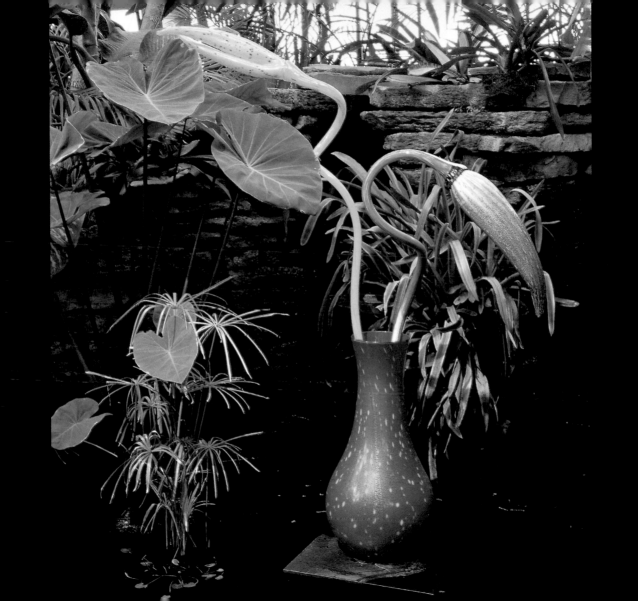

Art is similar to sports. Most people who get involved won't end up making a living at it.

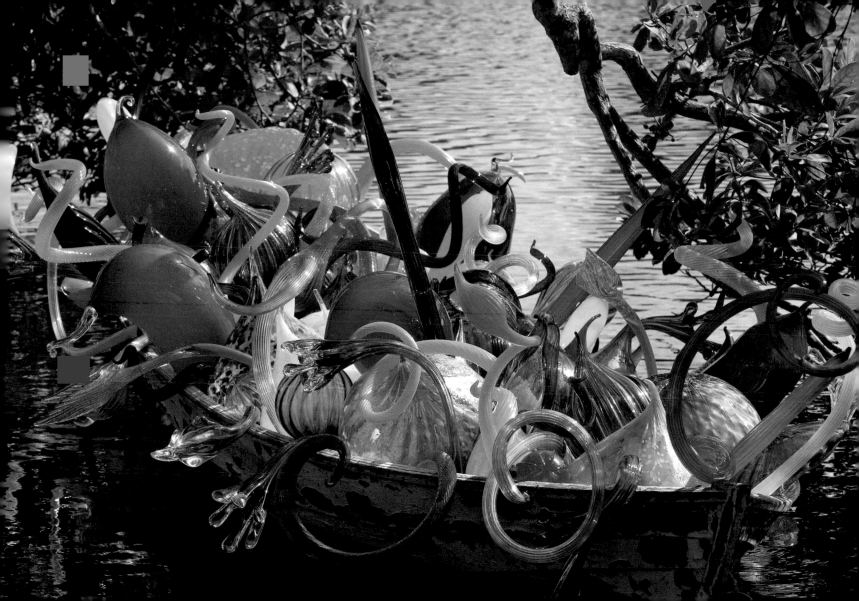

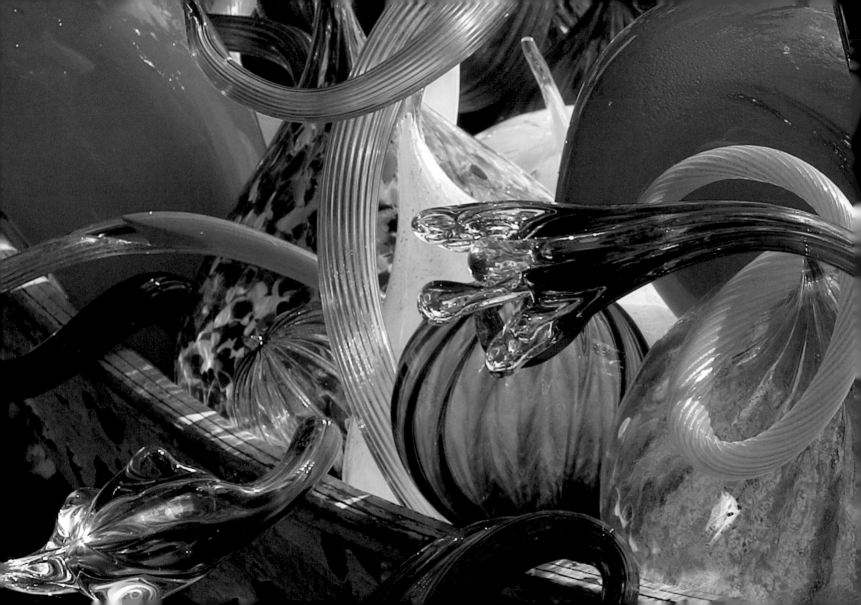

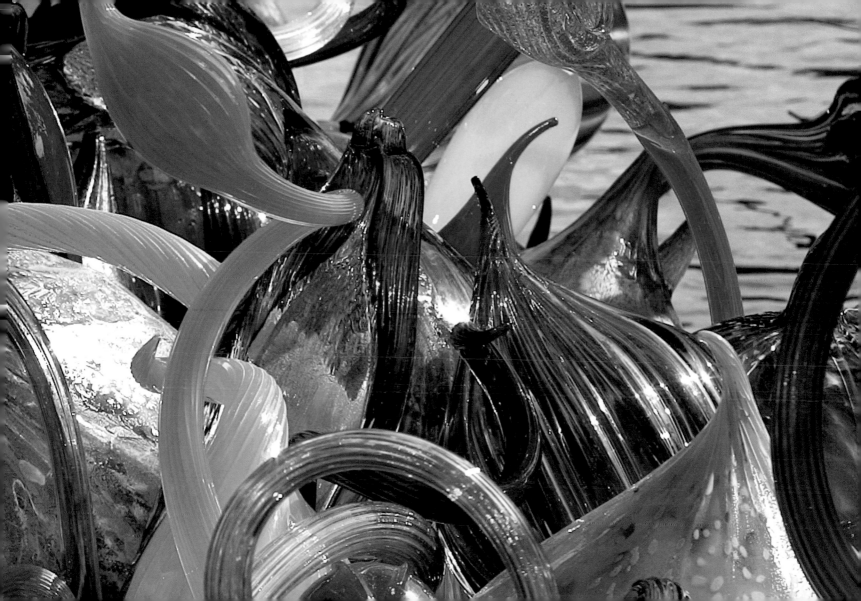

What I like about the *Blue Polyvitro Crystals*, is that you don't know what the hell they are.

Glade Lake Blue Polyvitro Crystals, 2005.
Fairchild Tropical Botanic Garden,
Coral Gables, Florida

327

I am hooked on glass. I am much more interested in glass than any other material. Although I find it a shame that glass hasn't been used with other materials more.

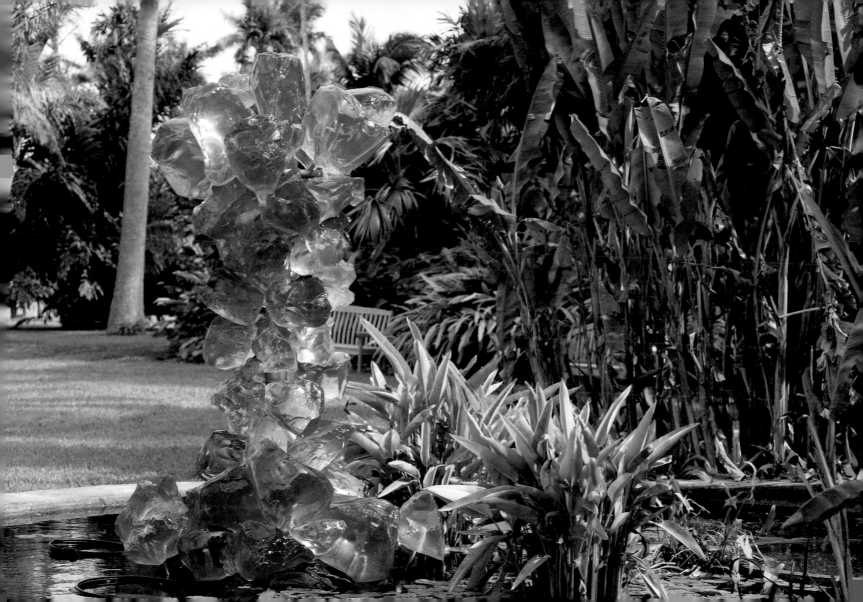

There was a spot in the exhibition that wasn't working very well, and ten days before the show opened, I decided to make a *Chandelier*.

Chartreuse Hornet Polyvitro Chandelier, 2005,
80 x 60 x 60 inches.
Fairchild Tropical Botanic Garden,
Coral Gables, Florida

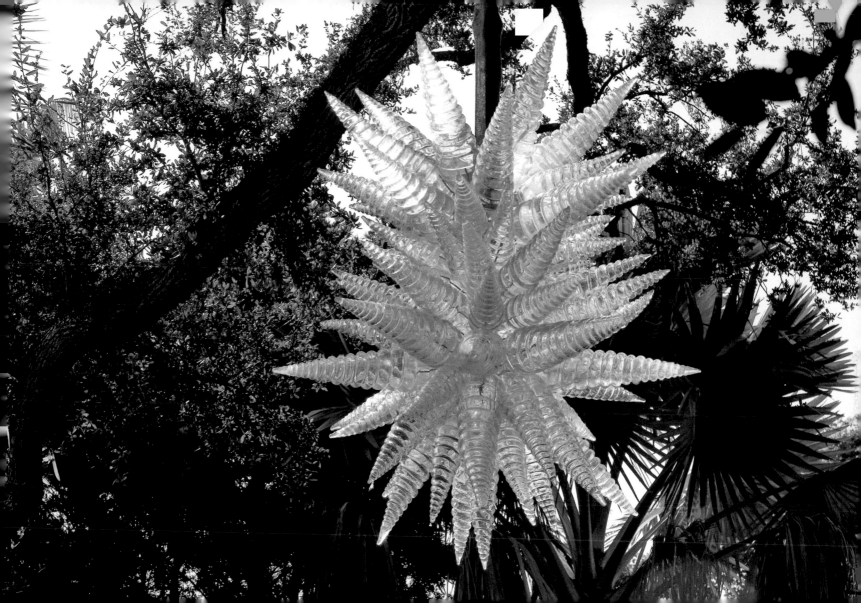

The technology really hasn't changed. We use the same tools they used 2,000 years ago. The difference is that when I started, everyone wanted to control the blowing process. I just went with it. The natural elements of fire, movement, gravity, and centrifugal force were always there, and are always with us. The difference was that I worked in this abstract way and could let the forces of nature have a bigger role in the ultimate shape.

Sunset Boat, 2006,
23 feet x 9 feet 6 inches.
Chatsworth, Bakewell,
Derbyshire, England

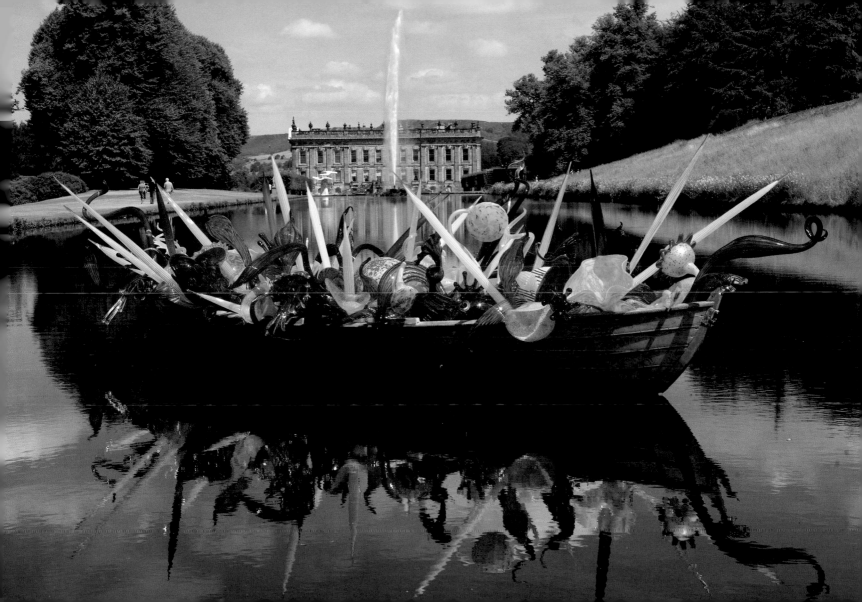

I had a great time working with Pino on the *Putti*. We started by putting them on sea creatures—dolphins, starfish, clam shells—and doing stories with them. I would love to be able to continue working on this series, because I like doing things for kids and I think I see them in many ways as being for children.

Glory hole, 2006. The Boathouse, Seattle, Washington

Black Sea Anemone and Fish on Gilt Striped Vessel, 2006, **36 x 21 x 21 inches**

331

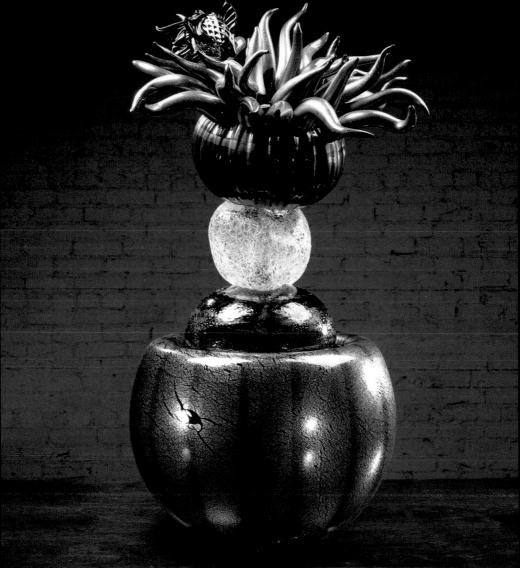

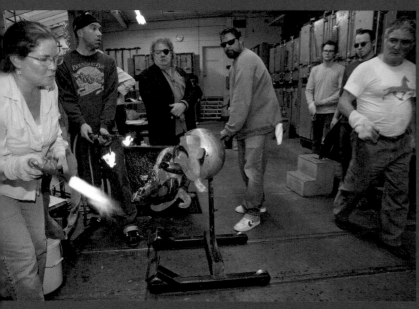

Putti Sealife blow with Pino Signoretto, 2006.
The Boathouse, Seattle, Washington

It's unbelievable how Pino works with his hands and mind with such finesse. The head, the hand, the heart, and the gut all working simultaneously. He's almost not thinking; he's just moving.

Black Pufferfish and Tubeworms
above Spotted Gold Vessel, 2007,
45 x 21 x 21 inches

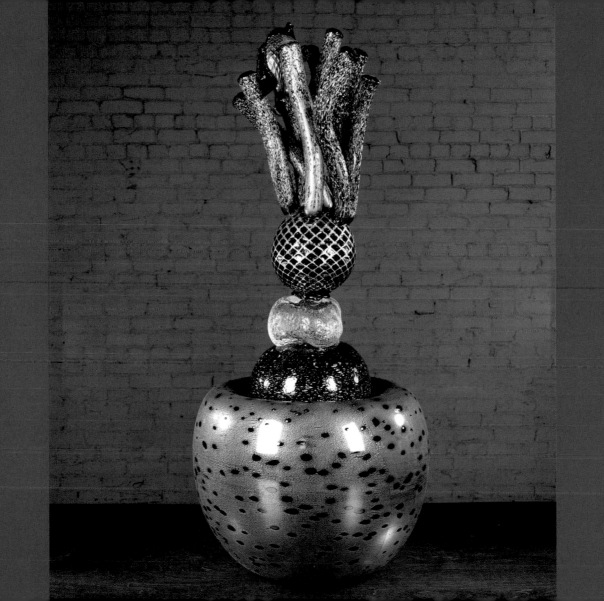

Lino Tagliapietra had been coming to Pilchuck for years. And then we invited Pino Signoretto from the same island of Murano—two of the great masters at that time—really, of all time. And I don't mean just this century, but for the thousand years of glass history in Venice.

Black Octopus Atop Gilded Vessel, 2006

333

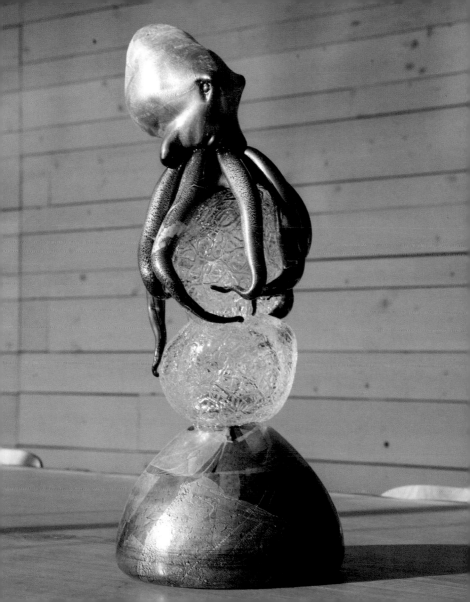

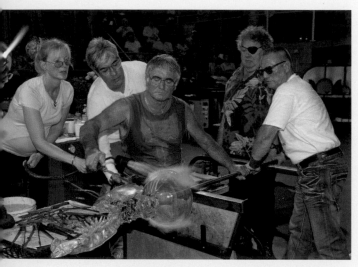

Putti Sealife blow, 2006. Museum of Glass, Seattle, Washington

There's always a certain rivalry between the greats in any medium, so you can imagine two great glassblowers from Italy, from Murano. Lino Tagliapietra specializes in glassblowing and Pino Signoretto in sculpting. I happened to be blowing Venetians with Lino, and Pino was working up at Pilchuck teaching. They asked me if I would come up and do a demonstration with Pino, and I suggested that I bring Lino along. I would make something that Pino would make a part for, a sculpted solid part, and Lino would blow another part, and we'd put them together.

Lobster and Cuttlefish Atop
Speckled Carmine Vessel detail, 2006, 36 x 17 x 17 inches.
The Boathouse, Seattle, Washington

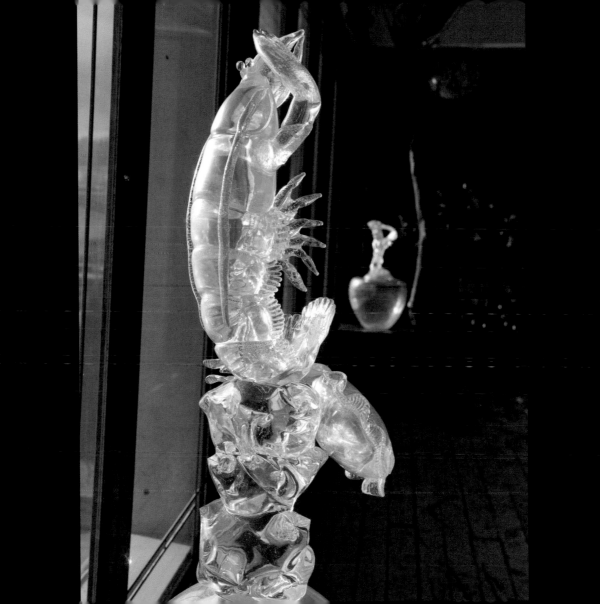

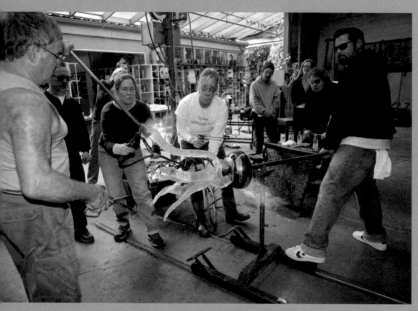

Putti Sealife blow with Pino Signoretto, 2006.
The Boathouse, Seattle, Washington

It's really the people that are the key, the gaffers, the great masters that I've worked with: Billy Morris, Rich Royal, Martin Blank. And Joey Kirkpatrick and Flora Mace, Joey DeCamp, Ben Moore, Jim Mongrain, Lino Tagliapietra, Pino Signoretto. All of these great masters that I have worked with and continue to work with have a lot to do with what the work is like.

Ivory Stingrays Swimming Atop Ultramarine Vessel detail,
2006, 38 x 16 x 16 inches.
The Boathouse, Seattle, Washington

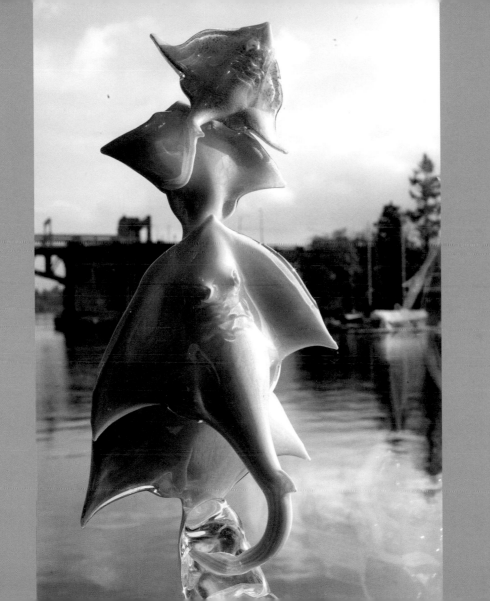

When my mother first saw the *Macchias*, she called them the "uglies."

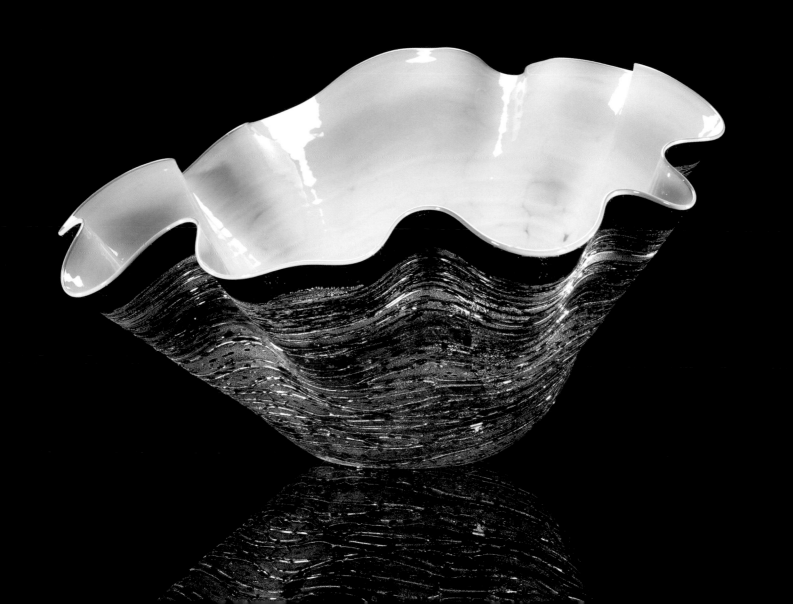

In the early years of the American glass movement, Chihuly, who received a Fulbright fellowship in 1968 to work at the distinguished Venetian firm of Venini Glass, recognized the need for American artists working in glass to gain knowledge of the historical traditions of the craft, to learn the techniques of working glass as practiced by the greatest glass masters.

Tina Oldknow, Corning Museum of Glass,
unpublished essay titled "Chihuly Over Venice:
Dale Chihuly's Shining Legacy," 1996

Jerusalem 2000 Cylinder,
2000, 17 x 18 x 13 inches

337

Since the Glass Magician set foot in the Holy Land, people have been obsessed with color and beauty rather than hatred and war. Now that's an achievement.

Noa Asher, Israeli singer, quoted in Peggy Anderson, "A Melting Wall in Jerusalem," The Associated Press, September 1999

LEFT:
Jerusalem 2000 Cylinder #50, 1999, 23 x 15 x 15 inches

RIGHT:
Jerusalem 2000 Cylinder #107, 1999, 26 x 22 x 13 inches

338

A lot of young people are extremely bright and creative. So they bring a completely different point of view.

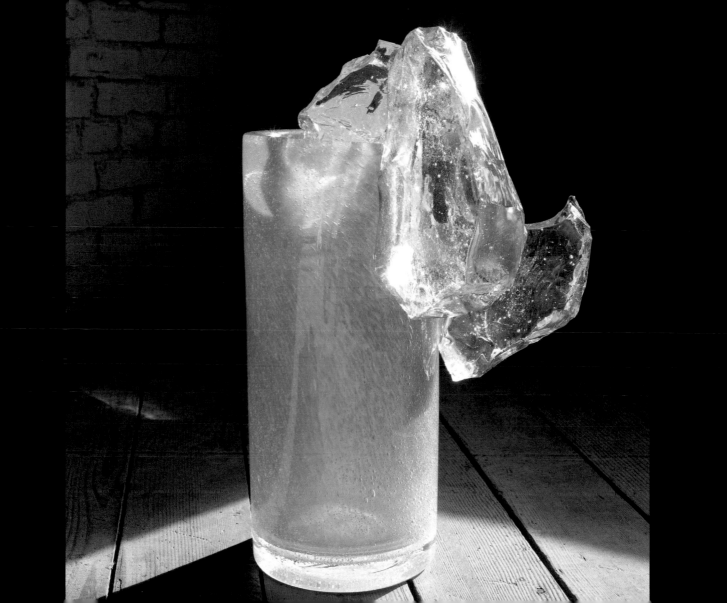

We were only at the Vianne Glass Company, near Bordeaux, for about a week. With the great crew that we brought along plus a great crew that was there to work with us, you wake up and you know that you're going to do good work. Because of that, no matter how I felt—up or down or otherwise—each day was going to have results.

Lincoln Square End of the Day Chandelier, 2006.
25 feet 8 inches x 10 feet 1 inch x 10 feet 1 inch.
Bellevue, Washington

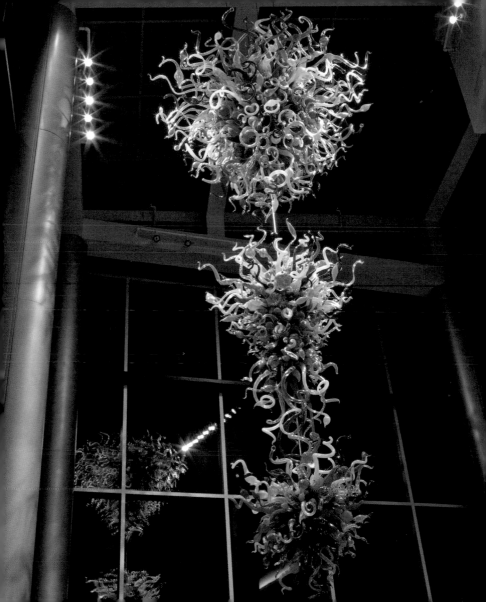

I don't really think about the survival of my work. I'm so prolific it can't help but survive me in some fashion. We're so used to things breaking; when you make glass, things break. When you're on the edge of blowing glass, you're going to lose pieces. We get used to losing things. So maybe that makes the attitude different about how we look at the work.

Lincoln Square End of the Day Chandelier detail

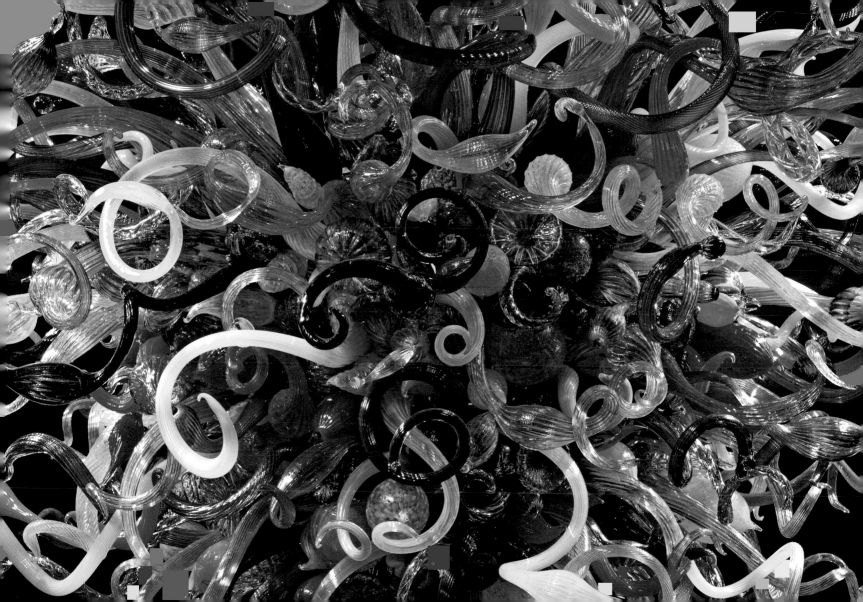

The delightful thing about much new art of quality is its mischievous ability to break the rules. Chihuly successfully resists being trapped in many of the pigeonholes that make for neat categories, but leach art of its complexity. First, he confidently bestrides the distinction between craft and art. And second, he has never felt the need to choose between abstraction and representation—between the natural and the invented which has proven the great bugaboo in art all these years.

Henry Geldzahler,
Chihuly: Color, Glass, Form, 1986, foreword

Lincoln Square End of the Day Tower **detail**

342

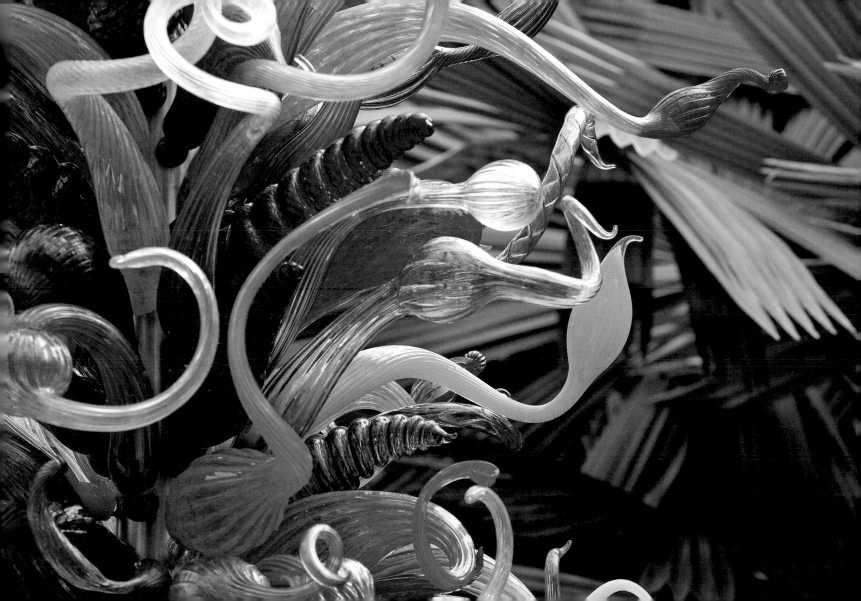

If you don't have the ability to believe in people—to trust their abilities and have the patience to teach them—you're never going to build a great team.

Fiori detail, 2007.
Point Defiance Park,
Tacoma, Washington

343

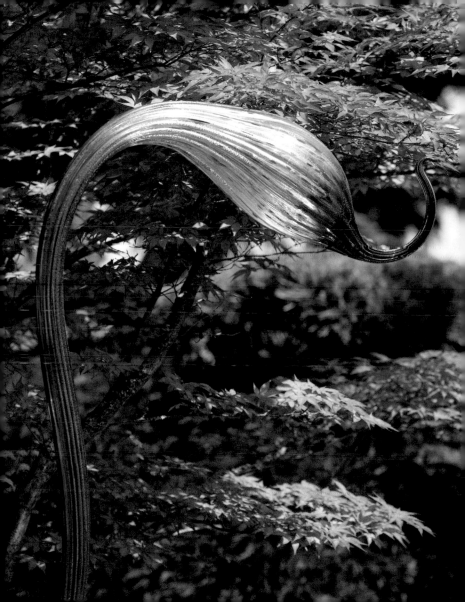

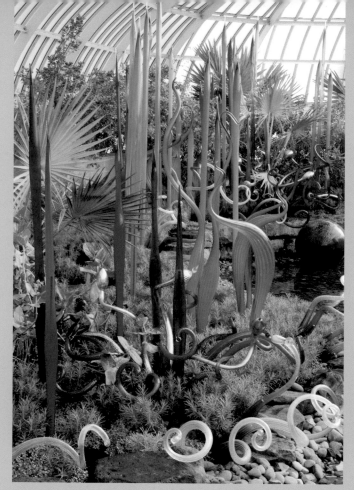

Cobalt Fiori, 2007. Phipps Conservatory and Botanical Gardens, Pittsburgh, Pennsylvania

Funniest thing, the material that's been used about the least with glass is clay. I've never understood why there hasn't been more of a relationship here. There's a weird thing about clay and glass—they're almost too close or something. I would find it difficult to be working in the two at the same time. I'm always amazed when people can do that.

Blue Marlins, **Cobalt Fiori**, and **Cobalt Reeds**, 2007. **Phipps Conservatory and Botanical Gardens, Pittsburgh, Pennsylvania**

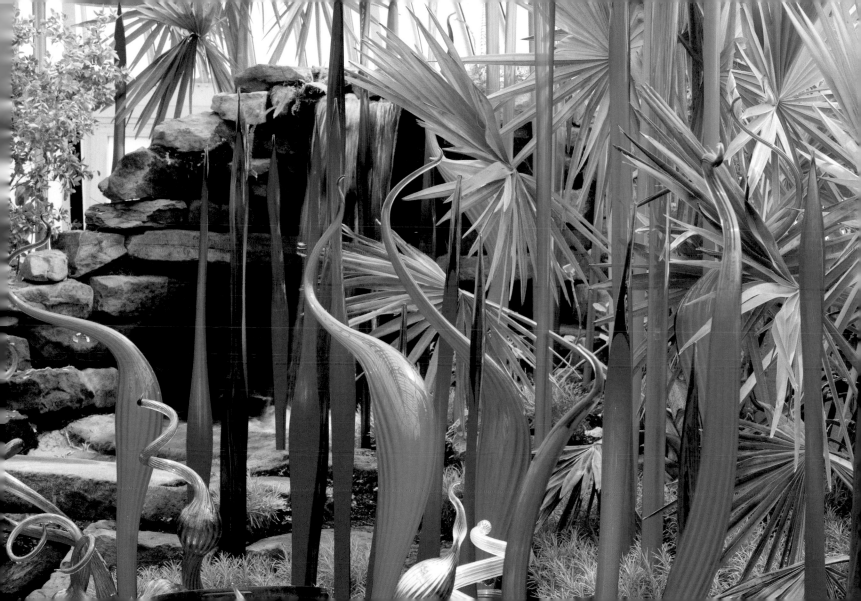

I want my work to appear like it came from nature, so that if someone found it on a beach or in the forest, they might think it belonged there.

Blue Reeds, 2007.
Phipps Conservatory and Botanical Gardens,
Pittsburgh, Pennsylvania

345

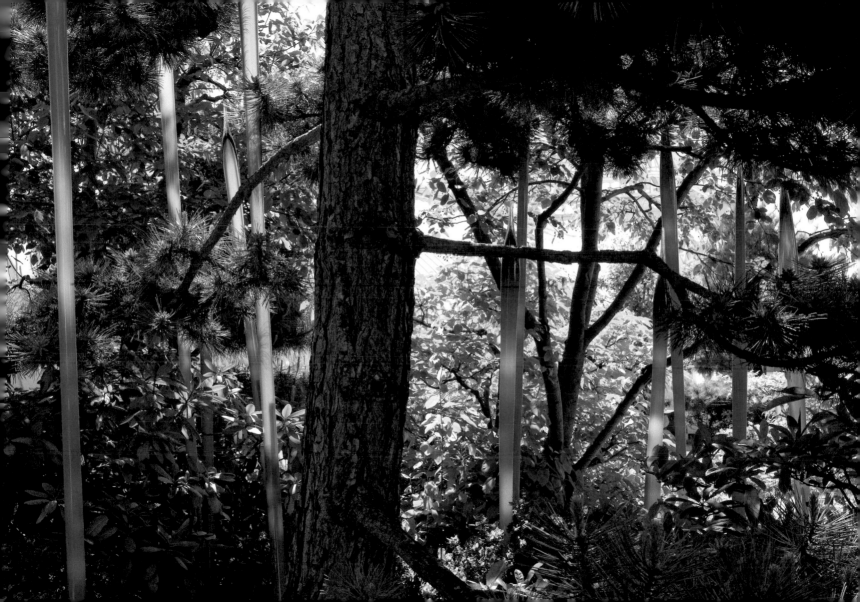

There's nothing like a chandelier. I've always loved chandeliers. It really hit me when I was eating in a restaurant in Lisbon, a tall space in a fancy restaurant in some rehabbed space, kind of like a loft. They hadn't done much to the space except for putting two gorgeous chandeliers in it. These two chandeliers turned the club from a warehouse into a palace. Sitting there eating I said, "My God, what a concept for space . . . something that's hanging up there. It's glass. It's light."

Goldenrod, Teal, and Citron Chandelier, 2007
12 feet 6 inches x 7 feet x 6 feet 8 inches.
Phipps Conservatory and Botanical Gardens,
Pittsburgh, Pennsylvania

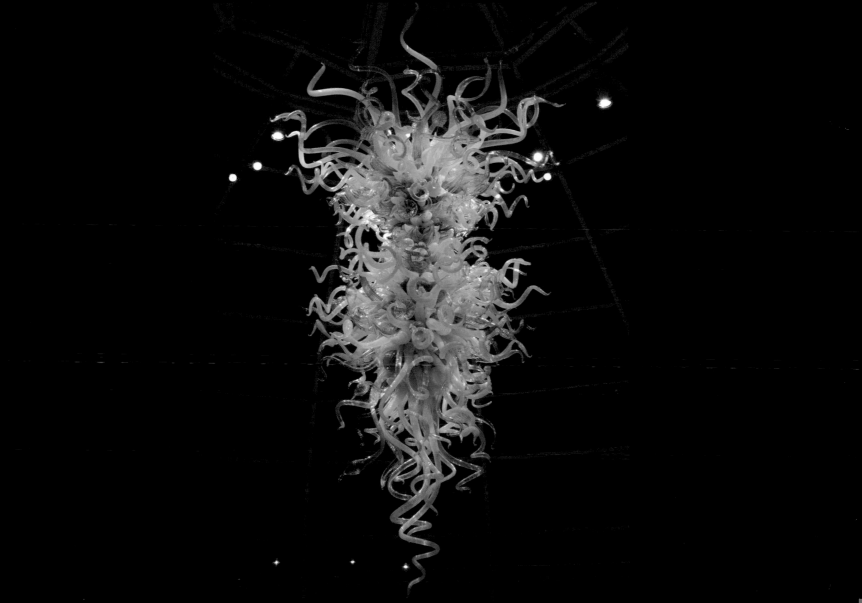

Fiori blow, 2006. Museum of Glass, Tacoma, Washington

347

Light plays a big part in so many things, but I don't think there's any material that really speaks to light, or addresses and accepts it more than glass—with the exception of some gems. If you've got a great ruby or emerald or diamond, of course, it is light itself, but we artists don't work much with those precious stones. Something that small in scale is not to my liking. I like to work bigger.

Amber Cattails, 2007.
**Phipps Conservatory and Botanical Gardens,
Pittsburgh, Pennsylvania**

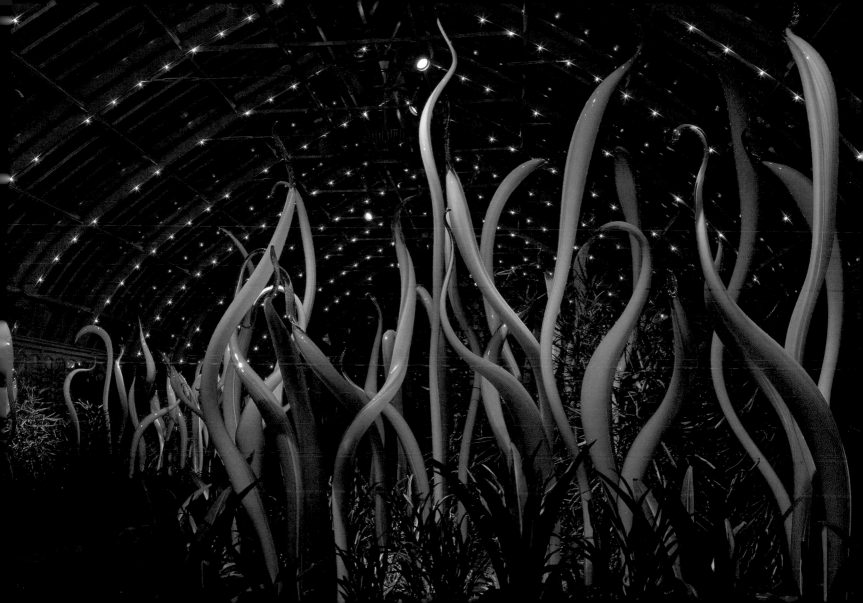

I never got totally absorbed into the blowing process, even though my work comes from the process and it often develops out of the process. This miraculous process of glassblowing. My real love was never the glassblowing, but the object itself.

Fiori Sun, 2007, 61 x 83 x 93 inches.
Phipps Conservatory and Botanical Gardens,
Pittsburgh, Pennsylvania

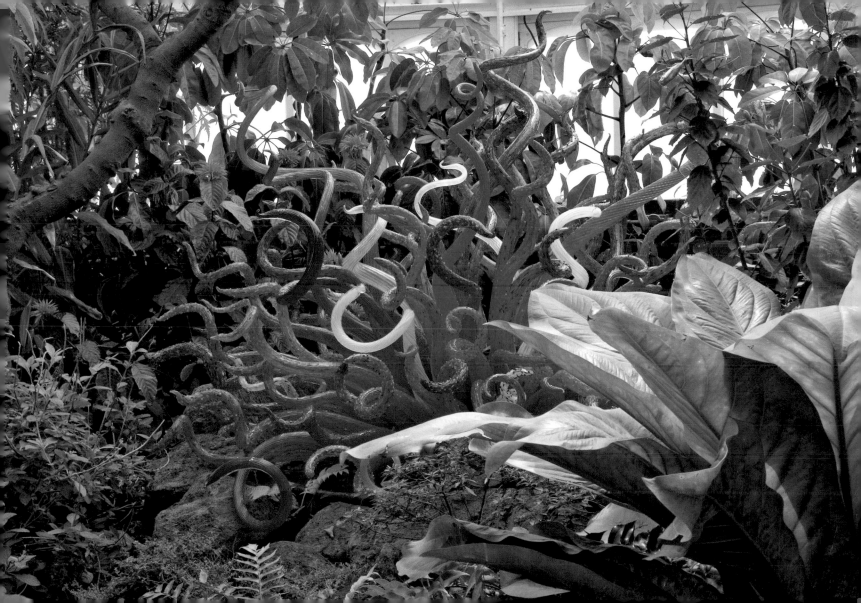

Glass has incredible strength. It's the only material you can really blow. Its raw materials are common and cheap. It's made using sand and fire. And it turns into a liquid. Imagine—the sand turns into a liquid!

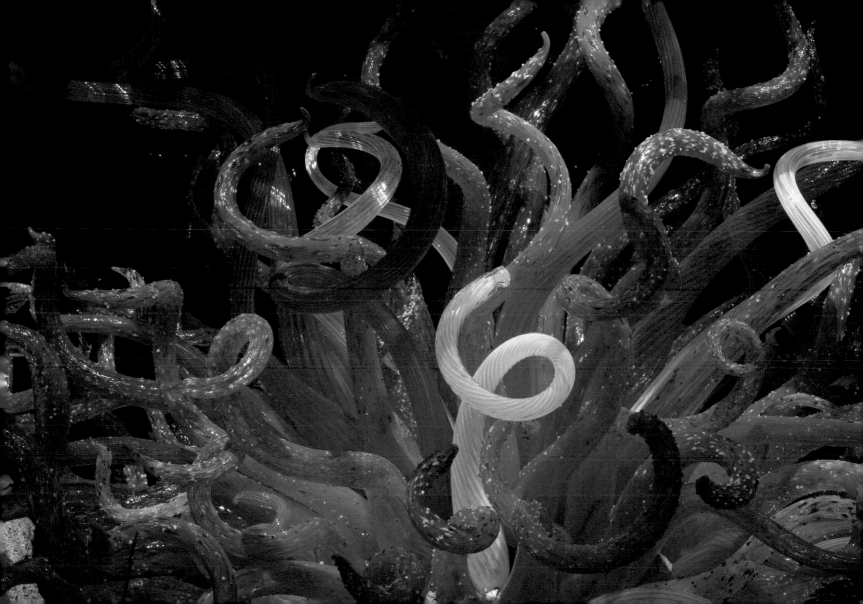

I like the work to reflect quick decisions, the end result being a frozen fluid thought—as direct as a drawing.

Desert Gold Star, 2007,
73 x 53 x 57 inches.
Phipps Conservatory and Botanical Gardens,
Pittsburgh, Pennsylvania

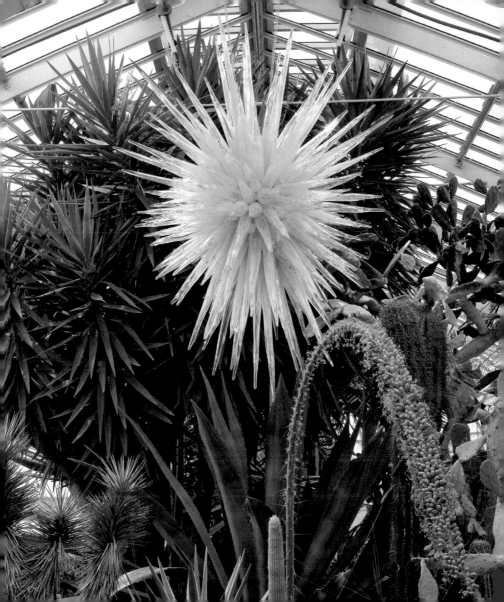

In art, it doesn't make any difference if you get a bad review. If people like it, they'll love it anyway. In theater, if you get a bad review, people won't go.

351

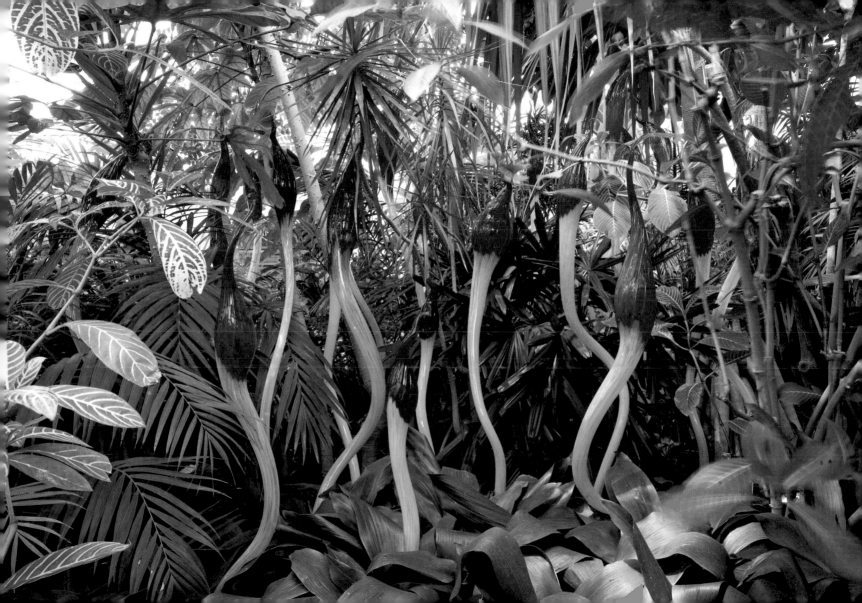

There's a certain amount of collaboration between me and everyone on the team. I work with the glassblowers and I tell the glassblowers what I want, but I also tell them they have to have the right feeling for it. I tell them: "You have to give me your input. You're the ones that are making the parts and each part is different. You have to have the rhythm and the feeling and find your pace. If you see something going a certain way, go with the flow. You have to listen to the glass."

Ferns, 2007.
**Phipps Conservatory and Botanical Gardens,
Pittsburgh, Pennsylvania**

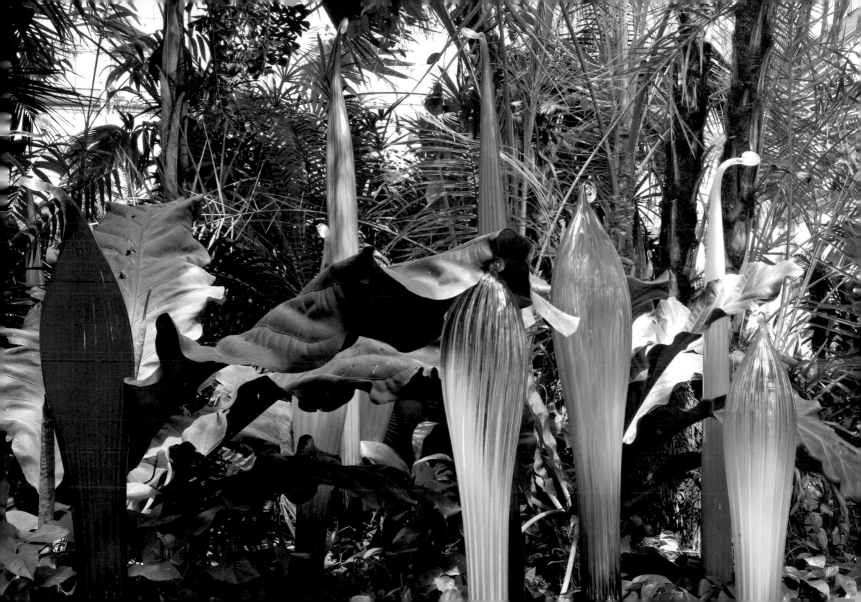

There is nothing even remotely similar to glassblowing, and there is nothing like glass itself. Fire is really the tool—it's the heat of the glory hole, and the heat of the furnace, and the blowtorches, and centrifugal force and gravity opening up these forms.

Violet Tumbleweeds and *Mirrored Hornets*, 2007.
Phipps Conservatory and Botanical Gardens,
Pittsburgh, Pennsylvania

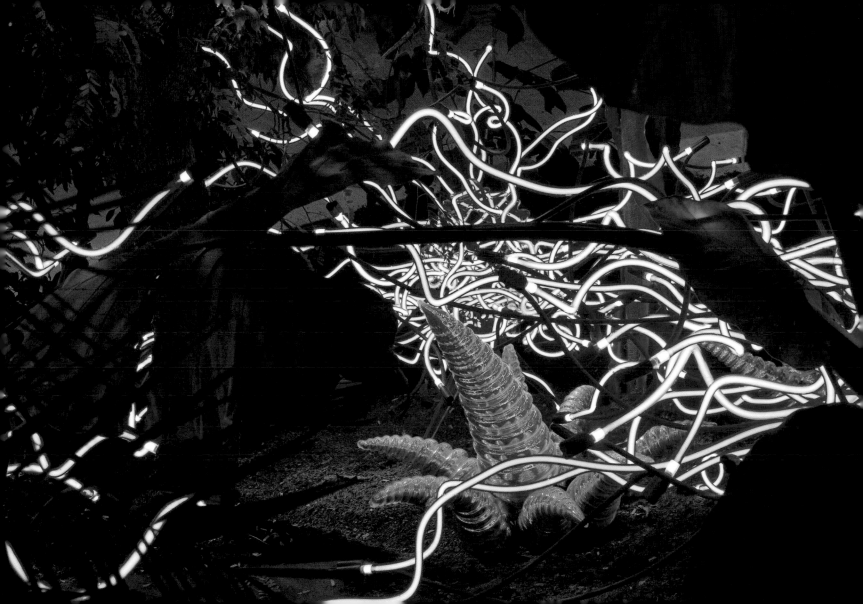

The role models for young people today are athletes, movie stars, rock and roll singers, and that's kind of a sad state of affairs. I like the idea that I can get young people interested in something they can do themselves.

Aquamarine Tumbleweed, 2007,
9 feet 7 inches x 6 feet 10 inches.
Phipps Conservatory and Botanical Gardens,
Pittsburgh, Pennsylvania

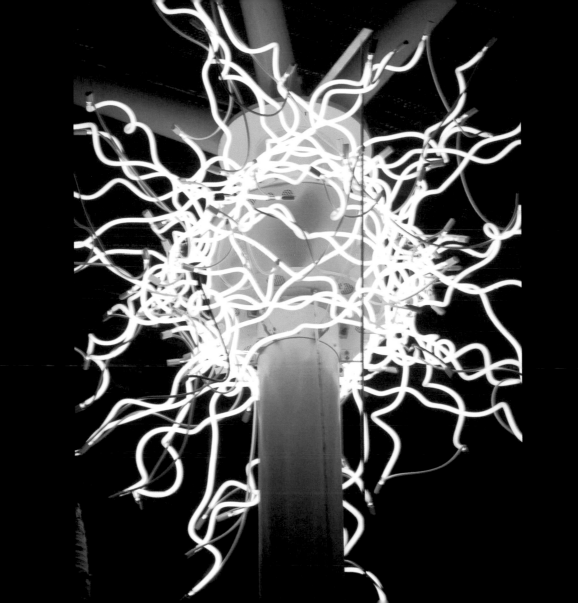

I really feel the only way to learn about art is to be around a working artist. I feel the only way to really learn a craft is to watch a craftsman.

Red Reeds, 2007.
**Phipps Conservatory and Botanical Gardens,
Pittsburgh, Pennsylvania**

355

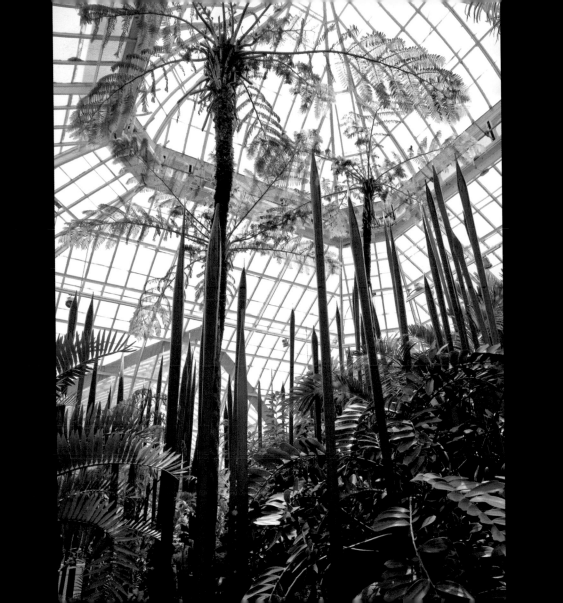

What I've always really been interested in is space. Even when I made a single *Cylinder* or *Macchia*, my interest was always in space. I was thinking not of the object itself, but how the object would look in a room. What I'm looking forward to is opening the ovens in the morning and taking the pieces out and then being able to work with them. Putting them together.

Celadon and Royal Purple Gilded Fiori,
2007, 76 x 40 x 47 inches.
Phipps Conservatory and Botanical Gardens,
Pittsburgh, Pennsylvania

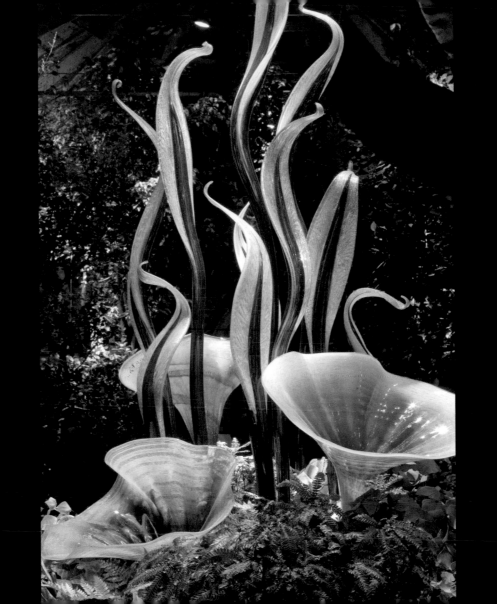

Important ideas come from some flash of hand—some moment—something that you can't describe.

Dark Gold Ikebana with Red Flower,
2001, 45 x 22 x 14 inches.
Phipps Conservatory and Botanical Gardens,
Pittsburgh, Pennsylvania

357

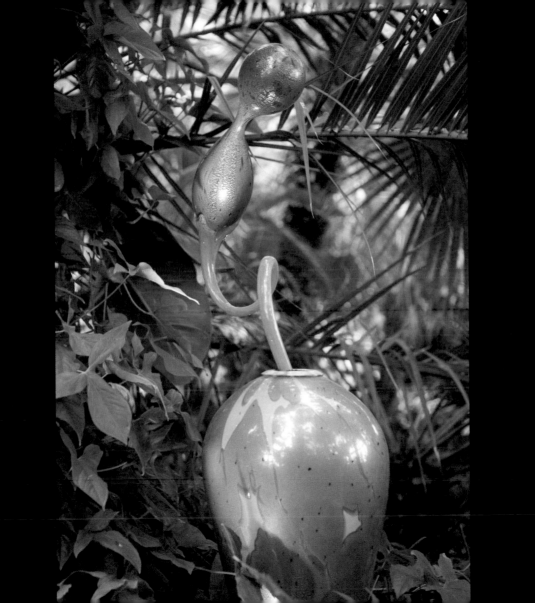

Persians blow, 2006. Museum of Glass, Tacoma, Washington

One thing that Dale always had a remarkable ability to do with the material was to work with it in just a piss-hot, liquid state. Which I always found just fascinating. He just let it run, let it rip in a very loose way, which was really exciting to be around.

Benjamin Moore, *Chihuly Projects*, rough cut of unpublished film by Peter West, 2001

Persian Pond detail, 2007.
**Phipps Conservatory and Botanical Gardens,
Pittsburgh, Pennsylvania**

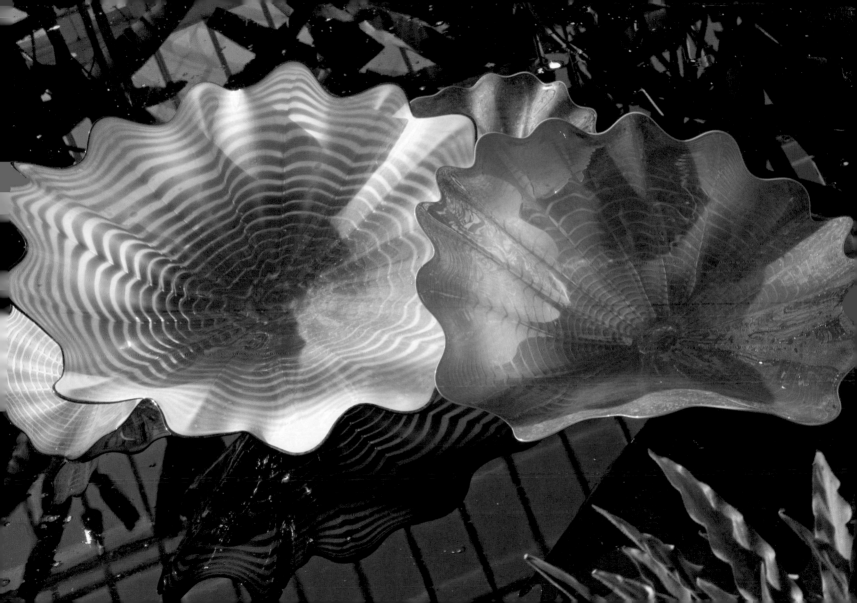

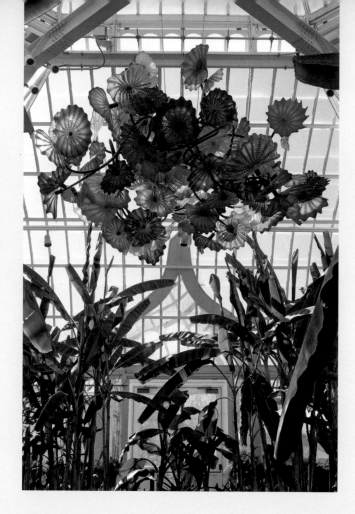

Contrary to popular opinion, which has it that every mortal who has ever seen a piece of glass by Dale Chihuly has melted and slobbered over it like Mencken over an oyster pot pie, Chihuly's art isn't that hard to resist. What you have to do is resist resisting, give in and let it have its way with you.

John Dorsey, "Chihuly's Colorful Works
Are Ultimate Sun Catchers,"
The Baltimore Sun, February 16, 1996

Persian Chandelier, 2007,
7 feet 10 inches x 9 feet 10 inches x 9 feet 4 inches.
Phipps Conservatory and Botanical Gardens,
Pittsburgh, Pennsylvania

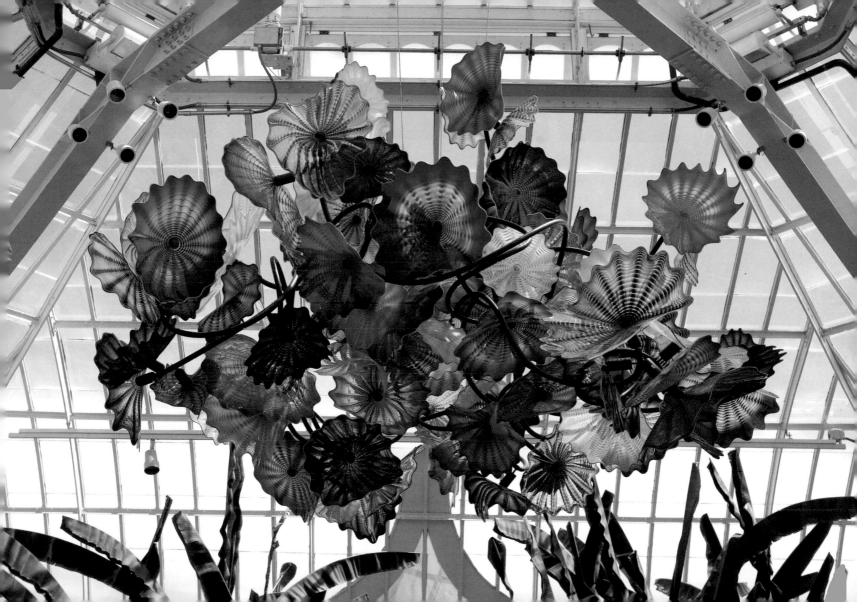

Ectoplasmic presences that seem composed of pure light, but turn out to be nested baskets of the thinnest glass. Shifting from milky translucence to clarity, Chihuly's pieces resemble fog distilled into form.

Chris Waddington, "Chihuly Shines in Lackluster Space,"
New Orleans Time-Picayune, November 15, 1996

Persian Chandelier detail

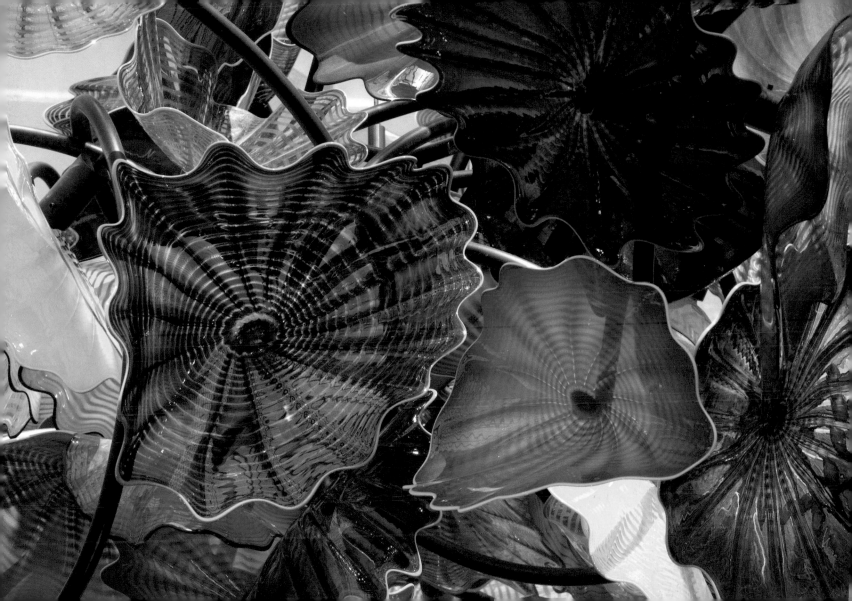

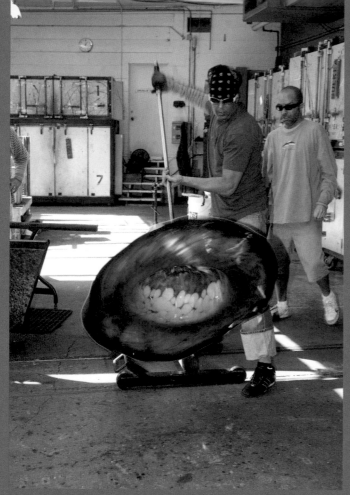

Macchia blow, 2006. The Boathouse, Seattle, Washington

I experimented with putting a layer of "white clouds" over the color. It allowed the color to become completely saturated over a neutral, white backdrop. It also enabled me to have one color on the inside and another color on the outside without any blending of the colors.

Macchia Forest, 2007.
**Phipps Conservatory and Botanical Gardens,
Pittsburgh, Pennsylvania**

361

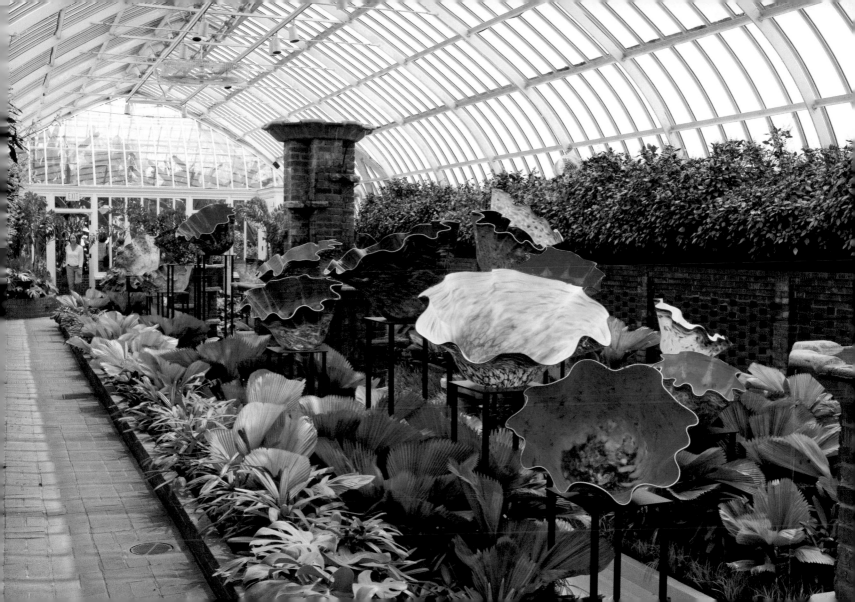

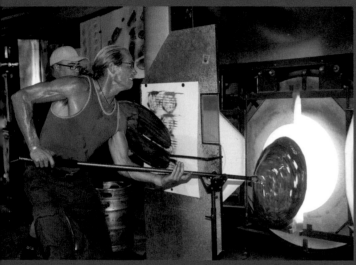

Macchia blow, 2006. Museum of Glass, Tacoma, Washington

I often show the *Macchias* in what we call a *Macchia Forest*, where a half dozen, even fifty of them, can be together on different-size stands. We use one light from above, and they appear to be glowing from below, because the glass sucks in the light and transmits it down into the *Macchia*. When they're on white pedestals, everybody thinks they are being lit from below. But because they're on steel pedestals on legs, you can see that they're really not lit from below. You have to accept the fact that they're lit from above, and you still wonder how the glass could glow and be alive the way it is with one single light.

***Macchia Forest* detail**

362

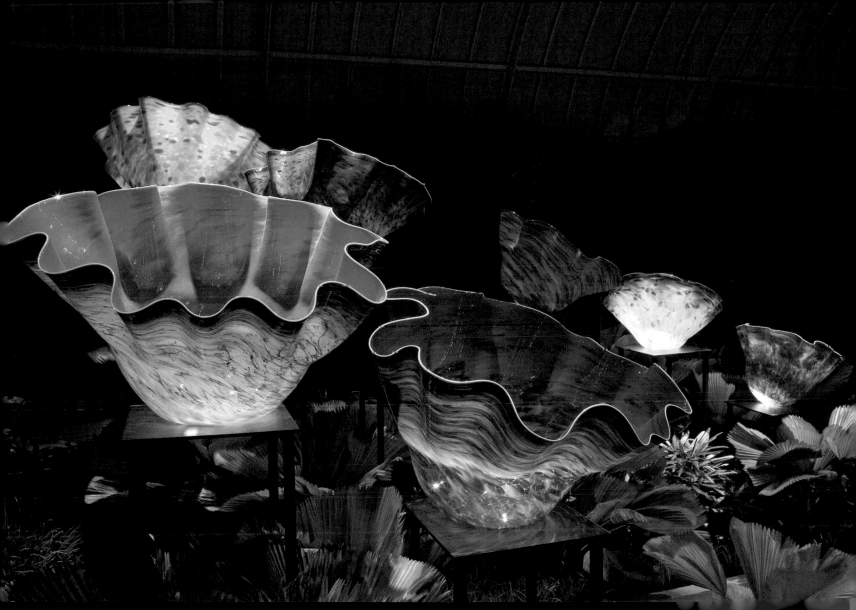

Glass and plastic are the two materials that I most like to work with. A third one, by the way, that's interesting is ice. It also accepts light, not unlike glass, although all three are different. I love to work with any one of them, or work with them in conjunction with one another.

363

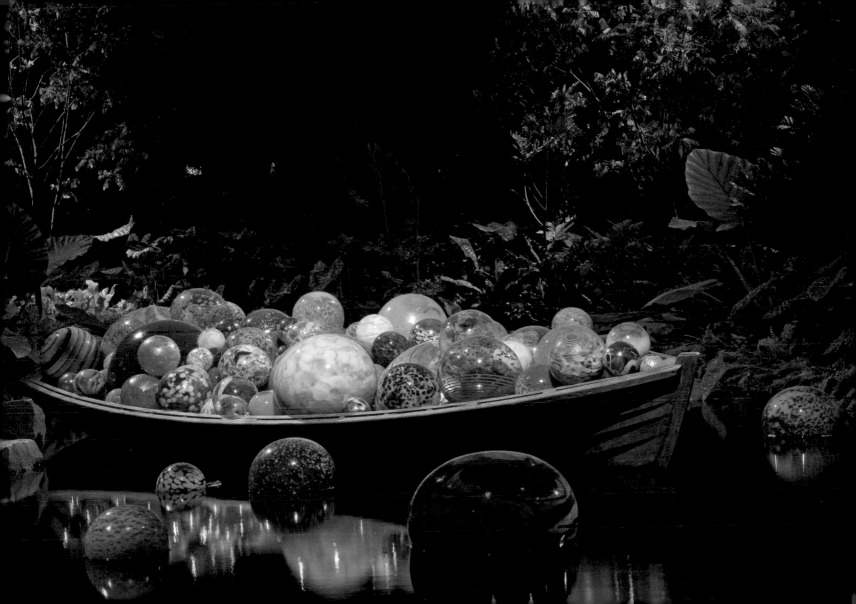

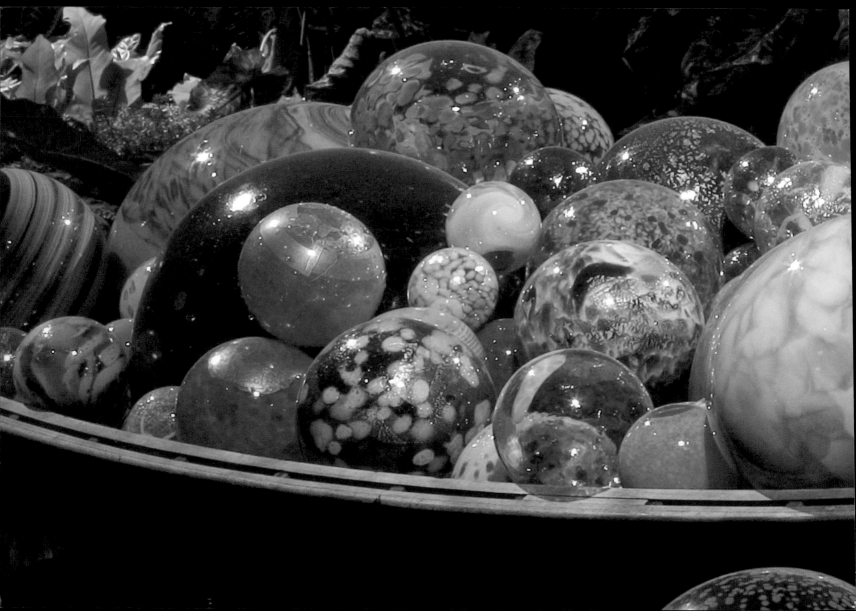

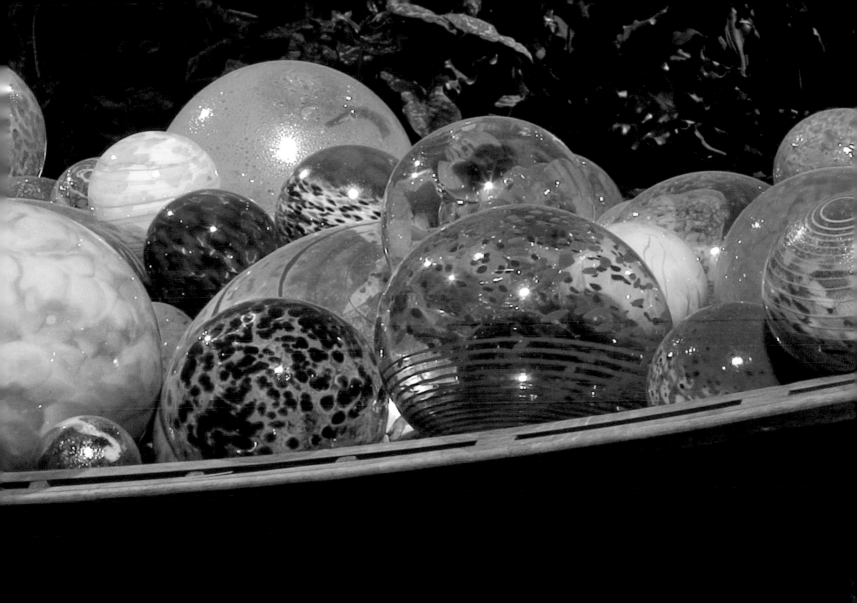

My philosophy is: When one is good, a dozen is better.

Float Boat, 2007,
3 feet x 22 feet 6 inches x 18 feet 8 inches.
Phipps Conservatory and Botanical Gardens,
Pittsburgh, Pennsylvania

364

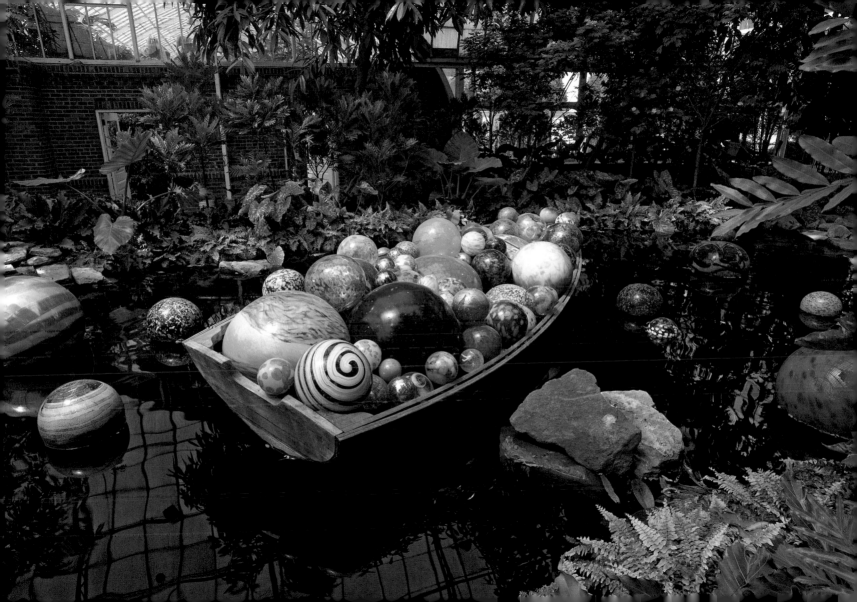

Artists have to be completely unafraid to test the ideas that they have. Artists have to keep pushing the envelope and not be afraid to do what comes to them. That's probably why there are so many cases of artists who lead strange lives. You can't get there without going where your passion takes you.

Palm Court Tower, 2007,
15 feet 10 inches x 6 feet 10 inches x 7 feet 3 inches.
Phipps Conservatory and Botanical Gardens,
Pittsburgh, Pennsylvania

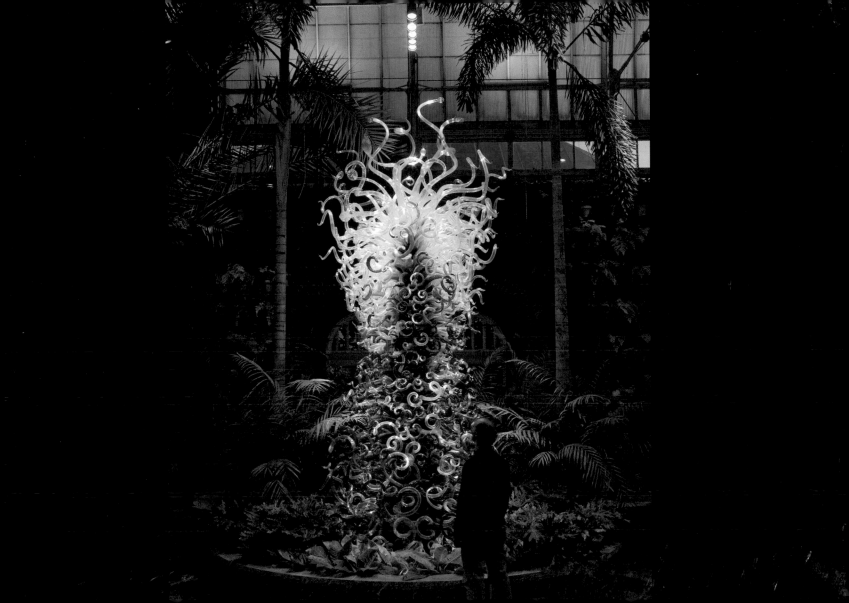

Chihuly with Italo Scanga in Poulsbo, Washington, 1992

I didn't learn from Italo Scanga by watching him make art.
I learned by watching him live.

Editor: Margaret L. Kaplan
Assistant Editor: Aiah R. Wieder
Designer: Laura Lindgren
Production Manager: Anet Sirna-Bruder

Library of Congress Control Number: 2007941846
ISBN 978-0-8109-7088-5

The texts, unless attributed to other sources, are based on various
interviews with Dale Chihuly. The photographs were made by Philip
Amdal, Parks Anderson, Theresa Batty, Dick Busher, Eduardo Calderon,
Shaun Chappell, Edward Claycomb, Jan Cook, Kate Elliott, George
Erml, Ira Garber, Claire Garoutte, Nick Gunderson, Scott Hagar, Russell
Johnson, Robin E. Kimmerling, Corrine F. Kolstad, Scott Mitchell Leen,
Tom Lind, Teresa Nouri Rishel, Terry Rishel, Roger Schreiber, Michael
Seidl, Leon Shabott, Mark Wexler, and Ray Charles White.

HNA ▪▪▪▪
harry n. abrams, inc.
a subsidiary of La Martinière Groupe
115 West 18th Street
New York, NY 10011
www.hnabooks.com

Printed and bound in China
10 9 8 7 6 5 4 3 2 1

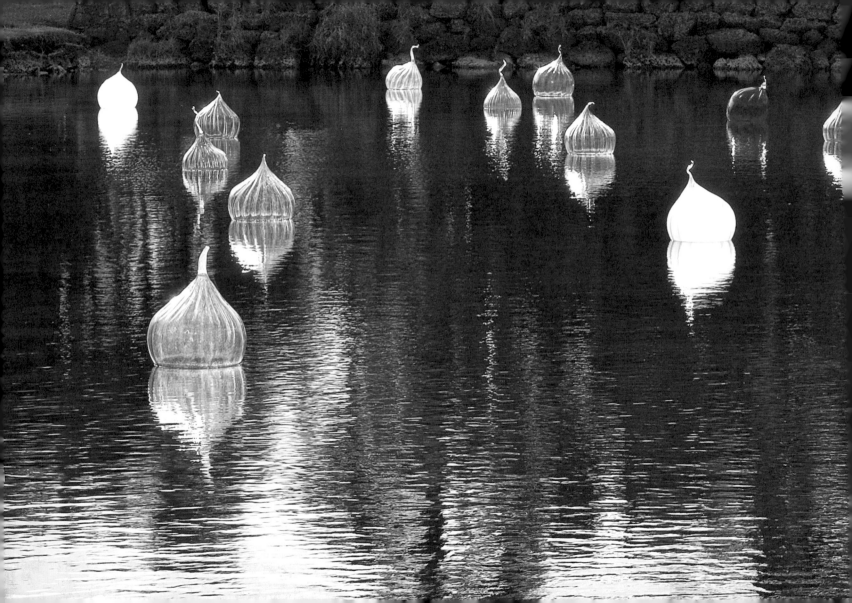